Contemporary Crafts and the Saxe Collection

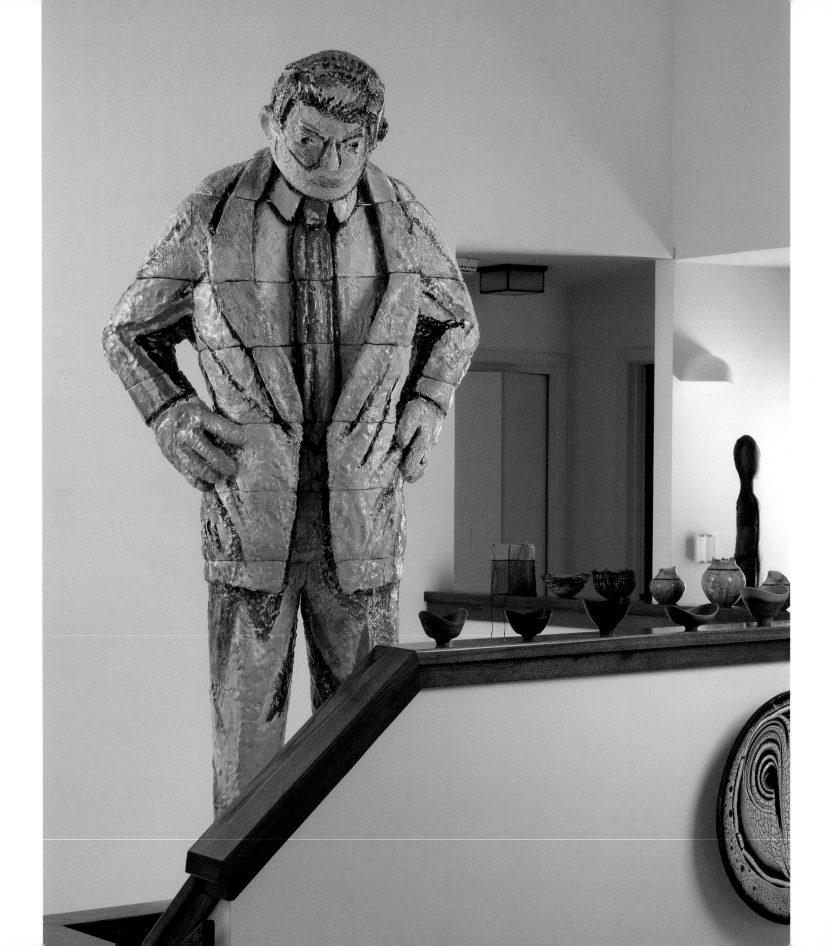

# Contemporary Crafts and the Saxe Collection

**Organized by Davira S. Taragin**

**With essays by Jane Fassett Brite, Edward S. Cooke, Jr., Helen W. Drutt English, Susanne K. Frantz, Martha Drexler Lynn, Laurie A. Stein, and Davira S. Taragin**

**Hudson Hills Press, New York · The Toledo Museum of Art**

First Edition

© 1993 by The Toledo Museum of Art
Box 1013, Toledo, OH 43697

Editor: Terry Ann R. Neff

Distributed in the United States, its territories and
possessions, Canada, Mexico, and Central and South America
by National Book Network, Inc.
Distributed in the United Kingdom and Eire
by Art Books International.
Distributed in Japan by Yohan
(Western Publications Distribution Agency).

Editor and Publisher: Paul Anbinder

Proofreader: Fronia W. Simpson

Indexer: Karla J. Knight

Designer: Howard I. Gralla

Composition: Trufont Typographers

Manufactured in Japan by Dai Nippon Printing Company

Frontispiece:
Viola Frey, *Man Observing Series II*, 1984, whiteware, steel, and cement

**Contemporary Crafts and the Saxe Collection** was published
on the occasion of the exhibition of the same title,
organized by The Toledo Museum of Art and on view there from
September 12 through November 14, 1993.

Exhibition Tour

The Saint Louis Art Museum
December 17, 1993–February 13, 1994

Newport Harbor Art Museum, Newport Beach, California
March 12–June 5, 1994

Renwick Gallery of the National Museum of American Art
Smithsonian Institution, Washington, D.C.
October 28, 1994–February 5, 1995

**The exhibition and national tour are sponsored by
Philip Morris Companies Inc.**

The Toledo Museum of Art, Toledo, Ohio, organizer of
the exhibition, gratefully acknowledges the generous support
provided by Joan and Milton Baxt, Bethesda, Maryland;
Byron and Dorothy Gerson, Franklin, Michigan;
Mr. and Mrs. Ben W. Heineman, Chicago, Illinois;
and Ronald and Anita Wornick, Burlingame, California.

Library of Congress Cataloguing-in-Publication Data

Taragin, Davira Spiro.
Contemporary crafts and the Saxe collection
organized by Davira S. Taragin;
with essays by Jane Fassett Brite . . . [et al.]:
edited by Terry Ann R. Neff. — 1st ed.
p.      cm.
Catalogue of an exhibition organized by the Toledo Museum of Art,
shown there Sept. 12–Nov. 14, 1993, and at other museums.
Includes bibliographical references and index.
ISBN 1-55595-073-6

1. Decorative arts — History — 20th century — Exhibitions.
2. Saxe, Dorothy — Art collections — Exhibitions.
3. Saxe, George — Art collections — Exhibitions.
4. Decorative arts — Private collections — Ohio — Toledo — Exhibitions.
5. Decorative arts — Ohio — Toledo — Exhibitions.
6. Toledo Museum of Art — Exhibitions.
I. Brite, Jane Fassett.   II. Neff, Terry Ann R.
III. Toledo Museum of Art.   IV. Title.
NK535.S28T37   1993
730'.09'04507473 — dc20
93-17546 CIP

# Contents

# Foreword

Glass has figured prominently in the history of The Toledo Museum of Art. The Museum's founder and primary benefactor, Edward Drummond Libbey, was responsible for bringing the New England Glass Company from Massachusetts to Toledo in 1888. Although the Museum today is a general art museum of international distinction in several fields, its first significant collections were of glass. More recently, the Museum was the site of the two 1962 landmark workshops where Harvey Littleton and Dominick Labino demonstrated to artists that glass could be used for individual expression in a studio environment.

As the Museum prepares for its centennial celebration in 2001, it is appropriate to reaffirm its long-standing commitment to glass. Dorothy and George Saxe have played an important role in helping to realize this goal. In 1990 these California residents generously donated to the Museum sixty-three objects from their distinguished studio craft collection. Included in the gift are fifty-seven pieces of contemporary glass, one drawing, three ceramic sculptures, and two turned-wood bowls. Combined with our existing holdings of postwar glass, this gift will enable the Museum to make a cogent statement about the role of the studio glass movement in late-twentieth-century art. We are greatly indebted to both Dorothy and George Saxe for helping us to realize this important aspect of our mission.

The Saxes' decision to make this gift to the Museum resulted from several years of careful deliberation and discussion. Realizing that the acceptance of studio glass within the mainstream of contemporary American art depended to a great extent upon museum involvement in the late 1980s, the Saxes searched for an institution that would make a strong commitment to showing and acquiring contemporary glass. In 1988 Paul J. Smith, the former director of the American Craft Museum, suggested that The Toledo Museum of Art contact the Saxes about its plans to expand the contemporary glass program. Delighted with the institution's focus on the medium and its policy that the glass collection always be available to the public, the Saxes began discussions with the former Museum director, Roger Mandle. My appointment as director in 1989 provided additional encouragement since I came to the Museum with a strong interest in glass that resulted from my tenure as director of the Chrysler Museum in Norfolk, Virginia.

The Saxes' approach to their proposed gift was exemplary: they asked the Museum to choose which examples of glass it most wanted. After careful study, we selected fifty-seven glass objects and one related drawing that would best enhance the existing collection; since the Saxes are collectors of all crafts, we asked that they also consider giving five ceramic and wooden works. These additional gifts will allow us to develop a small but select collection of studio craft objects, providing a broader context for understanding recent developments in glass.

Since the general policy of the Museum is to focus on established rather than emerging talent, we chose works by those artists working in glass who had largely trained in the 1960s and 1970s and were doing mature work by the 1980s. Wherever possible, we tried to focus on artists whose work was already represented in the Museum, so that ultimately the collection will document the evolution of the studio glass movement through an examination of the work of certain key figures. Consequently, some artists are represented in this exhibition and book with several pieces from different periods. Since the Museum believes strongly in the interrelationship of all the arts, some works additionally demonstrate the connections between recent developments in glass and contemporary trends in other media. We have thus also been exhibiting some of the pieces in our twentieth-century galleries.

One of the most rewarding aspects of working with the Saxes has been sharing in their deep interest in all the crafts. Since they have chiefly been associated with glass, we thought it appropriate to organize an exhibition that shows the extent of their wider pursuit of studio crafts.

I would like to thank Davira S. Taragin, Curator of 19th and 20th Century Glass, for organizing this exhibition and its accompanying publication. Her insights, enthusiasm, and humor have made this project exciting for all of us in the Museum. I am delighted that the exhibition will travel to three other American museums, and would like to acknowledge the help of the following individuals: Cara McCarty, The Saint Louis Art Museum; Bruce Guenther,

Newport Harbor Art Museum; and Michael W. Monroe, Renwick Gallery of the National Museum of American Art, Smithsonian Institution, Washington, D.C.

The Toledo Museum of Art is especially grateful to the *Philip Morris Companies Inc.* for its support of the exhibition and national tour. We also gratefully acknowledge the generosity of the following patrons of contemporary crafts: Joan and Milton Baxt, Byron and Dorothy Gerson, Mr. and Mrs. Ben W. Heineman, and Ronald and Anita Wornick.

Finally, I would like to express my warmest appreciation to Dorothy and George Saxe. Their passion for the objects and their belief in the artists have been an inspiration for us all. It is very fitting that such patrons be honored in 1993, the year that has nationally been proclaimed "The Year of American Craft."

*David W. Steadman*
*Director*

## Preface and Acknowledgments

Dorothy and George Saxe's gift of sixty-three studio craft objects to The Toledo Museum of Art in 1990 came at a propitious moment. The end of a century often heralds a time of reckoning and evaluation. In the year 2000 the studio craft movement will be a half-century old. It had its origins in the postwar period as a reaction against an earlier focus among craftsmen on material and function. Within the past decade alone, established masters have achieved new levels of expression while university studio programs continue to bring forth fresh talent. The public's acceptance of contemporary crafts and the financial support that collectors' patronage provided for individual craft artists through acquisitions have played enormous roles in encouraging quality work. Great advances have been made toward establishing a system of professional dealers, publications, and museum exhibitions, although more remains to be done. As we anticipate a new century and fresh opportunities, it is appropriate to examine the factors and events that have brought about the changes in attitude toward crafts that have occurred since the middle of the century.

The collection of Dorothy and George Saxe offers an excellent point of departure for such a study. As members of the generation of craft collectors who emerged in the 1980s, the Saxes became involved in collecting as a result of two seminal museum exhibitions in 1979: "New Glass: A Worldwide Survey" and "A Century of Ceramics in the United States, 1878–1978." As frequently happened with collectors in their generation, the Saxes responded first to glass and clay. Later, as their awareness of other media increased through dealer and museum exhibitions, they began to acquire jewelry, baskets, and some furniture and turned-wood objects. In those areas in which the Saxes see themselves as collectors, they have adhered to the established approach of the fine-arts world by buying from dealers rather than relying upon their personal contacts with artists — the latter being the more traditional approach within the craft world.

In some respects, with their patronage of young artists who have achieved stardom within a short period of time, the Saxes epitomize the generic contemporary art collector of the 1980s. As a result of their extensive travels and high visibility, they have become celebrities within the field, frequently influencing their fellow collectors. Indeed, an analysis of the Saxes' collecting patterns sheds light on the overall dramatic changes that have occurred in the art marketplace, especially in crafts, during the past ten years.

Although a private collection is almost always a personal statement, studies of art patrons can provide important insights into the cultural milieu. It is hoped that this publication will contribute such insights, and additionally will stimulate further research into crafts patronage and the public and private collections formed before and since World War II.

The organization of an exhibition of this scope requires the active participation of many. The success of this book is due primarily to the tireless efforts and thoughtful analysis of Terry Ann Neff, who willingly assumed its entire editorial coordination. Because critical evaluation of studio crafts at this time is difficult, as the movement is only now reaching maturity, one is particularly rewarded by the fresh insights that authors Jane Brite, Director and Curator, Walker's Point Center for the Arts; Edward S. Cooke, Jr., Charles F. Montgomery Associate Professor, History of Art Department, Yale University; Helen W. Drutt English, Founder/Director, Helen Drutt Gallery; Susanne K. Frantz, Head of Curatorial Department/ Curator, 20th Century Glass, The Corning Museum of Glass; Martha Drexler Lynn, Assistant Curator, Decorative Arts Department, Los Angeles County Museum of Art; and Laurie Stein, Curator, Werkbund-Archiv, Berlin, have brought to their essays. Paul J. Smith's comments on several of the essays were particularly helpful in placing some recent developments within a historical context. Barbara Snelling is to be commended for her assistance in the preparation of the checklist and bibliographic references. Tim Thayer and Robert Hensleigh are responsible for the sensitive photographs of the works in the exhibition. Elisabeth Cornu and members of the staff of the Objects Conservation Laboratory of the Fine Arts Museums of San Francisco are to be acknowledged for their coordination of the conservation of objects in this exhibition. Finally, I am grateful to Paul Anbinder, President of Hudson Hills Press, for his early interest in and commitment to this publication.

My efforts in preparing this catalogue and organizing the accompanying exhibition have been met with continual support and guidance from Director David W. Steadman and the staff of The Toledo Museum of Art. I would particularly like to thank Roger Berkowitz, Deputy Director, and Robert Phillips, Chairman of the Curatorial Department, for their advice and assistance during this entire project. Special gratitude is also due the Museum's library staff, Anne Morris, Judy Friebert, and Margaret Buhl, for their diligence in researching the careers of the artists represented in this publication. Kimberly Oberhaus provided outstanding support in the areas of typing and logistics.

Other members of the staff who provided invaluable assistance on the exhibition include (Development) Joan Babkiewicz, Margot Campos, Ross Pfeiffer, Cindy Rimmelin, Vickie Souder, Yanula Stathulis, Holly Taylor, Barbara Van Vleet; (Curatorial) Jeff Boyer, David Cutcher, Steve Frushour, John Henry Fullen, Sandra Knudsen, Darlene Lindner, Lee Mooney, Steve Nowak, Tina Trettin, Austin Tuttle, John Wachholz, Patricia Whitesides; (Education) Karen Giles, Marilyn Mavis, Claire Schaefer, and Stef Stahl; (Operations) Crist Bursa; (Performing Arts) Joyce Smar.

During the first stages of this project, the research and documentation of the Saxe Collection prepared by Louise Gregory proved invaluable. The aid provided by Barbara Harpell, Assistant to George Saxe, in updating this information and for handling on a regular basis the authors' inquiries about the collection has been essential to the success of the project. Over the past three years, numerous inquiries have been sent to artists, dealers, collectors, colleagues in other museums, and other individuals in the art world. It is not possible to list all of those with whom we have corresponded. However, I would like to take this opportunity to express my warmest appreciation to the many artists represented here who were so helpful in providing information about their work. Enormous thanks must also be extended to the numerous dealers contacted who not only have contributed to the growth of the field but continue to be leaders today. Finally, I would like to thank the many collectors who have been so willing to share their experiences in acquiring crafts. In addition to these many individuals, special thanks are to be extended to Roxanna Beatty and Robert M. Tilendis for their work with Ms. Neff on the preparation of the manuscript. I also would like to acknowledge the following for their help with research for the checklist: Gail Bardhan, Norma Jenkins, and Virginia Wright, Rakow Library, The Corning Museum of Glass; Mary Hujsak, American Craft Council Information Center; Signe S. Mayfield, Palo Alto Cultural Center; Tim Pogacar, Bowling Green State University; Carol Sedestrom Ross, American Craft Council; and Doris Stowens, American Craft Museum.

Of all of those who have worked on this project, I would like to express my deepest thanks to Dorothy and George Saxe. Over the past few years as I have worked steadily with them, I have been amazed and delighted by their overwhelming love for contemporary crafts and by their desire to see and learn yet more. Convinced that the studio craft movement is exceptionally fortunate to have two such devoted patrons, I am most grateful to have had the opportunity to work with these remarkable people.

*Davira S. Taragin*
*Curator, 19th and 20th Century Glass*

# Studio Craft Comes of Age

*Davira S. Taragin*

Like Dorothy and George Saxe, many American collectors who began building studio craft collections in the 1980s found themselves in a rapidly changing marketplace. During the 1940s, 1950s, and 1960s, which are now considered the early days of the studio craft movement, people bought crafts because they liked handcrafted objects or wished to help the artists. At first they acquired ceramics, jewelry, and a little furniture, and later, some glass; fiber, because of its fragility, was not purchased extensively for the home. Since few galleries showed contemporary crafts, purchases were generally made directly from the artists. The few museum exhibitions at the time that focused on contemporary crafts were usually regional juried shows. Above all, objects were never purchased for investment.

While the intervening years brought moderate changes to the marketplace, the craft world since 1980 has undergone significant changes, prompted perhaps by an increased interest in all the arts, including photography and graphic arts. The network of galleries, craft shops, and fairs promoting contemporary crafts, especially glass and ceramics, has expanded considerably in response to the growing body of work being produced by the trained craftspeople who have emerged, particularly in the 1970s, from university-sponsored degree programs. The steadily growing number of museum and gallery exhibitions, publications, and media-related periodicals has helped to focus attention on particular artists or media. This increased visibility has led to the emergence and identification of more people who classify themselves as collectors. Higher prices for objects and the ability of certain collectors to compete successfully on a regular basis in the escalating market have given celebrity status to some of these collectors as well as to the artists. Since the world of the crafts collector has changed so radically during this century, it is appropriate first to look at the milieu in which the early patrons in the postwar period became exposed to the transformation occurring in the crafts, and then examine the factors that over the past fifty years have made these objects into sought-after commodities.

The collector of the 1990s and the person who bought contemporary crafts in the 1950s share one common characteristic: both have pursued objects made by university-trained artists who have resented the inferior status that for many years has been accorded the handmade object. Since the break-up of the various artisans' guilds in the middle of the seventeenth century, painters and sculptors have tried to distance themselves from their colleagues, the craftspeople, by claiming an intellectual basis for their work over the artisans' reverence for materials and technique. Beginning in the mid-nineteenth century, the establishment of separate departments for the fine and applied arts in public art museums further reinforced the distinctions between the arts. Over the past 150 years, there have been numerous movements and schools, primarily in Europe, such as the Arts and Crafts movement, the Wiener Werkstätte, and the Bauhaus, that have fostered the elevation of the status of the craftsperson through an interdisciplinary approach to the arts; yet, the Industrial Revolution and, in this century, the presence of strong advocates for industrial design, such as The Museum of Modern Art in New York, have generally been responsible for craft's remaining a second-class citizen through the middle of this century.[1]

Any recent change in attitude toward the crafts can be attributed to the educational system in the United States. Although they ultimately were destined to train students to design for industry, schools such as the Cranbrook Academy of Art in Bloomfield Hills, Michigan, and the New Bauhaus in Chicago, with their European-trained faculty, encouraged in the 1920s and 1930s Bauhaus ideals regarding the relationship between art and life and, therefore, the equality of all the arts. At Cranbrook and Black Mountain College in North Carolina, crafts were part of the curriculum along with architecture and design. However, the real impetus in America for the revolution in thinking about the crafts resulted from the passage in June 1944 of Public Law 346, also known as the G.I. Bill, which provided an educational opportunity in the form of tuition, fees, and subsistence allowances for servicemen returning from World War II. According to the craft artist Ronald Hayes Pearson, these "servicemen were disillusioned with a mass type society: they wanted to lead a more meaningful life, and the craft field offered them some potential of this."[2] The G.I. Bill allowed veterans interested in the crafts to receive academic training in pro-

grams comparable to those of their counterparts in the "fine arts." Exposed to the same ideas as other art students, these craftspeople began to deemphasize function and the reverential treatment of materials — characteristics of American crafts of the prewar period — in favor of more innovative techniques and the conceptual concerns of contemporary painting and sculpture. In these environments, they often lost sight of the history of decorative arts, which was rarely taught. Instead, convinced that recognition for their work could come only by their making nonfunctional objects, many began to demand classification of their work as sculpture rather than as decorative arts or crafts.

This revolutionary approach to the crafts in America coincided with the blossoming of similar activity in Europe. Generally, the shift affected all the craft media at different times from midcentury through the 1970s, occurring in this country first in metal, fiber, and clay, and later in wood and glass. Known as the studio craft movement, it has manifested itself largely in unique or limited-edition works created primarily in small studio environments or in university programs. When industrial environments are used, the artist relies on technology primarily for the fabrication of his or her ideas.

The relationship between the consumer and maker has generally been an important factor in encouraging people to acquire crafts. Consequently, American collectors have made most of their acquisitions within this country. Until the mid-1970s, many of those acquiring contemporary crafts never considered themselves collectors or patrons of a particular art form or movement; they remained anonymous or known only to the artists from whom they purchased work. Some were motivated by a desire to help their friends, the artists; a few were so continually supportive that the artists reciprocated by giving them works to enjoy.

Of the few known early craft collectors, Fred and Mary Marer of Los Angeles are most frequently cited for their altruistic sincerity in helping the artists. The Marers' ceramic collection of approximately 250 works developed directly from Fred Marer's personal relationship with the artists working either with Peter Voulkos or elsewhere in Southern California beginning in the 1950s.[3] Ceramic sculptor Jun Kaneko recalls that over the years he gave the couple a number of his works as a way of expressing his appreciation for their kindness. Installation of the collection was not important to the Marers. According to Kaneko, "One-half of the collection was jammed into the house. The two garages in the back were jammed, and when they couldn't jam any more in those spaces, they put things in the closets."[4]

Marer's propensity to acquire works directly from the artists was typical of the early studio craft world. In fact, today's craft market had its beginnings in grass-roots marketing schemes. Most artists simply tried to sell work out of their studios. They would pass along to colleagues the names of individuals interested in seeing other crafts. Local guilds and artists' cooperatives tried even as early as during the Depression to reinforce these artists' efforts by organizing fairs and exhibitions and establishing retail shops. At first these efforts were very few in number, increasing gradually over the years.

Since initially there was very little contact among the various craft organizations, each group determined its own approach to marketing and inventory. For instance, the Southern Highland Handicraft Guild and the Southern Highlanders, Inc., which combined in 1950 to promote both the traditional and contemporary crafts of seven Southern Appalachian states, had retail stores at various times in Washington, D.C., and New York, as well as in North Carolina; they offered wholesaling services from a New York address.[5] On the other hand, the League of New Hampshire Craftsmen (for a period known as the League of New Hampshire Arts and Crafts), an organization consisting of all the craft cooperatives in the state, focused its energies on setting up stores in various locales throughout New Hampshire so that crafts by resident artists were readily available for purchase. Although the league initially handled reproductions of traditional handcrafted objects, David Campbell, its president from 1939 to 1962, was instrumental in encouraging more innovative studio craftspeople, such as the potters Edwin and Mary Scheier, to move to New Hampshire.[6] It should be noted that Campbell was so successful in promoting contemporary crafts while he was at the league that in 1959 he became president of the American Craftsmen's Council (later known as the American Craft Council) and, a year later, director of New York's Museum of Contemporary Crafts.

A 1951 guide to crafts in this country, written by Dorothy Glazer, advised craftspeople to attend the fairs organized by the Society of Vermont Craftsmen, the Southern Highlanders, Inc., and the League of New Hampshire Arts and Crafts even if they were not exhibiting, since the shows contained "the best of the work being done. . . ."[7] In general, the early fairs, such as the Midwest street fairs, the Pacific Arts and Crafts Fair of Bellevue, Washington (begun in 1947), and those organized by East Coast guilds and artists' cooperatives were the most popular and lucrative of all the early marketing strategies. Customarily held in fixed locations during the summer months, many of these fairs followed the same

format as the League of New Hampshire Arts and Crafts' annual fair that first took place in 1932. They catered to the retail trade, selling lower-priced ceramics as well as jewelry.

Aware of the lack of communication among the various craft guilds and, above all, among the craftspeople themselves, the East Coast philanthropist Aileen Osborn Webb founded in 1939 the Handcraft Cooperative League of America to provide a central marketplace and a unified voice and clearinghouse for information on the crafts. By 1960 her marketing and promotional network in support of the crafts consisted of America House, the foremost sales outlet for crafts in the United States from 1940 to 1971; the School for American Craftsmen, which offered a professional curriculum leading to both undergraduate and graduate degrees; the Museum of Contemporary Crafts (now known as the American Craft Museum), the first museum in this country devoted to contemporary crafts; *Craft Horizons* (now *American Craft*), one of the leading magazines in the field, recognized for its documentation and promotion of the studio craft movement; and, naturally, the American Craft Council, which, at various times and under a variety of names, has served as the umbrella organization for these and other activities. For many years this loosely connected group of organizations was the primary source on the national level for learning about and even purchasing studio crafts.[8]

During its thirty-year lifespan, America House occupied a critical place as the principal store in New York devoted exclusively to the sale of studio crafts (see fig. 1). Initially begun as a market outlet for the members of the various

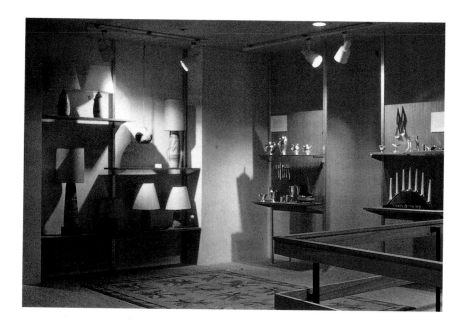

organizations that comprised the Handcraft Cooperative League of America, over the years America House has carried merchandise by the leading craft artists in this country.

Managed at first by Frances Wright Caroe, the daughter of Frank Lloyd Wright, it tried continually to improve and refine its program, even instituting in the 1960s a "Collector's Room for serious collectors of American craft" and an architectural and design service intended to match artists with potential commissions.[9] Particular emphasis was placed on improving the quality of the ceramics and jewelry, since they were the most popular items. Unfortunately, despite all these efforts, America House closed in 1971, amidst a controversy over the kind of work it sold. Ronald Hayes Pearson recently summarized the impact of its demise on those who benefited most from it, the artists. He noted, "It was the one place in the United States where a visitor to this country could see what was being done here. There has been nothing quite like it since."[10]

For many early patrons of studio craft, *Craft Horizons*, particularly during the tenure (1959–79) of editor Rose Slivka, and the exhibition program of the Museum of Contemporary Crafts served as the main sources of information about the field. Under the leadership of the directors Thomas S. Tibbs (1956–60), David R. Campbell (1960–63), Paul J. Smith (1963–87), and Janet Kardon (1989 to the present), the museum has organized a wide range of exhibitions. Many of those having long-term impact were organized during Smith's stewardship. In retrospect, some of the most noteworthy shows include the one-person exhibition of the work of furniture artist Wharton Esherick (1959); the retrospective exhibitions of the weaver Dorothy Liebes (1970) and ceramic sculptor Peter Voulkos (1978); and pioneering surveys such as "Designer-Craftsmen 1960," "Woven Forms" (1963), "Clay: New Ceramic Forms" (1965), "American Glass Now" (organized in 1972 in conjunction with The Toledo Museum of Art), and "New Handmade Furniture: American Furniture Makers Working in Hardwood" (1979).

Yet, it was the "Young Americans" show, initiated in 1950 to "stimulate interest in the work of the rising generation of American craftsmen,"[11] that evolved into the American Craft Council's most important ongoing program. This series has introduced the work of such leading craftspeople as furniture artist Wendell Castle; ceramists Andrea Gill, Wayne Higby, and Michael Lucero; fiber artist Gerhardt Knodel; and glass artists Richard Marquis and Steven Weinberg.

The information disseminated by the American Craft Council's programs was enhanced substantially in the

1940s and 1950s as the popularity of regional juried museum shows increased. One of the oldest and most highly respected is The Cleveland Museum of Art's "Annual Exhibition of Artists and Craftsmen of the Western Reserve," commonly known as the "May Show." Begun in 1919, this exhibition has always included work in all media by local established and emerging artists.[12] Over the years it evolved into an important source for buying crafts. Paul J. Smith recently recalled that sales were very active, with shows sometimes selling out immediately. Those who purchased works at these shows were always given special consideration. For instance, during the Depression the Pick-Quick Club was established to enable its members to place an option to buy on at least one object in the show before it officially opened; later, this club was replaced by preview parties held prior to the opening receptions.[13]

Beginning in the 1940s Cleveland's idea was emulated by both university and general art museums. Some of the most significant early shows were the Memorial Art Gallery's "Rochester Finger Lakes Exhibition," instituted in 1941; the Wichita Art Association's "Decorative Arts—Ceramic" exhibition, begun in 1945; The Detroit Institute of Arts' "Michigan Artist-Craftsmen" exhibition, established in 1946; the St. Paul Art Center's noted "Fiber-Clay-Metal" show, started in 1952; and the University of Kansas's "Designer-Craftsman Annual," dating from 1954. Generally, throughout the 1960s, ceramics, fiber, and, to lesser degrees, jewelry, holloware, and enameled objects accounted for most of the work in these shows; furniture was usually too expensive to ship.[14] In addition to these museum-sponsored, often low-budget shows, some craft organizations such as the Midwest Designer-Craftsmen and the Wisconsin Designer-Craftsmen regularly joined with museums in getting together juried shows of their members' work; at times these were circulated nationally by traveling exhibition services offered by the Smithsonian Institution or The American Federation of Arts. Besides these annual or biennial events, early collectors such as Robert L. Pfannebecker of Pennsylvania recall that the "California Design" shows organized by Eudorah Moore for the nonprofit organization California Design were very important sources of information; from 1955 to 1976 these shows presented through juried and invitational sections the state's accomplishments in the crafts as well as in mass-produced designs for the home.

By the late 1950s there were some cities where one could see a relatively broad spectrum of contemporary crafts. Activity usually concentrated around universities that were developing active craft programs. For instance, California was ripe in the late 1940s for the revolution that was beginning. According to a 1948 survey of the impact of the studio craft movement in the areas west of the Mississippi,

> California is the land of plenty of craftsmen. We found the California craftsmen particularly easy to talk with about marketing: they are more professional in their approach to their work than craftsmen in other regions. . . . The outlets for craftsmen are many and varied. San Francisco is outstanding in the representation of craft work in local shops.[15]

By the late 1950s the large number of university programs in ceramics had increased dramatically the availability of work. The state's art centers and museums responded to the new energy by organizing numerous one-person and survey shows of California crafts. In San Francisco exemplary crafts programs were developed by the department store Gump's, and small shops such as Nanny's Design in Jewelry became nationally known.[16]

When California's commercial contemporary art galleries began to develop in the late 1950s and early 1960s, they naturally responded to the new directions in the crafts. Coming from a tradition of alternative spaces that showed avant-garde art, many of the first professionally managed galleries, such as Ferus in Los Angeles, and Dilexi, Hansen-Peterman (shortly thereafter known as Hansen), and Quay in the Bay Area, sought to present the most dynamic work being done on the West Coast. For individuals such as Ruth Braunstein, Wanda Hansen, Walter Hopps, and James Newman, that mission meant exhibiting the exciting work that was emanating from the Otis Art Institute, where Peter Voulkos and his students were applying Abstract Expressionist principles to clay, as well as the Funk ceramics being produced at the University of California, Davis, under the direction of Robert Arneson.[17] Today the impact of galleries that showed clay in the 1960s can be found in the major West Coast collections formed during the period, such as those of Byron Meyer, Ed and Ruth Nash, and Rene DiRosa, which combine works in a variety of media. Interestingly, contemporary developments in fiber that were occurring in art centers and schools throughout the state during the decade were rarely shown at these spaces. Therefore, Ruth Braunstein's early support of the work of the fiber artist Dominic Di Mare is particularly commendable.

New York was also a pocket for sales activity in the 1940s and 1950s. In addition to America House, work by American artists was available through a few small, highly respected craft shops, such as Rabun Studios on East 67th Street. Several painting and sculpture galleries, such as Bertha Schaefer, did organize shows of craft media, with a particular emphasis on clay, as early as the 1950s. Finally, contemporary design stores specializing in Scandinavian

and mass-produced objects also gave considerable exposure to the crafts.

Of the two major Scandinavian design stores in New York at the time, Bonniers actually had a more active American crafts program than did Georg Jensen. Under the leadership of its president, Goran Holmquist, the former sponsored a few innovative one-person shows, including exhibitions of the work of ceramists Peter Voulkos (1956), Marguerite Wildenhain (1957), and Shoji Hamada (1963), and a survey of European and American contemporary ceramics (1959) that actually filled two floors of the store. Holmquist displayed pieces by the British ceramists Hans Coper, Bernard Leach, and Lucie Rie, and the Americans Karen Karnes and Robert Turner, as well as by metalsmiths such as Ronald Hayes Pearson. Holmquist bought directly from the artists rather than taking work on consignment. He also actively promoted the craft objects that the store sold, for example, arranging Karnes's functional planters and centerpieces in several storefront windows during the 1950s and early 1960s.[18]

Metropolitan Rochester, New York, the location of the School for American Craftsmen since 1950, also occupied a unique position within the history of the craft marketplace since it was the site of Shop One, one of the very few places in the United States in the 1950s to sell only quality work by avant-garde craftspeople. Never intended as an artists' cooperative, Shop One was founded in 1952 as a sales outlet for its four founding members, metalsmiths Pearson and John Prip, cabinetmaker Tage Frid, and ceramist Frans Wildenhain. Because of increasing interest and demand for high-quality objects, the work of twelve additional local craftspeople and examples of Scandinavian design were added to the inventory. In later years craft items were brought from all over the country for the shop. Shop One finally closed in 1977 after its original members had moved away and a different type of merchandise was instituted.[19]

Important changes to the marketplace began to occur in the late 1960s. First, more quality craft shops opened. Pioneering endeavors like Atlanta's Signature Shop, which opened in 1961, were joined by Betty Scheinbaum's Galeria del Sol in Santa Barbara, California; The Works in Philadelphia; The American Hand in Washington, D.C.; the Egg and the Eye in Los Angeles (later to become the Craft & Folk Art Museum); and others. Next, respected painting and sculpture galleries such as Allan Stone, Zabriskie, and Lee Nordness Galleries in New York and Yaw Gallery in Birmingham, Michigan, started showing work by artists who used craft media. Finally, the availability of crafts received an enormous boost with the inauguration of the annual American Craft Council fair.

These fairs, the first to encourage wholesale trade, became the main source for crafts in the 1970s.

Established in 1966 by one of the council's regional organizations, the first fairs were several-day juried events during which council members, primarily from the Northeast, could sell their work to both the public and the wholesale trade amidst informative, practical demonstrations by leading craftspeople and discussions on merchandising and buying crafts. In the early years a typical fair would have featured primarily pottery, with considerable fiber, jewelry, candles, and leatherwork. Each fair increased the amount of time set aside for wholesale selling to department stores and shops. Initially held at Stowe, Vermont, the fair's site changed several times in order to accommodate the increasing number of participants. Because of its enormous popularity, other American Craft Council fairs were instituted in major cities around the country.[20]

The impact of these council fairs was enormous. Before they existed, wholesalers' orders to craftspeople, who contacted them randomly and without recommendation, frequently went unfilled; the fairs, however, allowed the wholesalers to buy enough production ware to satisfy their needs. As a result, craft shops began to rely entirely on the fairs for their inventory; in fact, American Craft Council fairs have been responsible for a significant increase in the number of department and specialty stores, even museum shops, that carry crafts.

The fairs also gave the buyer the opportunity to meet the artists. Lois Moran, a longtime American Craft Council staff member who is currently senior vice-president of the council and editor and publisher of *American Craft* magazine, attributes to these events many of the friendships that have developed between the artists and the emerging collectors. For most artists, they provided regularly scheduled wholesale markets at a time when finding one literally meant traveling from shop to shop hawking one's wares. The fairs also became meeting areas, "around which people with common interests could share their ideas."[21] In the early years many craftspeople knew colleagues only from their locale; these fairs united the larger community. Because the demonstrations were usually by nationally established artists, such as ceramists Toshiko Takaezu, Robert Turner, and Peter Voulkos, and metalsmith Olag Skoogfors, these fairs were particularly important for emerging craftspeople, who had the opportunity to meet and watch the masters (see fig. 2).

While the fairs made crafts available to the public, in the late 1960s the single most important event to galvanize the country's attention and start Americans actively

buying crafts was the 1969 exhibition "Objects: USA." The show, which traveled to twenty-three cities in the United States and thereafter to venues in Europe, was the creation of Lee Nordness, a New York dealer. In 1967 Nordness persuaded Samuel C. Johnson, president of S.C. Johnson & Son, Inc. of Racine, Wisconsin, to allow him to build a corporate collection of approximately three hundred pieces of American studio crafts that would form a traveling show. According to Nordness, the purpose of the project was "to assist and promote the American artist-craftsman. Assistance will come financially by the outright purchase of major works. The promotion will be achieved through tours. . . ."[22] To accomplish this purpose, Nordness approached Paul J. Smith, then director of the Museum of Contemporary Crafts, to become involved with the project.

The sources that Nordness and Smith used to build the collection provide some indication of the craft market of the late 1960s. First, an initial list of potential artists was developed using the files of the American Craftsmen's Council. Key artists in each medium were consulted for additional recommendations. Then, according to Smith, the pair "undertook an extensive regional and national campaign, which meant going everywhere."[23] An important part of their mission was to identify and see emerging talent. Included among their numerous stops were visits to the handful of existing craft shops, to the American Craft Council fair in Mt. Snow, Vermont, to Fred and Mary Marer's collection, and to museums such as The Toledo Museum of Art and the M.H. de Young Memorial Museum in San Francisco, which had active exhibition programs.[24] They found that regional shows such as the "American Craftsmen's Invitational" at the Henry Art Gallery in Seattle and the "Wisconsin Designer-Craftsmen" show at the Milwaukee Art Center also provided invaluable information.[25]

In retrospect, "Objects: USA" is possibly the most important show and catalogue in the history of the studio craft movement. Today, Smith talks about it as "an exhibition that really had a major influence here and abroad. There had never before been an exhibition of this scope which brought together in one place a survey of the current work in all craft media."[26] The fact that it opened at the Smithsonian and then traveled to major national and international museums gave enormous credence to the entire movement. While there have been other major traveling shows, such as "Craft Today: Poetry of the Physical" at the American Craft Museum (1986) and "The Eloquent Object" at the Philbrook Museum of Art in Tulsa (1987), these shows have simply augmented the public's knowledge of the crafts. "Objects: USA" literally intro-

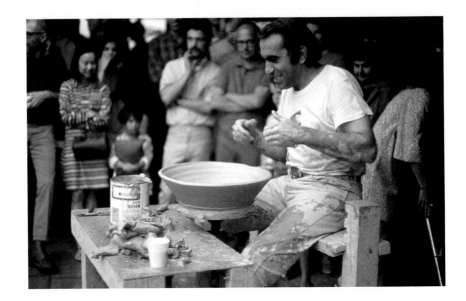

duced craft to them and, in fact, provided an impetus for some to begin collecting.

From the standpoint of institutional collecting, the exhibition was important since in the late 1970s, 123 objects, most of which were included in the show, were donated to the American Craft Museum by Johnson Wax Company. The show also had an impact on some private individuals who had already acquired antique glass, ceramics, jewelry, and furniture. For example, Elmerina and Paul Parkman of Washington, D.C., attribute their passion for the crafts to the show. At the time they saw the exhibition at the Smithsonian, they were buying late-nineteenth- and early-twentieth-century glass; they became so enthralled at seeing handmade objects by living artists that they decided to investigate further these contemporary developments.

By the mid-1970s the crafts marketplace was considerably altered. Although local guilds and organizations were vanishing, the number of collectors was increasing. A round-table discussion sponsored in 1976 by the American Crafts Council attributed the growth to the fact that the "fine arts aren't selling. [The galleries are looking for] anything that will sell."[27] The burgeoning of craft books definitely helped. In addition to numerous how-to guides that were surfacing, such pivotal books as National Geographic's *The Craftsman in America* (1975), Julie Hall's *Tradition and Change: The Craftsman's Role in Society* (1977), and LaMar Harrington's *Ceramics of the Pacific Northwest* (1979) were introducing crafts to a wider audience. In addition, the magazine *Craft*

*International,* which was published from 1980 to 1988 under the aegis, at times, of the Craft & Folk Art Museum of Los Angeles and the World Crafts Council, also became a viable resource under the editorial direction of Rose Slivka.

The situation was also being aided by the nationwide proliferation of shops, galleries, and museums showing crafts. Indeed, many of the best-known venues date from the early 1970s: Habatat Gallery (now Galleries), Dearborn, Michigan (1971); Exhibit A, Evanston, Illinois (1971); Contemporary Art Glass Group (now Heller Gallery), New York (1972); American Craftsman Gallery (became Hadler Gallery in 1974 and later Hadler/Rodriguez Galleries after another space was opened in Houston in 1978), New York (1972); Ten Arrow Gallery/Shop, Cambridge, Massachusetts (1972); The Elements Gallery, Greenwich, Connecticut (1973), and New York (1977); Fairtree, New York (1973); The Hand and The Spirit, Scottsdale, Arizona (1973); Julie: Artisans' Gallery, New York (1973); Richard Kagan Gallery, Philadelphia (1973); and Helen Drutt Gallery, Philadelphia (1974) and New York (1988). While some of these spaces were formed around art centers and schools, others were started because crafts simply were not accessible in certain cities. Some began as shops with nonfunctional and functional work next to each other. Many gradually have become similar to fine-arts galleries, specifically defining their aesthetic, instituting regularly scheduled exhibitions, and giving the artists space to store work as inventory.

Although the 1960s brought an increase in the number of craft exhibitions organized by small university art museums, the major art museums played a key role during the 1970s in validating contemporary crafts. During the decade the Smithsonian Institution designated the Renwick Gallery in Washington, D.C., as "the national showcase for design and craft";[28] The Metropolitan Museum of Art purchased works by Wendell Castle, Dale Chihuly, Wharton Esherick, Dominick Labino, Harvey Littleton, Albert Paley, and Tom Patti, and installed them in galleries devoted exclusively to twentieth-century decorative arts;[29] Boston's Museum of Fine Arts began its "Please Be Seated" program, commissioning contemporary furniture artists to create public seating for its permanent collection galleries; and Joan Mondale, in an effort to encourage museums to promote American crafts, borrowed works from the American Craft Museum and the Museum of Fine Arts, Boston, for the vice-president's residence and commissioned sixteen place settings for the residence's permanent collection.

However, the biggest factor finally to convince the New York art world of the legitimacy of crafts was their rise in price beginning in the late 1970s. West Coast galleries al-

ways were able to obtain higher prices for the ceramics that they sold because the works were marketed as sculpture rather than crafts. However, in 1979 Alice Westphal of Chicago's Exhibit A shook up the scene by drastically "changing the price structure to demonstrate that works by [her] chosen artists merited consideration that paralleled painting and sculpture."[30] Her intention was to encourage New York galleries to show these works, and she began to confer with some of them and to advertise in the national art periodicals. During the opening show of her Chicago gallery that year, Westphal sold Richard DeVore's vessels for as high as $4,000, a price more than ten times that of the artist's work in 1974. Westphal also arranged for exclusive agreements with her artists, a practice common in the fine arts but unknown in the crafts.[31] Lois Moran recalls that these changes, particularly those involving pricing, were a major breakthrough, since they "took the poverty code out of crafts and made people realize that the work was and should be seen on a greater par with the other phenomena in the arts."[32] With such prices one could no longer think of the craftsperson as a carefree, unencumbered, back-to-nature artist eking out a living selling pots or jewelry. Westphal's gamble was a success: by the early 1980s highly reputable New York fine-arts galleries, such as André Emmerich, Blum-Helman, and Max Protetch, had held ceramics shows.

Like the other art forms, the crafts benefited from the growing interest in the arts that appeared in the late 1970s and early 1980s as people had more disposable income. Museums responded to the new financial order by creating a social world that elevated its patrons to a new status. As the price of contemporary painting and sculpture skyrocketed, collectors of the fine arts turned to more affordable forms, including the crafts; those who had never before purchased art gravitated to the work because frequently, depending on the medium, the objects were three-dimensional, tactile, easy to understand and appreciate, and very sensuous. Collectors enjoyed either watching or hearing about the process of creation. In addition, in many instances, the artists were approachable and accessible, unlike their counterparts in painting and sculpture.

By the end of the 1970s, the craft collector was beginning to be recognized. The magazine *American Craft* (formerly *Craft Horizons*) was redesigned in 1979 to include regular articles on private collectors and galleries featuring crafts. Exhibitions of private collections, formerly rare, also became more prevalent. The ceramics collections of Fred and Mary Marer and Joseph and Elaine Monsen of Seattle were featured in shows during the early 1970s.[33] In addition, as director of the Museum of

Contemporary Crafts, Paul J. Smith had organized "Collector: Object/Environment" in 1965, demonstrating that crafts could be incorporated into a variety of public and private environments, and "The Collector" in 1974, which focused on the few craft collections he had been able to locate.

Beginning in 1978 the number of exhibitions of private collections increased significantly. Within the next few years, the collections of the following additional individuals were the subject of museum shows: Robert L. Pfannebecker at the Moore College of Art, Philadelphia (1980); Karen Johnson Keland at the Charles A. Wustum Museum of Fine Arts, Racine, Wisconsin (1981); Joan Mannheimer at the University of Iowa Museum of Art, Iowa City (1981); Ronald and Anne Abramson at the Dimock Gallery, George Washington University, Washington, D.C. (1982); Daniel Jacobs at the DeCordova and Dana Museum and Park, Lincoln, Massachusetts (1984); Diane and Sanford M. Besser at the Arkansas Arts Center Decorative Arts Museum, Little Rock (1985); and Jean and Hilbert Sosin at the University of Michigan–Dearborn (1987). The most telling indication of the transformation of crafts collecting in the United States occurred in 1982 when Paul J. Smith, while organizing "Approaches to Collecting," was able to identify approximately ninety collections that included a significant number of crafts objects. Dorothy and George Saxe's studio glass collection, then only two years old, was one of the seventeen private and corporate collections featured in the show.[34]

The 1980s brought a further increase in the number of craft collectors and galleries. Some of these collectors even began to achieve the celebrity status enjoyed by their counterparts who were pursuing contemporary painting and sculpture. Today, clay and glass collections now predominate, although there has been considerable activity recently in acquiring turned-wood bowls, baskets, and furniture. Several new sources for acquiring crafts have made international developments more available to American collectors. The American Craft Museum has formed an auxiliary, the Collectors Circle, which sets up for its members both national and international trips. The participants are able to augment their knowledge and their collections through visits to important collections, artists' studios, and galleries. Beginning in 1989 Christie's took the lead among the major auction houses in holding sales devoted exclusively to contemporary glass and ceramics. Over the past few years, the establishment of a viable secondary market through auctions has fueled the tendency toward collecting for investment. Finally, the Chicago International New Art Forms Exposition, established in 1986 by The Lakeside Group, has become an annual retail show to which primarily leading national and some international dealers in contemporary crafts bring work. Begun in response to The Lakeside Group's annual painting and sculpture exposition held every May since 1980 at Chicago's Navy Pier, CINAFE has been dominated by glass, reflecting the growing interest and market in this medium over the past decade. Clay has become less well represented, since dealers in the medium have not felt their gains at the event warranted the expense of participating. Each subsequent exposition, nevertheless, has seen an increase in the representation of jewelry, with fiber generally least well featured.[35] While sales are customarily handled solely by the dealers, many artists attend the events, since their interaction with potential buyers still affects the outcome.

Dorothy and George Saxe built their collection under circumstances that were very different from those that existed for individuals buying crafts in the early days of the studio craft movement. Many historians now feel that the Saxes, like other collectors of the 1980s and 1990s, have had an advantage because of the support system of galleries, exhibitions, and publications that has developed over the years. Yet within a larger context, both the Saxes and these other patrons are pioneers. Like other contemporary art collectors of the postwar period, they are pursuing still relatively unproven talent in order to support the art of today.

## Notes

**Author's note:** I wish to acknowledge the generous assistance of Helen W. Drutt English in the preparation of this essay. I would also like to thank Margaret Buhl, Judy Friebert, Mary Hujsak, Anne Morris, Donna Niehous, and Paul J. Smith for their considerable contributions. In addition, the following individuals provided important insights and information in interviews during research for this chapter: Louise Allrich, Rena Bransten, Ruth Braunstein, Garth Clark, William Daley, Mark Del Vecchio, Wanda Hansen, Douglas Heller, Walter Hopps, Jun Kaneko, Karen Karnes, Mary Koster, Sam Maloof, Penny McMorris, Michael Monroe, Lois Moran, Elmerina and Paul Parkman, Ronald Hayes Pearson, Robert L. Pfannebecker, John Prip, Rosanne Somerson, Jean and Hilbert Sosin, Sarah Stengle, Alice Westphal, and Nancy Yaw. Much valuable research on the emerging crafts market of the 1960s can be found in the Lee Nordness Papers, Archives of American Art, Smithsonian Institution, Washington, D.C. Permission to quote from his personal papers has been graciously granted by Lee Nordness.

1. For a succinct discussion of the factors that led to the rise of the studio craft movement in the United States, see R. Craig Miller, "Betwixt and Between: Contemporary Glass in American Art Museums," *The Glass Art Society 1991 Journal*, pp. 27–32.

2. Marcia Y. Manhart, "The Emergence of the American Craftsman—à la BA, BFA, MA, and MFA," in Janet Kardon, ed., *A Neglected History: 20th Century American Craft* (New York: American Craft Museum, 1990), p. 23.

3. For information on the Fred and Mary Marer Collection, see Claremont, California, Scripps College, Lang Art Gallery, *The Fred and Mary Marer Collection* (Claremont, 1974); Claremont, California,

Pomona College, Montgomery Gallery, *Earth and Fire: The Marer Collection of Contemporary Ceramics* (Claremont, 1984); "The Collector," *Craft Horizons* 34, 5 (Oct. 1974), p. 33.

4. Jun Kaneko in conversation with the author, May 1992.

5. "The Southern Highlanders, Inc. — Handicrafts," *Craft Horizons* 1 (Nov. 1941), p. 19; "Southern Highland Handicraft Guild and Southern Highlanders," *Craft Horizons* 3, 5 (May 1944), p. 21; *The Southern Highland Handicraft Guild Members Handbook,* Organization File, American Craft Information Center, New York.

6. For a detailed history of the league, see Betty Steele, *The League of New Hampshire Craftsmen's First Fifty Years* (Concord, New Hampshire, n.d.).

7. Dorothy Glazer, *Where to Sell Handcrafts* (Boston: Charles T. Branford Company, 1951), pp. 64–65.

8. For excellent histories of the American Craft Council and its various organizations, see "American Craft Council: A History in Brief, 1943–1990," *The Craft Report* 16, 175 (Oct. 1990), pp. 26–27, 40; "The American Craftsmen's Council," *Craft Horizons* 20, 1 (Jan.–Feb. 1960), pp. 36–41.

9. "The Collector's Room," *Outlook* 6 (Dec. 1965), p. 1; Kenneth Sawyer, "America House: Architectural and Interior Design Service," *Craft Horizons* 25, 1 (Jan.–Feb. 1965), pp. 7–8.

10. Ronald Hayes Pearson in conversation with the author, Jan. 1992.

11. "The Craftsmen's World," *Craft Horizons* 10, 1 (Spring 1950), p. 33. For a history of this exhibition, see Nina Stritzler, "'Young Americans': An Historical Overview," in New York, American Craft Museum, *Young Americans 1988* (New York, 1988).

12. Sherman E. Lee, "Fiftieth May Show May 1 through June 16: Annual Exhibition of Artists and Craftsmen of the Western Reserve," in Cleveland, The Cleveland Museum of Art, *The Bulletin of the Cleveland Museum of Art for May 1968: 50th May Show* 55, 5 (May 1968), pp. 122–23; Cleveland, The Cleveland Museum of Art, *A Study in Regional Taste: The May Show 1919–1975,* text by Dee Driscole, Jay Hoffman, and Mary Claire Zahler (Cleveland, 1977), p. 10.

13. "Exhibitions: Cleveland May Show May 4–June 12," *Craft Horizons* 20, 3 (May–June 1960), p. 43.

14. Boston, Museum of Fine Arts, *New American Furniture: The Second Generation of Studio Furnituremakers,* text by Edward S. Cooke, Jr. (Boston, 1989), p. 17.

15. Frances Wright Caroe, "Prevailing Winds," *Craft Horizons* 8, 8 (Aug. 1948), p. 28.

16. An excellent editorial on the state of the crafts in California in the 1950s is Richard Petterson, "California: A Climate for Craft Art," *Craft Horizons* 16, 5 (Sept.–Oct. 1956), p. 11. For a description of Nanny's Design in Jewelry, see Yoshiko Uchida, "A San Francisco Jewelry Shop: It Buys to Sell," *Craft Horizons* 17, 4 (July–Aug. 1957), pp. 12–13.

17. For further information on the early contemporary galleries of California, see Oakland, California, The Oakland Museum, *The Dilexi Years 1958–1970* (Oakland, 1984); San Francisco, Braunstein Gallery, *Braunstein Gallery Twentieth Anniversary* (San Francisco, 1981); New York, Whitney Museum of American Art, *Ceramic Sculpture: Six Artists,* text by Richard Marshall and Suzanne Foley (New York, Seattle, and London, 1981).

18. Karen Karnes to the author, Jan. 2, 1992, The Toledo Museum of Art, Saxe exhibition files.

19. For an early account of Shop One, see "Shop One," *Craft Horizons* 16, 2 (Mar.–Apr. 1956), pp. 18–23, passim.

20. For a good summary of the history of the American Craft Council fair, see Lisa Hammel, "Twenty-Year Venture," *American Craft* 45, 5 (Oct.–Nov. 1985), pp. 23–27; "A Fair to Remember," *American Craft* 50, 3 (June–July 1990), pp. 26–31; "The Fair Scene, Stowe, Vermont, August, 1966," *Outlook* 7 (Sept. 1966), [p. 3]. The Northeast Craft Fair moved from Stowe to Mt. Snow to Bennington, Vermont, and then on to Rhinebeck, New York. Since 1984 it has been held in West Springfield, Massachusetts. Additional council fairs and markets have been held in Atlanta, Baltimore, Minneapolis/St. Paul, New York, and San Francisco.

21. Pearson (note 10).

22. Lee Nordness's remarks at the Johnson Wax Press Conference, June 20, 1968, Nordness Papers, Archives of American Art.

23. Paul J. Smith in conversation with the author, Apr. 22, 1992.

24. They saw The Toledo Museum of Art's "Glass National" and the biennial exhibition of the Association of San Francisco Potters at the De Young Memorial Museum.

25. Lee Nordness, "Approaches to the Object," *Objects: USA* (New York: The Viking Press, 1970), p. 21.

26. Smith (note 23).

27. "The Decade: Change and Continuity — Panel 1," *Craft Horizons* 36, 3 (June 1976), p. 43.

28. "The Craftsman's World: Renwick Gallery Opens as National Showcase for Craft and Design," *Craft Horizons* 32, 1 (Feb. 1972), p. 3.

29. John Russell, "Gallery View: The Met Salutes the Decorative," *The New York Times,* Feb. 19, 1978, pp. 29, 32. After opening the installation, Penelope Hunter-Stiebel published the collection extensively. Among her articles are "William Harper: Talismans for Our Time," *American Craft* 41, 4 (Aug.–Sept. 1981), pp. 14–17; and "Contemporary Art Glass: An Old Medium Gets a New Look," *Art News* 80, 6 (June 1981), pp. 130–32, 134–35.

30. Alice Westphal in conversation with the author, Jan. 1992.

31. "The Gallery: Exhibit A," *American Craft* 39, 3 (June–July 1979), p. 16.

32. Lois Moran in conversation with the author, Dec. 1991.

33. Organized by Suzanne Foley, the exhibition "A Decade of Ceramic Art, 1962–1972, From the Collection of Professor and Mrs. R. Joseph Monsen" was shown at the San Francisco Museum of Art in 1972.

34. The following private collections were featured in the exhibition: Anne and Ronald D. Abramson; Betty Asher; Christine Carter; Judy and Pat Coady; Anne Davis; Rick Dillingham; Sandra and Louis W. Grotta, Jr.; Malcolm, Sue, and Abigale Knapp; J. Patrick Lannan Foundation; and Dorothy and George Saxe. Six corporate and government collections were also included: Best Products Co., Inc., Richmond, Virginia; Capital Bank, Houston; General Services Administration, Washington, D.C.; John Portman & Associates, Atlanta; Safeco Insurance Co., Seattle; and the Washington State Arts Commission, Olympia.

35. "Second New Art Forms Expo Draws Crowds to Navy Pier," *American Craft* 47, 6 (Dec. 1987–Jan. 1988), pp. 16–17; Jody Clowes, "CINAFE '91," *American Craft* 51, 6 (Dec. 1991–Jan. 1992), pp. 6–7.

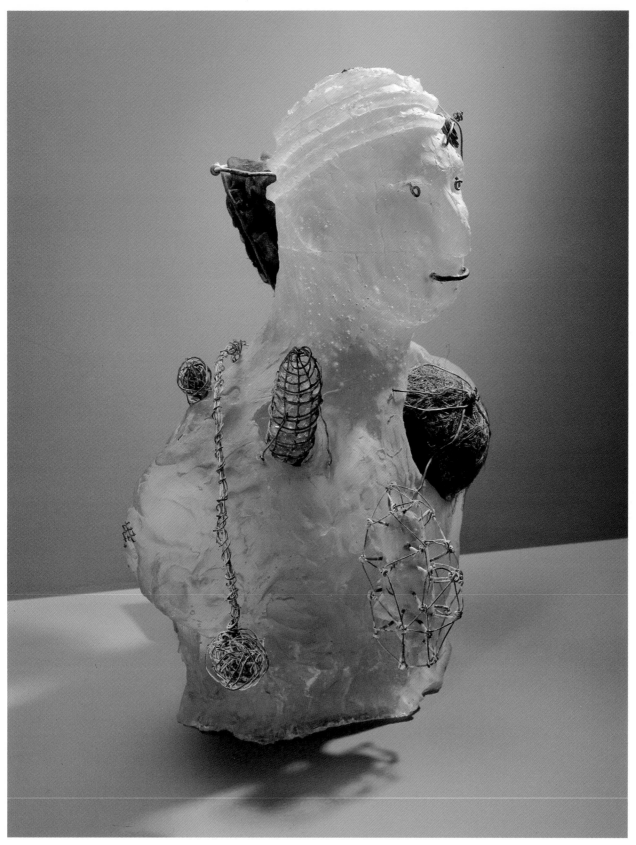

PLATE 1
Hank Murta Adams
**Norty,** 1988
(cat. 1)

# The Evolution of Studio Glass Collecting and Documentation in the United States

*Susanne K. Frantz*

The evolution of patronage for one of the most recently developed crafts, studio glass, is directly related to the way the medium evolved in the United States. Because glass melting and glassblowing by individuals not associated with industry did not begin to achieve momentum until the late 1960s, blown studio glass did not enjoy the decades of incubation shared by the other crafts. Other than in flame working (scientific glassblowing), apprenticeship or vocational education was not available for hot glass. There was no real studio or folk tradition, nor even opportunities for children to experiment in school. As a result, attention during the first decade of studio glass experimentation was focused largely on the acquisition of basic technical skills.

Before the 1960s there were individuals in the United States making and collecting studio glass. The glass was engraved, sandblasted, enameled, flame worked, and kiln formed, usually in the form of jewelry, paperweights, statuettes, lighting fixtures, and tableware. A larger group of craftspeople were producing two-dimensional stained glass and glass mosaic for the architectural community, but these were only marginally pursued by collectors, galleries, and museums.

What came to be known as "studio glass" developed from the generation of American ceramists working during and immediately after World War II. By the late 1950s, potters were turning their attention toward the potential of glass for the artist-craftsperson. A 1959 review of the annual exhibition of the Artist-Craftsmen of New York in *Craft Horizons* mentions "the glass workers, who are growing in numbers . . ." and describes their techniques as fusing, painting, and the making of stained glass.[1]

## The 1950–1960s

The glass of the late 1950s and 1960s was available to the purchasing public through regional and national multimedia fairs and exhibitions, such as the "Midwest Designer-Craftsman Fair," inaugurated in 1954. In 1956 jurors of one of the largest annual craft competitions, the "May Show" at The Cleveland Museum of Art, gave local artist Edris Eckhardt a special award for her work — the only glass entries of the exhibition.

Early shops offering handmade crafts, such as Bonniers in New York, presented decorative items and tableware made in European (mainly Scandinavian) and West Virginian glass factories. During the 1950s America House in New York was the most important national retail outlet for crafts.

For the craft patron of the 1950s and 1960s, *Craft Horizons* was the only guide to American glassmaking. Considerable print was devoted to stained glass, mosaic, and tableware. For example, The Corning Museum of Glass Director Paul Perrot discussed the rise of the artist-craftsperson in glass since World War II and stated that the technology was already available "to go it alone, or almost so."[2] In 1963, the year after two landmark glass workshops in Toledo, Harvey Littleton published an article in *Craft Horizons* on the work of the Bavarian glass artist Erwin Eisch.

The lack of practical information accessible to the non-technician was a fundamental and crucial problem for individuals working in glass. Again *Craft Horizons* offered the only advice available: Earl McCutchen, an instructor at the University of Georgia, published in 1955 an article on the fusing of glass scraps in a kiln. In 1956 Dido Smith reported on Edris Eckhardt's experiments with re-creating Roman gold glass. Kay Kinney published in 1962 one of the first books for the amateur, offering simple instructions on making objects from sheet glass heated in a kiln.[3]

Individuals wanting guidance for glassblowing had to make do with professional manuals, such as Samuel R. Scholes's reference for glass-plant engineers and technologists, *Handbook of the Glass Industry* (1941), and Fay Tooley's *Handbook of Glass Manufacture* (1953). In 1960 *Craft Horizons* published a two-part series on ancient glass forming by the physical chemist Frederick Schuler.[4] The second 1962 Toledo Glass Workshop generated a valuable mimeographed publication that recapped the seminar activities and included technical data, material resources, and guidelines for glassblowing.[5] To coincide with Harvey Littleton's one-person exhibition at New York's Museum of Contemporary Crafts in 1964, Dido Smith outlined Littleton's story for *Craft Horizons*.[6] Two historical surveys of glass, one by Dominick Labino and the other by Littleton, also offered some general glass-

blowing information; the latter became the primary text for studio glassblowing for the next decade.[7]

Among the many glass exhibitions organized by museums during the 1950s and 1960s, the majority surveyed aspects of glass history or contemporary commercial production design. One early exhibition that was inspirational to those contemplating studio glassmaking was the Museum of Contemporary Crafts' Louis Comfort Tiffany retrospective (1958). Although Tiffany himself did not blow glass, his firm's production confirmed the artistic potential of the medium.

Also held in 1958 was the landmark glass exhibition in the Czechoslovakian Pavilion of the World's Fair in Brussels. Although well documented in Europe, the monumental cast, blown, and leaded glass sculpture by Jaroslava Brychtová, Stanislav Libenský, Jan Kotík, and René Roubíček went unmentioned in American publications. Nevertheless, their work was a revelation and encouraged The Corning Museum of Glass to undertake the first contemporary international glass survey, "Glass 1959."

This show was followed in 1961 by the Museum of Contemporary Crafts' "Artist-Craftsmen of Western Europe," which included glass crafters Hanns Model (West Germany), Roberto Nierderer (Switzerland), and Alfredo Barbini (Italy) alongside the designers. In 1964 the museum mounted similar displays for Czech and Italian glass.

The American Craftsmen's Council did not include glass in its "Young American" competition series until 1962. By 1969 still only 15 out of 192 individuals included in this crafts exhibition were using glass.

One-person exhibitions given to living studio glass artists began in the United States with "The Life and Work of Frederick Carder," organized by The Corning Museum of Glass (1952). Carder was the founder of Steuben Glass and, although most noted for his association with industry, did create fused glass in a small kiln in his studio. Flame worker John Burton also was awarded a one-person exhibition, at the Seattle Art Museum (1958).

Despite the primitive state of early blown objects, museums were eager to display the new developments. The Art Institute of Chicago showed glass by Harvey Littleton as early as 1963. The next year he had a one-person exhibition at the Museum of Contemporary Crafts. That institution followed with Joel Philip Myers (1967), then Marvin Lipofsky (1969), Andre Billeci (1970), and Dale Chihuly (1971).

The new glass benefited from the encouragement of two of the world's great public collections, The Corning Museum of Glass and The Toledo Museum of Art. Both institutions took advantage of their connections to indus-

try to offer varying degrees of technical support as well as to undertake active exhibition programs.

At first the Corning Museum paid equal attention to studio glasswork created both before and after the 1962 Toledo workshops, showing the fused-glass "paintings" of Ruth Maria Kilby (1966) and Edris Eckhardt's kiln-fused work (1968). Its exhibition "Four British Schools of Design in Glass" (1968) sought to publicize the advanced state of British glass education. Dominick Labino was honored by the museum in 1969 with a retrospective exhibition of his work since 1964. Also in 1969 and 1970, Alfred University faculty members Andre Billeci and Eric Hilton received solo exhibitions. The University of Miami, Florida, Professor Robert Willson showed his solid hot-worked glass sculpture in Corning in 1970 as part of a three-year international tour.

The first two important survey exhibitions of studio glass took place in 1966, one on the West Coast and one in the Midwest. The "National Invitational Glass Exhibition" at San Jose State College was a transitional show in which some precursors of studio glass (David Arnold, John Burton, Roger Darricarrere, Edris Eckhardt, Earl McCutchen, and Priscilla Manning Porter) were shown with the new generation of molten glassblowers (Robert Fritz, Frank Kulasiewicz, Dominick Labino, Marvin Lipofsky, Joel Philip Myers, and Norman Schulman). The exhibition made clear that the excitement and novelty of hot glass were already overshadowing the work of the earlier generation.

The Toledo Museum of Art was particularly vital in the development of studio glass thanks to its role in Littleton's workshops and in establishing a studio glassmaking facility in 1969. The first "Toledo Glass National" survey show (1966) was quite different from San Jose's and had a greater impact nationally. Forty-two of the forty-three makers selected were blowing glass; Edris Eckhardt was the single kiln-forming representative.

The second "Toledo Glass National" (1968), which included fifty-seven glassblowers, circulated nationally. By 1970, when it was time to present the third survey, the overwhelming number of glassmakers caused the museum to change the format to an invitational, with only eleven invitees. Although the exhibition again toured nationally, the series was discontinued.

The proximity of the 1967 Montreal Expo afforded thousands of visitors from the United States an opportunity to see the spectacular monumental glass sculpture in the Czechoslovakian Pavilion. As Dale Chihuly commented on its impact: "I first saw the work of Stanislav Libenský and Jaroslava Brychtová at the World's Fair in Montreal, . . . it was the most impressive thing that I had

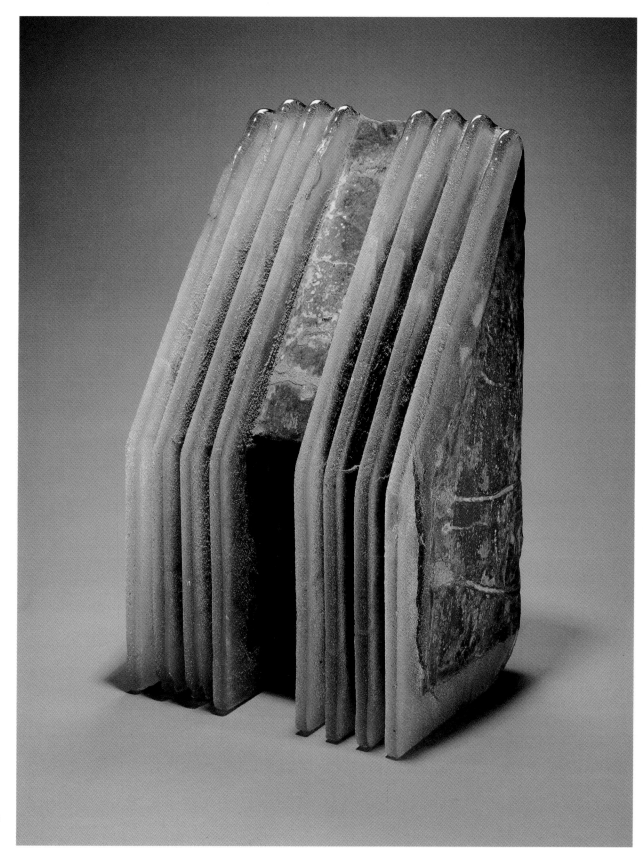

PLATE 2
Howard Ben Tré
**Cast Form XXIV** or **Blenko
#4,** 1981–82
(cat. 7)

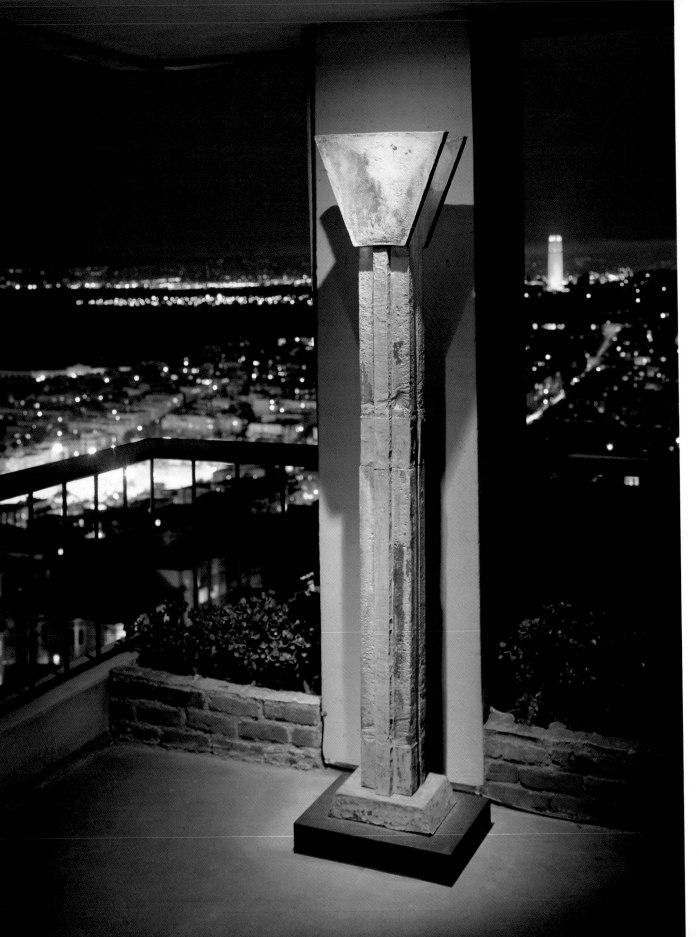

PLATE 3
Howard Ben Tré
**Column 16,** 1983
(cat. 8)

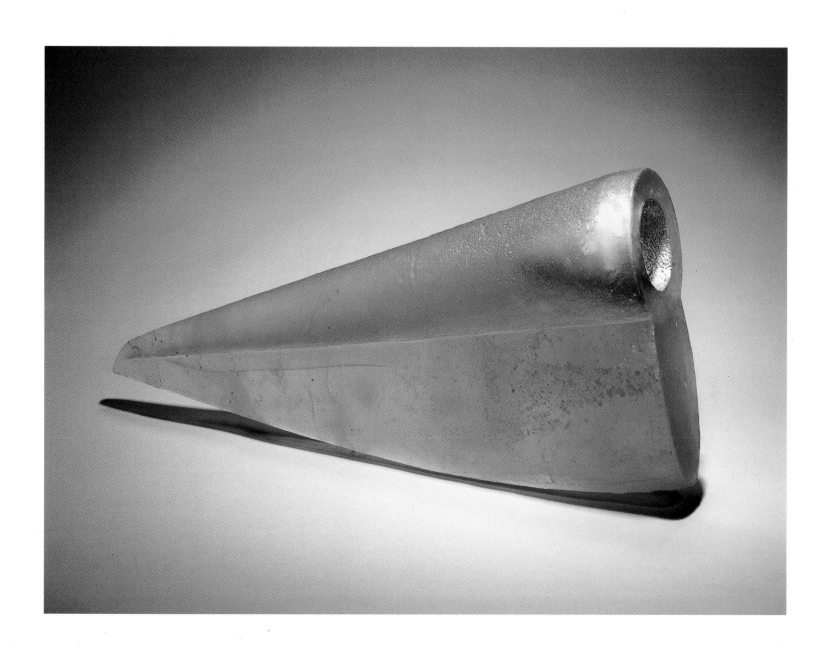

PLATE 4
Howard Ben Tré
**Cast Form 69**, 1989
(cat. 9)

ever seen."[8] Nevertheless, like the Czechoslovakian sculpture in the 1958 Brussels Expo, the new display was almost completely ignored in the pages of *Craft Horizons*. However, Libenský and Brychtová's cast double-panel *Blue Concretion* was brought temporarily to New York in 1968 as part of the Museum of Contemporary Crafts' exhibition "Architectural Glass." Of more profound impact on the crafts as a whole was the extensive 1969 survey in Washington, D.C., "Objects: USA," whose eighteen featured glassblowers provided many potential collectors and gallery owners with their first look at glass made outside of the factory.

While the Toledo and Corning museums were making their first few acquisitions, the earliest private collections of the new glass were being formed among the glassblowers themselves. Robert Florian, a high-school art teacher, amassed a sizable collection as a participant in workshops at the University of Wisconsin and at San Jose State College, where he also functioned as an event photographer. Harvey Littleton's collection of historic glass includes one section devoted to studio glass made by visiting artists using his studio.

In his essay for the catalogue *Objects: USA,* Lee Nordness speculated on the unpretentiousness and spirituality perceived in the crafts that drew some to become makers. In glass, an emphasis on beauty and optical effects, rather than on intellectualism, surely attracted (as well as distanced) some potential collectors and makers. Studio glass was soon received with enthusiasm by paying customers outside the glassmaking circle. Although, ostensibly because of overhead costs (it had always commanded comparatively higher prices than the other crafts), most early studio glass objects were inexpensive. In many cases the purchaser was already a collector of other types of glass, usually early American or paperweights. On other occasions the medium was included within encyclopedic contemporary craft collections.

Collections continued to be compiled through seasonal and weekend craft fairs. Sometimes the presence of a makeshift portable furnace for demonstrations provided an extra attraction. Glass's greatest draw was perhaps its novelty. Unlike other "home craft" processes, glassmaking and glassblowing were unfamiliar to most people in the United States. Visually, glass is an extremely accessible material whose natural beauty can be appreciated at any level of connoisseurship. The formative years of American studio glass were focused on the struggle for technical proficiency. Inept craftsmanship was often forgiven, permitting objects that might have been considered unacceptable in another medium to be exhibited in museums and sold in galleries. At the same time, the tendency prevailed among those making and collecting glass to equate technical achievement with aesthetic merit.

In 1969 the Lee Nordness Gallery had its first one-person shows of the work of studio glass artists. A gallery devoted in the 1950s to painting and sculpture, it had celebrated its tenth anniversary a year earlier by opening a large New York showroom. At that time it advertised that it was now adding "America's leading object makers" to the roster, to be shown with, and in the same depth as, painting and sculpture — a first for an art gallery.

## The 1970s

Interest in glassmaking grew as graduates of Littleton's classes at the University of Wisconsin departed to conduct workshops and establish new programs within existing educational institutions (usually under the auspices of the department of ceramics). By 1973 *Glass Art Magazine* listed in its "Guide to Glass Instruction" seventy educational programs. Soon the dramatic increase in glassmakers encouraged museums, publications, and eventually collectors to pay greater heed to the medium.

In 1972, in lieu of a fourth "Toledo Glass National," The Toledo Museum of Art and the Museum of Contemporary Crafts coorganized the traveling invitational "American Glass Now." Displaying the work of thirty-three glassmakers, the exhibition pointedly illustrated the enormous changes and advances in glassmaking during the last decade. Technically more varied and accomplished, the assured craftsmanship also opened the door to new formal possibilities and coincided with a movement away from the vessel in at least half of the works.

"American Glass Now" was also prophetic regarding the increasing scale of work and the combination of glass with other media. Amidst the tabletop-sized sculpture was a neon, sheet-glass, and dry-ice structure by Dale Chihuly and James Carpenter, who had earlier shown loosely blown and trailed milk-glass forms combined with neon / mercury. In 1972 Andre Billeci created the installation *Glass Environment* at The Corning Museum of Glass.

The surveys that would dominate glass exhibitions in the 1970s and throughout the 1980s continued with "International Glass Sculpture," organized by the Lowe Art Museum, Coral Gables, Florida, with the help of Robert Willson. Like so many presentations of the period, it featured a curious mixture of vessels and nonvessels by studio glassmakers, commercial firms, and artists collaborating with craftspeople.

A great deal of American studio glass activity centered around the Penland School in Penland, North Carolina. In 1974 Western Carolina University, in Cullowhee, initiated

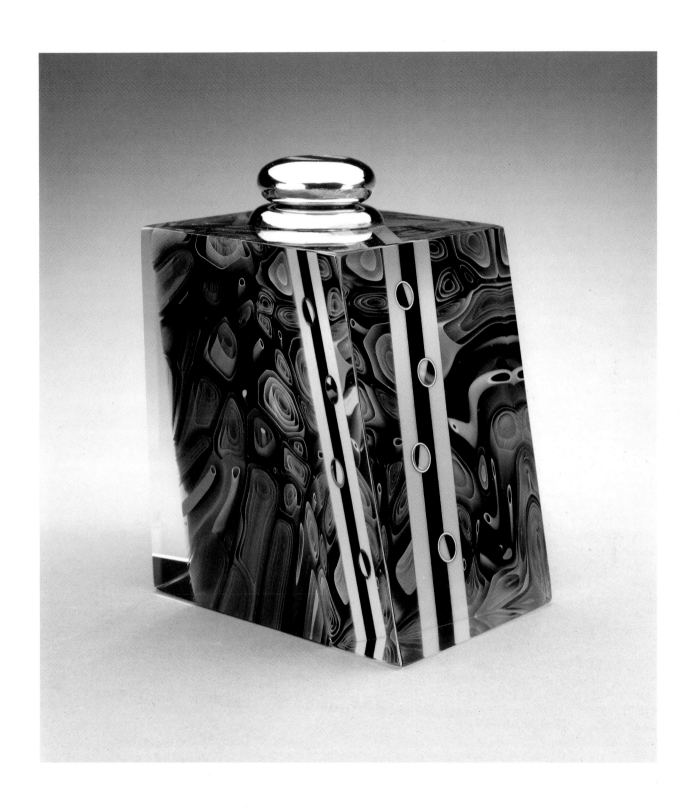

PLATE 5
William Carlson
**Kinesthesis Series Vessel,**
1980
(cat. 12)

a regional biennial exhibition that would eventually be known as "North Carolina Glass." Another important series generated in the southeastern United States was "New American Glass: Focus West Virginia" at the Huntington Galleries (later the Huntington Museum of Art), Huntington, West Virginia (1976). Half of the exhibition was devoted to studio glass, including a national invitational with fifty-one glassmakers and a second section of earlier pieces produced in collaborations between six glass artists and six West Virginia glass factories. The Huntington Galleries continued with annual shows of four artists, and then in 1986 with a second national survey, "New American Glass: Focus 2 West Virginia."

In 1977 the Museum of Contemporary Crafts broke its "Young Americans" show into three separate exhibitions according to medium. Dale Chihuly served as a juror for the first "Young Americans: Clay / Glass," which opened in 1978 with twenty-five glassmakers and sixty-seven clay artists.

The Leigh Yawkey Woodson Art Museum, in Wausau, Wisconsin, inaugurated in 1978 a series of three traveling exhibitions. "Americans in Glass" combined invitees with others selected by a jury. The triennial was unusual in its inclusion of two-dimensional glass along with the vessels and sculptures and in the employment of glassmaker David R. Huchthausen as consultant. In his statement for the catalogue, Huchthausen voiced an early concern for the future of studio glassmaking, urging resistance to obsession with the physical qualities of glass, questioning the appropriateness of the material for art, and finally suggesting that glassmakers undertake a reevaluation of their work.[9]

Of the many surveys, one overview in particular would provide the greatest stimulus for the acquisition of studio glass by public and private patrons. In 1979 The Corning Museum of Glass summed up the international state of glass with "New Glass: A Worldwide Survey," a juried presentation of 275 objects by glassmakers, designers, and companies from twenty-eight countries. Its tour demonstrated glass's new prestige. In addition to expected venues, an edited version of the exhibition was shown at The Metropolitan Museum of Art, New York, where it drew serious consideration from outside the glass circle. Showings at equally renowned foreign institutions, including the Victoria and Albert Museum, London; Le Musée des Arts Décoratifs, Paris; and in Japan (the first time American studio glass was shown there), had a stimulating effect on glass in those countries.

A number of important exhibitions were also held in Europe, including the 1974 ten-year retrospective honoring American Dominick Labino at the Victoria and Albert Museum. Coorganized by The Toledo Museum of Art and

the British firm Pilkington Glass, the exhibition traveled to Toledo in 1975. Although Continental exhibitions impacted on glass internationally, their influence on American private collecting was not profound. An exception was the Coburger Glaspreis of 1977, organized by the Kunstsammlungen der Veste Coburg, Federal Republic of Germany. This massive survey of European glass, with its detailed catalogue, provided information about foreign artists and encouraged their representation in collections and commercial galleries.

The first American periodical devoted exclusively to studio glass, *Glass Arts Magazine* (renamed *Glass* in 1977), appeared in 1973. The inaugural issue was pasted up in an Oakland production studio by glassmaker Albert Lewis. Considering its humble origins, the bimonthly offered surprisingly comprehensive information. In 1977 it initiated the first "Fragile Art" slide competition, attracting 600 entries from individuals and studios. By 1980 there would be only 175 entries — a decrease most likely explained by the increased exhibition opportunities for glassmakers. By 1983 the periodical that had proudly described itself as "the art magazine that's readable" had suspended publication. A new and unrelated publication assumed the name *Glass Art* in 1985. The *Glass Art Society Newsletter* (renamed the *Glass Art Society Journal* in 1979) began appearing in 1976 as a summary of the proceedings of that group's annual meeting. As studio glassmaking became more sophisticated, the early emphasis on technical know-how and educational programs gradually shifted toward theoretical discussions on the nature of art, craft, and design. *Glass Studio* first appeared in 1978, continuing intermittently after 1983. *New Work* magazine, a project of the New York Experimental Glass Workshop, was created in 1980 with an emphasis on aesthetic issues. The magazine was renamed *Glass* in 1990 (unrelated to the earlier *Glass* magazine).

In 1975 Ray and Lee Grover authored *Contemporary Art Glass*, one of the first books on international glass published in the United States. Although incomplete, as the only publication of its kind, its listing of ninety-eight individuals served as a guide for many aspiring collectors over the next decade.

In 1977 The Corning Museum of Glass began its international slide review, *Contemporary Glass*, illustrating objects and makers on microfiche. In 1980, when the name was changed to *New Glass Review* and the format to a printed volume, the review evolved into a valuable documentary periodical.

The cachet of the "New Glass" venue at The Metropolitan Museum of Art was no doubt a factor in the decision of a major contemporary art periodical, *Art News*, to publish in 1981 an article on studio glass by the museum's

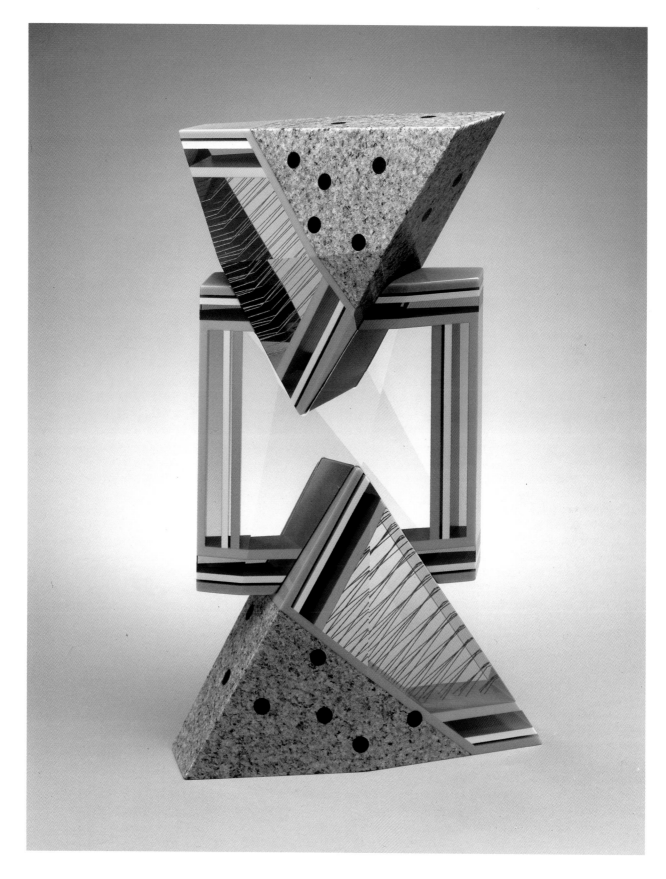

PLATE 6
William Carlson
**Pragnanz Series II**, 1986
(cat. 13)

decorative-arts curator, Penelope Hunter-Stiebel. The essay retold the history of modern glass and profiled several prominent studio glassmakers.[10]

Museum exhibitions provided legitimization of the new glass and spurred the market. Most work collected in the 1960s and early 1970s took the vessel form. Ultimately many collectors came to favor the increasingly prevalent abstract and figurative work and, unfortunately, deemed the vessel passé and regressive. Ironically, in the mistaken belief that they were excluding the container form from their collections, some collectors continued to acquire works using the vessel as the basis for sculpture, albeit in a subtle, barely discernible manner.

Serious collecting was encouraged as prominent artists shifted their marketing from craft fairs to gallery affiliation. Galleries offered novice glass collectors guidance and moral support. Among the dozens of galleries representing studio glass, and the core group that would eventually dominate the field, two of the earliest establishments remained the most viable.

In 1971 Habatat Gallery in Dearborn, Michigan, featuring glass as well as other media, was founded by Ferdinand Hampson and Thomas Boone. In 1973 its first annual national invitational exhibition featured twelve glassmakers. An account of the gallery's second annual "Glass National" in 1974 described opening night as "crowded with collectors buying fast and furiously — even the $175 pieces!"[11] Habatat was an early supporter of foreign studio glass and was instrumental in the promotion of Czechoslovakian work within the United States.

The Contemporary Art Glass Group, New York, formed in 1972 by Douglas Heller and Joshua Rosenblatt, employed rented galleries until opening a small gallery on Madison Avenue in 1974. For larger exhibitions, they used Lever House, where they presented "Contemporary Art Glass '76" and "Glass America 1978." The composition of these national sales exhibitions drew upon the membership of the Glass Art Society. The Contemporary Art Glass Group would ultimately occupy four locations on or near Madison Avenue. In 1982 the name was changed to Heller Gallery and an auxiliary space opened in the SoHo district, where the gallery consolidated two years later.

As late as 1976, Paul J. Smith, speaking at the opening of the first international studio glass exhibition, "Modernes Glas aus Amerika, Europa und Japan," at the Museum für Kunsthandwerk, Frankfurt, stated that in the United States there were few patrons and collectors of glass art and only three or four galleries in New York with a serious commitment to the new glass. Throughout the United States and Canada, however, numerous craft galleries and shops were interested in the new glass and a few were focusing primarily on the medium.

In 1974 the Museum of Contemporary Crafts provided a look at six private collections in its exhibition "The Collector." Glass was represented by Sy and Theo Portnoy of Scarsdale, New York, who had begun collecting (and then selling) glass after seeing "Objects: USA." The couple emphasized that they acquired their personal glass collection purely for enjoyment rather than investment.

As "Objects: USA" had stimulated interest in 1969, ten years later "New Glass" had an explosive impact. The crafts were undoubtedly beneficiaries of disposable income and the booming art market of the 1970s. More than a few notable collections were assembled quickly, with more emphasis on accumulation than connoisseurship. An interest emerging from life-style philosophies that encouraged hands-on dabbling in the crafts was sustained as would-be collectors aged and had more income for luxury purchases. Such nostalgic feelings and the non-intimidating aura of the crafts may also partially account for the tendency of glass collectors themselves and their children to experiment with glassblowing.

One of the most important events of the 1970s, and certainly the most significant contribution by a pair of future respected glass collectors, was the founding in 1971 of the Pilchuck Glass Center (later renamed the Pilchuck Glass School) by Dale Chihuly with the support of John H. and Anne Gould Hauberg. The Haubergs had wanted to start a craft school to be associated with the Pacific Northwest Arts Center. Chihuly persuaded them to provide land on a tree farm north of Seattle for his innovative educational plans to bridge craft and art.

By the late 1970s and early 1980s, the Toledo Museum and the Corning Museum were being emulated by a growing number of museums assembling significant collections of the new glass, including the American Craft Museum, New York; The Chrysler Museum, Norfolk, Virginia; Cooper-Hewitt National Museum of Design, New York; The Detroit Institute of Arts; High Museum of Art, Atlanta; Huntington Galleries, Huntington, West Virginia; Indianapolis Museum of Art, Indiana; Los Angeles County Museum of Art; Leigh Yawkey Woodson Art Museum, Wausau, Wisconsin; National Museum of American History and the Renwick Gallery of the National Museum of American Art, Smithsonian Institution, Washington, D.C.; Museum of Art, Rhode Island School of Design, Providence; and the Wheaton Museum of Glass, Millville, New Jersey.

In 1977 The Metropolitan Museum of Art purchased its first piece of studio glass, *Amber Crested Form* by Harvey Littleton. The museum has gone on to acquire works by Howard Ben Tré, William Carlson, Dale Chihuly, Dan Dailey, Michael Glancy, David Huchthausen, Joel Philip Myers, Narcissus Quagliata, and Steven Weinberg. The

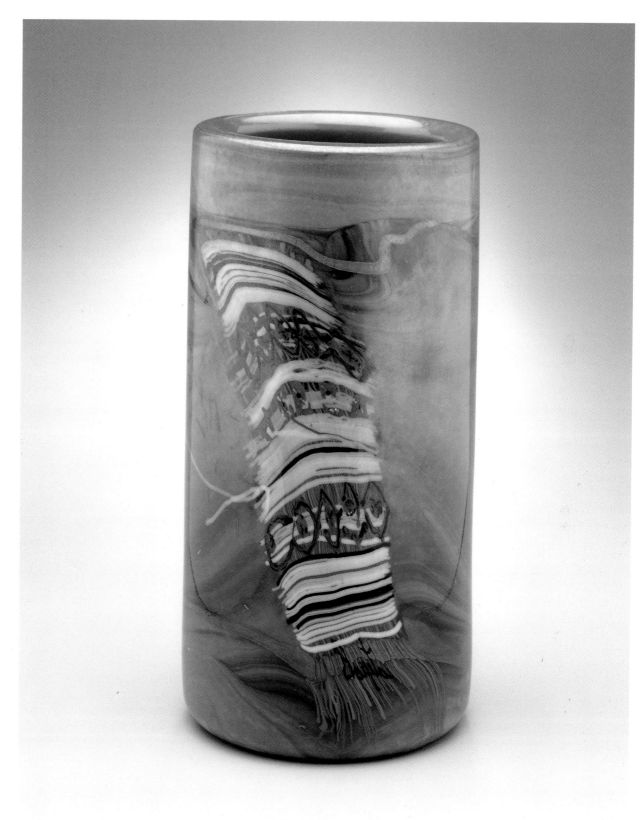

PLATE 7
Dale Chihuly
**Untitled Blanket Cylinder,**
1975
(cat. 14)

PLATE 8
Dale Chihuly
**Venetian Drawing,** 1988
(cat. 15)

PLATE 9
Dale Chihuly
**Transparent Terra Rosa Venetian,** 1988
(cat. 16)

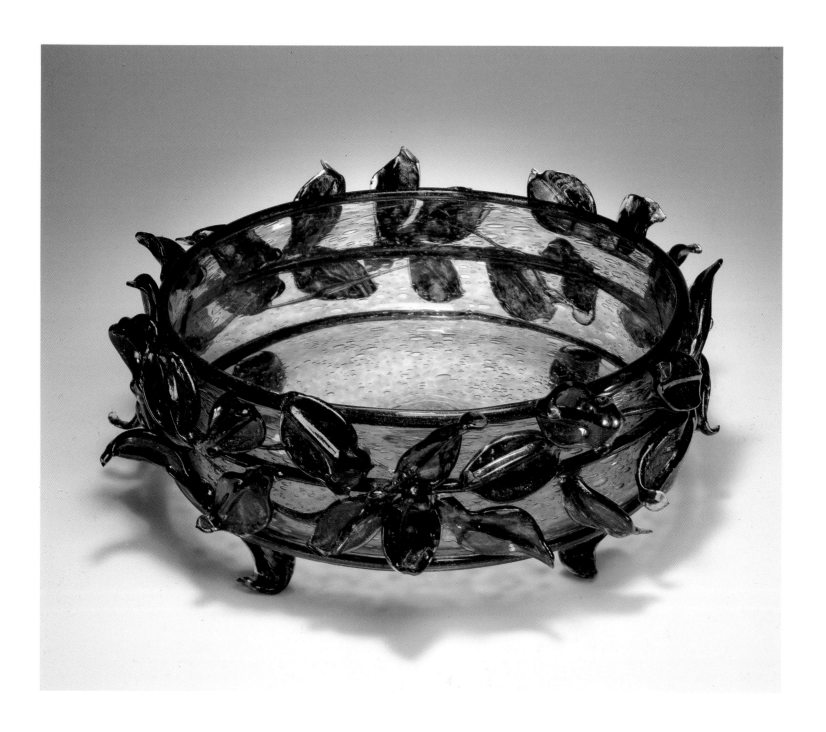

Museum of Modern Art acquired objects by Sydney Cash, Dale Chihuly, Harvey Littleton, Tom Patti, and Toots Zynsky. The Solomon R. Guggenheim Museum and the Whitney Museum of American Art in New York, as well as the Philadelphia Museum of Art, added a limited number of pieces to their collections.

Like most studio craft objects absorbed into museum collections, most glass is accessioned within decorative-arts or design departments. Only a few forward-thinking museums, such as The Detroit Institute of Arts and The Toledo Museum of Art, integrate the glass within the display of modern art. As always, most exceptions to the design and decorative-arts assignments have been works incorporating glass by non-glasscraft-associated artists, such as Vito Acconci, Josef Albers, Arman, Alexander Calder, Joseph Cornell, Salvador Dalí, Felix Droese, Lucio Fontana, Barbara Hepworth, Wassily Kandinsky, Mario Merz, Lucas Samaras, Robert Smithson, and John Torreano. The categorization of the glass sculpture made during the 1950s and 1960s designed by well-known artists and produced by the Fucina degli Angeli, Venice (see pl. 52), varies from museum to museum, as it does for the sculptures commissioned by the French glass firm Daum.

The 1980s saw countless exhibition overviews in small and large museums throughout the United States. In 1981 the DeCordova Museum and Sculpture Park, Lincoln, Massachusetts, surveyed glass created in New England in "Glass Routes." Anniversaries, especially of the Toledo Workshops, provided convenient reasons for many shows, including the twenty-year celebration "American Glass Art: Evolution and Revolution" at The Morris Museum, Morristown, New Jersey, in 1982.

Like its predecessor, the 1981 catalogue for the Leigh Yawkey Woodson Art Museum's second "Americans in Glass" generated as much discussion and interest as the exhibition itself. In his essay, David Huchthausen called for the beginning of serious critical evaluation of the field — a topic that had been, and would generally continue to be, painfully avoided. By 1984 Huchthausen's and, to a degree, the other jurors' statements for the third catalogue were the embodiment of frustration and disappointment, expressing the futility of exhibitions based solely on a commonly shared material.[12] Although the third "Americans in Glass" show would travel in Europe until 1986, it would be the last of the series.

The lack of quality evaluation of studio glass had been a matter of complaint since the days when Robert Arneson could conclude a review of an exhibition of blown glass with the sentence: "If I see another drippy glass bubble, I'm going to blow my mind."[13] Not surprisingly for such a young field, most writing on the subject consisted of biographical, descriptive, and technical reportage rather than analysis. Eventually a debate arose as to whether a new set of criteria, as well as methodology, specific to the material need be invented or if existing critical standards need only be applied. Also contributing to the reluctance of writers to make judgments was the nature of the small and close-knit glassmaking field; adherents tended to mistake aesthetic criticism for personal attack.

In March 1985 the first extensive review of a glass exhibition written by a disinterested observer appeared in a prominent art periodical (under the heading "Decorative Arts"). Robert Silberman's "Americans in Glass: A Requiem" in Art in America[14] clearly took its cue from the jurors' statements in the "Americans in Glass" catalogue. Silberman continued the issue of the "good glass artist" as opposed to the "good artist," but urged that new glass avoid unqualified assimilation into the fine arts — a process he believed meant abandoning its unique tradition.

The exceptional photogenic properties of glass had long been familiar to insiders, and in the mid-1980s glass became an appealing lure for art-book publishers. A few lavishly illustrated publications, such as this author's Contemporary Glass and Dan Klein's Glass: A Contemporary Art, were produced, targeting an audience starved for information. The period also saw the production of a considerable number of equally luxurious "vanity" publications by artists, galleries, and collectors.

An encouraging trend by a few museums was the narrowing of subject scope in the realization that survey exhibitions were no longer scholarly contributions. In 1980 "Czechoslovakian Glass: 1350–1980," coorganized by The Corning Museum of Glass and the Museum of Applied Arts in Prague, brought the advancements of Czech and Slovak glass to the attention of the American public. The Corning Museum would organize a similar historic look at Russian glass in 1989. "Cast Glass Sculpture," at the Art Gallery, California State University, Fullerton (1986), focused on the technique that would lead the next decade. The catalogue was notable for its essay by the art critic Donald Kuspit, who applied an "outsider's" eye to the work. The Tucson Museum of Art's "Sculptural Glass" (1983) was the first of several exhibitions of large-scale, site-specific sculptures. The most ambitious was the Renwick Gallery's "Glassworks" (1990), which featured constructions in the galleries which the public was invited to watch in process.

Museums also became interested in presenting touring retrospectives of prominent glassmakers. "Dale Chihuly: A Decade of Glass" was a ten-year retrospective organized in 1984 by the Bellevue Art Museum, Bellevue, Washington. In 1985 the High Museum of Art, Atlanta, originated "Harvey Littleton: A Retrospective Exhibition," and in 1987 "Dan Dailey: Simple Complexities in

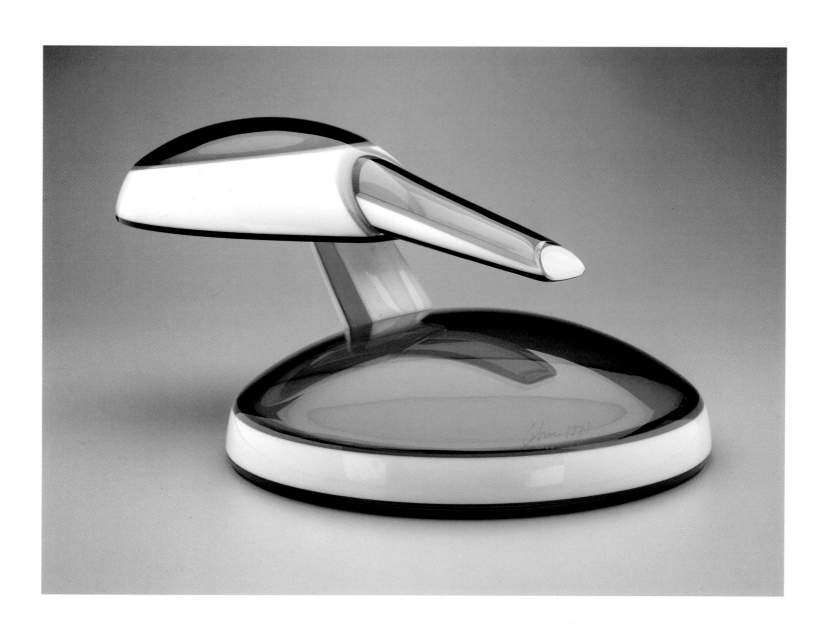

PLATE 10
Michael Cohn
**Space Cup #49,** 1981
(cat. 17)

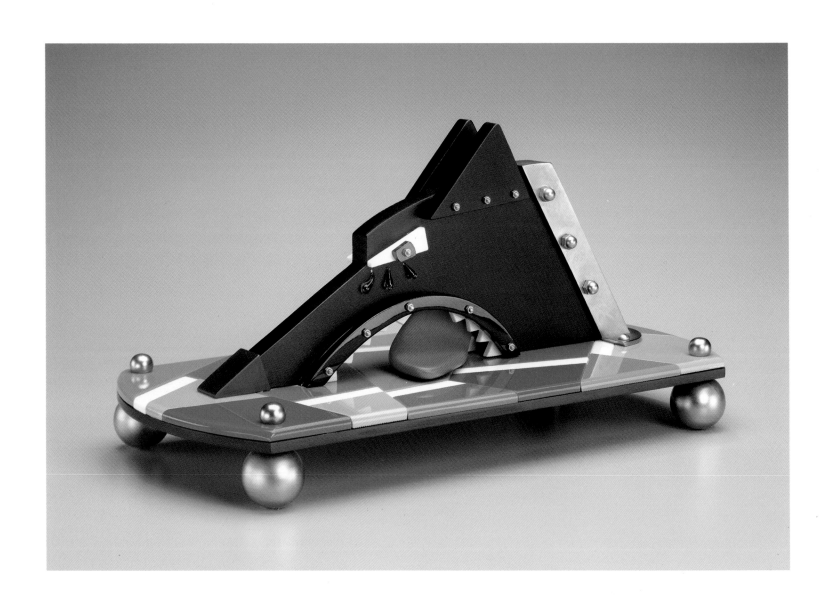

PLATE 11
Dan Dailey
**Sick as a Dog,** 1984
(cat. 19)

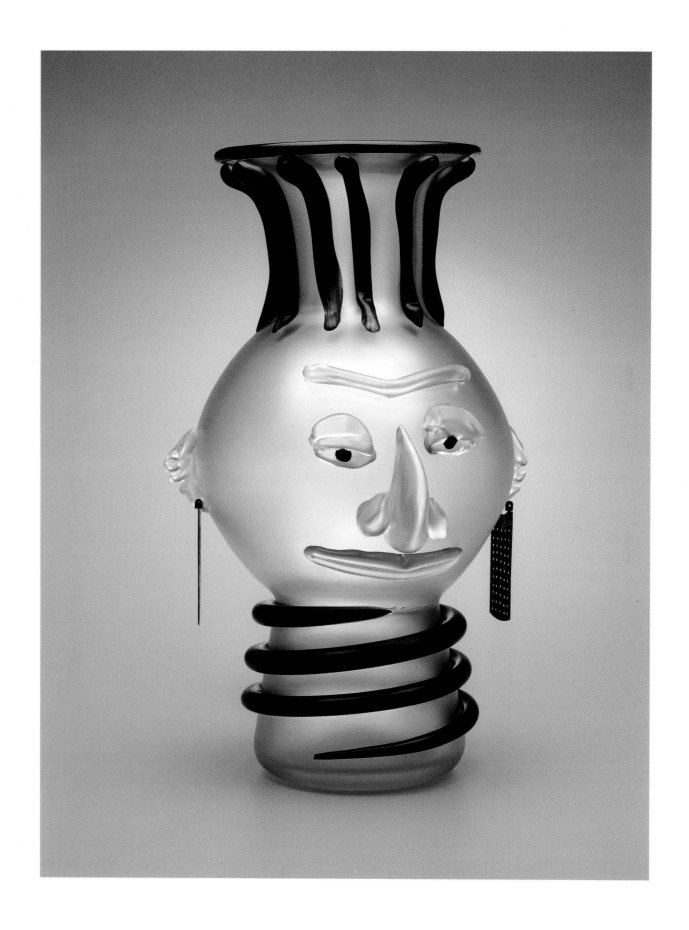

PLATE 12
Dan Dailey
**The Chef,** 1988
(cat. 20)

Drawings and Glass 1972–1987" was produced by the Philadelphia Colleges of the Arts. In 1989 The Phillips Collection, Washington, D.C., circulated "Howard Ben Tré: Contemporary Sculpture." During the late 1980s, the public also witnessed important exhibitions featuring glass by artists not associated with the craft, such as the Mario Merz and Christopher Wilmarth retrospectives at the Solomon R. Guggenheim Museum and The Museum of Modern Art, New York. Two notable exceptions to the narrowing concept were mammoth touring surveys in which glass was prominently featured: "Craft Today: Poetry of the Physical," by the American Craft Museum, and the "The Eloquent Object," by The Philbrook Museum of Art, Tulsa, Oklahoma.

The 1970s saw a rise in the number of corporate craft collections overseen by private curators. Those highlighting glass were the Capital Bank of Houston and the Safeco Insurance Company, Seattle. In 1989 an additional corporate assemblage, the Prescott Collection of Pilchuck Glass at the Pacific First Centre in Seattle, was dedicated. The commissioned works (functional and sculptural) were incorporated throughout a prominent commercial building in downtown Seattle, making it one of the few corporate collections completely accessible to the public.

Although the commissioning of glass art dates from the glass mosaics of the Romans, its application to studio glass was new. By 1977 the process was sufficiently widespread to warrant publication in the *Glass Art Society Newsletter* of an attorney-authored sample "commission agreement" between artist and collector.[15] The glass collectors Anne and Ronald Abramson of Washington, D.C., were noted for underwriting architectural elements and sculpture that were sometimes made available as loans to appropriate public and private locales.

Studio glass also attracted greater commercial interest, appearing in design and architecture magazines as accent pieces for stylish interiors. Commercial establishments catering to the style-conscious affluent buyer commissioned editions of vases and other "art glass" tableware.

By the mid-1980s, several private collections that had been developing over the preceding ten-odd years went on public display, for example, Jane and Bill Brown's collection at Western Carolina University, Cullowhee, North Carolina (1984). Many collectors were eager to share their glass with a larger audience.

Selections from the Dorothy and George Saxe Collection were shown at The Oakland Museum, California, and at the American Craft Museum in 1986–87. The Saxes, like many others, had begun collecting glass in 1980 after seeing "New Glass" and "Young Americans: Clay / Glass." Jean and Hilbert Sosin, glass collectors since 1971, exhibited their collection at the University of Michigan–

Dearborn, in 1987, and in 1989 Donald and Carol Wiikin, also early studio glass collectors, showed parts of their collection at the McLean County Arts Center in Illinois.

In addition to the excitement of pursuing the art, collectors are attracted by the social aspects of the museum world. One of the first gatherings for glass collectors took place in 1983 at the Tucson meeting of the Glass Art Society. Approximately twenty collectors and dealers, joined by a few glassmakers, discussed buying and display practices as well as their overall roles within the field. Collectors' organizations offer an arena for exchanging information. Groups also assist in educational and other programs to benefit the field and pass on their enthusiasm.

Groups of glass collectors at first organized on the basis of region. The Studio Glass Collectors' Group convened in 1980, in part to support the collecting of contemporary glass by The Detroit Institute of Arts. The Metropolitan Contemporary Glass Group, formed largely of collectors centered in the New York vicinity, was founded in 1984, as was the Contemporary Glass Group of Delaware Valley. In 1987 the North Shore Studio Art Glass Group, based in suburban Chicago, was formed.

In the early 1980s, the Edgewood Orchard Gallery in Fish Creek, Wisconsin, initiated its highly successful annual glass weekend, which attracted up to several hundred enthusiasts. The strong desire of collectors to gather together more formally was an incentive for the nonprofit Creative Glass Center of America at Wheaton Village, Millville, New Jersey, to initiate in 1985 its biennial "Glass Lovers Weekend." Proceeds from the event support the artists' fellowship program of the center.

The Art Alliance for Contemporary Glass, the rapidly growing national association of studio glass collectors, was formed in 1987 to promote the glass arts. Its first annual meeting was held in September 1989 in Chicago in conjunction with the Chicago International New Art Forms Exposition.

In 1979 *Craft Horizons* magazine was renamed *American Craft* and redesigned in a more contemporary image. This format change coincided with the excitement of the "New Glass" tour and the attendant growth of a collecting audience. From this point forward, the galleries changed from having almost no advertising policy at all, to taking out full-page and color advertisements.

A staggering number of galleries featuring glass opened, changed names, and closed their doors. By 1984 the membership of the short-lived Glass Art Dealers Association numbered thirty-two.[16]

Foreign studio glass eventually became an important presence in American galleries and private collections. After the 1989 "Velvet Revolution" in Czechoslovakia, a new atmosphere open to foreign investment prevailed

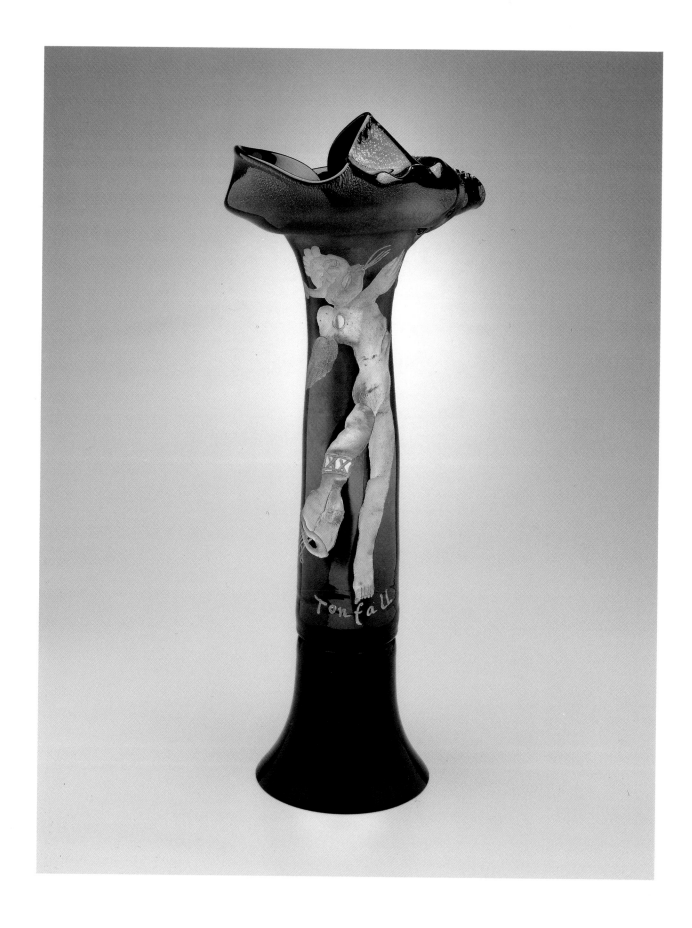

PLATE 13
Erwin Eisch
**Tonfall,** 1981
(cat. 26)

and a few galleries began to establish representation in Prague. In 1991 the Heller Gallery sponsored the "Prague Glass Prize" at the Union of Czechoslovakian Artists. An edited version of that survey exhibition was shown in New York in 1992.

Many collectors actively sought out foreign artists and dealers and made a point of attending international events. The vigor and commitment of the American collectors made them an especially interesting phenomenon in countries where no comparable activity existed; the German periodical *Neues Glas* profiled Jean and Hilbert Sosin (1986) and Elmerina and Paul Parkman (1987).

A trend that had its beginnings in the 1970s was the "crossover" of artists working with glass from galleries associated with the crafts to those of fine art, which drew a greater degree of serious attention from journals and critics. Art galleries brought the work to a different collecting audience — one accustomed to paying higher prices and often more accepting of larger-sized objects, at times with a decreased emphasis on the inherent physical properties of the glass and using glass in combination with other media.

A trend in the opposite direction was the inclusion of artists previously unassociated with glass as a craft within craft-focused exhibitions and collections. Works by Nicholas Africano, Larry Bell, Donald Lipski, and Italo Scanga, among others, soon came to the attention of medium-oriented collectors through their participation in the Pilchuck Glass School and in the Glass Art Society annual meetings.

Periodicals and exhibitions also reflected the blending between glassmakers and those who simply used glass as one material. Articles by well-known critics for *New Work* (later *Glass*), such as Carter Ratcliff and Kim Levin, considered work from outside as well as inside the craft communities. The Tacoma Art Museum in Washington organized "Glass: Material in the Service of Meaning" (1991), an exhibition of American artists incorporating glass into their work, but not making work *about* glass.

A recurrent concern among collectors since the 1970s was the rapidly escalating prices of contemporary glass. Those who had started buying early had acquired works with relatively modest investments. By 1981 the *Glass Art Society Journal* found it appropriate to publish an essay by dealer Ferdinand Hampson stating that the previous two years had seen a drastic price increase and that prices for the top artists had increased 100 percent.[17] Hampson's suggested explanation for this rapid climb included the increasing number of collectors as a result of public exposure through museum exhibitions. According to Hampson, competition for objects caused prices to rise. Collectors were ambivalent toward a situation that increased the value of individual collections while pushing sales prices higher.

In the late 1980s, the issue of "editions" replaced the topic of advancing prices. Although usually represented as one-of-a-kind objects, many studio glass objects were made by blowing or casting into molds, thus allowing the creation of similar works. Other designs were repeatedly produced with slight changes. Collectors began to urge dealers and artists to disclose the number in a series. It soon became apparent that the degree of change necessary to constitute a work unique was a legal matter.

On January 1, 1992, legislation was enacted in New York State requiring that any piece of sculpture made after January 1, 1991, and sold by an art dealer or auction house had to be accompanied by disclosure in writing of the number of casts made of the object. Curiously, due to intense lobbying by representatives of Steuben glass, the law specifically *excluded sculpture executed in glass*. The implications of this legislation can only continue to cloud the issue for glass. It may also contribute to the prejudice that at times excluded glass objects from consideration as serious works of art.

The years 1989 and 1990 were crucial for those interested in the resale value of contemporary glass. Although it had long been offered at public sale by galleries and in European and minor American auctions, it was not until February 1989 that a major international auction house, Christie's, New York, offered 157 lots of glass made for the most part after 1985. Unfortunately, the works were being sold by order of the American National Bank of Cleveland during an embezzlement investigation of the Ohio owners. Although sales results exceeded the low estimates, the uneven and generally mediocre quality of the collection provided an inauspicious entry for studio glass into the secondary market. Later that year Christie's presented The Martin and Jean Mensch Collection of Contemporary Glass as part of a sale of contemporary paintings, drawings, and sculpture.

Both Christie's and Sotheby's, New York, held auctions of contemporary glass in 1989 and 1990 to benefit the nonprofit New York Experimental Glass Workshop and the Creative Glass Center of America. Results were again generally positive; however, by 1991 the novelty of auction fever seemed to have subsided as the economy faltered.

By the mid-1980s, a few collectors were selling or giving away works in an effort to focus and upgrade. Some, discouraged by the increasing prices and scale of the newest work, were leaving the field altogether. Still others chose to bestow gifts on museums.

In 1977 the American Craft Museum received approximately one-third of the "Objects: USA" collection from

S. C. Johnson & Son, Inc., forming the core of their permanent collection. The first two large gifts of contemporary glass came from individual collectors. Joan and Sheldon Barnett gave a total of fifty works to the Milwaukee Art Museum in 1990, and in 1991 The Detroit Institute of Arts received over sixty objects in memory of David Jacob Chodorkoff. The transference of fifty-seven glass objects and one drawing from the Dorothy and George Saxe Collection to The Toledo Museum of Art in 1990 made the Toledo collection, because of its strong glass holdings, one of the most significant to date.

The foresight and generosity demonstrated by the Saxes, Barnetts, Chodorkoffs, and other collectors will no doubt be repeated. Paul and Elmerina Parkman, American studio glass collectors since the early 1970s, have enriched their experience through a broad range of educational and archival studies that give back to the field. They have found the most satisfying rewards of collecting to lie "beyond the acquisition of the object."[18] After all, as stated by the Swedish artist Bertil Vallien, "Today the only justification for an artist-craftsman is as a ploughshare: to have a meaning, to disturb and inspire — not just to satisfy a desire for possessions."[19]

## Notes

1. An excellent discussion of the overall development of American crafts during the first half of the twentieth century can be found in the introductory essay of *Objects: USA* by Lee Nordness. Those establishments featuring studio glass in the 1970s included Appalachian Spring and Third Spring Galleries, Washington, D.C.; Helen Drutt Gallery, Philadelphia; Florence Duhl Gallery, New York; Edgewood Orchard Gallery, Fish Creek, Wisconsin; Egg and the Eye, Los Angeles; The Elements Gallery, Greenwich, Connecticut, and New York; Sarah Eveleth Antiques (later The Glass Gallery), Washington, D.C.; Fairtree Gallery, New York, and its sister gallery, Galeria del Sol, Santa Barbara, California; Galerie Elena Lee / Verre d'Art, Montreal; Hadler Gallery, New York (later Hadler / Rodriguez Galleries, New York and Houston); The Hand and The Spirit (later Joanne Rapp Gallery / The Hand and The Spirit), Scottsdale, Arizona; Hills Gallery, San Francisco; Holsten Gallery, Stockbridge, Massachusetts; Incorporated Gallery, New York; Mindscape Gallery, Evanston, Illinois; Theo Portnoy Gallery, New York; The Works, Philadelphia; and Yaw Gallery, Birmingham, Michigan.

2. Paul Perrot, "New Directions in Glassmaking," *Craft Horizons* 20, 6 (Nov.–Dec. 1960), pp. 23–25.

3. See Earl McCutchen, "Glass Molding: Experimenting on a Low Budget," *Craft Horizons* 15, 3 (May–June 1955), pp. 38–50; Dido Smith, "Gold Glass: An Ancient Technique Rediscovered," *Craft Horizons* 16, 6 (Dec. 1956), pp. 12–15; Kay Kinney, *Glass Craft: Designing, Forming, Decorating* (Philadelphia: Clinton Company, 1962).

4. Frederick Schuler, "Ancient Glassmaking Techniques," *Craft Horizons* 20, 2 (Mar.–Apr. 1960), pp. 33–37; and "Ancient Glass Blowing," *Craft Horizons* 20, 6 (Nov.–Dec. 1960), pp. 38–41.

5. Toledo, Ohio, Toledo Glass Workshop, *Glass Workshop Report* (Toledo, 1962).

6. Dido Smith, "Offhand Glass Blowing," *Craft Horizons* 24, 1 (Jan.–Feb. 1964), pp. 22–23, 53–54.

7. Dominick Labino, *Visual Art in Glass* (Dubuque, Iowa: William C. Brown, 1968); and Harvey Littleton, *Glassblowing: A Search for Form* (New York: Van Nostrand Reinhold, 1971).

8. New York, Heller Gallery, *Libenský-Brychtová: Glass Sculpture* (New York, 1988), p. 2.

9. Wausau, Wisconsin, The Leigh Yawkey Woodson Art Museum, *Americans in Glass,* text by David R. Huchthausen (Wausau, 1978), p. 3.

10. Penelope Hunter-Stiebel, "Contemporary Art Glass: An Old Medium Gets a New Look," *Art News* 80, 6 (Summer 1981), p. 130.

11. Sylvia Vigiletti, "Second Annual National Glass Exhibition," *Glass Art Magazine* 2, 4 (Aug. 1974), pp. 44–47.

12. See Wausau, Wisconsin, The Leigh Yawkey Woodson Art Museum, *Americans in Glass* (Wausau, 1981), pp. 3–4; and Wausau, Wisconsin, The Leigh Yawkey Woodson Art Museum, *Americans in Glass* (Wausau, 1984), pp. 7–11.

13. Robert Arneson, "Six Glassblowers," *Craft Horizons* 27, 5 (Sept.–Oct. 1967), pp. 39–40.

14. Robert Silberman, "Americans in Glass: A Requiem," *Art in America* 73, 3 (Mar. 1985), pp. 47–53.

15. Michael C. Skindrud, "Legal Problems and Protection for the Artist," *Glass Art Society Newsletter* 2, 5 (1977), p. 27.

16. Noteworthy glass exhibitors by the first half of the 1980s included Sandra Ainsley Gallery, Toronto; American Glass Art Gallery, Santa Monica, California; Contemporary Artisans (later renamed Elaine Potter Gallery), San Francisco; Convergence, New York; Del Mano Gallery, Los Angeles; Designs Recycled (later renamed Eileen Kremen's Designs Recycled), Fullerton, California; D / Erlien Fine Art, Limited, Milwaukee; Edelweis, Gallery, New York; Marilyn Faith Gallery, Chicago; Fendrick Gallery, Washington, D.C.; Foster / White Gallery, Seattle; Glass Art Gallery, Toronto; Glass Veranda, Boston; Great American Gallery, Atlanta; Greenwood Gallery, Washington, D.C.; Hadler / Rodriguez Galleries, Houston; Hildebrandt Gallery, Philadelphia; Robert L. Kidd Associates Incorporated, Birmingham, Michigan; Maurine Littleton Gallery, Washington, D.C.; Meyer Breier Weiss, San Francisco; Anne O'Brien Gallery, Washington, D.C.; Oktabec Gallery, Los Angeles; Perception Gallery (later renamed Judy Youens Perception Gallery), Houston; Betsy Rosenfield Gallery, Chicago; Ivor Russell Glass Art Gallery (undergoing three name changes from 1982 until becoming Kurland / Summers in 1983), Los Angeles; Snyderman Gallery, Philadelphia; Sarah Squeri Gallery, Cincinnati; Stein Glass Gallery, Portland, Maine; Studio Glass Gallery of Great Britain, Montclair, New Jersey (later renamed Miller Gallery and moved to New York); Tifanee Tree (and its offshoot, The Branch Gallery), Washington, D.C.; Traver / Sutton Gallery (later renamed William Traver Gallery), Seattle; and B. Z. Wagman Gallery, St. Louis. Other galleries achieving prominence at a later date included Garland Gallery, Santa Fe, New Mexico; Christy Taylor Gallery, Boca Raton, Florida; Vesperman Glass Gallery, Atlanta; and Brendan Walter Gallery, Santa Monica. Although the Leo Kaplan Gallery in New York had included studio work with their other glass offerings for several years, in 1991 a second gallery, Leo Kaplan Modern, was opened to represent studio glass and contemporary furniture.

17. Ferdinand Hampson, "New Interest in Glass Sends Prices Soaring," *Glass Art Society Journal,* 1981, pp. 38–40.

18. Paul and Elmerina Parkman, "Beyond Acquisition," *Glass Art Society Journal,* 1989, pp. 58–62.

19. Bertil Vallien, *Glass* 45 (Fall 1991), p. 10.

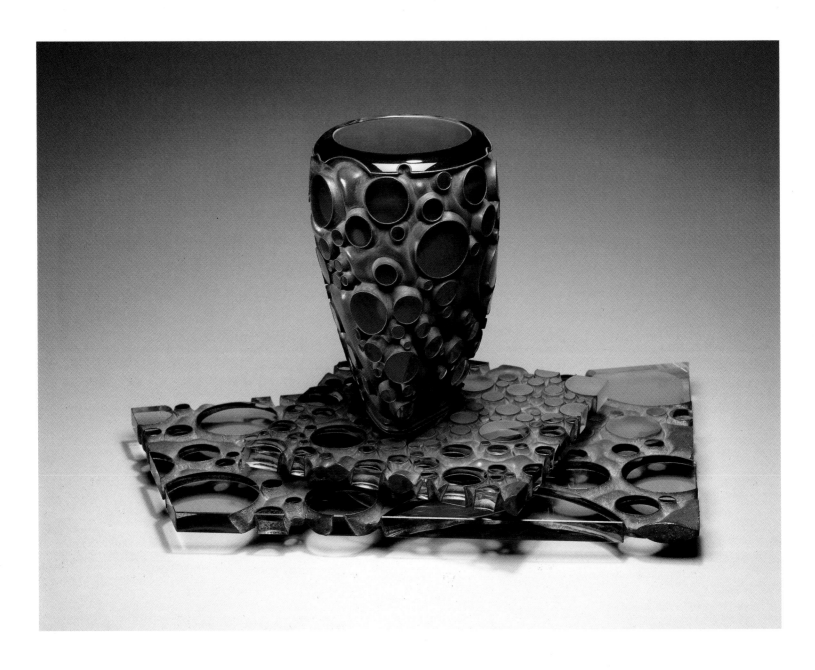

PLATE 14
Michael Glancy
**Sovereign Cloister — Beyond War**, 1986
(cat. 29)

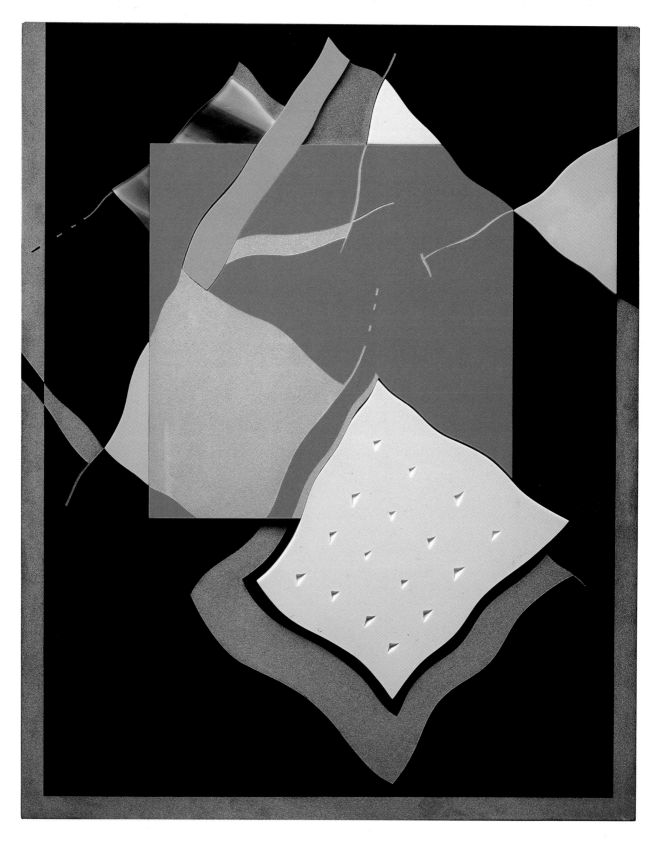

PLATE 15
Henry Halem
**Square Penetration,** 1981
(cat. 30)

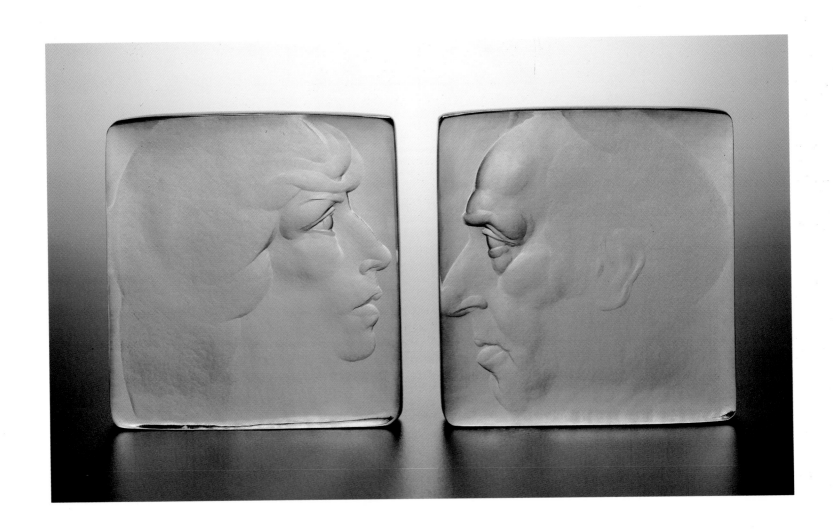

PLATE 16
Jiří Harcuba
**Portraits of Dorothy and George Saxe,** 1983
(cat. 31)

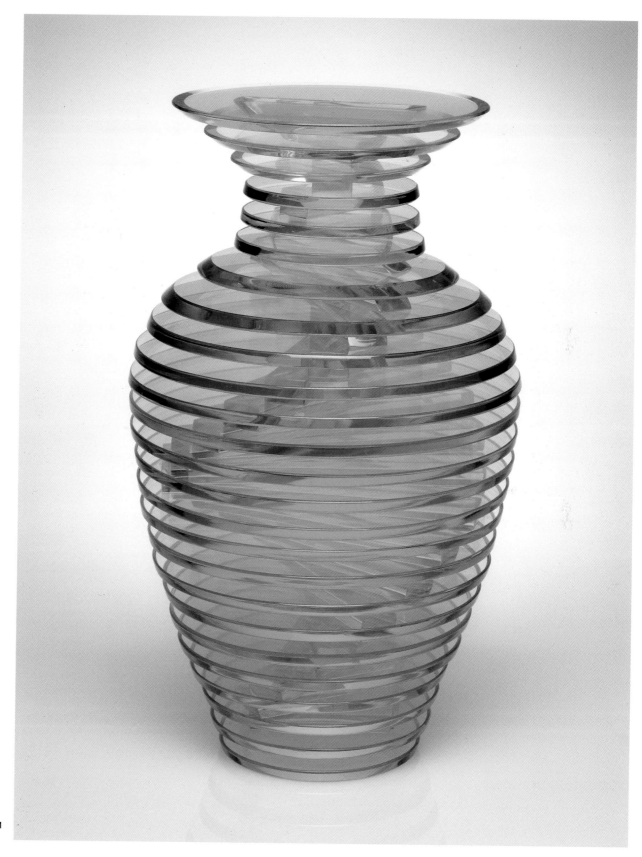

PLATE 17
Sidney R. Hutter
**Plate Glass Vase #26,** 1981
(cat. 39)

PLATE 18
David R. Huchthausen
**Leitungs Scherbe LS 282**, 1982
(cat. 36)

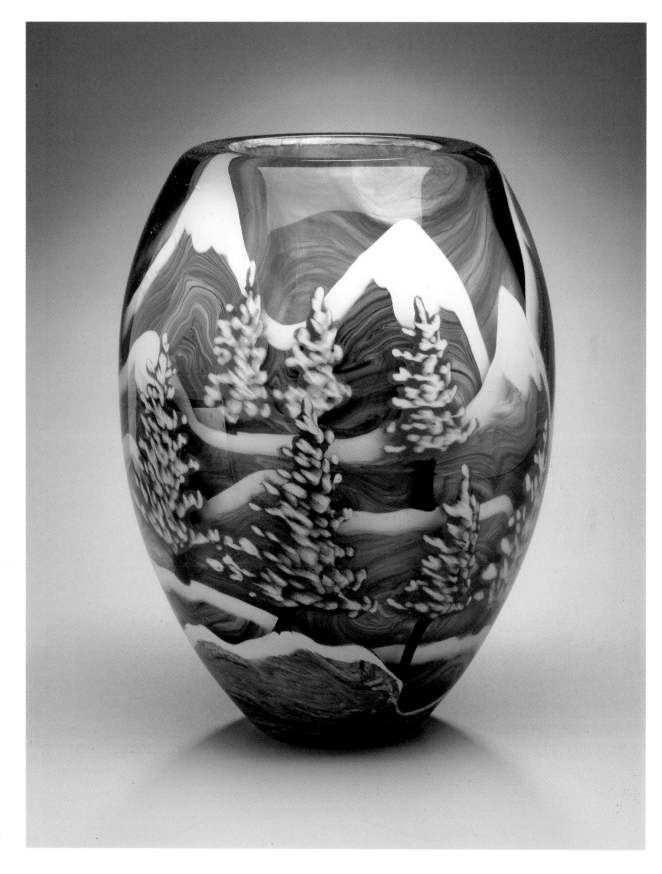

PLATE 19
David R. Huchthausen
**Alpine Landscape,** 1978
(cat. 35)

PLATE 20
Margie Jervis and Susie Krasnican
**Spotlit Bowl**, 1982
(cat. 41)

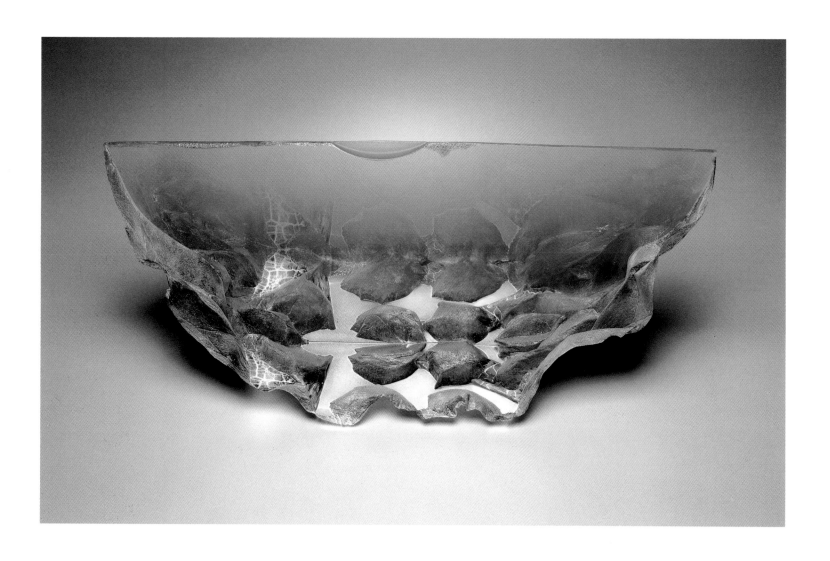

PLATE 21
Kreg Kallenberger
**Hidden Springs,** 1989
(cat. 42)

PLATE 22
Robert Kehlmann
**Composition #55**, 1979
(cat. 43)

PLATE 23
K. William LeQuier
**Sentinel III,** 1985
(cat. 44)

PLATE 24
Stanislav Libenský and Jaroslava Brychtová
**Head-Dish**, 1956
(cat. 45)

PLATE 25
Stanislav Libenský and
Jaroslava Brychtová
**The Cube in Sphere,**
1978–79
(cat. 46)

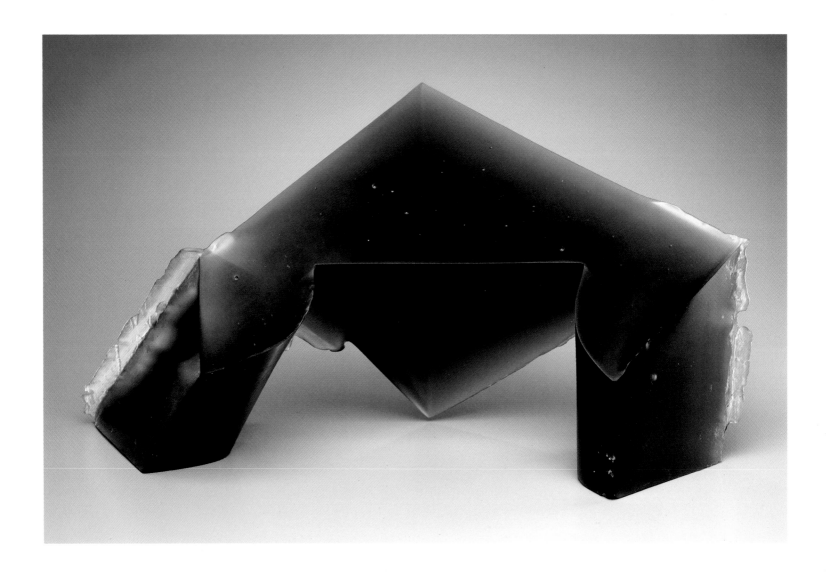

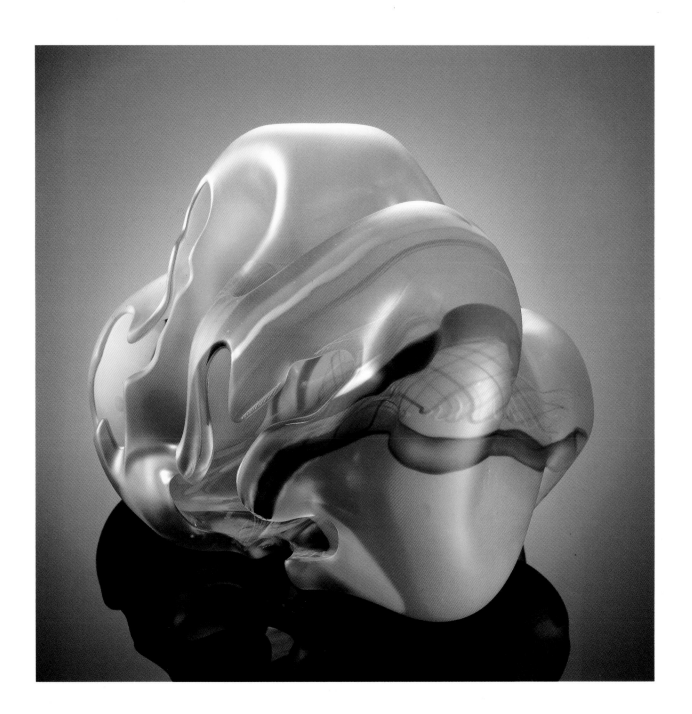

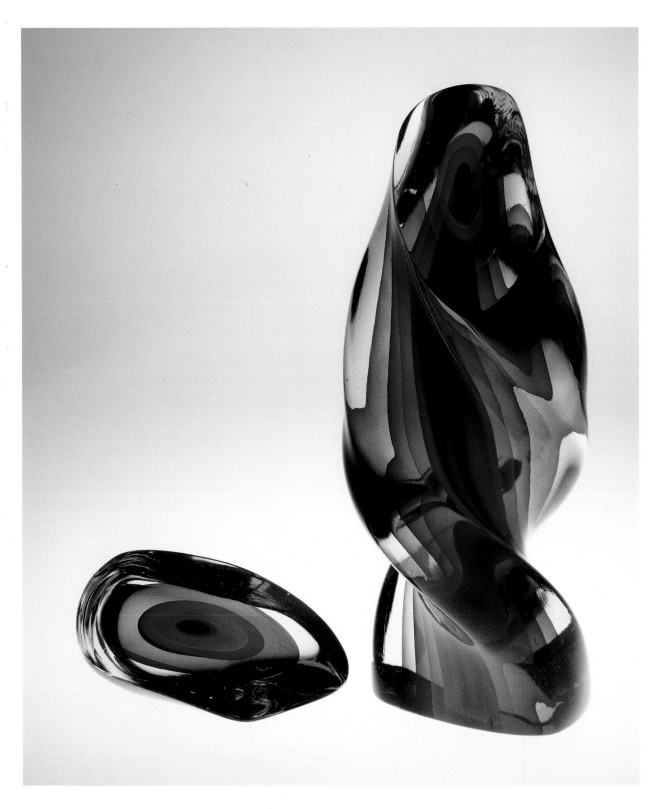

PLATE 28
Harvey K. Littleton
**300° Rotated Ellipsoid,** 1980
(cat. 51)

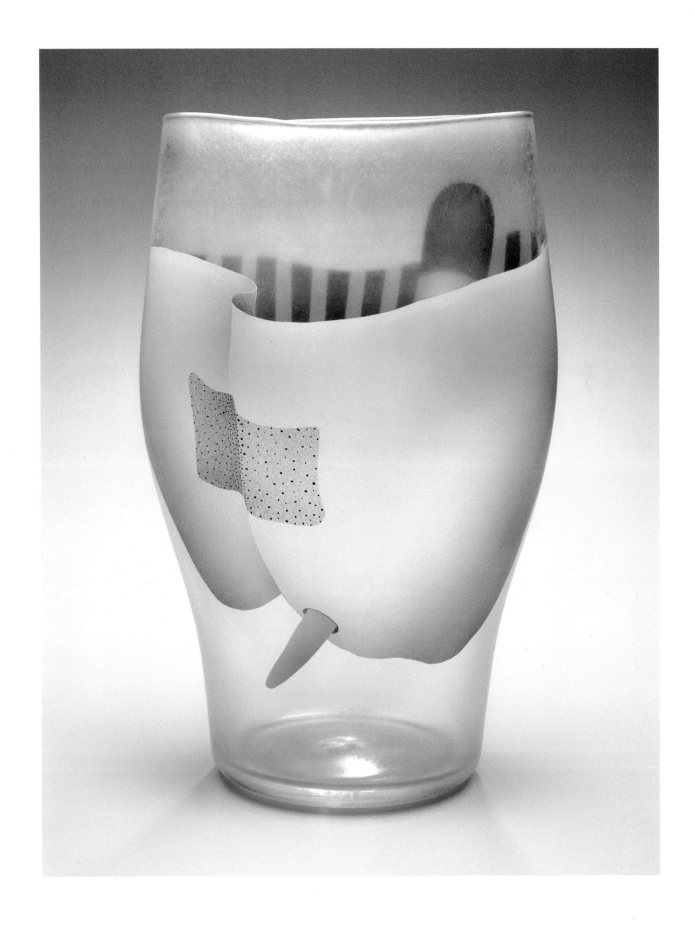

PLATE 29
Richard Meitner
**Untitled,** 1984
(cat. 60)

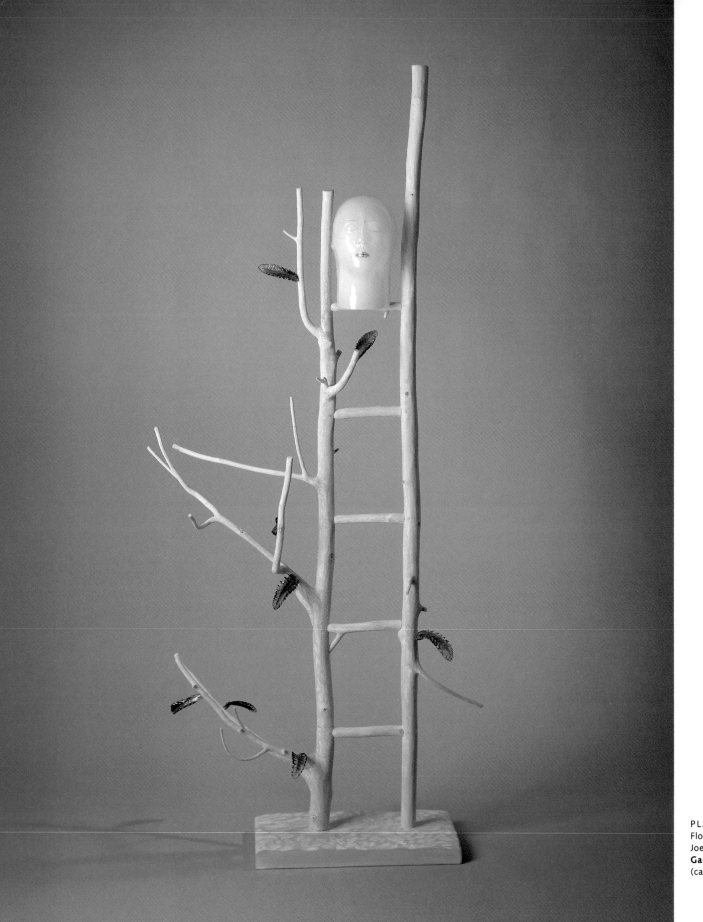

PLATE 30
Flora C. Mace and
Joey Kirkpatrick
**Garden of Ladders,** 1989
(cat. 54)

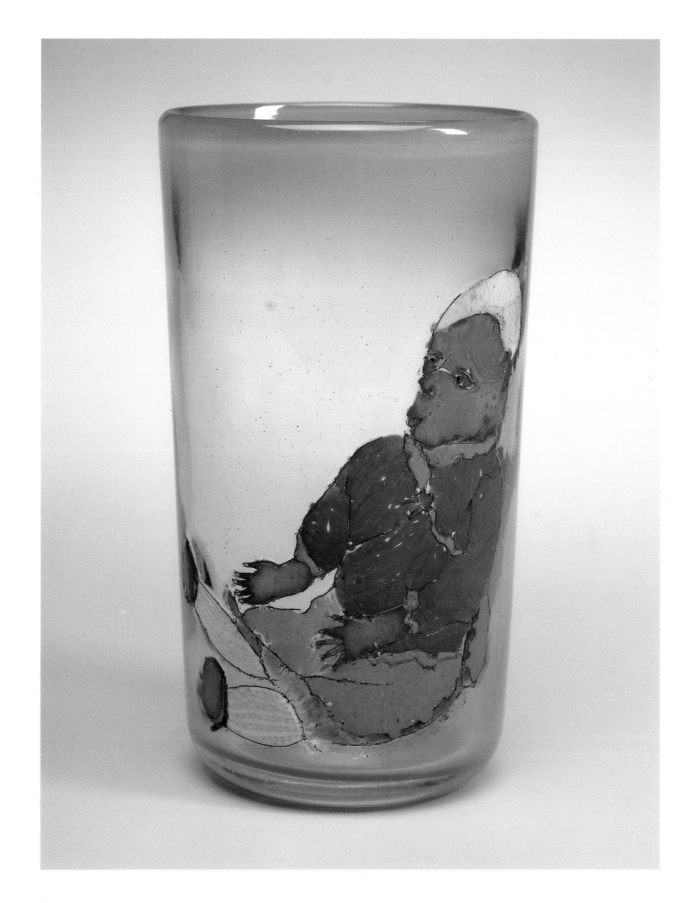

PLATE 31
Flora C. Mace and
Joey Kirkpatrick
**First Doll Portrait /
The Chinaman,** 1980
(cat. 53)

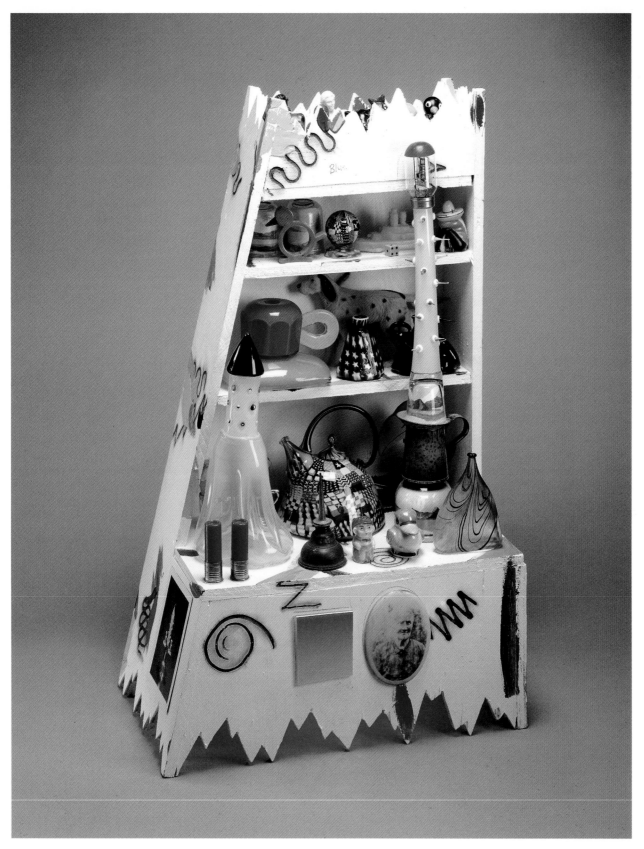

PLATE 32
Richard Marquis
**Personal Archive Unit —
Granite-Ware Landscape
Lamp,** 1981–84
(cat. 58)

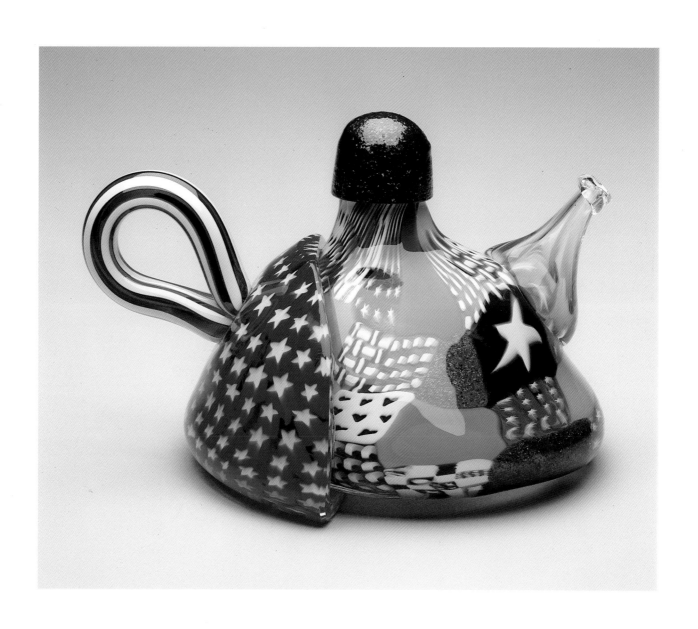

PLATE 33
Richard Marquis
**FWS #2**, 1979
(cat. 57)

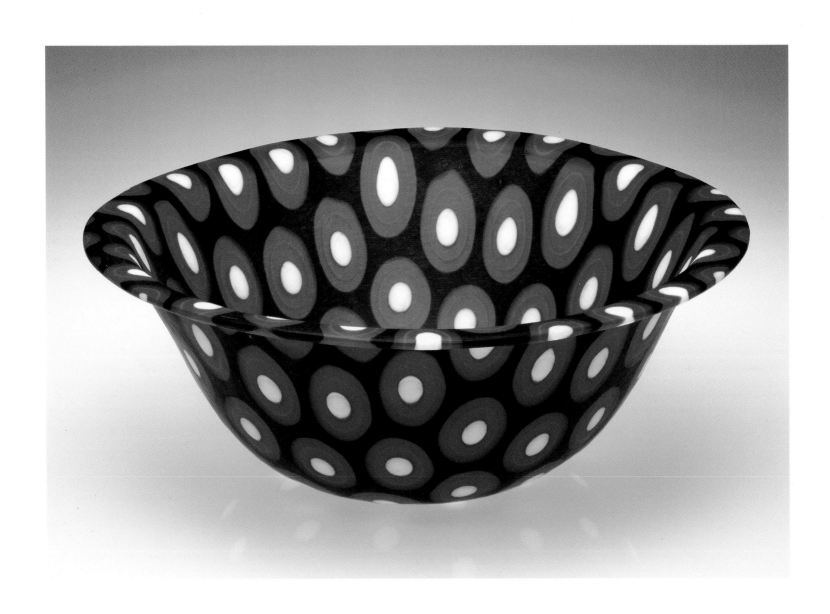

PLATE 34
Klaus Moje
**Untitled (Bowl or Lifesaver),** 1979
(cat. 61)

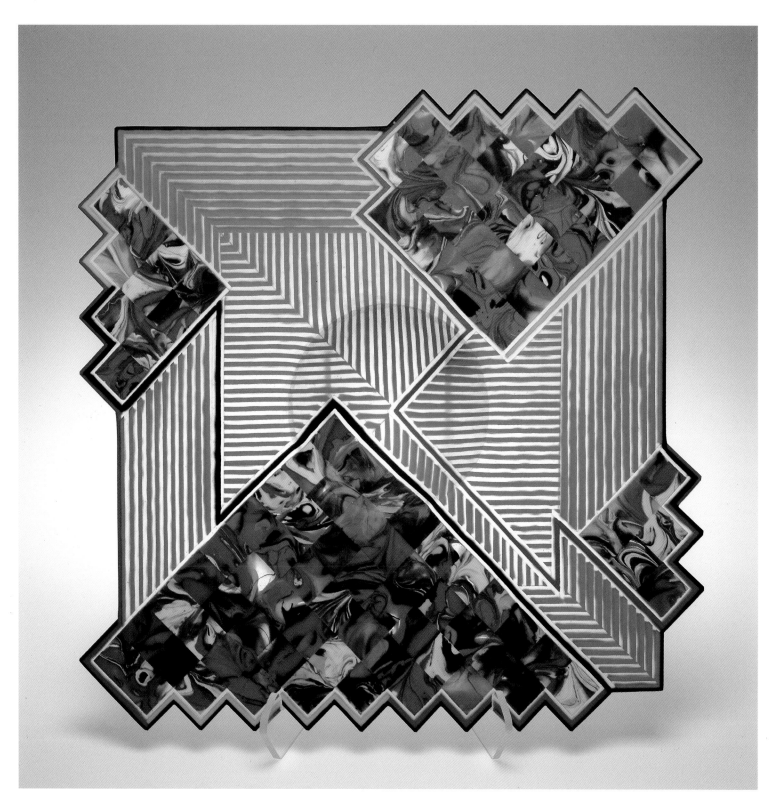

PLATE 35
Klaus Moje
**Untitled 11–1989 #47**, 1989
(cat. 62)

PLATE 36
William Morris
**Petroglyph Vessel,** 1989
(cat. 64)

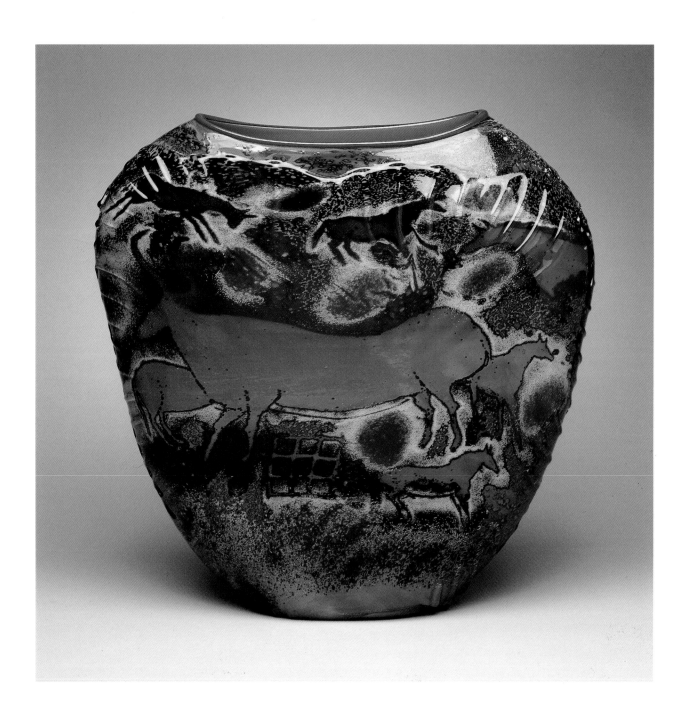

PLATE 37
William Morris
**Artifact Still Life,** 1989–90
(cat. 65)

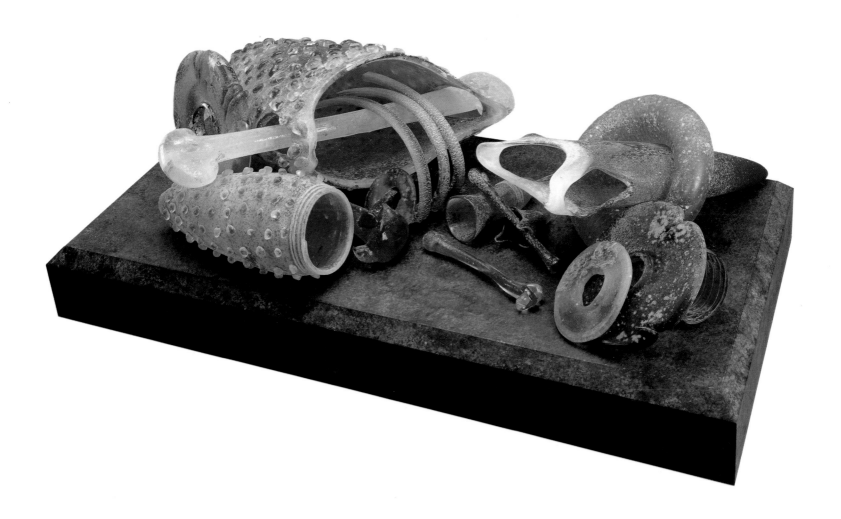

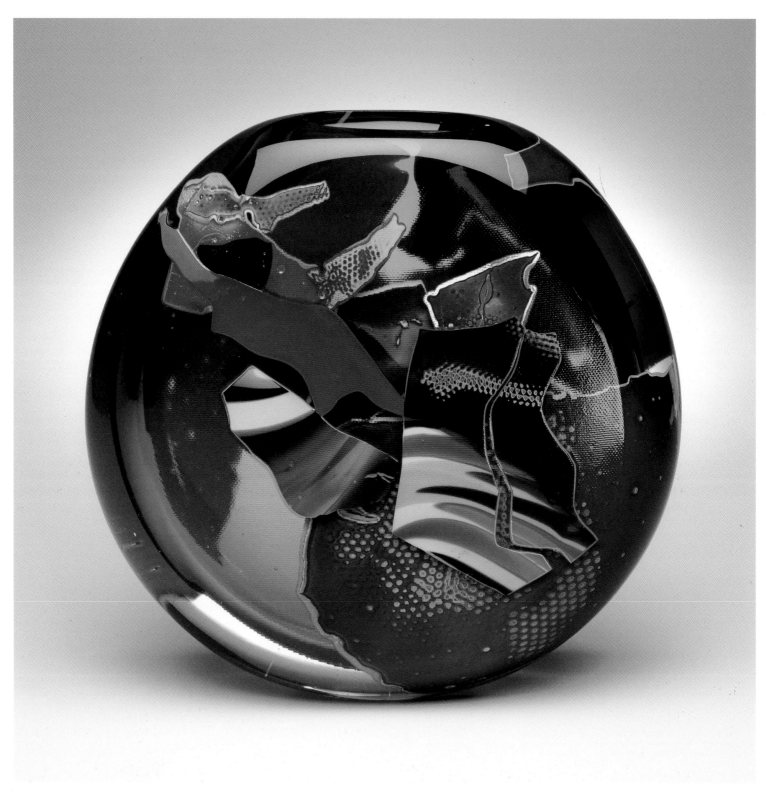

PLATE 38
Joel Philip Myers
**Untitled**(CFOURTURBLUEJPM),
1988
(cat. 68)

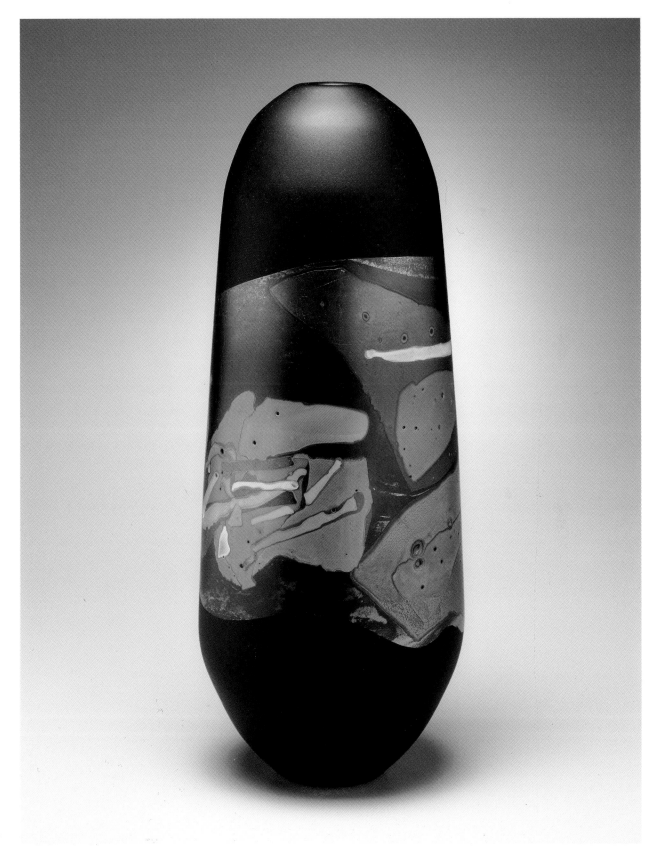

PLATE 39
Joel Philip Myers
**Untitled (CFBLACD)**, 1981
(cat. 67)

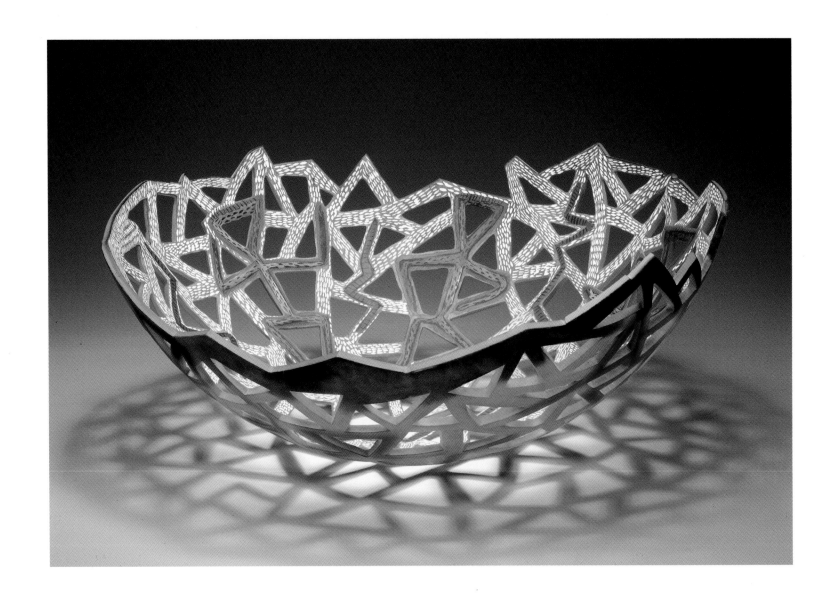

PLATE 40
Jay Musler
**Rock around the Clock,** 1982
(cat. 66)

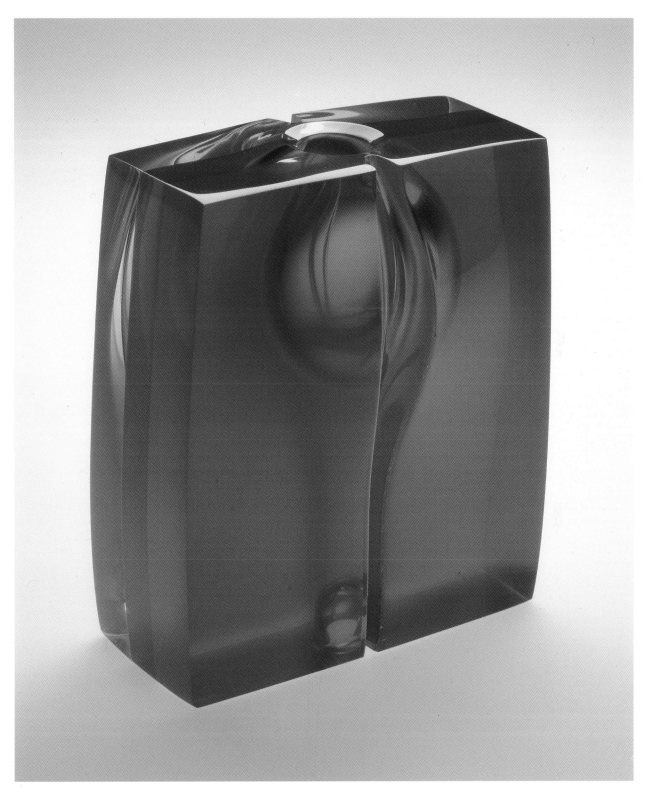

PLATE 41
Thomas Patti
**Split Ascending Red,** 1990
(cat. 74)

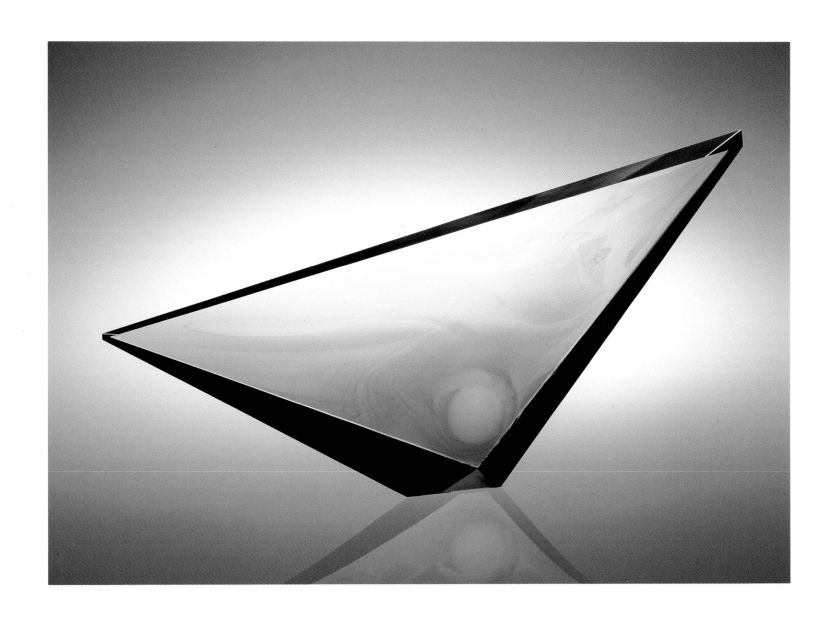

PLATE 42
Mark Peiser
**IS 458 (After the Storm),** 1988
(cat. 77)

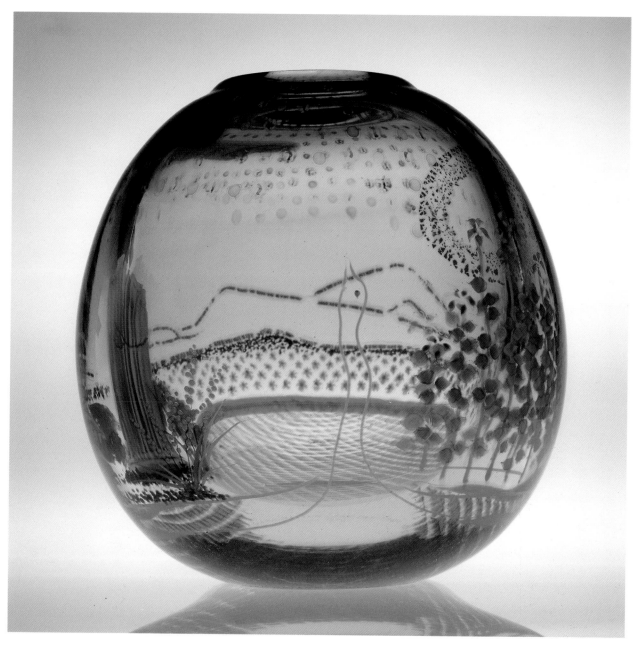

PLATE 43
Mark Peiser
**Leda and the Swan**, 1980
(cat. 76)

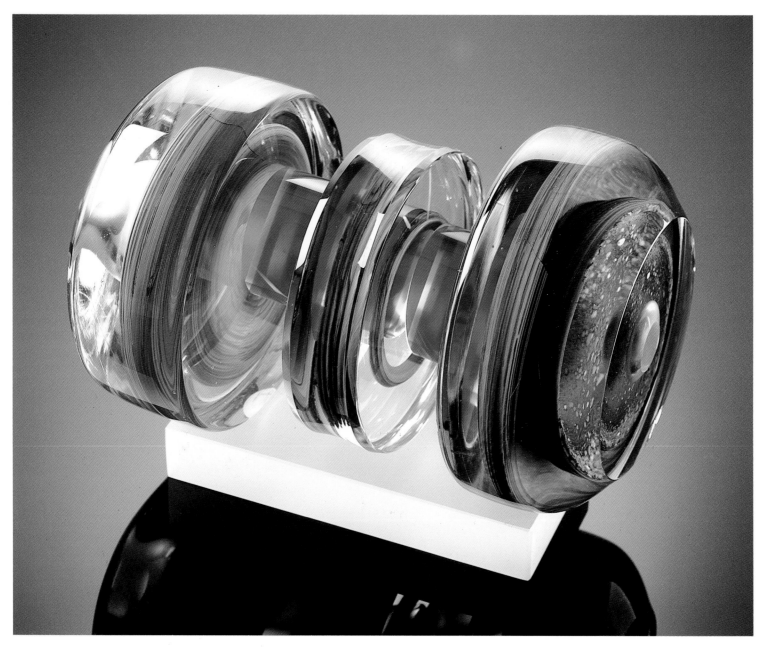

PLATE 44
Michael Pavlik
**Equivocal Equinox,** 1983
(cat. 75)

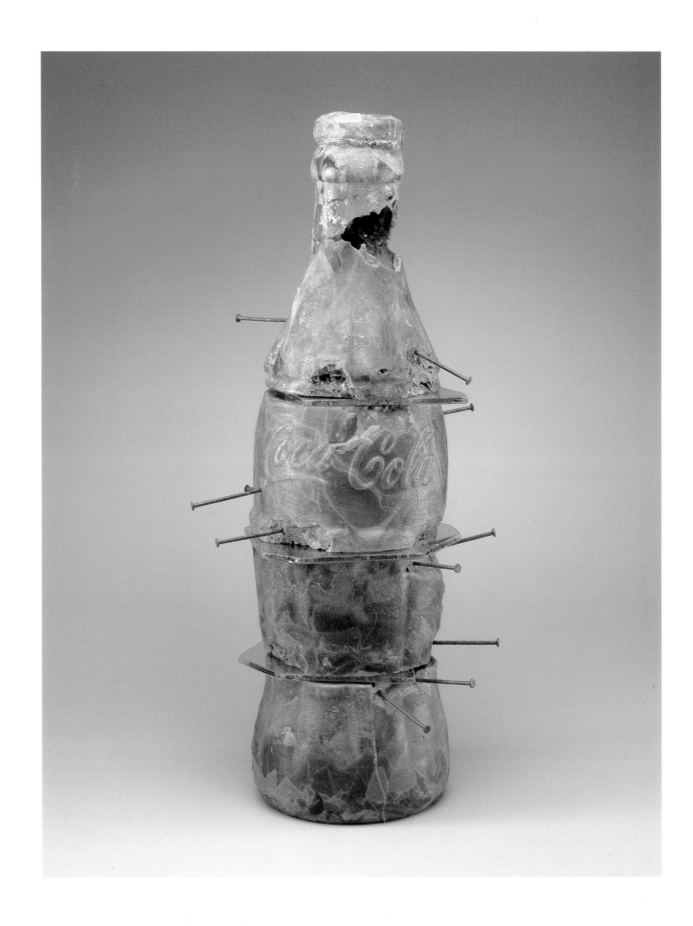

PLATE 45
Clifford Rainey
**Fetish**, 1989
(cat. 81)

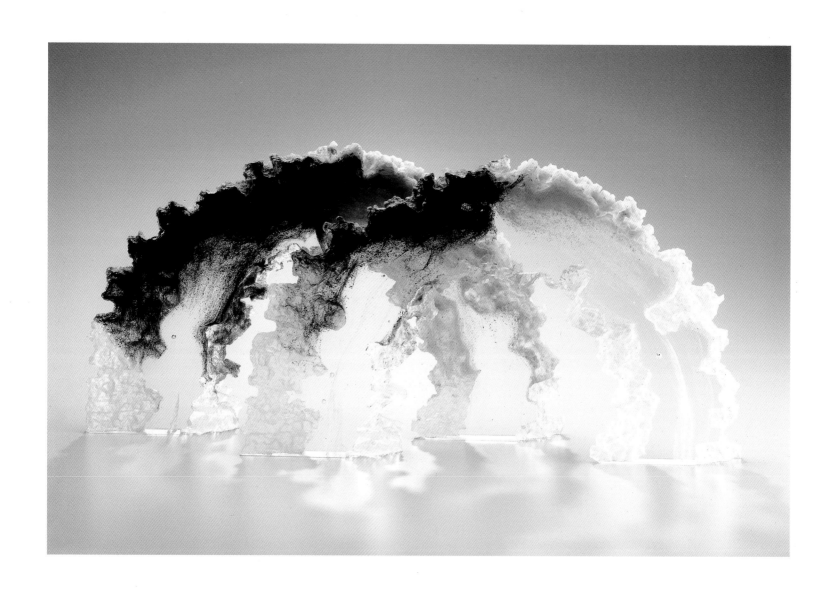

PLATE 46
Colin Reid
**Double Arches R 237 A & B,** 1987
(cat. 82)

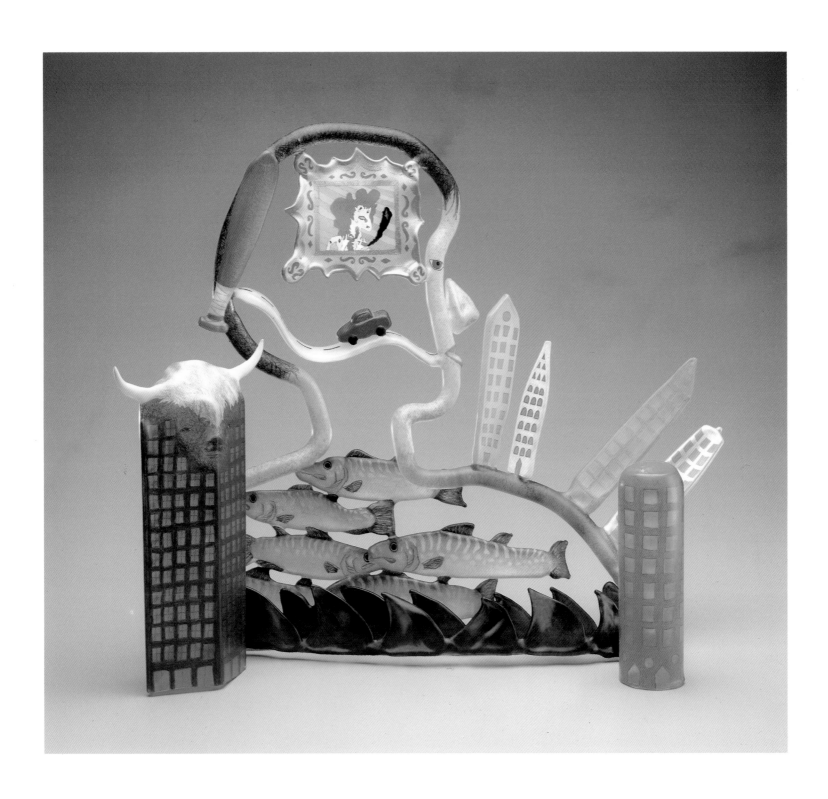

PLATE 47
Ginny Ruffner
**City of Broad Shoulders,** 1989
(cat. 87)

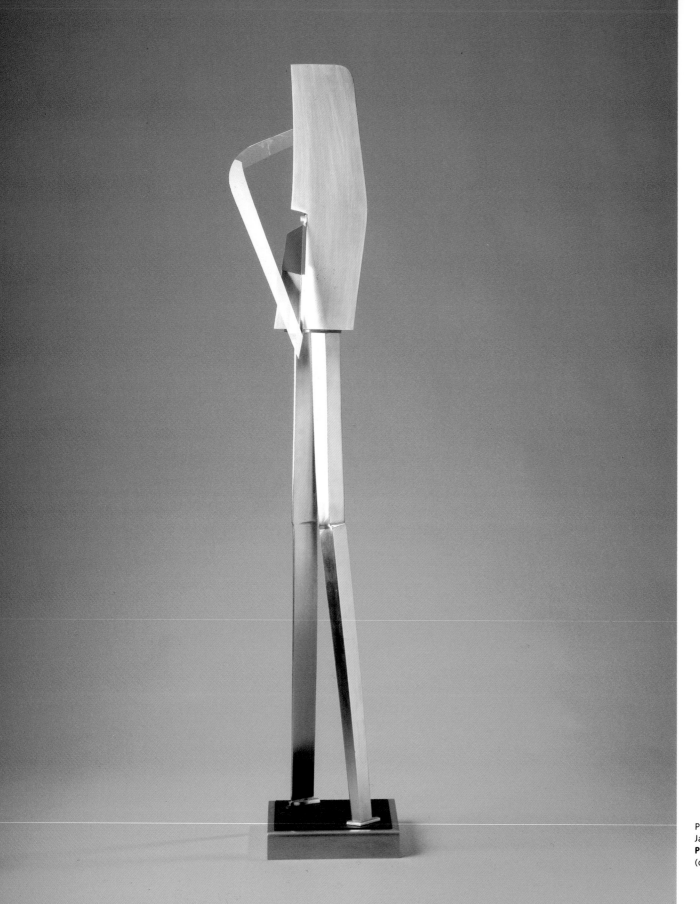

PLATE 48
Jack Schmidt
**Purple Walker,** 1988
(cat. 91)

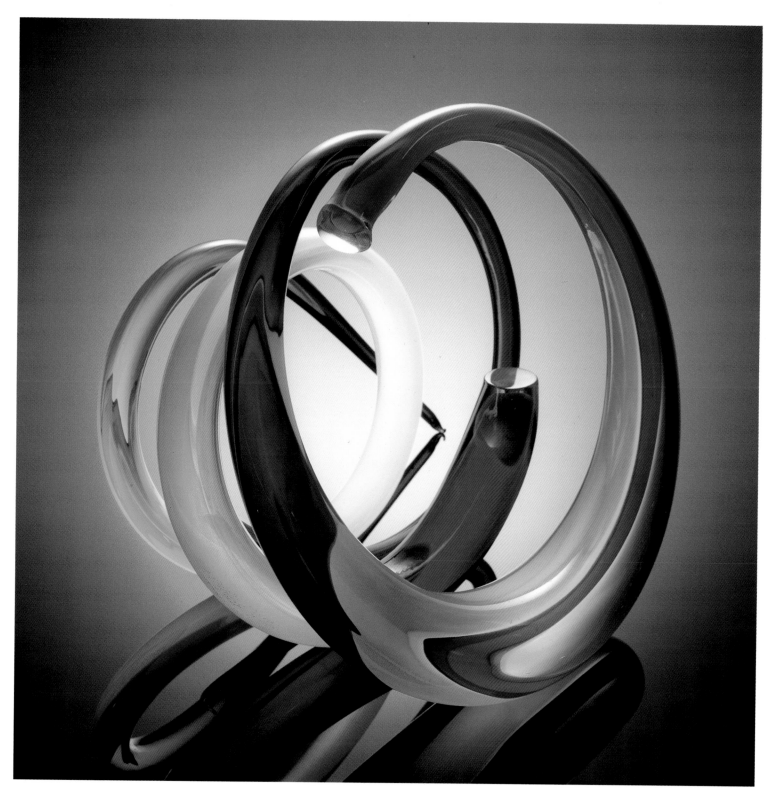

PLATE 49
Paul Seide
**Radio Light,** 1985
(cat. 92)

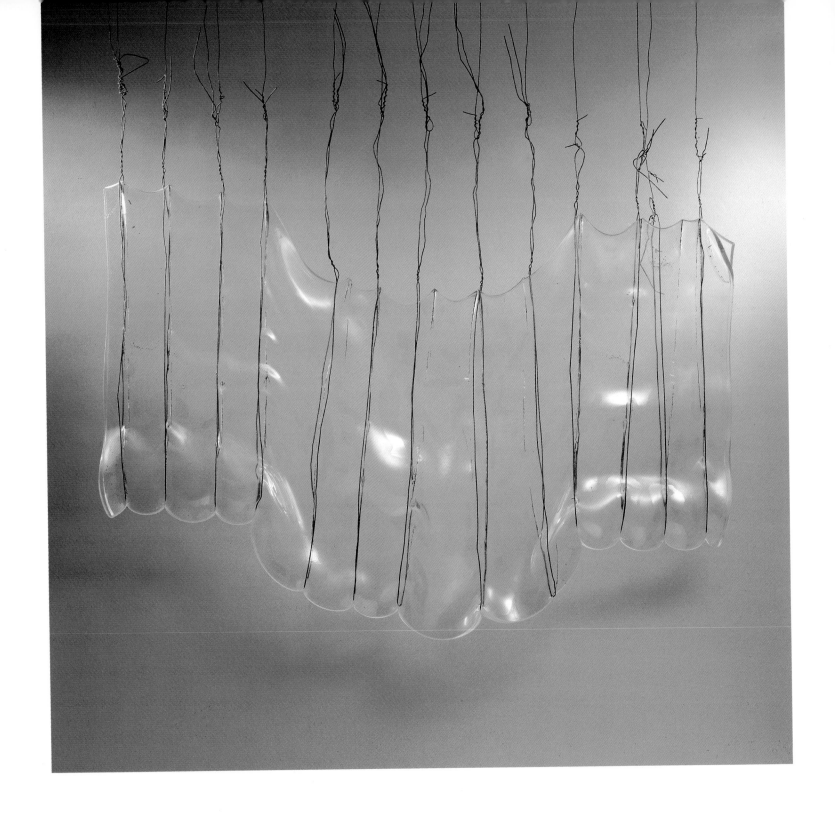

PLATE 50
Mary Shaffer
**Hanging Series #24,** 1978
(cat. 95)

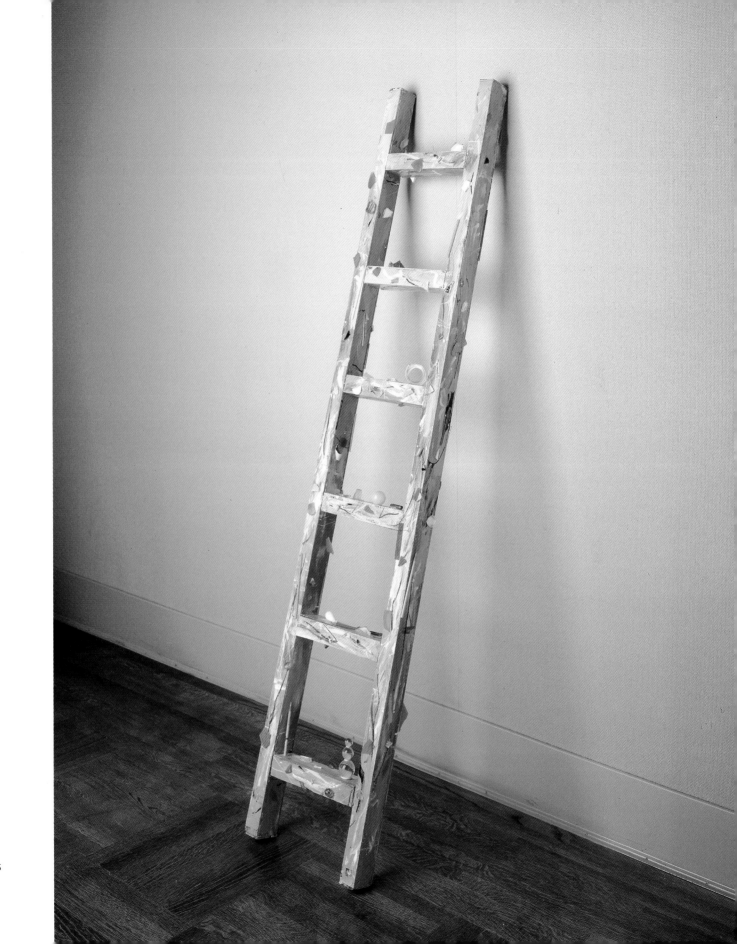

PLATE 51
Therman Statom
**Pink Ladder,** 1986
(cat. 102)

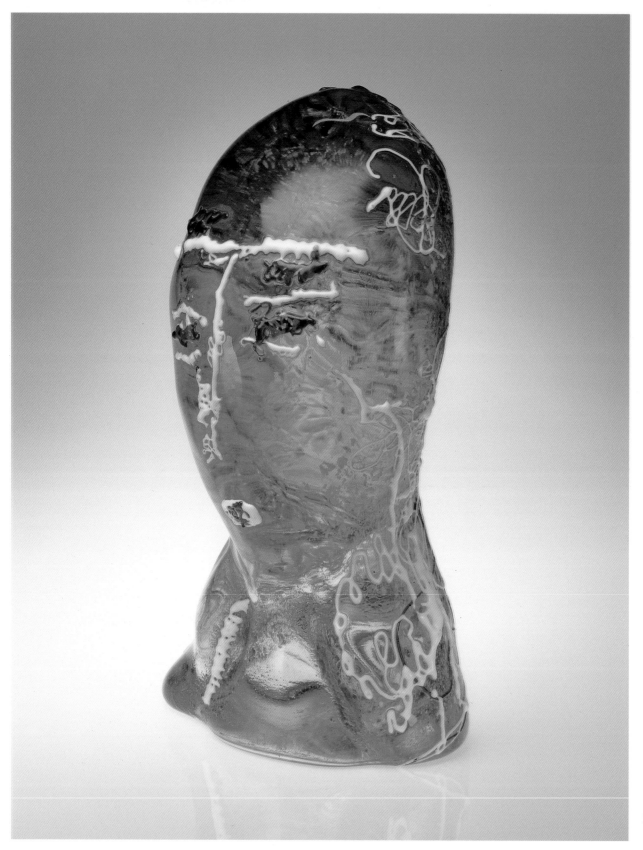

PLATE 52
Mark Tobey
**Volto,** 1974
(cat. 110)

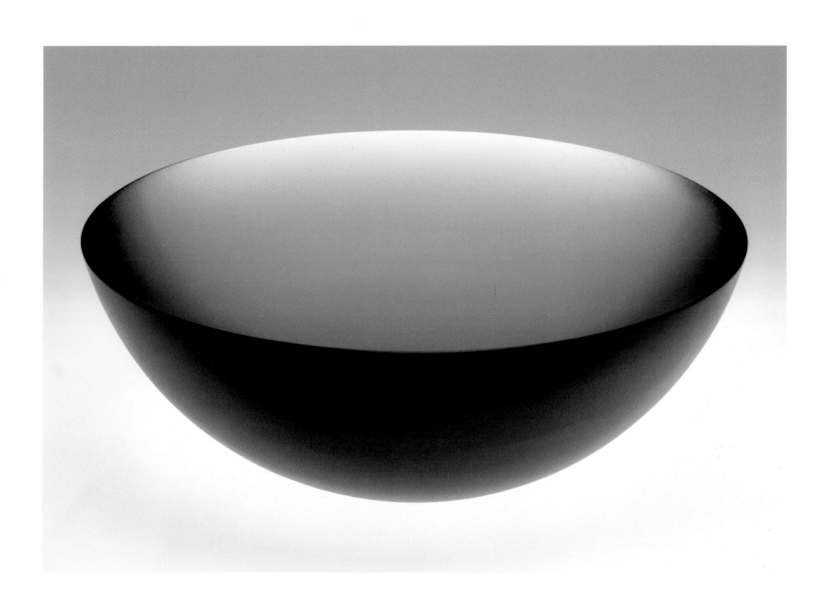

PLATE 53
František Vízner
**Sculpture VIII**, 1987
(cat. 115)

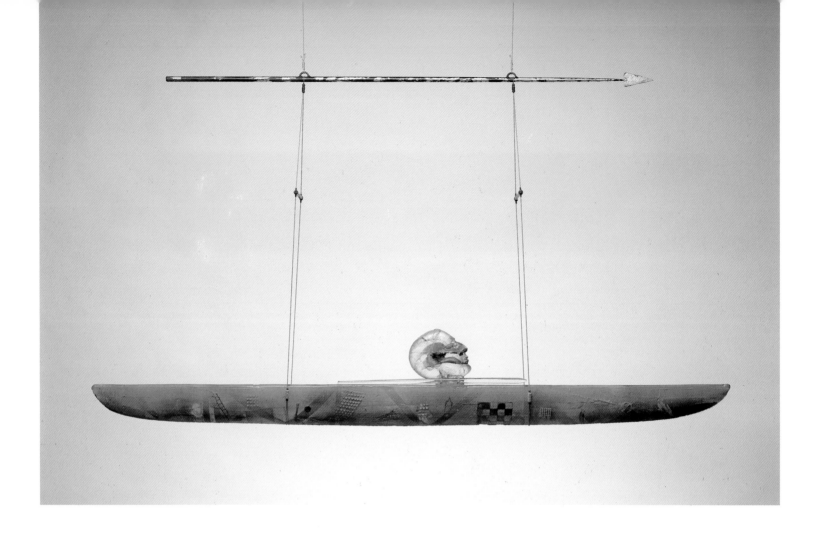

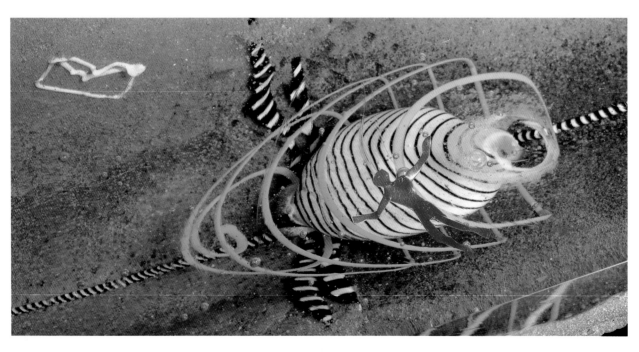

PLATE 54 A, B
Bertil Vallien
**Crystal Arrow,** 1987 (with detail)
(cat. 114)

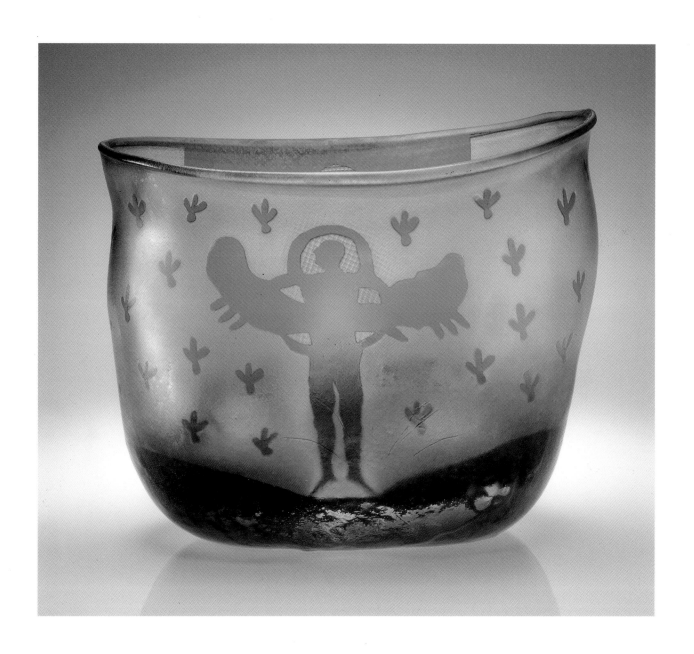

PLATE 55
Bertil Vallien
**Untitled,** 1980
(cat. 113)

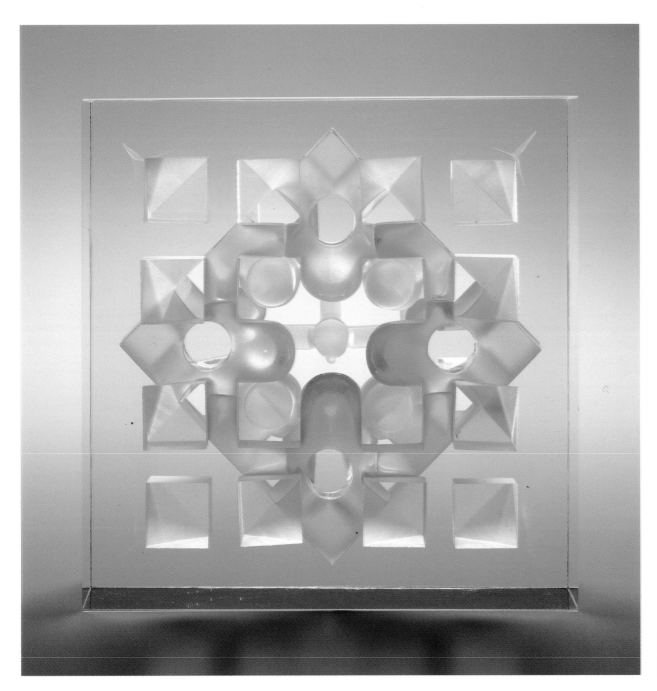

PLATE 56
Steven Weinberg
**Untitled 800808**, 1980
(cat. 118)

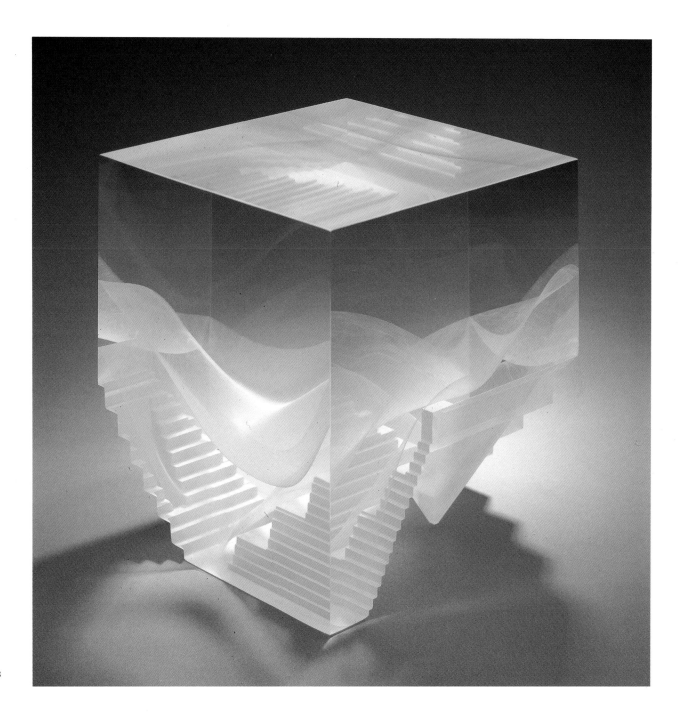

PLATE 57
Steven Weinberg
**Untitled 880206,** 1988
(cat. 119)

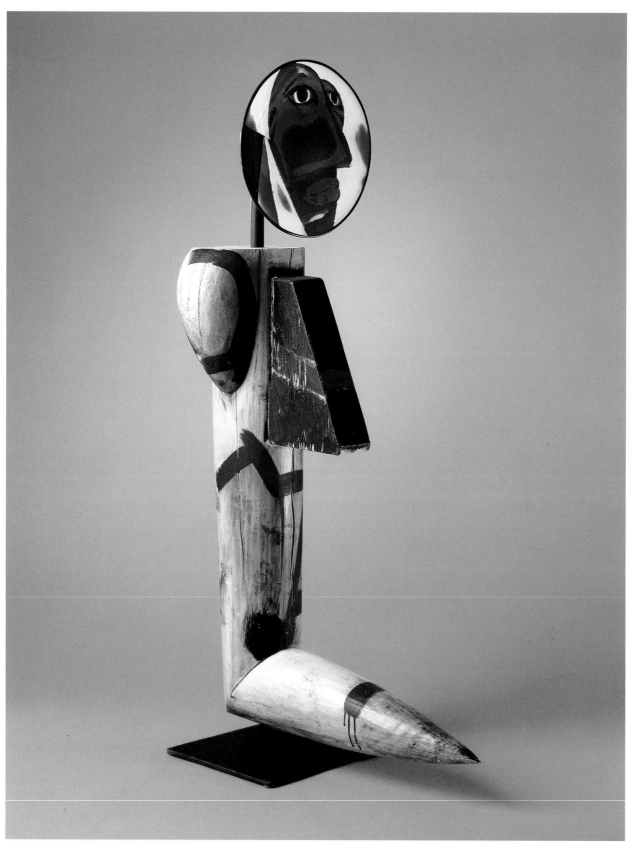

PLATE 58
Ann Wolff
**December Woman,** 1988
(cat. 120)

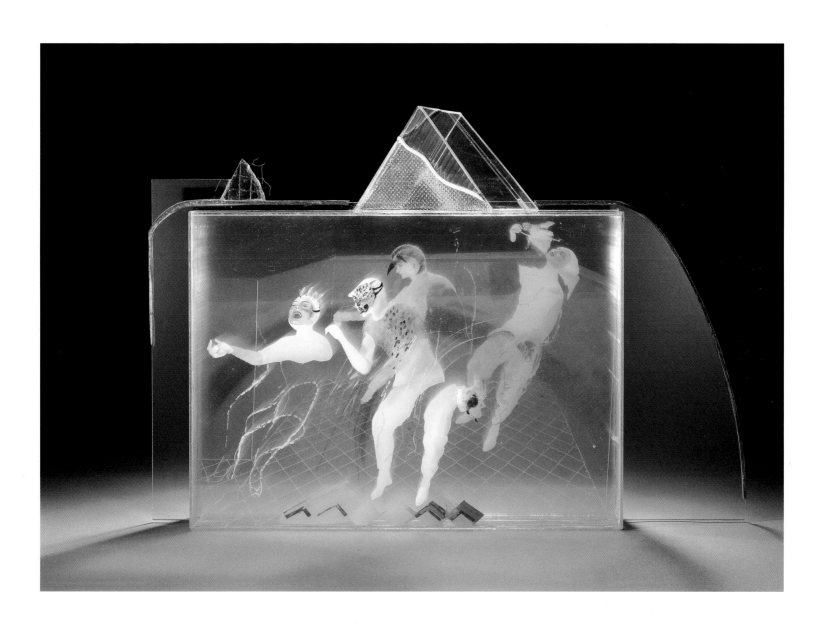

PLATE 59
Dana Zámečníková
**Theater,** 1983
(cat. 122)

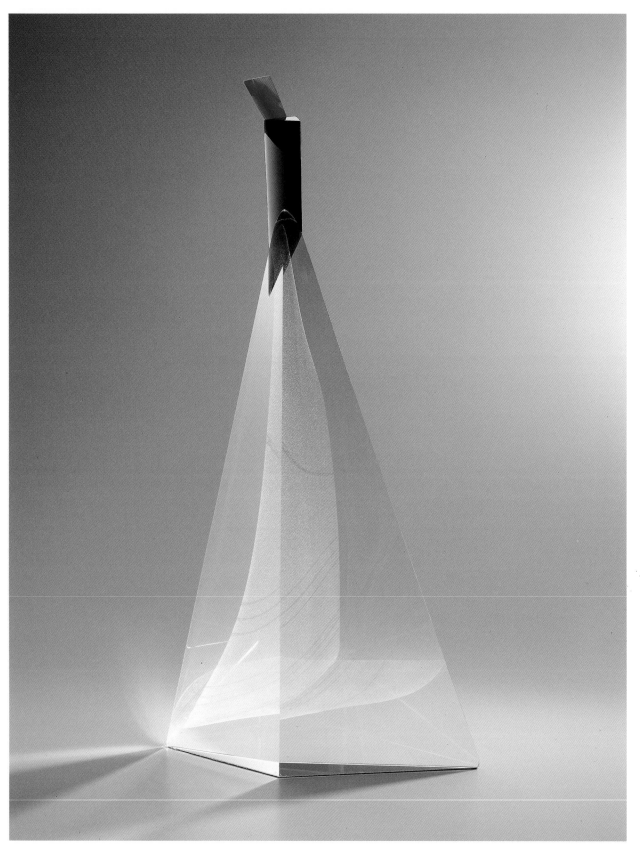

PLATE 60
Yan Zoritchak
**Fleur Celeste #7202,** 1987
(cat. 123)

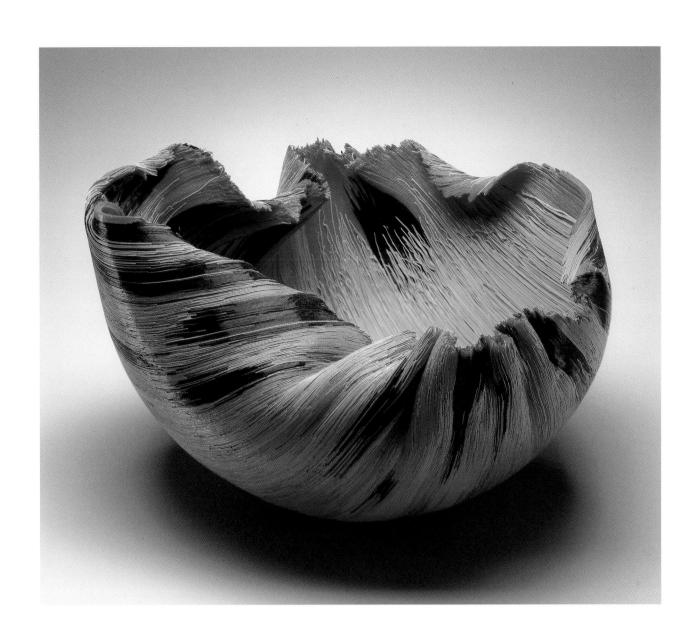

PLATE 61
Toots Zynsky
**Untitled** (from the Tierra del Fuego Series), 1988
(cat. 124)

PLATE 62
Robert Arneson
**Alfred,** 1981
(cat. 4)

# Clay Leads the Studio Crafts into the Art World

*Martha Drexler Lynn*

Clay is the most fortunate of craft media. Long prized by Western European cultures as a decorative-arts material and treasured by non-Western cultures as an art medium, clay has led the other twentieth-century crafts to acceptance in the larger art world.

Ceramics predate recorded history. Initially employed to fashion utensils, clay was also made into objects for religious rituals, during which vessels literally and figuratively became containers for the spirit. Clay's easy application to both utilitarian and symbolic uses is a unique attribute, which today engenders polemic. Makers of functional pots view clay artists as pretentious destroyers of clay's humble heritage; ceramics artists view the functional potter as an anachronism. In fact, recent developments in clay — and its consequent expansion in public and private collecting — turn on this tension. One is either a ceramics artist or a functional potter; as a collector, one focuses on sculptural works or vessel ceramics. Although some artists and collectors have not been influenced by the artificial separation of Useful versus Art, such attitudes have fueled passionate debates that only very recently have seemed less relevant.

Clay is a familiar medium, surrounding us from our morning mug to the dinner dishes; most of us have worked with clay in grammar school or at summer camp. Such familiarity elicits an immediate tactile response and encourages a direct appreciation for ceramic objects. Ironically, it also reinforces an insecurity about clay's validity as an art medium.

For artists, clay is an easily available, inexpensive medium that through kiln firing can be made semipermanent. It has a long history in art both as a preparatory material in which ideas are explored and as a finished product.

Unlike previous periods, when small "studios" were organized like factories under the direction of a designer (for example, Susie Cooper or Clarice Cliff), and the patron or commissioning body would determine the content, today's studio ceramists make works that express personal issues, emotions, and iconography. Following fine-arts production models, late-twentieth-century studio ceramics stand in direct contrast to the traditional "crafts" (a short form for "handicrafts") and the model seen in midcentury handmade clay. The unique studio works are the opposite of the mass-production clay that characterized late-nineteenth-century ceramic output. This new orientation accounts for the surge in collecting of clay. Handmade studio ceramics allow for the expression of individuality and relate well to everyday life.

## The 1940s–1960s

During the mid-twentieth century, owning and using handmade crafts expressed a rejection of the dull sameness implied by mass production. During the 1940s and 1950s, when mass-produced ceramics made up the majority of available clay goods, crafts were sold either directly by the craftsperson or in a sprinkling of craft shops. A few enterprising ceramists opened small-scale potteries to sell their wares directly to the public.[1] Occasional touring exhibitions helped to validate interest in handmade objects.

During this time there developed a limited body of literature about ceramics. Often hobbyist oriented, books and magazines promoted the use and collecting of crafts as honest and unpretentious activities; the mere involvement with handmade ceramics allowed would-be craftspeople to partake of clay's honorable associations. This point of view was presented forcefully in *A Potter's Book* (1941) by the British ceramist Bernard Leach, in which he outlined how to make a small-sized studio kiln for the production of functional wares. This was the first book of its kind in the twentieth century,[2] and it posited that through the return to a preindustrial life-style of pot making, a satisfying and honorable living could be achieved. This concept appealed to many early studio potters in the United States and fit neatly into their desires for an independent life-style.

Also in 1941, as further evidence of interest in the studio ceramics movement, *Craft Horizons* magazine was founded, directed initially to both the devoted hobbyist and the dedicated amateur ceramist. Over time, as pot making underwent a transition from a hobby activity to an amateur craft form, the editorial angle changed.[3]

*Ceramics Monthly,* founded in 1953, continues to straddle the working potter's interests and the growing professional potter-artist market.

The shift away from hobby-only interest in clay toward a professional class of potters began during the later 1950s. Several potters, Peter Voulkos among them, were exposed to Abstract Expressionism, which postulated that the process of making a work of art was one of its most valuable qualities.

This approach struck a chord with ceramists, who consciously adapted some of the current art theory to their field. No other three-dimensional medium was as deft as clay in recording the action of the hand that formed it. Ironically, it was in *Craft Horizons* that this new approach was first hailed. In 1961 editor Rose Slivka's seminal article "The New Ceramic Presence" chronicled clay's entry into the sculptural world through the works of Peter Voulkos and his students at the Otis Art Institute in Los Angeles. To the craft-based potters, the expressive and casually crafted "vessel" forms produced in Los Angeles violated all of the basic tenets of fine craftsmanship, good design, and practical function. Even worse, they smacked of art-world pretensions, which were antithetical to the mission of the humble brown pot. From this time on, the line between the two camps was drawn. As the expressive clay pot matured into the content-driven message pot and clay moved into the larger art world, this tension continued. In the Dorothy and George Saxe Collection are several pieces by artists who played key roles during this innovative time (see figs. 1–4).

Slivka's perceptive article had far-reaching effects. It alerted both the ceramics audience and the wider art world that clay was becoming a powerful and expressive medium. For the former, clay's new range represented a betrayal; for the latter, the application of painting theory to clay removed its long-standing taint of function. Soon commercial fine-arts galleries, including the Felix Landau and Stuart Primus galleries in Los Angeles and others across the country, began to show clay next to paintings and sculptures. John Coplans wrote a critical article for *Art in America,* and the ceramist Ken Price was featured on the cover of *Artforum* (1963).

Clay's entrance into the larger art world was assured. Its initial institutional admittance, however, came through the museum's back door. The groundwork for this acceptance was laid by clay's historic place in non-Western cultures. Believing clay to be an important medium of artistic expression, China, Japan, and the countries of the Middle East produced stunning ceramics. It was the Asian porcelains that caught the Western eye. Coveted by European kings and nobles, seventeenth- and eighteenth-century Asian porcelains were imported and entered princely pri-

**Figure 1**
Peter Voulkos
(American, born 1924)
*Coffee Pot,* 1955
Glazed stoneware
11½ × 8¾ × 4¾ inches
Los Angeles County
Museum of Art, Gift of
Howard and Gwen Laurie
Smits (M.87.1.175 a,b)

vate collections. These decorative and functional wares testified to the refined taste and lavish resources of the upper classes. When these aristocratic holdings were later converted to collections in public fine-arts museums, clay came to be placed next to paintings and sculptures within an institutional context.

During these early centuries, there also developed a tradition of small ceramic table sculptures that were didactic as well as ornamental. These figurative decorations, often made of terra-cotta, were intended to remind diners of popular theatrical and mythological figures and groups drawn from familiar stories.[4] Their validity was not disputed until the nineteenth century, when all useful objects and the medium they were usually made from became tainted with the implication of function. In the hierarchy of arts in which paintings and sculptures are at the top and functional works are at the bottom, ceramics were classified as among the minor or applied arts and denigrated as purely decorative and crassly useful.[5] As new theories of function emerged during the second half of the twentieth century, however, introduced by Marxist and non-Western art-historical methodology,[6] it became clear that this perception overlooked the fact that all art had both explicit and implicit functionality. Clay (and

other craft media) was finally judged capable of being art, despite a tradition linked to utility and historical marginalization.

As clay's new range of expression and sculptural content became evident, museums took note: non-Western ceramics had a place in their Asian collections, so perhaps American studio ceramics were acceptable as well. Although institutional collecting was slow during this period, a change of outlook was signaled by a burst of clay exhibitions at prestigious museums. In 1960 The Museum of Modern Art in New York presented "Peter Voulkos: Ceramic Sculpture and Painting"; five years later, during its inaugural year on Wilshire Boulevard, the Los Angeles County Museum of Art hosted another Voulkos exhibition. In 1960 California's Oakland Museum originated "Ceramics and Paintings by Robert Arneson"; in 1962 the M. H. de Young Memorial Museum in San Francisco presented "Robert Arneson: Ceramics, Drawings and Collages." Shows of this type continued throughout the 1960s, with "Works in Clay by Six Clay Artists" at the San

Francisco Art Institute (1962) and "John Mason — Ceramic Sculpture" at the Los Angeles County Museum of Art (1966). One of the seminal shows of the period was "Abstract Expressionist Ceramics" at the University of California, Irvine (1966). A number of multimedia shows, such as "Funk Art" curated by Peter Selz at the University Art Museum, Berkeley, California (1967), which featured clay artists alongside leading painters and sculptors, were also mounted.

Interestingly, this increased exposure for sculptural and content-driven clay works also opened the way for fine-arts museums to feature vessel ceramics. The Los Angeles County Museum of Art presented "Ceramic Work of Gertrud and Otto Natzler" (1966) and "Gertrud and Otto Natzler Ceramics: Collection of Leonard M. Sperry" (1968). Other exhibitions across the country featured works by Maija Grotell and Laura Andreson, among others. All of this activity gave the museum imprimatur to the collecting of ceramic artworks.

The emergence of clay as a serious art medium coincided with its entrance into college art curricula. Originally in the guise of hobby courses for the otherwise employed, ceramics were taught at high-school night classes. Beatrice Wood got her technical start from such classes. By the 1950s, however, with the impetus provided by the G.I. Bill, art schools and colleges were offering ceramics courses alongside painting and drawing. The resulting professional ceramists, armed with techniques and art theories, graduated with the expectation of making a living from their art.

Perhaps most telling, however, was the shift in language used to describe the field and its practitioners. The term "ceramist" was swapped by some for the more prestigious "clay artist" — itself on occasion rejected in favor simply of "artist." The historical connotations of clay receded as the content of the works took center stage. All of these changes marked and helped to encourage clay's entry into the larger art world.

Clay's acceptance as an art medium also coincided with an increased demand in the art market for new products. Fresh stock was needed to replenish each successive week's artistic "hit." As the demand threatened to exceed the output, earlier restrictions on what constituted appropriate media began to fall away. Although clay was the first craft medium to benefit from this new ecumenicalism, eventually all the crafts were boosted.

As the ceramics field continued to mature, so did the pool of collectors. During the early years of the studio ceramics movement (1940s–1950s), clay collectors were motivated by a love of the medium without any investment concerns. The collection of Fred and Mary Marer of Claremont, California, is an example of this attitude, aug-

**Figure 2**
Jerry Rothman
(American, born 1933)
*Sky Pot*, 1961
Stoneware
20 × 13 × 6 inches
Los Angeles County
Museum of Art, Gift of
Howard and Gwen Laurie
Smits (M.87.1.142)

mented by a desire to render support to artists in whom the Marers believed. Fred Marer was already familiar with studio ceramics when, at a show at the Otis Art Institute, he contacted Peter Voulkos to see if he could buy pieces made by the students. Voulkos said, "Sure — come over any time."[7] From then on, Marer selected pots directly from the kiln. While others were leery of work that explored process rather than craftsmanship, Marer eagerly acquired pieces, often in exchange for a few dollars or a gift of a three-pound tin of coffee that he would frequently buy at a sale.[8]

As might be expected, the Marer collection contains masterpieces, such as Peter Voulkos's *Walking Man* (early 1960s), balanced by lesser works. Perhaps the most interesting aspect of the collection is its early pieces by Ruth Duckworth, John Mason, Ron Nagle, Ken Price, and Betty Woodman. These works provide a background for the later development of these seminal clay artists. The Marer collection eventually contained more than eight hundred pieces.[9] In 1974 and again in 1984, parts of the collection were exhibited at the Galleries of the Claremont Colleges in Claremont, California. The Marer collection preserves a detailed snapshot of the remarkable early years of expressive clay.

During this period there were also collections assembled by those who worked within the clay movement. Laura Andreson, head of the ceramics department at the University of California, Los Angeles,[10] acquired her diverse collection out of love of the medium and as a teaching aid.

Figure 3
Robert Arneson
(American, 1930–1992)
*No Deposit No Return,*
1961
Earthenware
12 × 6 × 6 inches
Los Angeles County
Museum of Art,
Purchased with funds
provided by the Smits
Ceramics Purchase Fund,
Twentieth Century Art
Deaccession Fund, and
the Decorative Arts
Council (M.91.245)

## The 1970s

By the end of the 1960s, clay was recognized as a powerful and expressive art form. Over the next ten years, its audience continued to increase in sophistication. Artists sold more, galleries opened, museums presented exhibitions, magazines proliferated, and the number of collectors grew.

As artists produced more works, they needed additional venues for making and selling their wares. By the early 1970s, there emerged a number of commercial ceramics studios offering space for rent. Typical of this phenomenon was the Clayhouse in Santa Monica, California. In this fully equipped workshop for the working potter, bench space was rented out by the week or month. Amateur and semiprofessional potters could rent kiln time, buy supplies, and get advice from fellow ceramists. The Clayhouse later developed a shop adjunct for the marketing of tenant-made ceramics. The Clay Studio in Philadelphia was a similar organization. These artist-

potter studios helped build a core of working ceramists and offered them a market outlet.

Another form of artist-driven marketing very accessible to the general public was the multimedia craft store organized as an artists' cooperative. Staffed by artists and presenting participating artists' work, these outlets continued to serve as the principal sources from which ceramics could be obtained. Due to their policies of displaying and selling works offered by any participating amateur potter, quality was variable.

There were also the craft shops, among which was the early and important American Hand in Washington, D.C., which featured a range of artists from across the country. It developed such a following that by the late 1970s potential buyers would line up before the opening of each new show in order to guarantee an opportunity to buy unique works. Such enthusiasm was essential in developing a collecting public.

Institutional recognition also increased, especially in terms of exhibitions featuring single artists. Significant among these were "Robert Arneson — Retrospective," at the Museum of Contemporary Art, Chicago (1974); "Jack Earl — Porcelains" (1971), "David Gilhooly — Ceramics" (1978), and "Peter Voulkos: A Retrospective" (1978), at the Museum of Contemporary Crafts, New York; "Richard Shaw / Robert Hudson: Works in Porcelain," at the San Francisco Museum of Art (1973); "Stephen De Staebler: Sculpture," at The Oakland Museum, Oakland, California (1974); "Happy's Curios: Kenneth Price," at the Los Angeles County Museum of Art (1978); and "Ron Nagle: The Adaline Kent Award Exhibition," at the San Francisco Art Institute Galleries (1978). This early exposure established these artists as leaders in the field and initiated for the crafts the "artist-as-star" system, pioneered by painters and sculptors.

Other museum offerings featured important group and mixed-media shows, among them "Ceramics and Glass 1974," at The Oakland Museum (1974); "Craft Multiples" (1975) and "The Object as Poet" (1976), at the Renwick Gallery of the National Collection of Fine Arts, Smithsonian Institution, Washington, D.C.; "American Crafts 1976," at the Museum of Contemporary Art, Chicago (1976); and "Nine West Coast Sculptors," at the Everson Museum of Art, Syracuse, New York (1976).

During the 1970s there were also two important collection shows. The first was the San Francisco Museum of Art's "A Decade of Ceramic Art, 1962–1972, From the collection of Professor and Mrs. R. Joseph Monsen" (1972). The second was the Marers' first exhibition, "Fred and Mary Marer Collection," held at Scripps College, Claremont, California (1974).

An increased number of galleries, both fine arts and crafts, mounted ground-breaking clay exhibitions. New York played a prominent role: Sidney Janis Gallery's "Sharp-Focus Realism" included clay artist Marilyn Levine (1972); Fairtree Gallery presented "Exhibition of Master Potters" (1975); Hadler / Rodriguez Galleries featured "Karen Karnes: Works 1964–1977" (1977); Allan Frumkin, one of the early and loyal New York supporters of clay, presented "Robert Arneson — Portraits" (1977). In Chicago, Exhibit A devoted a show to Ruth Duckworth (1977). Such exhibitions continued the momentum driving clay's acceptance.

## The Year 1979: Beginning of the 1980s

The year 1979 was particularly pivotal for clay, because it forecast developments that were to mature during the 1980s. Early signs of coming changes could be seen in the contemporary magazines. In 1979, when *Craft Horizons* changed its name to *American Craft* and moved away from the practical aspects of the field, it acknowledged the growing professionalism of the crafts movement and also spurred that growth.

Also, as the 1970s became the 1980s, a new type of retail outlet appeared. Following their fine-arts prototypes, these galleries featured high-quality (and high-priced) craft-material artworks, displayed in a manner similar to that used with painting and sculpture. Appropriating their presentation to crafts transferred some of the art aura as well, and helped justify higher prices. Tirelessly offering a mix of media and operated by knowledgeable and passionate dealers, these galleries educated and refined the eyes of the next generation of clay collectors. Their professionalism included supplying artists' résumés and sometimes slim catalogues with third-party essays.

Through information and connoisseurship, these galleries served as conduits for new talent entering the marketplace, as well as sustaining the exposure of established artists.

One of the earliest and most important galleries of this type was opened in 1974 in Philadelphia by the longtime passionate craft supporter Helen W. Drutt English. On the West Coast, there were in Los Angeles Liz Mandell, and in San Francisco, Dorothy Weiss (formerly of Meyer Breier Weiss) and Elaine Potter. In Chicago a number of galleries also sprang up, among them Betsy Rosenfield Gallery, Objects Gallery, and Esther Saks Gallery. Large urban centers were not the only sites for such galleries. Linda Durham, Linda Farris, Elaine Horwitch, and Joanne Rapp, whose galleries were located in smaller cities, all presented a variety of craft works and promoted new and established talent.

A second type of new gallery entered the field at this time. Single-medium galleries existed in the fine-arts world, but were slow to come to crafts. A natural outgrowth of an enlarged group of professional artists and artworks and the increased acceptance of clay by the art public, these specialized galleries further refined the ceramics field.

Chief among the early ceramics-only galleries was the Garth Clark Gallery, founded first in Los Angeles in 1981 and then in New York in 1983. Garth Clark chose to focus on vessel-related ceramic forms. Educated at the Royal College of Art in London, Clark brought a scholarly bent and a European perspective to the ceramics business. Champion of the often denigrated vessel, Clark selected, presented, and educated at a level not seen before in contemporary ceramics.

Clark had burst on the scene in 1978. Working with ceramist Margie Hughto and the Everson Museum of Art, Syracuse, New York, Clark curated the exhibition and accompanying book *A Century of Ceramics in the United States, 1878–1978* (1979). Free from intimate connections with the American ceramics movement, Clark was able to offer an objective and scholarly perspective on clay not possible from those linked to the field. By reviving the Everson Museum of Art's tradition of presenting contemporary ceramics, he injected additional life into the slumping vessel movement. By writing one of the few existing books on late-twentieth-century studio ceramics, Clark established for himself a unique and leading position within the marketplace. Earlier books had been either high-end how-to, single-medium, or regional studies. Clark was the first to insist on clay as part of a larger world tradition. Following Clark's lead, Elaine Levin and Barbara Perry added to the literature with *The History of American Ceramics, 1607 to the Present: From Pipkins*

*and Beanpots to Contemporary Forms* (1988) and *American Ceramics: The Collection of Everson Museum of Art* (1989), respectively.

While during the 1970s many single artists had been highlighted by exhibitions, regional awareness came to the fore as the decade closed. This trend was reflected in specialized exhibitions that explored regional differences, such as "Another Side to Art: Ceramic Sculpture in the Northwest, 1950–1979," at the Seattle Art Museum (1979), and "Northern California Clay Routes: Sculpture Now," at the San Francisco Museum of Modern Art (1979). West Coast ceramics even got international attention when "West Coast Ceramics" opened in 1979 at the Stedelijk Museum in Amsterdam.

## The 1980s

The decade of the 1980s fulfilled the promises of 1979: all aspects of the studio ceramics world experienced exponential growth. A notable increase in collecting of both vessel and sculptural works led to a number of exhibitions featuring these collections. Among these were "The Robert L. Pfannebecker Collection," at the Goldie Paley Gallery, Moore College of Art, Philadelphia (1980); "Centering on Contemporary Clay: American Ceramics from the Joan Mannheimer Collection," at the Museum of Art, University of Iowa, Iowa City (1981); "Contemporary Vessels: Two Los Angeles Collections," at the Baxter Art Gallery, California Institute of Technology, Pasadena (1984), which placed side by side the vessel collections of Betty Asher and Gwen Laurie Smits; a second Marer exhibition at the Galleries of the Claremont Colleges, "Earth and Fire: The Marer Collection of Contemporary Ceramics" (1984); "Passionate Vision: Contemporary Ceramics from the Daniel Jacobs Collection," at the DeCordova and Dana Museum and Park, Lincoln, Massachusetts (1984); the "Carroll and Hiroko Hansen Collection of Ceramic Art," at the Arvada Center for the Arts, Arvada, Colorado (1985); "Teapots: Sanford M. Besser Collection of Contemporary Ceramic Teapots," at the Decorative Arts Museum, Little Rock, Arkansas (1985); "Surface / Function / Shape: Selections from the Earl Millard Collection," at Southern Illinois University, Edwardsville (1985); "What's New? American Ceramics since 1980: The Alfred and Mary Shands Collection," at the J. B. Speed Art Museum, Louisville, Kentucky (1987); and to celebrate the donation of 170 pieces, "Contemporary Ceramics from the Smits Collection," at the Los Angeles County Museum of Art (1987). Each collection demonstrated the particular eye of the collector and together revealed the multifaceted potential within studio clay.

PLATE 63
Rudy Autio
**Sitka Ladies and
White Horse,** 1982
(cat. 5)

During the 1980s there also were a number of shows that arose from a desire to place clay within a larger historical continuum.[11] In addition, a number of survey shows[12] and several other important exhibitions were mounted by fine-arts museums. In 1981 the Whitney Museum of American Art, New York, developed "Ceramic Sculpture: Six Artists," featuring the work of West Coast artists Robert Arneson, David Gilhooly, John Mason, Ken Price, Richard Shaw, and Peter Voulkos — the leading names in both vessel and sculptural work. Although it was criticized for provincialism and prompted John Perreault to write an excellent review titled "Fear of Clay,"[13] it did provoke conversation and allowed a public perhaps not aware of clay as an expressive medium to see the range that clay could encompass.

On the West Coast, "Viola Frey: A Retrospective" opened in 1981 at the Crocker Art Museum in Sacramento, California, and then traveled until 1983. "American Porcelain: New Expressions in an Ancient Art," curated by Lloyd E. Herman at the Renwick Gallery, Washington, D.C., featured 108 artists working in porcelain. The catalogue devoted one page to each artist's statement and a picture of one work; at that time it was a veritable encyclopedia of the medium.

During the 1980s, mainstream art magazines also came to include the occasional article about clay. While featuring only the artists who had been vetted by the larger art world, this press attention nevertheless expressed a degree of acceptance not seen before. There were also new magazines devoted totally to the crafts: *Craft International* was founded by Rose Slivka in 1980, and *American Ceramics* was started by Michael McTwigan in 1982. All of these helped further to validate the medium and educate the collector and public.

Fine-arts galleries continued to present both vessel and sculptural clay alongside the work of painters and sculptors. Among the dealers who included clay were the early pioneering San Francisco gallery owners Rena Bransten, who features works by Ron Nagle and Viola Frey, and Ruth Braunstein, who represents Peter Voulkos; Fuller / Goldeen, then in San Francisco, and the present successor, Dorothy Goldeen Gallery, in Santa Monica, California, which represents the late Robert Arneson; John Berggruen of San Francisco, who shows Stephen De Staebler; and Charles Cowles of New York, who features work by Manuel Neri and Ken Price.

Toward the end of the decade, two new avenues for the marketing of crafts emerged. In 1985 the Chicago International New Art Forms Exposition was sponsored by The Lakeside Group in Chicago. Drawing from both American and European galleries, CINAFE offered an integrated forum for clay to be presented next to the other craft media.

Although not a source for innovative shows, it remains a means of exposure to the public. The second sales venue was the auction house. Known primarily for their presentation of historical material, auction houses had skillfully developed secondary markets for Arts and Crafts and twentieth-century production furniture. In response to the insistent demand for more sales, auction houses tackled contemporary crafts. Beginning as fund-raising ventures for the American Craft Museum and various AIDS groups, and carefully watched by collectors and dealers, they did test the waters of the resale market for both older and contemporary works.

During the period from 1950 to 1990, clay's popularity increased dramatically. Bolstered by the incorporation of serious subject matter and attention from the larger art world and institutions, clay moved from a hobby medium to an accepted art medium. None of this would have been possible without the increased professionalism of the artists and their dealers and the willingness of the larger art world to accept clay as a valid medium. Collectors reflected and furthered these developments. A study of their choices and rationales reveals the maturation of clay in the late twentieth century.

## Notes

1. Ironically, this type of studio was a return to medieval production. The Industrial Revolution replaced this genre of organization with the factory, which was seen as a great improvement over previous systems.

2. Few books about ceramic technique have survived. Two important ones are *The Three Books of the Potter's Art which treat not only of the practice but also briefly of all the secrets of this art, a matter which until to-day has always been kept concealed* (1548) by Cavaliere Cipriano Piccolpasso, and the entries in *L'Encyclopédie; ou, Dictionnaire raisonné des sciences, des arts et des métiers de Denis Diderot* (1763).

3. This new perspective was even reflected in the name of the publication when it dropped the word "Horizons" in 1979 and called itself *American Craft*. This coincided with the name change of the museum (which opened in 1956 as the Museum of Contemporary Crafts) to the American Craft Museum. *American Craft* is the publication arm of the American Craft Council.

4. Eighteenth-century terra-cotta works were originally made because the material could be much more easily worked than bronze or marble, thus ultimately translating into lower fabrication costs. The inherent beauty of terra-cotta and, eventually, porcelain led to clay's becoming the medium of choice for table sculptures.

5. Immanuel Kant presented this concept in his *Critique of Judgment* (1790). It was adopted by nineteenth-century theorists to separate "free" art from handicrafts, which were "mercenary."

6. See John Berger, *Ways of Seeing* (London, 1972); Donald Preziosi's *Rethinking Art History: Meditations on a Coy Science* (New Haven and London, 1989).

7. Claremont, California, Galleries of the Claremont Colleges, *Earth and Fire: The Marer Collection of Contemporary Ceramics*, text by Douglas

Humble, Kay Koeninger, and Mary M. Longtin, with the assistance of Max van Balgooy (Claremont, 1981), p. 11.

8. Ibid.

9. Ibid., p. 9.

10. Laura Andreson taught ceramics at the University of California, Los Angeles, from 1936 until 1970.

11. This motivation was evidenced in a number of shows, including "Potter's Art in California, 1885–1955," at The Oakland Museum, Oakland, California (1980); "Ceramic Echoes: Historical References in Contemporary Ceramic Art," at the Nelson-Atkins Museum of Art, Kansas City, Missouri (1983); "Cranbrook Ceramics, 1950–1980," at the Cranbrook Academy of Art Museum, Bloomfield Hills, Michigan (1983); "Art in Clay: 1950s to 1980s in Southern California," at the Los Angeles Municipal Art Gallery (1984); and "Robert Arneson: A Retrospective," at the Des Moines Art Center, Des Moines, Iowa (1986). All of these exhibitions extended contemporary clay beyond the moment and connected ceramics to its past.

12. These included "Craft Today: Poetry of the Physical," which served as the inaugural exhibition at the newly rebuilt American Craft Museum, New York (1986); "American Ceramics Now: The 27th Ceramic National Exhibition," at the Everson Museum of Art, Syracuse, New York (1987), which revived the ceramics national from earlier in the century; "Clay Revisions: Plate, Cup and Vase," at the Seattle Art Museum (1987); and "American Clay Artists, 1989," at the Port of History Museum, Philadelphia (1989).

13. John Perreault, "Fear of Clay," *Artforum* 20, 8 (Apr. 1982), pp. 70–71. Also see Hilton Kramer in *The New York Times*, Dec. 20, 1981, sec. 2, p. 31.

PLATE 64
Bennett Bean
**Bowl #154,** 1990
(cat. 6)

PLATE 65
Christina Bertoni
**By This Immovability All Things Are Moved,** 1987
(cat. 11)

PLATE 66
Stephen De Staebler
**Pointing Figure Column,**
1985
(cat. 22)

PLATE 67
Ruth Duckworth
**Untitled,** 1982
(cat. 23)

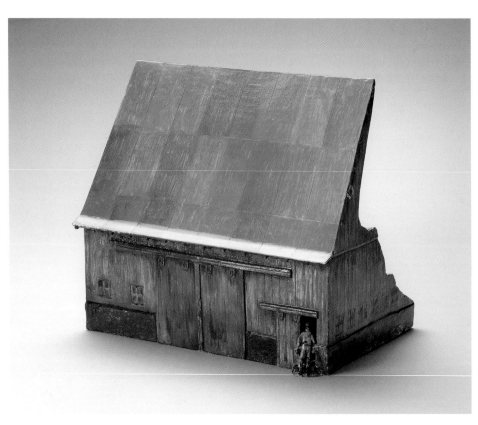

PLATE 68
Jack Earl
**Josiah Wedgewood built his city . . .** , 1979 (two views)
(cat. 24)

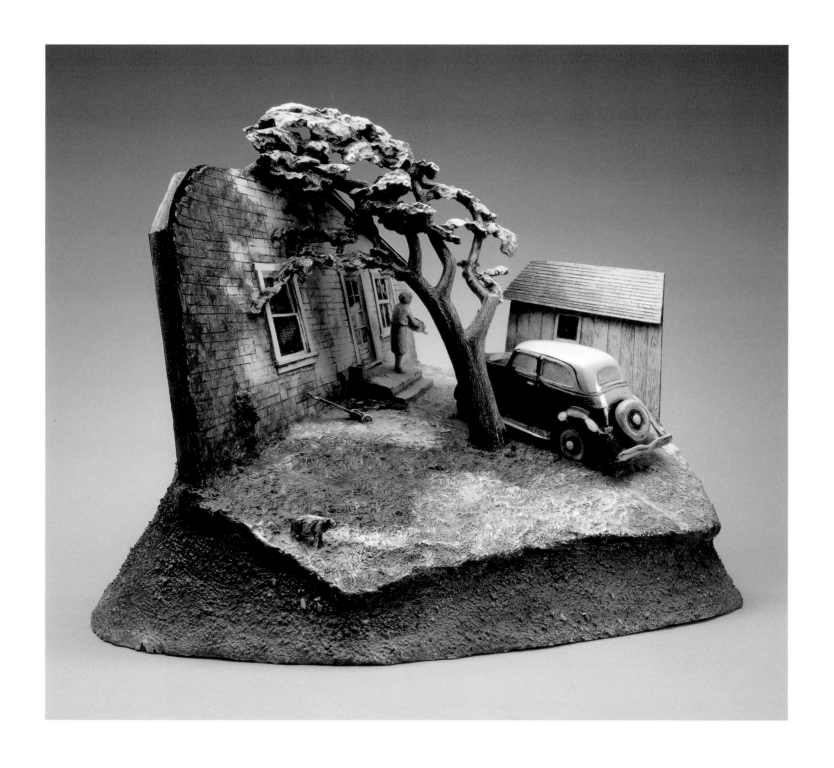

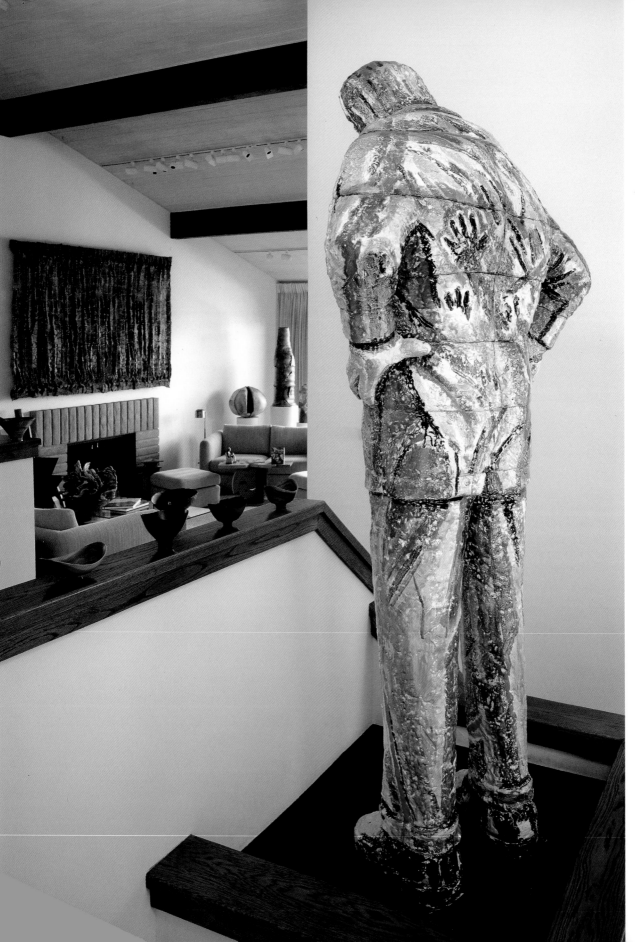

PLATE 70
Viola Frey
**Man Observing Series II,**
1984
(cat. 27)

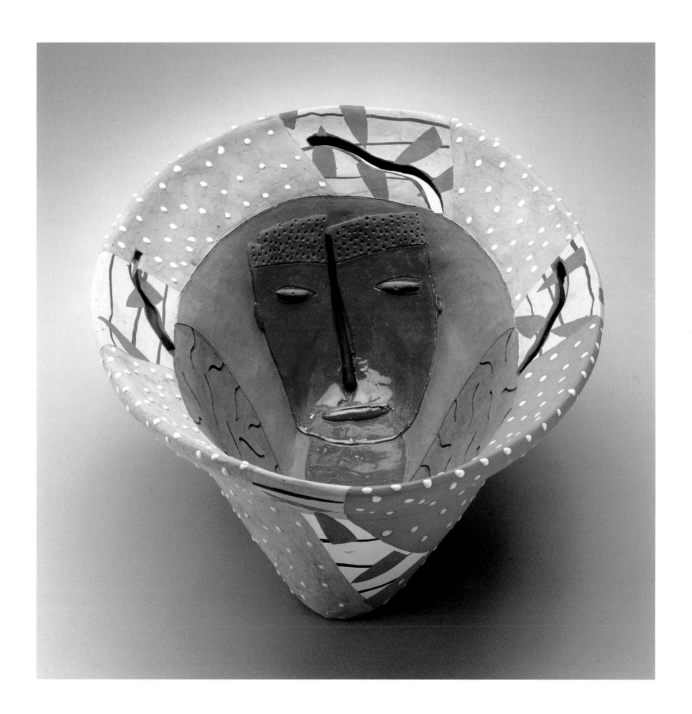

PLATE 72
Wayne Higby
**Rapids Canyon,** 1984–85
(cat. 33)

PLATE 73
Jan Holcomb
**Unexpected, Unknown,** 1984–85
(cat. 34)

PLATE 74
Robert Hudson
**Teapot,** 1973
(cat. 37)

PLATE 75
Margie Hughto
**Winter Sky,** 1983
(cat. 38)

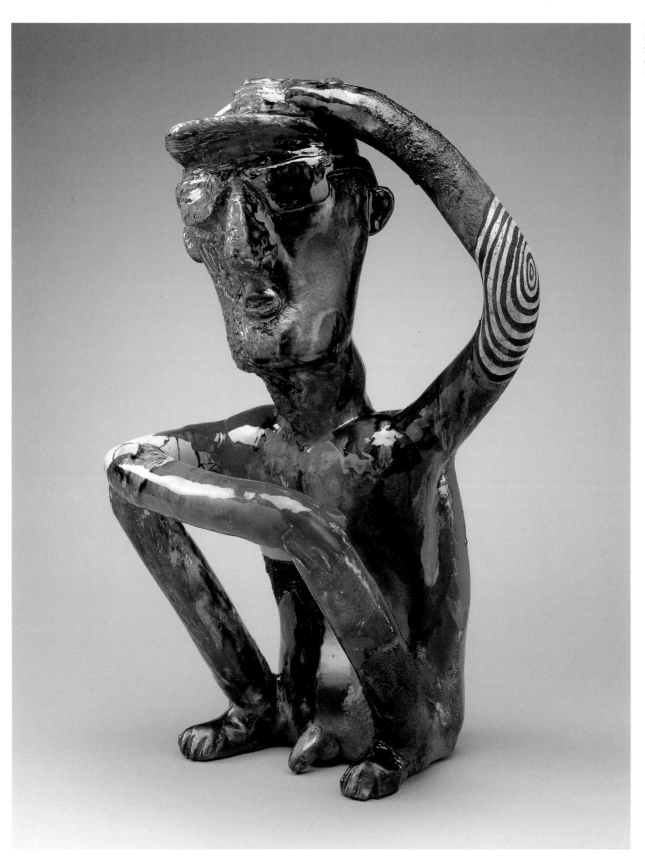

PLATE 77
Judy Moonelis
**Untitled (Green Storm),** 1985
(cat. 63)

PLATE 78 (left)
Ron Nagle
**Untitled (Saxe Appeal),** 1982
(cat. 69)

PLATE 79 (above)
Ron Nagle
**Red and Turquoise Knob Job,** 1984
(cat. 70)

PLATE 80
Kenneth Price
**Untitled (Ferro or Block),**
1983
(cat. 78)

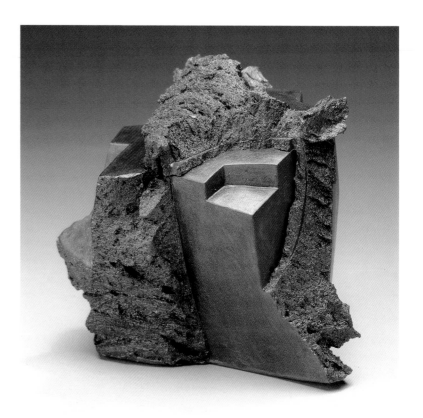

PLATE 81
Kenneth Price
**Gunktor,** 1985
(cat. 79)

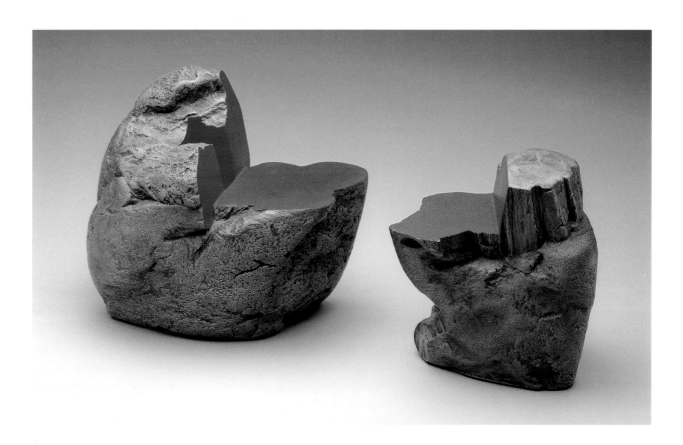

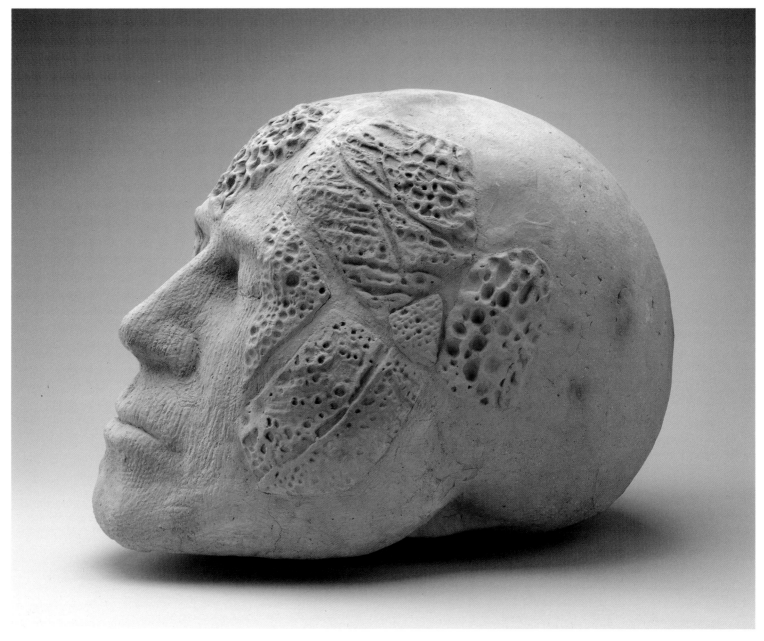

PLATE 82
Daniel Rhodes
**Abique Head (#245),** 1988
(cat. 83)

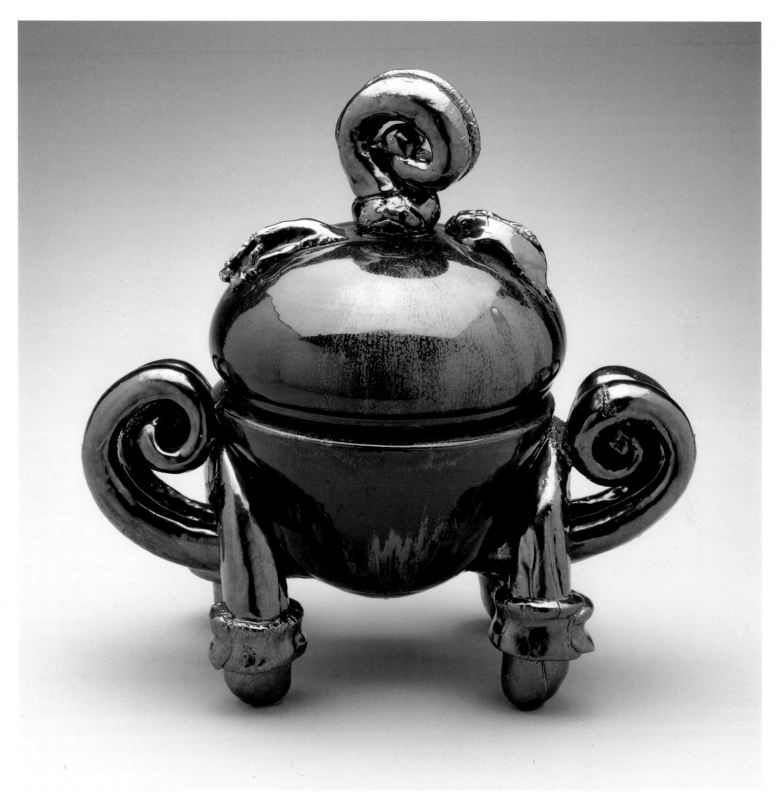

PLATE 83
Jerry Rothman
**Classic / Baroque Tureen,** 1978
(cat. 86)

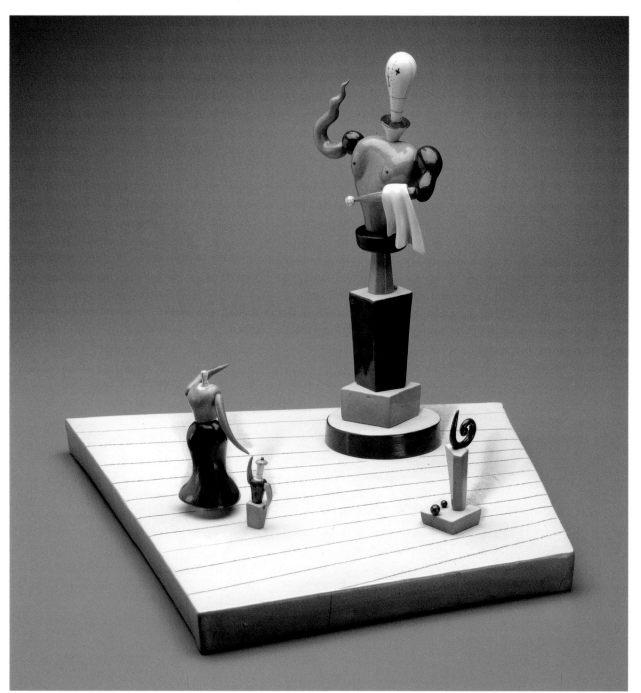

PLATE 84
Tom Rippon
**That's Your Father,** 1984
(cat. 85)

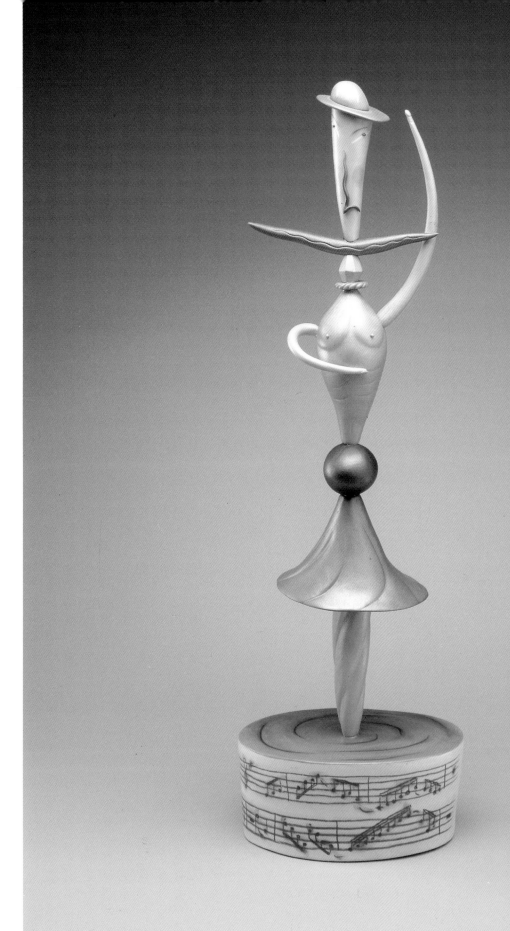

PLATE 85
Tom Rippon
**Pirouette,** 1981
(cat. 84)

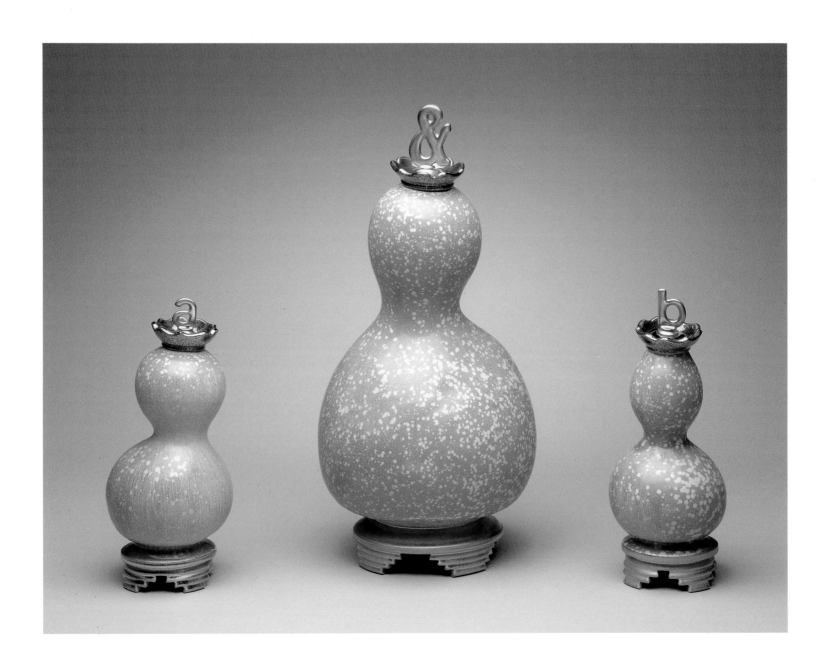

PLATE 86
Adrian Saxe
**A&B (Gourd Garniture),** 1987
(cat. 89)

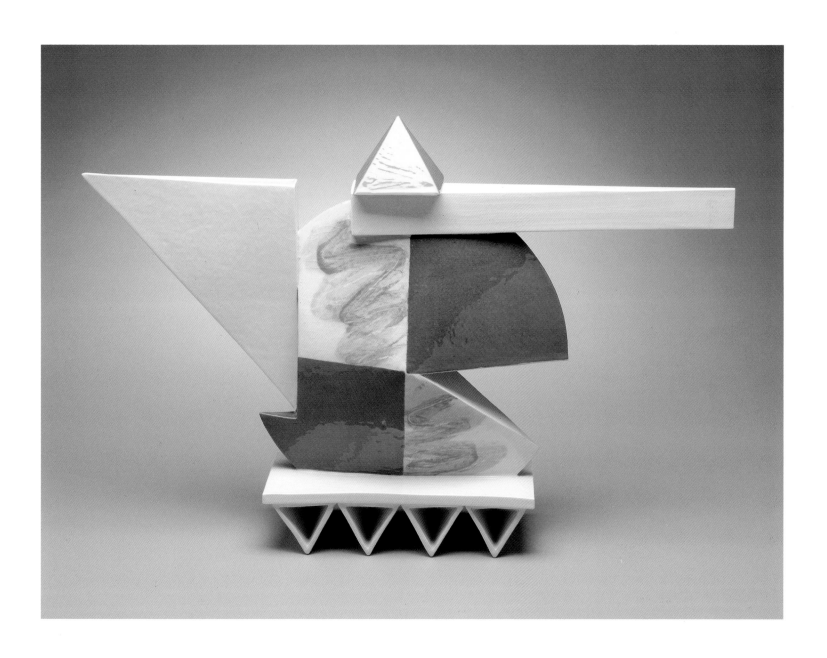

PLATE 87
Peter Shire
**Pinwheel Teapot,** 1980
(cat. 98)

PLATE 88
Richard Shaw
**Boy with Blue Glove,** 1985
(cat. 97)

PLATE 89
Richard Shaw
**Book Jar with Ash Tray,** 1980
(cat. 96)

PLATE 90
Robert Sperry
**Untitled #794**, 1987
(cat. 99)

PLATE 91
Rudolf ("Rudy") Staffel
**Light Gatherer,** 1985
(cat. 100)

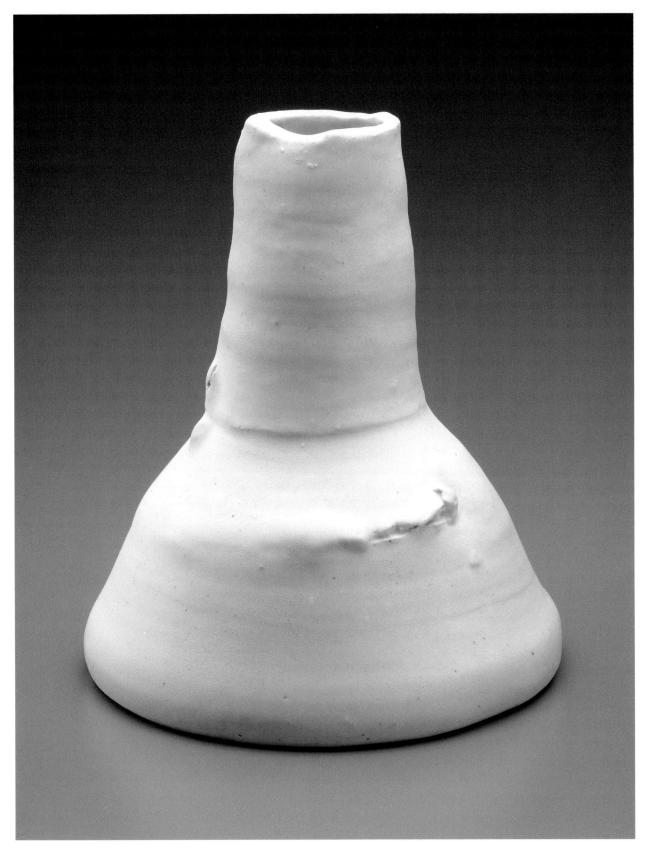

PLATE 92
Robert Turner
**Form IV,** 1989
(cat. 112)

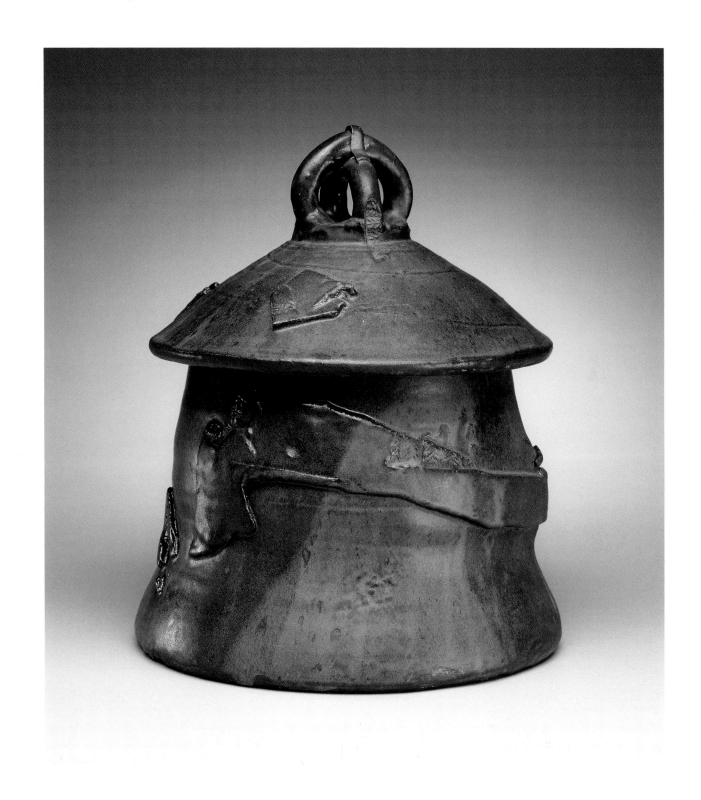

PLATE 93
Robert Turner
**Ashanti,** 1987
(cat. 111)

PLATE 94
Peter Voulkos
**Untitled (Ice bucket),** 1983
(cat. 117)

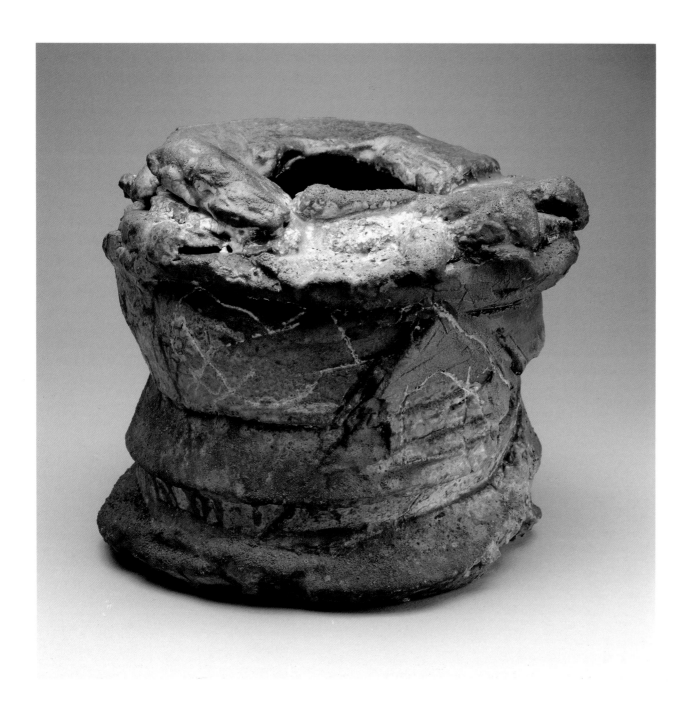

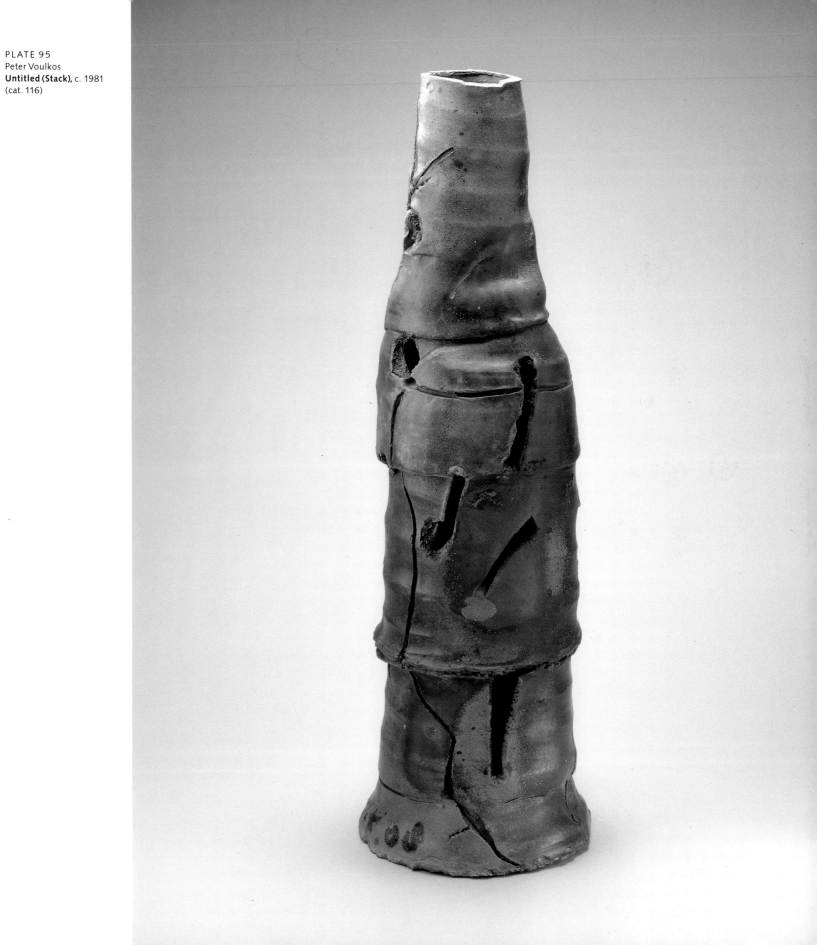

PLATE 96
Irvin Tepper
**Roger,** 1986
(cat. 106)

PLATE 97
Beatrice Wood
**Large Footed Bowl #63B,**
1987
(cat. 121)

PLATE 98
Neda Al Hilali
**White Square,** 1981
(cat. 3)

## Fiber Art Gathers Momentum

*Jane Fassett Brite*

Contemporary fiber art occupies a unique position among the art / craft media. Perhaps because fiber has more facets — tapestry, wall hangings, quilts, sculpture, baskets, wearables, paper — it is by nature a fragmented field. Thus, unlike crafts such as glass or metalwork, which have progressed more or less continuously since their inception, contemporary fiber in the United States has had both strong and slow moments. Few galleries show fiber and even fewer show it exclusively; there are not enough major or minor exhibitions; and fiber is diffused by being strong in different parts of the country at different times. Innovative fiber has been shown less frequently than other media at art fairs, craft shops, and galleries because it can be more cumbersome to transport and hang. The fact that maintenance can be complicated has been a factor in its limited acquisition by museums and collectors. In the absence of a concentrated effort to keep fiber prominent in the eyes of the art world and public, it has not been as frequently collected as other crafts. Despite doing well in the corporate arena, it has lacked a base of collectors — a necessary component in keeping a medium alive and flourishing, as well as in helping galleries and museums to remain current and active in acquisitions. It is, nevertheless, a growing and vital area, and recent interest in collecting fiber portends a bright future.

World War II changed the face of the American art world and, with a special significance, the craft world. Craft grew out of the decorative arts made in factories and small studios, and most significantly, from homecraft. Fiber art evolved within this movement. As each facet of fiber moves into the mainstream of art, it takes flight from its heritage, be it Native American baskets, pioneer quilts, eighteenth-century New England knitting factories, fishermen's knots, or the European Gobelins and Aubusson traditions. This heritage continues today to influence each generation of fiber artists.

### The 1940s–1960s

At the end of World War II, many servicemen, taking advantage of the G.I. Bill, entered colleges and universities. For the most part students during the 1950s, these young artists began to produce good work and discovered a desire to share it. They would trade among themselves or sell at small gatherings at their schools. Modest exhibitions were integrated into the degree program or organized as an offshoot of the school's interest in an art field.

In the late 1950s and early 1960s, art fairs came into being and craft shops and galleries began to open, partly in response to the need for an outlet for work being produced by the faculty and emerging graduates. A small segment of the population was taking notice of handmade objects, such as fiber works, versus clean, bright, mass-produced designer objects. Craft organizations, such as the Arizona Designer Craftsmen in Tempe and the Louisiana Craft Council in Baton Rouge, were founded to offer support to artists as well as opportunities for exhibition. There are now twenty-three craft councils in America and a number of councils just for weavers and basketmakers. Exhibitions were also sponsored by universities, colleges, and art alliances. For example, the "Annual International Textile Exhibition" was held at the Weatherspoon Art Gallery, University of North Carolina, Greensboro (1944–50). The University of Wisconsin–Milwaukee, sponsored several national weaving shows, as did the University of Illinois at Urbana–Champaign.

Art fairs proliferated from the 1960s until the mid-1980s when they leveled off. They have run the gamut from very sophisticated American Craft Council fairs to local displays in shopping centers. They serve their purpose: many collectors bought their first pieces at art fairs. The collectors Elmerina and Paul Parkman, from metropolitan Washington, D.C., whose collection includes some fiber, talk readily about how they acquired many objects from craft fairs.[1] Karen Johnson Boyd, from Racine, Wisconsin, recently honored by the American Craft Council as a supporter of studio craft, states that she bought from fairs in the early years.[2] She has just given 193 works, including 39 fiber pieces, to the Charles A. Wustum Museum of Fine Arts in Racine. In addition to collectors, museum and gallery curators also occasionally peruse fairs for new talent.

Due in large part of the influence of the weaver and designer Jack Lenor Larsen, the American Craft Museum has been a leader in presenting and recognizing fiber art.

Larsen's long involvement with the museum began when Mrs. Vanderbilt Webb founded the American Craftsmen Cooperative Council in 1943. Larsen participated in the first major show on the medium, "Wall Hangings & Rugs" (1957). A weaver and designer, he began collecting American and ethnic fabrics, as well as baskets, glass, and ceramics. His own work was included in the early multi-media shows at the Museum of Contemporary Crafts (later the American Craft Museum), New York, "Young Americans" (1958, 1962, and 1963). Larsen has worked to draw public attention to fiber. In 1968 he and Mildred Constantine organized "Wall Hangings" at The Museum of Modern Art in New York, where Constantine was a curator (1948–71). The exhibition marked the first time a major museum of modern art featured fiber art. Constantine has also been a significant force in the field, working with Larsen on exhibitions and books that have helped shape and strengthen the medium: *Wall Hangings* (1969), *Beyond Craft: The Art Fabric* (1972), and *The Art Fabric: Mainstream* (1981). She is currently at work on an exhibition surveying the generations in fiber art.[3]

In 1961 a breakthrough show was held at the Staten Island Museum, New York. It featured Lenore Tawney, a fiber artist whose work was startling because it was three-dimensional, rather than a conventional piece hanging flat on a wall. Tawney was an innovator in working off-loom, incorporating a variety of stitches and weaves. Her works have been shown since the 1960s in prominent galleries such as Hadler Galleries in New York, Fairweather Hardin Gallery in Chicago, and Willard in New York. More recently, Tawney has shown at the Mokotoff Gallery in New York and the Helen Drutt galleries.

The year 1962 also marked the beginning of the Biennale Internationale de la Tapisserie in Lausanne, Switzerland. Erika Billeter guided these exhibitions to prominence, establishing the shows as a major force in disseminating international influences. For example, in 1965 the biennale included experimental pieces by Dutch and Polish artists; in 1967 Poland again had a strong presence, as did Yugoslavia and Czechoslovakia. Mildred Constantine's influence was felt at the biennale as well, for she was a juror from 1971 to 1979.

"Woven Forms," an exhibition of dimensional weavings, was held at the Museum of Contemporary Crafts in 1963. In 1965 the museum showed "The Art of Personal Adornment," one of the first wearable-fiber shows. "Body Covering" (1968) was another of their shows in this vein. Wearable art began in the 1960s with tie-dyed T-shirts and patched jeans, which evolved into clothes with fancy stitching, beads, and bangles. Beginning as a West Coast phenomenon, it did not catch on with the broader public and galleries until somewhat later, but the museum's shows were prophetic of the future trend.

"Objects: USA" (1969) was a turning point for the field. Among the fiber artists who showed in this exhibition were Sheila Hicks, Walter Nottingham, Joan Michaels Paque, Cynthia Schira, and Jean Stamsta.

During the 1960s universities were experiencing a strong and growing interest in fiber. Fiber instructors were attached to art departments, art-education, or, occasionally even today, to home-economics departments. While generally the primary emphasis was on weaving, departments today are focusing more on mixed media and encouraging experimentation in off-loom and non-traditional materials. Ed Rossbach pioneered this approach in the 1950s and 1960s at the University of California, Berkeley. Cranbrook Academy of Art in Bloomfield Hills, Michigan, had Marianne Strengell; the University of Wisconsin–Milwaukee, had Dorothy Meredith; San Francisco had Dorothy Liebes; UCLA had Bernard Kester; Black Mountain College in North Carolina had Anni Albers. Fiber's pockets of strength in the Carolinas, on the West Coast, and in the Midwest owed much to these teachers who generated a strong following: Trude Guermonprez worked with Albers at Black Mountain before moving to San Francisco; Kester taught Neda Al Hilali, Kris Dey, Françoise Grossen, and Gerhardt Knodel. An especially active craft organization or art alliance also impacted fiber's strength in a particular place, as did an area's heritage, such as the strong Scandinavian influence in Wisconsin and Michigan.

The Arrowmont School of Arts and Crafts, Gatlinburg, Tennessee (1969); Penland School of Crafts, Penland, North Carolina (1929); and the Haystack Mountain School of Crafts in Deer Isle, Maine (1951), have been important in the fiber field. Penland was started by Lucy Morgan, who wanted to revive traditional crafts, especially weaving. These schools continue to be important to the advancement of the field.

## The 1970s

The work done by museums and galleries in the 1970s laid the foundation for the increased exposure of fiber art. In 1970 the Museum of Contemporary Crafts held the first major retrospective of the pioneer fiber artist Dorothy Liebes. Liebes designed upholstery fabric in the 1960s that incorporated metallic threads and unusual color combinations. She also used metallic fiber in innovative wall hangings, along with nontraditional materials such as bamboo and wooden slats. In 1979 The Art Institute of Chicago held a retrospective of Claire Zeisler's

work. Zeisler, along with artists such as Kay Sekimachi, Jean Stamsta, and Lenore Tawney, began during the late 1950s and early 1960s to abandon the loom, virtually creating the transition from weaving to fiber art. The shift from two-dimensional wall hangings to three-dimensional works sometimes also prompted a move to monumental scale, especially for Zeisler and Stamsta. Sekimachi would create very complex free-hanging works that sometimes include unusual materials such as translucent filaments.

Traditional tapestry wall hangings, ranging from decorative to highly intimate images, continue to be made. Recent works present a diversity in execution as well as content, sometimes including paint, photography, or three-dimensional elements. Chloë Colchester, in writing about Cynthia Schira, discusses how the artist makes the most of the textile medium.[4] Schira also has shown at major galleries, including the Hadler / Rodriguez Galleries, Houston and New York; Contemporary Arts Gallery, Portland, Oregon; and Franklin Parrasch, New York. Mary Bero's boldly figurative minitapestries have been carried by the gallery Mobilia, Cambridge, Massachusetts; The Octagon Gallery, Ames, Iowa; and Zolla / Lieberman Gallery, Chicago (see fig. 1).

In the mid-1970s, inspired in part by the forthcoming American Bicentennial, there was a revival of interest in historical crafts. In fiber art the impact was seen in a surge of making, exhibiting, and collecting quilts. The National Quilting Association, now a parent group for hundreds of quilt organizations across the country, was founded in 1970. Quilts have been one of the most frequently collected of fiber media, entering myriad private and public collections. There are now several museums devoted to quilts: the American Museum of Quilts and Textiles in San Jose, California; the New England Quilt Museum in Lowell, Massachusetts; and the Museum of the American Quilter's Society in Paducah, Kentucky. Many major museums have significant quilt collections, including New York's Metropolitan Museum of Art; The Art Institute of Chicago; the Los Angeles County Museum of Art; the Denver Art Museum; and the Spencer Art Museum, Lawrence, Kansas.

Those who began the art-quilt movement in the mid-1970s were basically self-taught as quilters, although some were art-school trained. Michael James played with color and value in ways so sophisticated that artists' ideas of color were changed. Nancy Crow also influenced the development of the genre. Contemporary quilting has diverged considerably from its heritage. The advent of machine-pieced quilts brought artists to the genre who otherwise would not have become involved; modern quilters experiment with new materials, such as beads and oil paint, and incorporate techniques such as silkscreening. Faith Ringgold, whose work is in New York's Metropolitan Museum of Art and the High Museum of Art in Atlanta, uses photo imagery in her quilts while making important cultural statements.

Historical quilts were well on their way to being valuable collectibles by 1979, when the first "Quilt National" exhibition was held at The Dairy Barn Southeastern Ohio Cultural Arts Center in Athens. This greatly anticipated biennial now draws many entries and travels widely. Ruth Snyderman of The Works Gallery in Philadelphia has decided to have "a focus on quilts, rather than other fiber pieces such as tapestries."[5] The gallery's shows have received a good response from both private and corporate collectors. Galleries such as The Great American Gallery (now the Connell Gallery) in Atlanta, the Bernice Steinbaum Gallery in New York, and the Janis Wetsman Collection in Birmingham, Michigan, also have become major proponents of contemporary quilts. I. Michael Danoff, director of the Des Moines Art Center in Iowa, collects historical quilts.

Excitement about quilting fed the art-clothing phenomenon, which began in California. First hand-quilted,

then machine-pieced jackets became very popular. Tim Harding, formerly a garment cutter, uses reverse appliqué to make beautiful rag-quilted coats that look like moving sculpture (see fig. 2). Gayle Fraas and Duncan Slade's quilted coats use ethnic and commercial designs as sources of influence. Geraldine Miller began by making tapestries, then made clothing as wall hangings, and finally clothing as wearable art. Kaffe Fassett has revolutionized knitting through his writings and his use of color in sweater designs, particularly in Britain.

Wearable art has been a fun, light-hearted genre of fiber which has received considerable stimulus from free thinking on the West Coast. In 1972, feeling that wearable art should be seen performed, not hanging lifeless in a gallery, a group of Seattle-area artists formed The Rag. The group last performed in 1985. Julie: Artisans' Gallery in New York has since 1973 been one of the most visible centers for the promotion of wearable art. Its founder, Julie Shafler Dale, published in 1986 a seminal book on the subject, *Art to Wear*. The gallery Mobilia, Cambridge, Massachusetts, has also played in important role in the field since 1978. An exciting offshoot of wearable art is jewelry, which often crosses over into fiber—for example, Joyce Scott's beaded necklaces.

A number of shows at the Museum of Contemporary Crafts in the 1970s had an emphasis on fiber: "Furs and Feathers" (1971), "Sculpture in Fiber" (1972), "Fabric Variations: Tie and Fold-dye Wall Hangings and Environments" (1972), "Sewn, Stitched and Stuffed" (1973), "Make It — Wear It — Share It!" (1973). The year 1974 saw the first biennial "International Exhibition of Miniature Textiles" held at the British Craft Centre, London. In 1977 Jack Lenor Larsen organized "Dyer's Art: Ikat, Batik, Plangi" at the Museum of Contemporary Crafts. The Cleveland Museum of Art held "Fiberworks" in 1977.

Although the shows were important, a lack of continuity remained. The only annual exhibitions to work toward were local; fiber continued to be scattered and regionalized. Support from museums, galleries, the public, and artists did not develop. Collectors' groups, which evolve in conjunction with an interest on the part of museums or galleries in acquiring fiber, and which are an important factor in determining a medium's continuing vitality, were few and far between.

Entering juried and invitational exhibitions and working toward them was a chief goal of fiber artists, for occasionally these shows would lead to important public commissions. Commission situations always involve considerable additional work of a business and political nature. In an article on commission fibers, Janet Koplos addresses both practical and aesthetic concerns: "Every

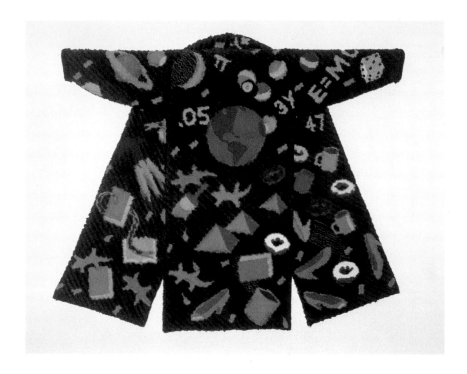

public commission has a story all its own, an almost-human individuality. Completely apart from the few logistical considerations . . . public fiber offers its own peculiar aesthetic challenges."[6]

Gerhardt Knodel, now head of the fiber department at Cranbrook Academy of Art, was a major groundbreaker in working with architects and consultants in commission fibers. Since the late 1960s he has dealt with textiles for the purpose of defining space. His first major architectural commission was in 1975–76 for John Portman & Associates' Renaissance Center in Detroit (see fig. 3).[7]

During the 1970s large-scale fiber commissions were a growth industry. In *Fiberarts,* Louise Allrich stated: "Corporations have become the Medici for fiber artists. It is a very powerful market and it has certainly affected us."[8] Sheila Hicks, who is particularly suited to architecturally challenging commissions because she studied with the architect Luis Berragán, did an installation for the MGIC Building in Milwaukee in 1974. Banks have often been important leaders in corporate collecting in America. Security Pacific Bank of California initiated a three-part program in 1974: 1 to 1½ percent of its branch office construction costs go toward acquisition; direct financial support for outside cultural programs; and monthly performances and exhibitions at the headquarters in downtown Los Angeles.[9]

The Ruth Kaufmann Gallery, which opened in 1969 in New York, was a motivating force in the 1970s in the area

**Figure 2**
Tim Harding
(American, born 1950)
*Wizard Coat I*, 1990
Cotton with free reverse appliqué
53 × 68 × 3 inches
Collection of Sandra Nelson, Minneapolis

Figure 3
Gerhardt Knodel
(American, born 1940)
*Free Fall,* 1977
Wool and mylar
70 × 10 × 15 feet
Renaissance Center,
Detroit (removed 1990)

Unlike the metalworkers and ceramists, fiber artists have no national organizations that span the entire field. The biennial conferences organized by the Handweavers Guild of America have been seen as a central focus for fiber, but they are mostly for handweavers. This is changing because of the Surface Design Association and Charles Talley's magazine, *Surface Design,* and its commitment to serious criticism and research. Arts organizations, such as Fiberworks Center for the Textile Arts, in Berkeley, California (which closed in 1987), were important as a grounding for the field. They served as audience and support to a largely unnurtured medium. They held classes, workshops, and lectures, ran galleries, published newsletters, and gave regular exhibitions:

> From the start, Fiberworks served as an important aesthetic catalyst, ever at the cutting edge of creative change. As founder Gyöngy Laky recalled, "Back in 1974, Bay area artists Ed Rossbach, Kay Sekimachi, Katherine Westphal, Trude Guermonprez and others were exploring a field that had very little visibility." The fledgling organization moved quickly to fill the void. It generated an astonishing array of programs of artistic and educational merit . . . all to satisfy the cravings of a committed and impassioned community. . . .[11]

Magazines have been of importance: *Fiberarts* was founded in 1976; *Surface Design* and *Threads,* founded respectively in 1978 and 1985, also focus on fiber art. *Fiberarts* has critically championed installations by fiber artists, emphasizing material and architectural spaces. *Surface Design* addresses issues of content and message. Another journal, *Crafts Report,* has been significant in helping the arts to become more businesslike. *American Craft* has also featured fiber artists. Constructive criticism has been a problem. Fiber is rarely reviewed in art journals other than those devoted to craft. Too often the critics in these journals, although well-meaning, and the artists themselves, who are too insular, do not make enough demands on fiber artists. Fiber is reviewed more often than critiqued or instructively compared to other art media. While fiber is sometimes accused of having no content, the critics themselves discuss it in terms of decoration, not ideology, thereby continuing the cycle. Books, such as those accompanying the exhibitions organized by Larsen and Constantine, have been a more important and constant source for the field, perhaps even more consistently than for other craft media, which have only recently had a proliferation in the literature.

The issue of content in fiber has been an important one. In a 1978 article, Gerhardt Knodel addressed the question of expression:

of large commissions for fiber artists. Kaufmann has worked with many of the most significant national and international fiber artists, including Magdalena Abakanowicz, Olga de Amaral, Madeleine Bosscher, Françoise Grossen, Sheila Hicks, Ferne Jacobs, Ed Rossbach, Kay Sekimachi, and Lenore Tawney. Kaufmann continues to enhance the field: she has just given her collection of miniature textiles, which includes works by Helena Hernmarck, Hicks, Ritzi Jacobi, Sachiko Morino, Alan Saret, Michelle Stuart, Tawney, and others, to The Minneapolis Institute of Art.

The Allrich Gallery has also been a leader in the area of corporate commissions. Commission work, especially during California's building boom in the 1970s, provided a solid base for the gallery to develop its exhibition program. Allrich encourages artists to do a healthy balance of exhibitions and commission work. Collectors such as the Saxes, who have acquired works by Neda Al Hilali, Lia Cook, and Nance O'Banion from The Allrich Gallery, consider it to be a major impetus for fiber arts and credit Allrich for educating and encouraging them.[10]

137

Most fiber work historically came from a craft involvement, that is, the love of making something, usually something useful, and usually something which resulted from a tradition which dictated style, technique, and materials. . . . We must recognize that all art has craft involved in it. Some painters are only good craftsmen. Not all painting is art. In the area of weaving, there are a lot of people who are good weavers, but they don't transcend the craft of weaving. Their work is technically competent, but lacks expression.[12]

This commentary still holds true for fiber art. In trying to be supportive, critics who ignore questions of content and expression are in effect refusing to look at fiber seriously. Committed and educated fiber artists, however, certainly work from philosophical inspirations comparable to those of any painter. For example, Joyce Scott's beaded necklaces are really collars that have images depicting racial problems in the United States and apartheid in Africa (see fig. 4). Her work is a mix of mythology, politics, history, voodoo, humor, and soul, contradicting the notion that fiber art does not deal with content.

## The 1980s

"The Critical Eye: A Seminar on Art Criticism and Writing about Fibre" in 1986 in Banff, Canada, conducted by international figures from the fiber field, determined that fiber suffered from a lack of exposure, mainstream critics, and a vocabulary. With the exception of Ruth Kaufmann, Modern Master Tapestries, Hadler/Rodriguez, Helen Drutt, Heller Gallery, and Twining galleries, the New York art world basically ignored fiber. The Cooper-Hewitt National Museum of Design, Smithsonian Institution, in New York has an extensive collection of textiles, and the Textile Museum in Washington, D.C., holds some fiber workshops and exhibitions, but by and large, neither museum contributes heavily to contemporary fiber, choosing instead to focus on historical textiles. Washington's Renwick Gallery and the American Craft Museum in New York have made the most continual efforts. The Renwick Gallery, formerly under Lloyd E. Herman and today under the curatorial direction of Michael W. Monroe, has given fiber regular exposure in shows such as "Objects: USA" (1969), "The Object as Poet" (1977), "Threads: Seven American Artists and Their Miniature Textile Pictures" (1982), "The Flexible Medium: Art Fabric from the Museum Collection" (1984), and "The Woven and Graphic Art of Anni Albers" (1987).

During the 1980s fiber art languished somewhat at the American Craft Museum. Other media blossomed, became more mainstream, and were pursued by collectors.

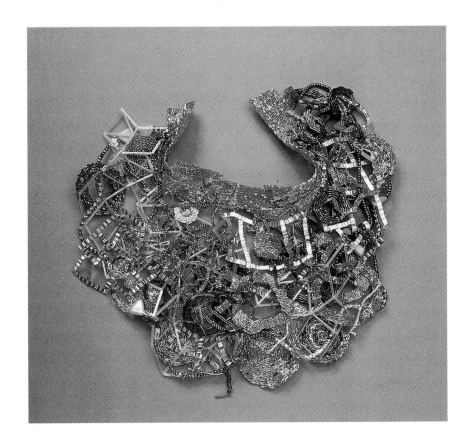

One important exhibition, "Interlacing: The Elemental Fabric" (1987), was organized by Jack Lenor Larsen with the assistance of Betty Freudenheim. Larsen also curated "The Tactile Vessel: New Basket Forms," drawn from the permanent collection of the Erie Art Museum, Pennsylvania (1989). A few important shows took place elsewhere: "The Art Fabric: Mainstream," organized by Larsen and Constantine for the San Francisco Museum of Modern Art (1981); "Fiber R/Evolution," at the Milwaukee Art Museum and the University of Wisconsin, Milwaukee (1986); and "The Eloquent Object," at The Philbrook Museum of Art, Tulsa (1987). These three exhibitions traveled nationally and included catalogues; all had major impact on the field. Also at the American Craft Museum, Director Paul J. Smith's "Approaches to Collecting" show (1982) included several corporate collections, among them that of John Portman & Associates. The museum's "Collection of the American Craft Museum: The Dreyfus Gift of Textiles" (1989) demonstrated that fiber's biggest collectors and supporters since the 1960s had been corporations and that some of their collections were museum quality.

Although most fiber collections are part of a larger craft collection, a change occurred in the 1980s with the prolif-

**Figure 4**
Joyce J. Scott
(American, born 1948)
*Mardi Gras–Jamming,*
1992
Glass beads, thread, and wire
8¼ × 12 × 5 inches
Collection of Karen Johnson Boyd, Racine, Wisconsin

PLATE 99
Lia Cook
**Lattice: Ode to O.Be,** 1982
(cat. 18)

eration of basketmakers. One simple explanation for the focus on baskets is that, unlike many other fiber art forms, they require little display space. In addition, historical basketry has long had great appeal, which has extended to contemporary baskets. Numerous early shows and good attention by the press furthered their popularity. The Miller/Brown Gallery in San Francisco and Barbara Okun of St. Louis were among the first to show baskets. *Fiberarts* has devoted several issues exclusively to basketry and has given the form considerable space since its growing popularity in the late 1980s. There have also been important books on the genre, such as Rob Pulleyn, ed., *The Basketmaker's Art: Contemporary Baskets and Their Makers* (1986), and Shereen LaPlantz, ed., *Basketry Round Up* (1992).

Fiber sculpture was encouraged at the Lausanne Biennale. In 1986 the title of the twelfth biennale was "Textile as Sculpture." Among the entries that were directly or indirectly related to basketry was Katsuhiro Fujimura's *Untitled*—two enormous corrugated cardboard baskets that filled the room. Fujimura's fusion of traditional Japanese elegance and simplicity with Western scale marked a significant milestone in contemporary basketry; Japanese fiber became an important influence on the field in the 1980s.

Although baskets have long been made and used by people in their native cultures, they have not been seen as an art form, despite their display in decorative-arts and natural-history museums to give a sense of historical context. This attitude has changed, in part thanks to Ed Rossbach's innovation and experimentation: he exhibited baskets along with other nonloomed fiber art (see fig. 5). His first book on baskets, *Baskets as Textile Art* (1973), gives an extensive overview of ethnic baskets, ending by discussing contemporary basketmakers. In 1986 he published *The Nature of Basketry*, a revision of his earlier book.

The Chodorkoff Collection (Michigan) of baskets evolved from a base of ethnic baskets and contemporary glass. Four years ago the Chodorkoffs began collecting baskets at the Chicago International New Art Forms Exposition at Navy Pier; they bought work by Lillian Elliott, Mary Giles, and Ed Rossbach. The Chodorkoffs stay current in the field through periodicals; when they travel, they visit commercial galleries, university galleries, and museums. They estimate that they have spent more of their disposable income on art objects than nonart objects. This scenario is very similar to the stories of other collectors. Fiber pioneer Claire Zeisler, as a collector, acquired a magnificent historical collection that she continued to build. Diane and Sanford M. Besser from Little Rock, Arkansas, and Santa Fe, New Mexico, have estab-

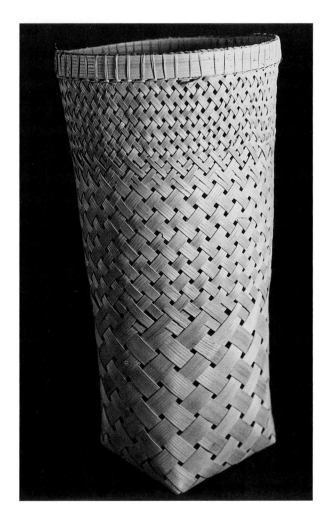

lished a major collection of contemporary baskets. William and Donna Nussbaum in St. Louis and Joyce and John Heiman and Barbara and Ed Okun in Santa Fe are also major collectors. The Wadsworth Atheneum in Hartford, Connecticut, The Detroit Institute of Arts, and the Erie Art Museum in recent years have begun actively purchasing baskets.

Several galleries that show baskets along with other contemporary media have emerged over the last ten years, among them Bellas Artes in Santa Fe and New York (the latter now closed); Barbara Okun Gallery, formerly in St. Louis and now in Santa Fe; Sybaris Gallery in Royal Oak, Michigan; Katie Gingrass Gallery, Milwaukee; and Banaker, Walnut Creek, California.

## Present Day

The early 1990s have again brought a proliferation of fiber to the forefront in museum exhibitions. One of fiber's most significant practitioners, Lenore Tawney, was featured in a traveling retrospective organized by the American Craft Museum in 1990. This same year the Textile Museum showed "Ed Rossbach: 40 Years of Exploration and Innovation in Fiber Art." Within the past two years, the Renwick Gallery has organized an exhibition of Cynthia Schira's tapestries as well as a survey of John McQueen's baskets. The Besser Collection was featured in "Objects and Drawings from the Sanford and Diane Besser Collection," at The Arkansas Arts Center, Little Rock (1992). Independent curator Mary Jane Jacob has organized since the 1980s a number of contemporary art shows in which fiber is treated simply as another art form. These exhibitions exposed the rich and varied evolution of the field.

The recent interest by collectors in fiber art, particularly in baskets and quilts, marks a change within the field; an infrastructure seems at last to be developing. Fiber study groups are on the rise. The Textile Study Group of New York, which began in 1977, has approximately ninety members. Curators, artists, and consultants are brought in as guest speakers; there are monthly newsletters, occasional workshops and exhibitions, and other projects. Patterned after the New York group is a fiber group in Washington, D.C., cofounded by Lois Lunin and Nancy Payne.

In August 1991 Friends of Fiber Art International was formed, "with the primary purpose of promoting fiber as an art medium and encouraging the serious collecting of fiber art. It is based on the premise that the best way to help artists is by developing a community of collectors."[13] This group was founded by Camille Cook, a Chicago-area collector who was inspired by the success of the collectors' group, the Art Alliance of Contemporary Glass. Cook patterned its travel program after that of the Collectors Circle of the American Craft Museum. The members travel to exhibitions, buy and donate pieces, and encourage museum acquisition and exhibition of fiber. The formation of this group will give fiber art a position and recognition that have been lacking.

Lotus Stack, curator of textiles at The Minneapolis Institute of Art, and Christa C. Mayer Thurman at The Art Institute of Chicago have made huge strides in just a few years in developing major fiber centers in Minneapolis and Chicago, through exhibitions and study groups. Stack and Sheila Hicks were instrumental in the acquisition for the Minneapolis Institute of Ruth Kaufmann's collection of miniature textiles.

There have always been a few dedicated collectors of fiber, such as Sharon and Mark L. Bloome from Washington, and Robert L. Pfannebecker from Pennsylvania who has collected work by John McQueen, Warren Seelig, and others. More recently, Eleanor and Sam Rosenfeld and Elmerina and Paul Parkman from metropolitan Washington, D.C., and others have showed an increased interest in fiber. Also important to the field is the fact that The Museum of Modern Art and The Metropolitan Museum of Art have begun to be more active in collecting fiber.

Fiber art moves toward the twenty-first century with increasing exuberance. Artists and collectors are finding unlimited possibilities for innovation and expression in a field marked by great diversity.

## Notes

**Author's Note:** I am grateful to the collectors, artists, critics, and museum personnel who responded to my queries. Among these individuals are Louise Allrich, James Auer, Karen Johnson Boyd, Ann Butcholder, Mildred Constantine, Lillian Elliott, Sheila Hicks, Mary Hujsak, Ruth Kaufmann, Nancy Konensburg, Lois Lunin, Patricia Malarcher, Michael Monroe, Nance O'Banion, Elmerina and Paul Parkman, Eleanor and Sam Rosenfeld, Ed Rossbach, and Lotus Stack. I wish to thank also my staff at Walker's Point Center for the Arts for giving me encouragement and support to complete this project. Thanks also to the J. B. Speed Museum for their assistance and to the Dorland Mountain Colony in Temecula, California, and the Ragdale Foundation, Lake Forest, Illinois, for an artist-in-residence grant. My very special gratitude to Linda Corbin-Pardee, whose patience, editorial expertise, and typing provided assistance and clarification.

1. Elmerina Parkman, written survey for the author, Oct. 1991.

2. Karen Johnson Boyd, in conversation with the author, Oct. 1991.

3. Mildred Constantine, interview with the author.

4. Chloë Colchester, *The New Textiles: Trends and Traditions* (New York: Rizzoli, 1991), pp. 143–44.

5. Penny McMorris, "Quilts at the End of the '80s," *Fiberarts* 16, 3 (Nov.–Dec. 1989), p. 39.

6. Janet Koplos, "Public Fiber: Looking at the Logistics," *Fiberarts* 12, 1 (Jan.–Feb. 1985), p. 37.

7. For an insight into Knoedel's personal goals, see Betty Park, "Conversing with Gerhardt Knodel," *Fiberarts* 12, 1 (Jan.–Feb. 1985), p. 31.

8. Rob Pulleyn, "Commissions. The Process, the Problems, and the Prospects," *Fiberarts* 6, 5 (Sept.–Oct. 1979), p. 45.

9. "Not Just Another Bank" (insert), *Fiberarts* 6, 5 (Sept.–Oct. 1979), p. 55.

10. Dorothy and George Saxe, interview with Davira S. Taragin, Dec. 1991.

11. Charles Talley, "In Memoria on Fiberworks Center for the Textile Arts 1973–1987," *Fiberarts* 14, 5 (Nov.–Dec. 1987), pp. 44–46.

12. Donna Olendorf, "Gerhardt Knodel," *Fiberarts* 5, 6 (Nov.–Dec. 1978), p. 44.

13. Camille Cook, interview with the author, June 1991.

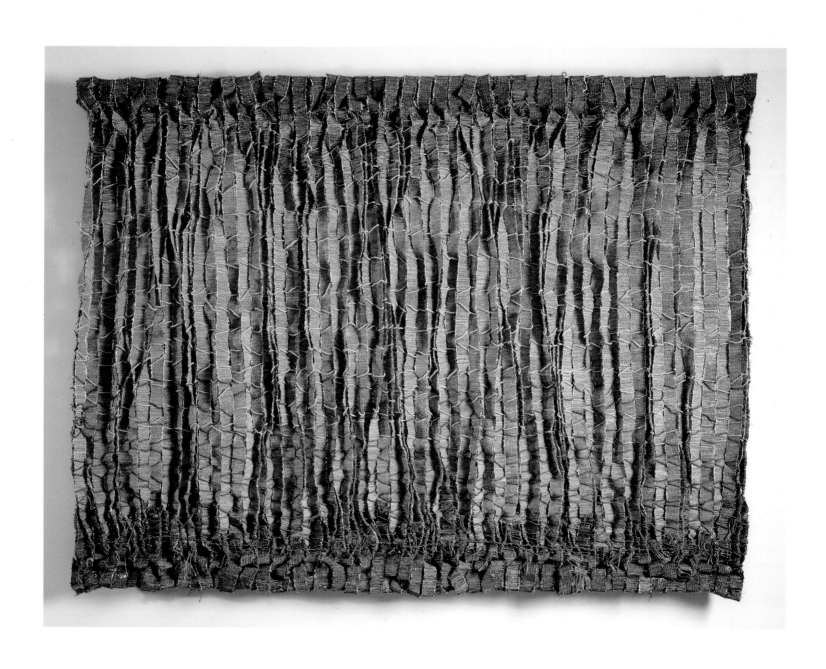

PLATE 100
Olga de Amaral
**Riscos I (Fibra y Azul)**, 1983
(cat. 21)

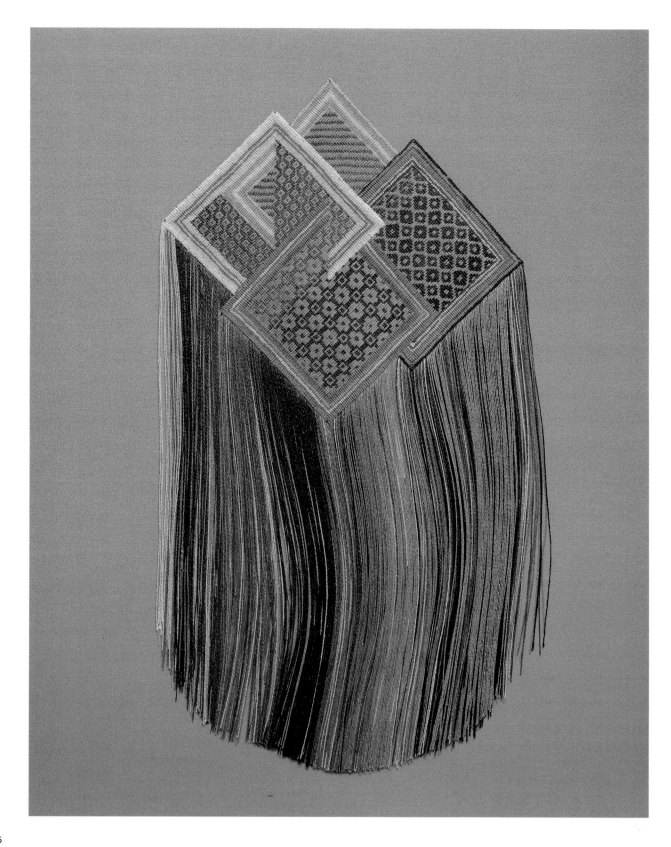

PLATE 101
Diane Itter
**Bandana Split #3,** 1985
(cat. 40)

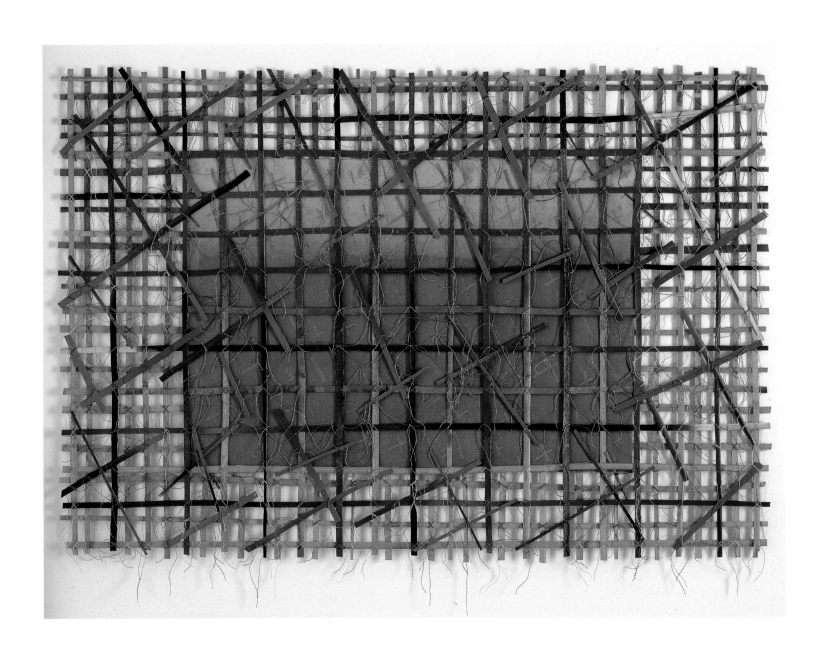

PLATE 102
Nance O'Banion
**Naked Compound Compression**, 1982
(cat. 71)

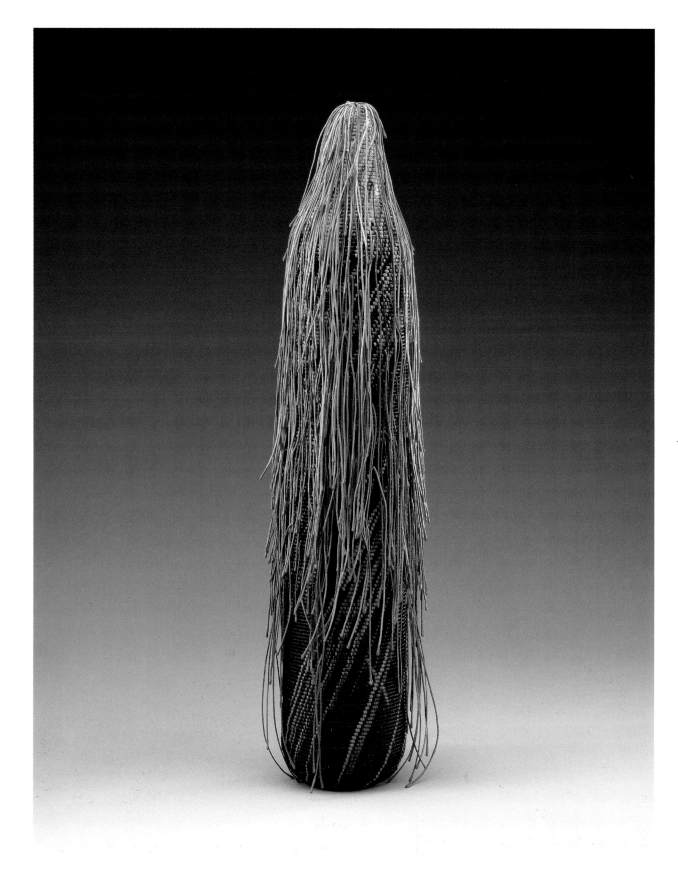

PLATE 103
Jane Sauer
**Thank You, P.M.,** 1984
(cat. 88)

PLATE 104
Cynthia Schira
**Near Balceda,** 1984
(cat. 90)

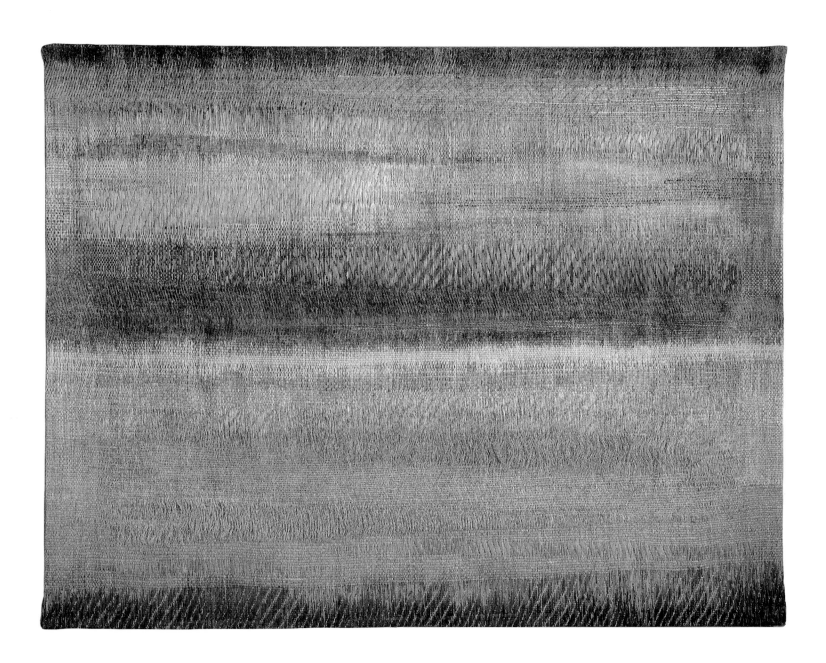

PLATE 105
Kay Sekimachi
**Untitled,** 1987
(cat. 94)

**Untitled,** 1982
(cat. 93)

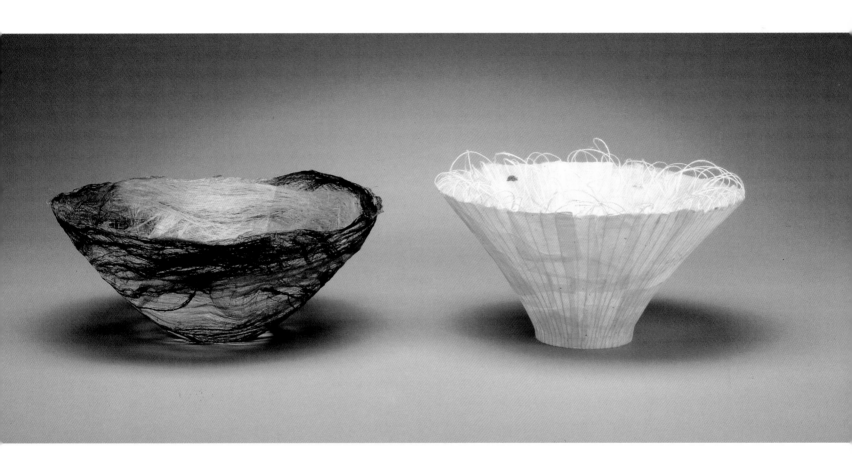

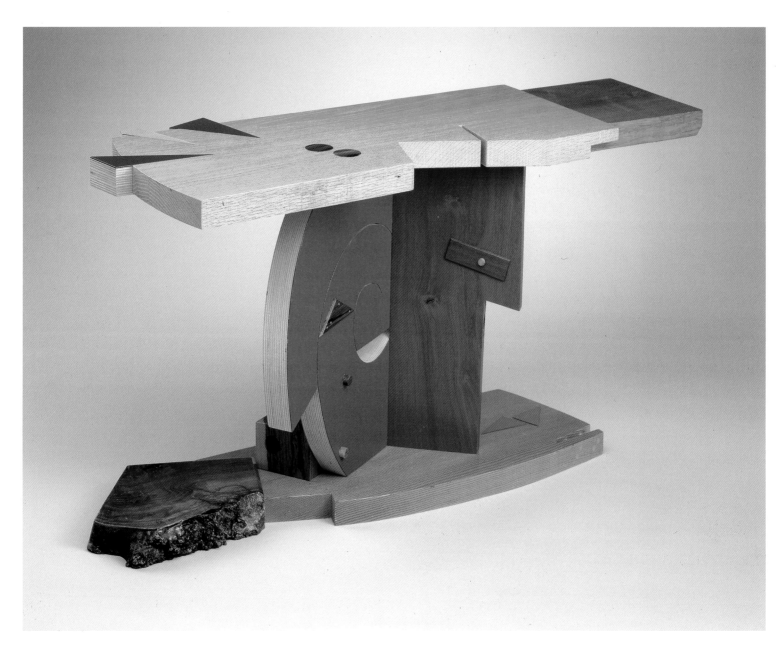

PLATE 106
Billy Al Bengston
**Kane Variation #20**, 1983
(cat. 10)

# Wood in the 1980s: Expansion or Commodification?

*Edward S. Cooke, Jr.*

In the 1980s a heightened degree of commodification affected much of the visual arts as well as the quality of life in general. More than a natural growth in production or consumption, commodification entailed the constant marketing pressures of salespeople and the investment-driven choices of purchasers. Particularly in regard to domestic and personal furnishings, there was a significant increase in the number of consumers seeking or buying goods in the belief that these objects would make them feel happier, allow them to express their individuality, or demonstrate their social power. For many of these people, having became more important than being or doing.

One segment of the visual arts that attracted increased attention during this "shelter decade" (named for the "shelter" or interior-design magazines) was the studio crafts. Academically trained craftspeople working in small studios were able to respond to the aesthetic desires of different constituencies and produce works that, by cost and relative uniqueness, could bestow power and prestige on the purchaser. Studio crafts therefore fulfilled two different consumer motives: the pursuit of fashion and the display of social status.[1]

Lathe turners and furniture makers working in wood would seem one group of studio craftspeople most vulnerable to the commodification of art. Both fields have grown dramatically in the past decade and gained national recognition, but has this growth been natural or driven by commodification? Some collectors genuinely love the objects they buy and want to preserve them for posterity. Others pursue collecting as a selective materialistic activity that bestows sacred nonutilitarian significance on assemblages of objects. It is therefore essential to chart the development of a collecting impulse within wood. Since collecting is predicated upon exposure and education, one needs to recognize developments within those areas and then examine consumers' responses.[2]

From the 1950s through the 1970s, most woodworkers placed particular emphasis upon the natural beauty of the medium and the display of technical expertise. Work from this period is characterized by warm-toned, naturally finished woods and a design sense that emphasized pure organic form. Furniture also featured modeled edges and exposed joinery. Two exhibitions from the 1970s summa-

rized well the developments of the preceding two decades: "Woodenworks," at the Renwick Gallery of the National Collection of Fine Arts, Smithsonian Institution, Washington, D.C. (1972), and "New Handmade Furniture," at the American Craft Museum, New York (1979). Work in these shows ranged from the formal emphasis of Sam Maloof to the more contrived organicism of Wendell Castle and Mark Lindquist.

While the exhibitions revealed the homogeneous aesthetics of the field, they were also important in that they indicated the existence of a critical mass of studio craftspeople and products. The sizable number of makers can be directly traced to internal developments within the field before 1979. In furniture the number of academic programs offering courses and degrees in woodworking and furniture design had grown steadily in the 1960s and 1970s. Nondegree programs, such as the Leeds Design Workshop in Easthampton, Massachusetts, and the Wendell Castle Workshop in Scottsville, New York, offered additional training opportunities. Woodworking courses also become more desirable in summer craft schools, such as Penland School of Crafts in Penland, North Carolina, and Haystack Mountain School of Crafts in Deer Isle, Maine. The result of this surge in woodworking education was a greater number of practitioners pursuing full-time careers in the field. Yet no nationwide, medium-based network accompanied this increase. Most woodworkers kept in contact with classmates or neighbors, but apparently had little need for a larger forum.[3]

In wood turning, Albert LeCoff began a series of symposia in 1976. Based in Philadelphia, these workshops and demonstrations attracted a national audience of woodworkers interested in lathe work and encouraged interchange among turners. However, the symposia did not foster the establishment of centralized wood-turning activity. Turners congregated for the conferences but then practiced their craft in relative isolation. The internal dynamic of the wood field is evident even in the sole relevant publication at this time: *Fine Woodworking*. This periodical was established as a trade journal written by and intended for the active woodworker, particularly the amateur. In contrast to clay, glass, metal, and fiber, wood was a decentralized medium, lacking national organiza-

tions and periodicals that established common agendas and advocated the spread of information. In wood, a loose, informal network of makers persisted.[4]

While the field was developing internally during the 1970s, there was little public exposure besides the two shows mentioned above. Most furniture makers worked on commissions and relied on word of mouth to reach new clients. If the makers showed their work publicly, it was primarily at small craft shops, American Craft Council fairs, and small regional museums. Galleries, which fill an essential role in educating and nurturing the public, played little part. Small craft galleries, such as The Elements in New York and Greenwich, Connecticut, and The Works in Philadelphia, carried some wood objects, but they carried more examples of clay, textiles, and glass. Richard Kagan, a Philadelphia woodworker, established a gallery specifically for wood furniture and vessels in 1973. However, the importance of his gallery lay not in his sales, but in its effect upon the makers themselves. Students and younger woodworkers without commissions had something to aim for, while established makers could examine new developments firsthand. The Kagan Gallery afforded peer recognition and an environment that encouraged the interchange of technical information and design ideas.[5]

In furniture, 1979 proved to be a pivotal year. Just as "New Handmade Furniture" summarized the developments since the 1950s and offered a portfolio of current work, Garry Knox Bennett and Wendy Maruyama looked to the future and produced pieces that signaled a greater interest in the development of ideas. Bennett made a padauk display cabinet replete with bent-laminated rails on the glass door and tightly fitted, expressive joinery, but then drove a bent nail into the upper door on the front facade and surrounded the nail with a series of hammer marks (fig. 1). The intentional disfiguring of the nail and surrounding wood represented Bennett's insistence that furniture makers move beyond a confining reverence for wood and an obsession with technical virtuosity. Respect for the material and a concern for technical accomplishment were merely means rather than ends unto themselves.

Maruyama made a writing desk with sharply geometric shapes and then decorated the wood surface with scribbled crayon decoration (fig. 2). In so doing, she demonstrated an interest in color and decoration appropriate to the idea of a writing desk. When *Fine Woodworking* featured these two pieces of furniture in the fall of 1980, purists and traditionalists protested the "desecration" of furniture and lamented the lack of standards. The field, however, ultimately followed the lead of Bennett and Maruyama and began to explore color, humor, illusion,

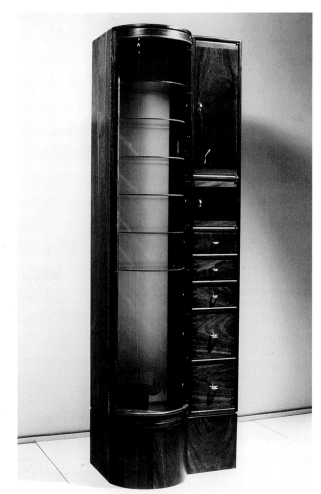

Figure 1
Garry Knox Bennett
(American, born 1934)
*Nail Cabinet*, 1979
Padauk, glass, copper, and
fluorescent tubes
78 × 24 × 24 inches
Collection of the artist

social commentary, and functional issues without sacrificing concern for material and technical integrity. The variety of approaches opened up the possibilities for collecting wood. Since people respond favorably to furniture and vessels for different reasons, the greater diversity of expression broadened the potential market. But diversity also contributed to a more active marketing of wood.[6]

The effect of more skilled makers, along with a wider range and greater quantity of good work, stimulated the development of galleries that focused specifically upon wood for an extralocal market. In 1980 Warren and Bebe Johnson established Pritam & Eames in East Hampton, New York, and Bernice Wollman and Judy Coady established Workbench Gallery in New York City. These galleries were concerned with sales, but they also sought to educate and cultivate a discerning clientele. While the not-for-profit Workbench Gallery focused upon thematic

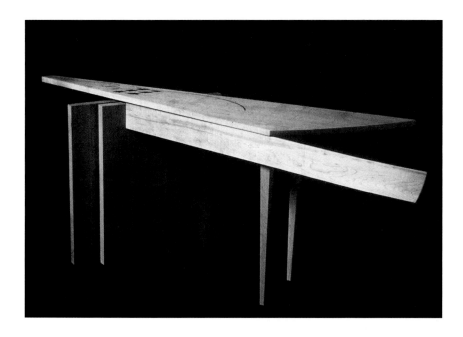

**Figure 2**
Wendy Maruyama
(American, born 1952)
*Writing Desk,* 1980
Maple, epoxy resins, and
crayon
72 × 30 × 18 inches
Collection of Terry B.
Martin, Nashville,
Tennessee

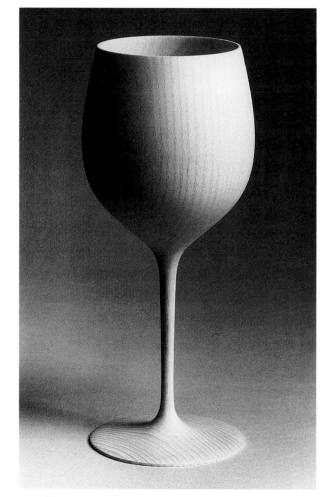

**Figure 3**
Robert Street
(American, born 1919)
*Translucent Goblet in
Wood,* 1980
Western ash
H. 7 inches, dia. 3 inches
Collection of the artist

shows, Pritam & Eames and Snyderman Gallery, a Philadelphia gallery that began to focus on furniture in 1983, assembled stables of furniture makers, mounted exhibitions, and offered assistance to clients interested in commissioning works.[7]

A parallel development took place in turning. Many turners began to explore design and technique and to consider forms other than smoothly finished bowls. In 1981 Kagan Gallery and The Works (the pan-crafts gallery also owned by Rick and Ruth Snyderman) mounted concurrent turned-wood exhibitions organized by Albert LeCoff to coincide with the tenth wood-turning symposium. Robert Street's exquisite *Translucent Goblet in Wood* (fig. 3), which approached the fluidity of blown-glass goblets, was the most noteworthy example in the shows. It manifested a continued concern with form and grain but suggested a new interest in expressiveness. Street's goblet and other works in these shows encouraged turners to push the familiar boundaries of turning and spurred on a small group of collectors, such as Irving Lipton of Encino, California, but failed to establish a significant gallery interest in turning.[8]

A few furniture makers and turners, skeptical of craft-based galleries, pushed for their work to be viewed as art. They aggressively raised their prices, pursued museum acquisition, and sought to market their production through fine-arts galleries. Wendell Castle, the foremost example of this impulse, had a show of illusionistic furniture at Carl Solway Gallery in New York in 1978. While this show received little public attention at the time, Castle's 1981 and 1983 shows at Alexander F. Milliken gallery in New York attracted considerable interest. For the Milliken shows, Castle produced a group of furniture inspired by the work of Emile-Jacques Ruhlmann, the noted French *ébéniste* of the early twentieth century. Castle not only marketed the fine art of workmanship in the SoHo gallery district, but established a whole new price level for studio furniture. He sold a desk and two chairs for $75,000, a price that far surpassed the previous record (see fig. 4).[9]

In turning, Mark Lindquist and David Ellsworth followed similar paths. Lindquist explored the sculptural effects of burl-edged bowls and turned-and-carved vessels, while Ellsworth developed thin-walled, nonfunctional vessels. Both were eager to place their work in galleries and museum collections and set price levels far above those of other turners who produced functional bowls of pleasing shape and grain. Like Castle, they undertook more speculative work, emphasized technical skill as an art form, and deplored the low prices typical of craftwork at the time.[10]

By the mid-1980s, furniture and turning began to attract a broader audience and national recognition. The

cumulative effect of gallery education and the exhibition of consistently good work led to an expansion of the market. The pioneering galleries were joined by others such as Hokin/Kaufman Gallery in Chicago (now closed) and Gallery Fair in Mendocino, California. Art galleries such as Clark and NAGA in Boston also began to mount annual furniture exhibitions, which turned out to be their most popular and successful shows.[11]

With wood's increased exposure and a growing competition among galleries, publicity assumed an important role in the presentation of material. Many galleries began to rely on color slides and photographs to showcase their work. It is no coincidence that painted surfaces, richly colored woods, and strong graphic designs dominated the field during the mid-1980s. These types of furniture, rather than complex or quiet examples, were the most clearly understood in photographic images. The difficulty of showing the full range of one maker's work and the problems inherent in gathering, shipping, and displaying a sizable number of pieces for one show reinforced the importance of good photography. Even graphic design of invitations and advertisements for *American Craft* and other magazines became noticeably more professional during this period.

Two publications and several traveling exhibitions also served to broaden the public's awareness of studio furniture. In *Contemporary American Woodworkers* (Salt Lake City, Utah, 1986), Michael Stone chronicled the personal histories of ten of the field's founders: Wharton Esherick, Maloof, Stocksdale, and others. Stone's well-researched volume provided an essential historical foundation for furniture makers, gallery owners, and the interested public. Patricia Conway and Robert Jensen's *Ornamentalism: The New Decoration in Architecture and Design* (New York, 1982) linked the studio work of Bennett, Castle, Judy Kensley McKie, Trent Whitington, and Ed Zucca to a broader movement in architecture and design. During an era in which leading architects, such as Michael Graves, were deified and commodified, such linkage bestowed great legitimacy on the growing field of wood.[12]

Conway and Jensen were indebted to the educational outreach of Workbench Gallery. Workbench and Formica Corporation jointly organized the traveling exhibition "Material Evidence: New Color Techniques in Handmade Furniture" (1985), in which nineteen studio furniture makers used the plastic laminate Colorcore® to construct furniture. With a wide variety of styles and ideas, the show served as an American version of Memphis-designed furniture. It demonstrated to an American audience that studio furniture transcended wood and was not necessarily serious design (see fig. 5). A touring exhibition of Castle's clocks, "Masterpieces of Time," at the Taft

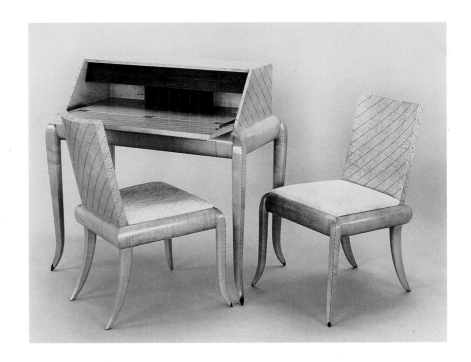

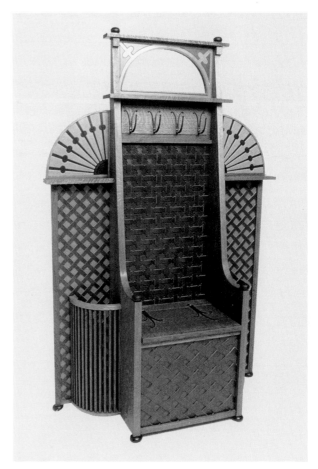

Figure 4
Wendell Castle
(American, born 1932)
*Lady's Desk with Two Chairs*, 1981
Curly English sycamore, amaranth, ebony, Baltic birch plywood, curly English sycamore veneer, ebony inlay, and plastic inlay
Desk: 40⅜ × 41½ × 22¼ inches
Chairs: 34¾ × 21 × 26 inches each
Collection of Peter T. Joseph, New York

Figure 5
Mitch Ryerson
(American, born 1955)
*Hall Piece*, 1984
COLORCORE®, white oak, iron, mirror, and maple
71 × 47 × 17 inches
Collection of Patrick and Judy Coady, Great Falls, Virginia

PLATE 107
Mark Lindquist
**Ascending Bowl #9**, 1983
(cat. 48)

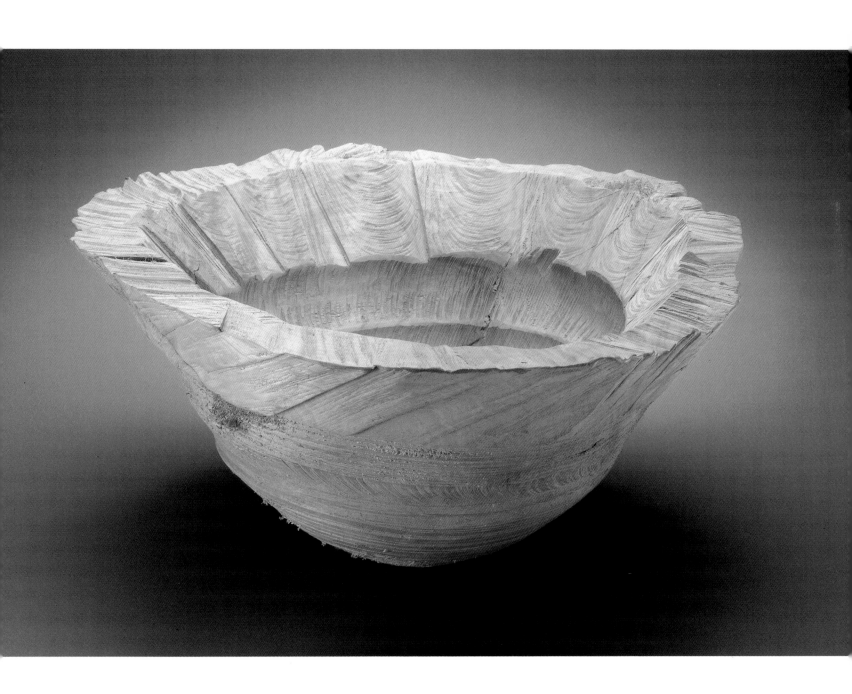

Museum, Cincinnati (1985), also attracted national attention, not so much for the concepts of the clocks, but for their scale, ostentation, and six-figure prices.[13]

The 1986 exhibition "Craft Today: Poetry of the Physical," at the American Craft Museum, New York, served to announce the full acceptance of studio furniture. In quality and quantity of work, wood dominated the show. Large color photographs in the slickly produced catalogue made the objects very alluring, and a national tour made both the objects and catalogue available to a wide audience. Soon after "Poetry of the Physical," *House & Garden, Metropolitan Home, Metropolis,* and other interior-design magazines began to feature studio furniture or to include interiors with examples of the recent work. This exposure brought studio furniture to the attention of a broad, popular audience. Turning also gained more visibility from "Poetry of the Physical." Mark Lindquist's *Silent Witness #1 / Oppenheimer (Totemic Series)* (fig. 6), a totemic column of turned forms that evokes the work of Constantin Brancusi and explicitly demonstrates the sculptural possibilities of turning, received considerable exposure.[14]

Broader exposure led to the emergence of new markets for studio furniture makers and lathe-turners. Previously, most work was simply purchased spontaneously or commissioned for specific use. In the 1980s, more young professionals in their thirties and forties, especially those in venture capital and investment companies, began to buy studio furniture for use. Most purchased just a few pieces, either all from the same maker or a small number from several. A new, exceptional group of buyers, such as Ronald and Anne Abramson, Andrew and Virginia Lewis, and Peter Joseph, began to collect broadly from numerous craftspeople. These leading collectors each purchased more than fifteen pieces of studio furniture by various makers. Museums also demonstrated an interest in the field. In the 1970s only the Museum of Fine Arts, Boston, had specifically collected studio furniture. The museum acquired fourteen pieces of furniture by Sam Maloof in 1976 and placed them in the galleries for public seating. The "Please Be Seated" program was expanded with the addition of work by Tage Frid, George Nakashima, Wendell Castle, and Judy McKie in 1979. Vessels by James Prestini and Bob Stocksdale entered the museum's collection in the early 1980s. Following Boston's lead, museums such as the Museum of Art at the Rhode Island School of Design, the Yale University Art Gallery, and The Detroit Institute of Arts began to build collections in the 1980s.[15]

While these publications, exhibitions, and patterns reflect a heightened public awareness of the field, many furniture makers continued to play a major role in its de-

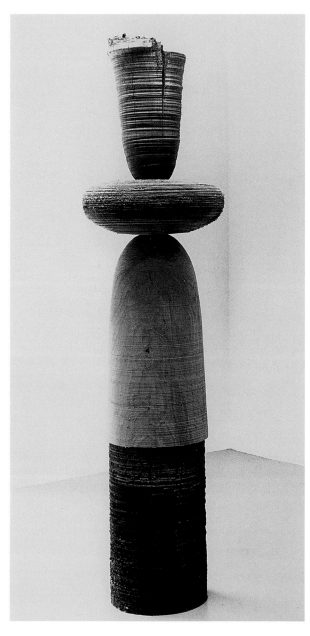

Figure 6
Mark Lindquist
(American, born 1949)
*Silent Witness #1 / Oppenheimer (Totemic Series),* 1983
Walnut, elm, and pecan
H. 85 inches, dia. 22 inches
Collection of Margaret Pennington, Nokomis, Florida

velopment. Two smaller shows developed by makers had particular impact on the field: "Color / Wood," Brookfield Craft Center, Brookfield, Connecticut (1982), and "Furniture in the Aluminum Vein," at the Kaiser Center Art Gallery, Oakland, California (1986). The former, organized by James Shriber, emphasized the role of paint and color in freeing up and energizing the field. Norman Petersen curated the aluminum show in order to encourage furniture makers to incorporate other media.[16]

Turning also enjoyed wider coverage during the mid-1980s, though not to the same degree as furniture.

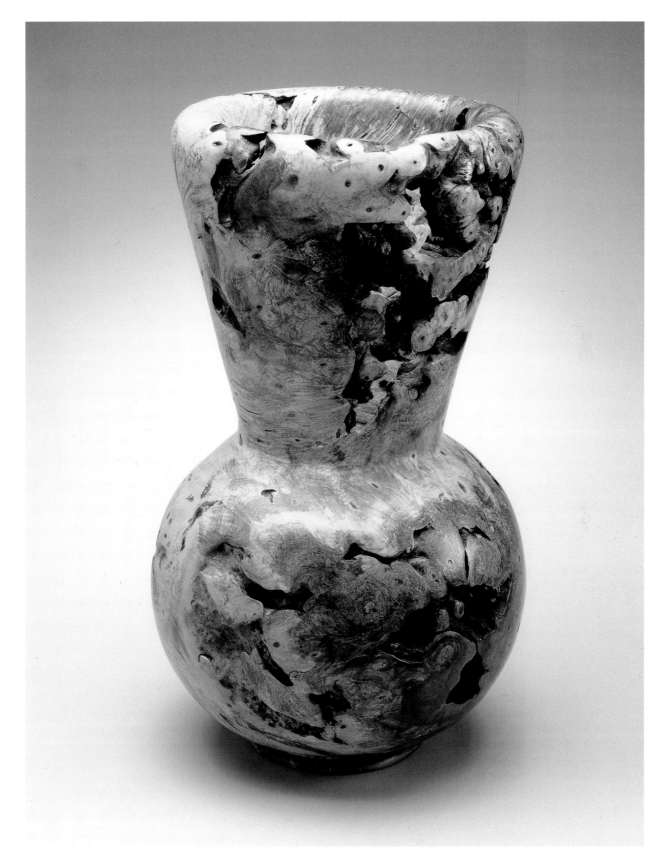

PLATE 108
Melvin Lindquist
**Buckeye Root Burl Vase**,
1983
(cat. 49)

The 1985 exhibition "Woodturning: Vision and Concept," at the Arrowmont School for the Arts and Crafts, Gatlinburg, Tennessee, served as a catalyst within the turning community and continued the new pluralistic tone first seen in the 1981 shows. In the following year, LeCoff established the Wood Turning Center in Philadelphia to serve as a central clearinghouse for information and exhibitions on turning. "Vision and Concept" did not include a catalogue, but it did serve as the foundation for the subsequent "Lathe-Turned Objects: An International Exhibition," at the Port of History Museum, Philadelphia (1988). This exhibition, organized by the Wood Turning Center, included a color catalogue that generated wider interest.[17]

Although broad public knowledge of turning was nascent in the mid-1980s, serious collecting had begun to emerge by this time. Because of size, relative low cost for a unique object, and ease of shipping, turned vessels had always been a staple of craft shows. In the 1980s, as prices for clay and glass escalated and turning diversified, many collectors viewed turned vessels as a field of opportunity. Turned wood was an ideal collecting category: most turners concentrated on the vessel or bowl, in which variation was achieved through different shapes or woods. A collector could thus pursue closure of a certain sort: all the shapes by a certain turner, all types of vessels in a certain type or species of wood, and so on. Coinciding with the rise in collecting was a rise in prices, reflecting both a new posture on the part of the makers and the impact of gallery markup.

In 1985 the collection of Edward Jacobson, who had assembled a group of turned vessels as an art investment, was exhibited at the University Art Museum, Arizona State University, Tempe, and the Renwick Gallery, National Museum of American Art, Smithsonian Institution, in Washington, D.C., among other museums, and published in a handsomely designed, fully illustrated catalogue entitled The Art of Turned-Wood Bowls. The exhibition and book introduced nonturners to the field and legitimized the collecting of turned vessels.[18]

Dorothy and George Saxe's collecting of wood typifies the mid-1980s approach. Since 1981 they have purchased twenty-nine vessels by Bob Stocksdale, most of them directly from the maker, instead of through dealers, as was their customary practice. To complement this encyclopedic assemblage of forms and woods, they have added, primarily from galleries, vessels made by David Ellsworth, Mark and Melvin Lindquist, Ed Moulthrop, William Hunter, and others. The Saxes have been far less active in collecting furniture. They have purchased three examples directly from Sam Maloof and single pieces by Alan Marks and Garry Knox Bennett, all three of whom are California

makers. The only non-California pieces of furniture are by Alphonse Mattia and Jay Stanger. The small quantity and local focus of the furniture contrast dramatically with the depth of the Stocksdale collection and the complementary turnings. The Saxes' collecting of vessels more closely follows their clay collecting.

At the end of 1989, two museum exhibitions triggered an explosion of interest in studio furniture: "Furniture by Wendell Castle," at The Detroit Institute of Arts, and "New American Furniture," at the Museum of Fine Arts, Boston.[19] These two shows provided historical analysis of the medium, legitimized the field with institutional support, and educated a wider audience about its roots and dynamic heterogeneity. The success of this outreach provided the catalyst for nationally prominent critics to write on studio furniture: John Updike wrote a review article for Art & Antiques, and Arthur Danto wrote a commentary for The Nation.[20] Newsweek, USA Today, and other national publications also drew popular attention to the exhibitions.

Hard on the heels of the two exhibitions came Patricia Conway's Art for Everyday: The New Craft Movement, a profusely illustrated book that demonstrated that collecting and daily use of studio furniture could coexist.[21] While other media were represented and discussed, wood furniture dominated the volume. Capitalizing on this new awareness of and interest in studio furniture, the collector Peter Joseph established the Peter Joseph Gallery in New York. Based on Fifth Avenue, the new gallery focuses primarily on furniture. It has aggressively pursued the market through widespread publicity and catalogues featuring leading writers such as Danto and Witold Rybczynski. The latter's article on John Dunnigan was even reprinted as a design review in the Sunday New York Times.[22] Work shown at Leo Kaplan Modern and Franklin Parrasch Gallery in New York has given furniture additional visibility in the New York art world. In fact, review articles appeared in Art in America, and Sculpture included a cover feature. The growth of American interest in studio furniture is also revealed by the sales of Britain's leading studio furniture maker, John Makepeace. Makepeace's primary market is the United States.[23]

Turning also seems poised for greater national recognition. In 1991 the Wood Turning Center mounted its first entirely juried exhibition, "Challenge IV," and actively sought to involve more nonturners. The exhibition tour and catalogue have already brought a developmental sense to the field and helped to educate newcomers. New work, such as Stoney Lamar's Metropolis #3 (fig. 7), reveals a strong new direction in personal manipulations of turning techniques. Despite active collecting and some commodification during the 1980s, turning has retained

**Figure 7**
Stoney Lamar
(American, born 1951)
*Metropolis #3,* 1990
Pear
22 × 17 × 10 inches
Collection of Allen
Caniglia, Mooreston,
New Jersey

control of its future. This strength is most clearly seen in the central importance of the two turning publications, *American Woodturner* and *Turning Points*. Both established in 1986, they provide news about the field, for the field, written by active participants.

The new heightened interest in furniture might foreshadow a commodification similar to the one that occurred in glass in the 1980s. Certainly architects, fine artists, industrial designers, and studio craftspeople in other media are all trying their hands at furniture. But the commodification seems incomplete and will probably remain so. Most obviously the collecting of furniture is shaped by certain inherent restrictions: lengthy fabrication time, high cost, and awkward size and weight. A furniture maker cannot be as prolific as a turner, ceramist, or glass artist. Each piece of furniture is therefore more labor intensive and more expensive. Furniture is also difficult to ship. Whereas clay, glass, and turned vessels are "UPS-able art," furniture requires crating and special shipping.[24] In this regard, collecting furniture requires wealth and space.

Beyond material and technical restrictions, taste is of prime importance. Buying furniture remains a very personal sort of investment. The complexity, intimacy, functional references, and layers of meaning do not allow widespread acceptance and accommodation within one's household. Taste's primary role is revealed through the continued importance of commissions to furniture makers and the decentralized collecting of speculative show work. There is an increasing number of those who may own fewer than fifteen pieces of studio furniture, but refined assemblage rather than purposeful collecting describes current sales. Since the early 1980s, galleries have sought to market studio furniture as "the antiques of the future" or as "undervalued art investments," but taste continues to restrict full acceptance of either designation.[25]

The impact of institutional collecting has also been mixed. Museum visitors have been exposed to greater quantities of contemporary wood, but the works are not collected and displayed with a common philosophy. Studio furniture and wood turning have been collected by a variety of museum departments: American Decorative Arts and Sculpture at the Museum of Fine Arts, Boston; Twentieth-Century Design at The Metropolitan Museum of Art in New York and The Detroit Institute of Arts; and American Art at the Philadelphia Museum of Art. As a result, museum visitors are not really sure how to evaluate the works. Some see them as functional furniture or vessels, some as examples of modern design, and some as contemporary sculpture.

The makers themselves have recognized this unique characteristic of their market and have sought to create specific relationships with the new galleries. Furniture makers have rejected exclusivity, opting instead for a balance between loyalty to past purchasers and clients and a willingness to work with galleries to tap new markets. How this balance plays out in the changed economic climate of the 1990s bears watching.

## Notes

**Author's note:** I would like to acknowledge the assistance of several people in the development of the ideas and information in this essay: John Dunnigan, David Ellsworth, Warren and Bebe Johnson, Richard Kagan, Albert LeCoff, Wendy Maruyama, Alphonse Mattia, Gene Metcalf, Rick Snyderman, Rosanne Somerson, Bob Stocksdale, and Ed Zucca.

1. On the commodification of the arts in the 1980s, see Kevin Phillips, *The Politics of Rich and Poor: Wealth and the American Electorate in the Reagan Aftermath* (New York: Random House, 1990) and Robert Hughes, "The Decline of the City of Mahagonny," *The New Republic,* June 25, 1990, pp. 27–38. The connection between commodification, collecting, and control is discussed in Russell Belk, "Possessions and

the Extended Self," *Journal of Consumer Research* 15 (Sept. 1988), pp. 1–30. Robert Janjigian, *High Touch: The New Materialism in Design* (New York: E. P. Dutton, 1987) is a good example of how design writers adapted the language of commodification. The author constantly points out how new studio work provides social distinction and satisfies personal needs.

2. A good introduction to the various motives in collecting and the importance of exposure and education is Russell Belk et al., "Collectors and Collecting," *Advances in Consumer Research* 15 (1988), pp. 548–53.

3. Boston, Museum of Fine Arts, *New American Furniture: The Second Generation of Studio Furnituremakers*, text by Edward S. Cooke, Jr. (Boston, 1989), pp. 10–23.

4. John Kelsey, "Turning Conference," *Fine Woodworking* 3 (Summer 1976), pp. 44–45; and Kelsey, "Two Meetings," *Fine Woodworking* 7 (Summer 1977), p. 65.

5. John Kelsey, "Craftsman's Gallery," *Fine Woodworking* 3 (Summer 1976), p. 10; Richard Kagan, conversation with the author, June 1991; and Ed Zucca, response to the author's questionnaire, May 1991.

6. Boston (note 3), p. 23. The importance of the developments between 1979 and 1981 is stressed in Dona Meilach, *Woodworking: The New Wave* (New York: Crown Publishers, 1981).

7. Leslie Cochran, "To Market, to Market: The Growing Interest in Handmade Furniture," *Craft International* 5, 2 (Oct.–Nov.–Dec. 1985), pp. 13–15; and Warren and Bebe Johnson, response to the author's questionnaire, June 1991.

8. *American Craft* 41, 6 (Dec. 1981–Jan. 1982), pp. 36–37; and John Kelsey, "The Turned Bowl," *Fine Woodworking* 32 (Jan.–Feb. 1982), pp. 54–61. One notable exception to this trend is the annual turning show at Highlight Gallery in Mendocino, California, first mounted in 1982.

9. Detroit, The Detroit Institute of Arts, *Furniture by Wendell Castle*, text by Davira S. Taragin et al. (New York: Hudson Hills Press, 1989), pp. 54–65.

10. Compare, for example, the differences in prices between Bob Stocksdale and Lindquist and Ellsworth: Bob Stocksdale, "Exotic Woods," *Fine Woodworking* 4 (Fall 1976), pp. 28–32; Mark Lindquist, "Spalted Wood," *Fine Woodworking* 7 (Summer 1977), pp. 50–53; and David Ellsworth, "Hollow Turnings," *Fine Woodworking* 16 (May–June 1979), pp. 62–66. In the late 1970s, many of the traditional turners, such as Stocksdale, priced their work between $35 and $60; Lindquist and Ellsworth tended to ask prices between $250 and $350.

11. Anthony Chastain-Chapman, "Fine Furnituremaking," *American Craft* 44, 6 (Dec. 1984–Jan. 1985), pp. 10–17.

12. Michael Stone, *Contemporary American Woodworkers* (Salt Lake City, Utah: Peregrine Smith, 1986); and Patricia Conway and Robert Jensen, *Ornamentalism: The New Decoration in Architecture and Design* (New York: Clarkson N. Potter, Inc., 1982).

13. Washington, D.C., Smithsonian Institution, *Material Evidence: New Color Techniques in Handmade Furniture* (Washington, D.C., 1985); Detroit (note 9), pp. 74–79.

14. Paul J. Smith and Edward Lucie-Smith, *Craft Today: Poetry of the Physical* (New York: Weidenfeld & Nicolson, 1986).

15. Various responses to the author's questionnaire, May–Oct. 1991.

16. Ibid. See also *Fine Woodworking* 41 (July–Aug. 1983), pp. 70–73; and ibid. 61 (Nov.–Dec. 1986), pp. 60–64.

17. David Sloan, "Arrowmont Woodturning Conference," *Fine Woodworking* 56 (Jan.–Feb. 1986), pp. 64–66; "Lathe-Turned," *American Craft* 46, 1 (Feb.–Mar. 1986), pp. 36–39; and Philadelphia, Wood Turning Center, *Lathe-Turned Objects* (Philadelphia, 1988).

18. Edward Jacobson, *The Art of Turned-Wood Bowls: A Gallery of Contemporary Masters — and More* (New York: E. P. Dutton, 1985). The importance of closure is discussed by Brenda Danet and Tamar Katriel, "No Two Alike: The Aesthetics of Collecting" (unpublished manuscript, 1987). I am indebted to Gene Metcalf for a copy of this paper, as well as his knowledge of collecting theory. On prices in turning, see Richard Raffan, "Current Work in Turning," *Fine Woodworking* 67 (Nov.–Dec. 1987), pp. 92–95; and Albert LeCoff's letter to the editor, ibid. 68 (Jan.–Feb. 1988), p. 4.

19. Detroit (note 9); and Boston (note 3).

20. John Updike, "Put-Ons and Take-Offs," *Art & Antiques* 7, 2 (Feb. 1990), pp. 70–75, 104; and Arthur Danto, "Furniture as Art," *The Nation*, Apr. 23, 1990, pp. 571–75.

21. Patricia Conway, *Art for Everyday: The New Craft Movement* (New York: Clarkson N. Potter, Inc., 1990).

22. "If a Chair Is a Work of Art, Can You Still Sit on It?" *The New York Times*, May 5, 1991, sec. 2, p. 38.

23. See the reviews of the Wendell Castle shows at the American Craft Museum and Peter Joseph Gallery and the John Cederquist show at Franklin Parrasch Gallery: *Art in America* 79, 10 (Oct. 1991), pp. 154, 156. A high chest by Cederquist appeared on the cover of *Sculpture* as a lead for Constance Stapleton's "The New Art Furniture," *Sculpture* 9, 4 (July–Aug. 1990), pp. 34–39.

24. The term "UPS-able" was used by Richard Kagan in conversation with the author.

25. Cochran (note 7) and Stapleton (note 23).

PLATE 109
Sam Maloof
**Untitled**, 1990
(cat. 56)

PLATE 110
Alphonse Mattia
**Hors d'Oeuvre Server**, 1984
(cat. 59)

PLATE 111
Jay Stanger
**Side Chair**, 1986
(cat. 101)

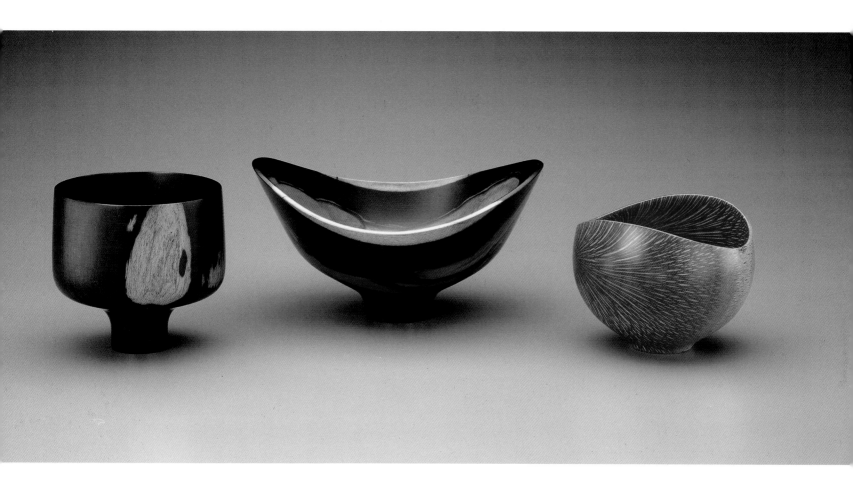

PLATE 112
Bob Stocksdale
**Footed Blackwood Bowl**, 1983
(cat. 104)

**Ebony Bowl**, 1981
(cat. 103)

**Macadamia Bowl**, 1986
(cat. 105)

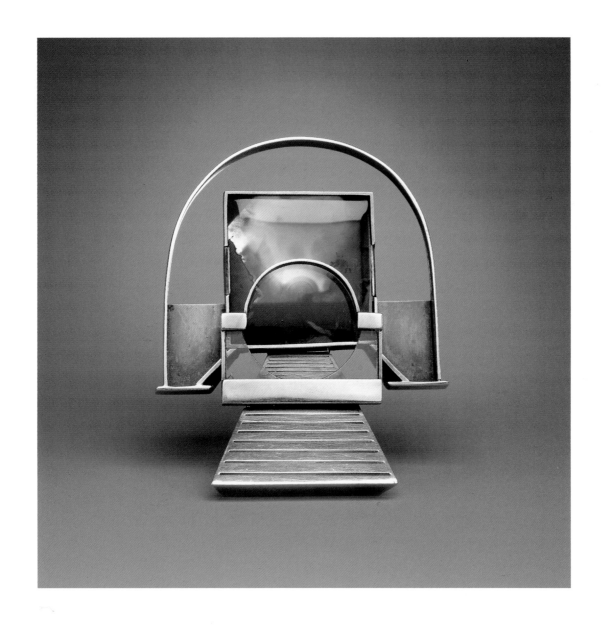

PLATE 113
Deborah Aguado
**Rangefinder,** 1981
(cat. 2)

# In Search of a History: The Evolution and Patronage of Contemporary Metalwork and Jewelry

*Laurie A. Stein*

The summer 1990 issue of *Metalsmith* magazine included a strong critical assessment of the current state of the jewelry field.[1] The article, "The Closing of Doors: An Interview with Garth Clark," sought to explain the short life-span of Clark's CDK Gallery in New York. Simultaneously, it initiated an explosive, frank, and incisive discourse on contemporary metalwork which lasted for almost a year in the subsequent issues of *Metalsmith*[2] and continues as a topic of conversation among artists, writers, collectors, curators, and dealers.

CDK Gallery opened in autumn 1988 with an exhibition of the work of eleven major American jewelers; its presence signaled a positive move in the arena of contemporary metalwork. With the backing of the respected ceramics dealer Garth Clark,[3] the gallery aimed to provide a new forum for the exhibition and sale of works and lead to a broader base for scholarship and collecting activities. Clark intended the gallery to function as "an acknowledgment of jewelry as an art form."[4] The closing of CDK Gallery after only eight months prompted the writer Judith Mitchell and the artist Donald Friedlich (one of the eleven included in the gallery's opening show) to interview Clark and publish his statements. The intensity of response by the readership of *Metalsmith* generated a follow-up article of interviews with other professionals and collectors in the field.[5]

Although CDK Gallery was by no means a solitary trailblazer, it was a volatile presence, and through the CDK articles and the strong responses they elicited, serious frustrations and vulnerabilities within the field were exposed. Disappointment and concern for the short life of CDK served as a catalyst in the metalwork field for healthy debate, definition, critical self-analysis, and new directions.

The debate centers on the need to define the role of contemporary metalwork in the studio craft movement, the viability of establishing a collecting base through the traditional gallery system, and the possibilities for legitimization of the field through museum acquisitions. The paucity of scholarly and analytical literature and the need to clarify the language and parameters of the field are also major topics of discussion. The jeweler Jamie Bennett states, "We need critical and sensible evaluation that asks jewelers, and more

particularly, has jewelers asking themselves, what does your work have to do with jewelry and what are the consequences of your inquiry? . . . Some artists have already begun to do that, but there's very little critical documentation or alternate exposure. The level of writing has not been very stringent or demanding — or even there."[6] Garth Clark claims that "jewelry lacks a critical language that is pertinent to its own unique character,"[7] and Susan Cummins of the Susan Cummins Gallery in Mill Valley, California, suggests that "the first step is to define and understand the limitations of jewelry, because every art form derives its strength from its limitations."[8]

There is also a lack of clear definition of terms and categories within contemporary metalwork. Titles such as jewelry, sculpture, body ornament, personal adornment, academic jewelry, bijoux jewelry, holloware, and metalwork are tossed around and argued endlessly. These distinctions are often overly complex for the nonprofessional. Are contemporary metalwork and jewelry separate fields, or should jewelry be considered under the larger umbrella of metalwork? According to the artist Ronald Hayes Pearson, he is "a metalworker who does a lot of jewelry."[9] However, in the CDK articles, discussion is focused specifically on jewelry: the artists refer to themselves as jewelers, the collectors refer to themselves as collectors of jewelry, and the gallery restricted its representation to jewelry. Analysis of literature, exhibitions, and collectors shows that separate categorization has become more common throughout the last decades and the genre is generally divided into: jewelry (which includes enamels, body sculpture, and all forms of wearable and conceptual jewelry in metal and other materials) and metalwork (which includes all holloware, architectural metalwork, serially produced metalwork, and metal furniture). Furniture and industrial design are not considered in most literature on studio craft metalwork. It may be hoped that the validity and usefulness of such strict categorization will eventually become focal points of debate within the field.

After an intense era of rich and rapid developments in metalwork from the 1930s through the 1980s, the field in the United States is apparently now ripe for reevaluation

and reappraisal. It is a propitious and logical moment, therefore, to undertake a study of the evolution of metalwork and its patronage in the studio craft movement.

The world of metalwork has undergone a dramatic revolution in the last decades. Today there exist numerous excellent galleries that show metalwork, of which Yaw Gallery, Birmingham, Michigan (founded 1962); Joanne Rapp Gallery / The Hand and The Spirit, Scottsdale, Arizona (1972); Julie: Artisans' Gallery, New York (1973); Helen Drutt Gallery, Philadelphia (1974); and the Susan Cummins Gallery, Mill Valley, California (1984) are only a small selection. There are still relatively few private collectors in comparison with other studio craft media such as glass and clay, but pioneers such as Helen W. Drutt English, Sue and Malcolm Knapp, and Sandra and Louis W. Grotta, Jr., have assembled important collections of metalwork and jewelry. Museums such as the Renwick Gallery of the National Museum of American Art, Smithsonian Institution, in Washington, D.C., and the National Ornamental Metal Museum in Memphis, were established during the 1970s and have become the sites for major exhibitions of American metalsmiths' work.[10]

The Society of North American Goldsmiths was founded in 1970 as a professional association. Its major activities include sponsorship of an annual conference and support for the quarterly journal *Metalsmith*.[11] It encourages the exchange of ideas and provides a forum for professional dialogue. With the postwar establishment of training programs for metalwork at universities around the United States and the subsequent increase of highly qualified metalworkers, the field has become large and active.

### The 1930s–1950s

The mid-1930s to the early 1950s was another era of experimentation and redefinition in the field, and many of the issues raised in the current debate are similar to those of the earlier period. In what has been referred to as "the project of modernism,"[12] sculptors and painters (including Alexander Calder and Salvador Dalí) and metalsmiths (including Sam Kramer, Art Smith, Margaret de Patta, Paul Lobel, and Ed Wiener) created jewelry inspired by avant-garde fine-arts movements, such as Cubism, Constructivism, Surrealism, and the Bauhaus. Mutual influences flowed freely between the fine arts and metalwork. In Greenwich Village, Sam Kramer made Surrealist-inspired pieces of "Fantastic Jewelry for People Who Are Slightly Mad."[13] He incorporated nontraditional gemstones and unusual materials into his outrageous and unconventional work (see fig. 1).

Alexander Calder produced jewelry beginning in the early 1930s. His work is mainly in silver and copper, influ-

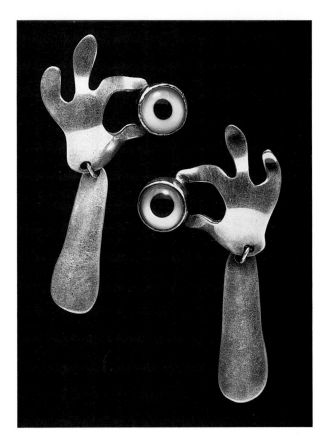

**Figure 1**
Sam Kramer
(American, 1913–1964)
*Earrings*, c. 1948
Sterling silver and glass
2 9/16 inches
Collection of Mark
Isaacson, New York

enced by ancient jewelry and Indian and Eskimo traditions. He exhibited at the Willard and Nierendorf galleries in New York during the early 1940s and at the Alexander Girard Gallery in Detroit. Harry Bertoia, the head of the metalworking studio at the Cranbrook Academy of Art in Bloomfield Hills, Michigan, was also a major presence in the emerging Modernist jewelry movement; his works were often exhibited alongside those of Calder. Known today for the revolutionary metal chair he designed in the 1950s in association with the architect / designer Charles Eames, Bertoia utilized two styles in his work in metal: a textured, free style for much of his jewelry and a cleaner style for holloware pieces (see fig. 2).[14]

Bertoia's holloware reflected the blossoming in the 1930s and 1940s of a new, sleek vessel style. Reflecting the Art Deco taste for streamlined metalwork, artists such as Peter Müller-Munk and Russel Wright produced clean-lined holloware designed for hand or mass-production at affordable prices. Companies such as the Chase Brass and Copper Company, the International Silver Company, and Towle Silversmiths collaborated with metalworkers to produce lines of wares. American Modernist design was born.

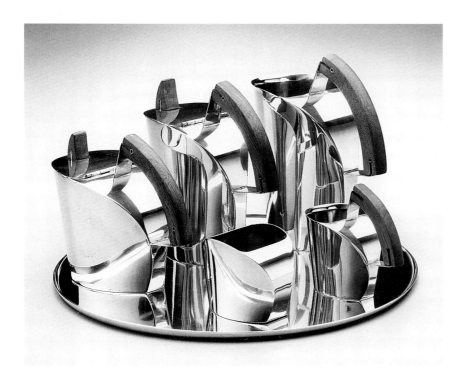

**Figure 2**
Harry Bertoia
(American, born 1915 in
Italy; died 1978)
*Coffee and Tea Service,*
1940
Silver and cherry
9¾ × 15½ inches
Collection of Cranbrook
Academy of Art Museum,
Gift of Mrs. Joan R.
Graham

The design field was heavily influenced by European traditions from the Bauhaus and Scandinavia. For example, Margaret de Patta, one of the most important jewelers of the 1930s–1950s, studied at Chicago's School of Design under Bauhaus émigré Lázsló Moholy-Nagy. De Patta's style, incorporating nontraditional materials, geometric and abstract forms, and innovative stone settings, combined Bauhaus principles and philosophy with the aesthetics of Surrealism and Constructivism.[15]

Aside from scattered courses offered at Cranbrook, Chicago's School of Design, and several universities, there were relatively few formal, full-length metalwork and jewelry training programs in the United States during the 1930s and 1940s. Finding that there was "almost nowhere" to gain modern silversmithing experience in the United States, some students, such as Margret Craver, went to Sweden and Denmark to study holloware in the studios of Scandinavian masters.[16]

In 1944 Craver's frustration at the lack of training opportunities in America led her to instigate several remarkable programs. Through association with Handy & Harman Precious Metal Refiners in New York, she developed a rehabilitation program of metalsmith training for the armed forces. Two years later she initiated the first modern metalsmithing patronage by a corporate sponsor when she convinced Handy & Harman to fund summer workshop conferences in raising and holloware techniques.

The goal of the postwar conferences was to "teach silversmithing to art teachers in colleges, universities and art schools."[17] Taught between 1947 and 1953, primarily by European masters, these workshops were, in effect, the first serious, formal training programs for metalwork in the United States; their legacy is evident in the work of well-known participants such as Alma Eikerman, John Paul Miller, Earl Pardon, and Arthur Pulos.

Metalwork designed at the conferences was shown in the first important holloware exhibition held after World War II. Organized by Craver at The Metropolitan Museum of Art in New York in 1949, "Form in Handwrought Silver" displayed contemporary silver in a didactic installation with photographs, explanatory texts, and technical information. The installation included the statement, "Handwrought silver is unique in the same way that a painting or a piece of sculpture is unique" (see fig. 3). Thus it is clear that as early as 1949, the relationship between craft, fine art, and industrial design was already emerging in the United States as an issue for discussion of definition in the field.[18]

The Metropolitan Museum established a tradition of support for both decorative arts and applied, or industrial, arts when in 1917 the institution initiated regular exhibitions. Museums, including The Brooklyn Museum and The Detroit Institute of Arts, began playing major roles in supporting metalwork and jewelry after World War II.

By the late 1940s, jewelry had already been the subject of major exhibitions. The Museum of Modern Art mounted "Modern Jewelry" in 1940 and "The First National Exhibition of Contemporary Jewelry" in 1946. They included the work of Calder and Bertoia. "The Second National Exhibition of Contemporary Jewelry" was held at the Walker Art Center in Minneapolis in 1948. In these landmark early exhibitions, modern metalwork was already being exhibited in strictly defined and separate categories of holloware and jewelry — strict categorization of metalwork and jewelry existed even in the early Modernist movement.

The postwar conferences and exhibitions raised three primary concerns: 1) the need to train competent metalworkers, 2) the problem of defining the relationship between individual or handmade metalwork / jewelry and industrial design or applied art, and 3) the goal of mounting metalwork exhibitions in American museums. The final two issues remain relevant in current debates about the state and future directions of the field.

One of the most important factors in the rise of contemporary metalwork and jewelry from the 1950s was the popularity and consequent growth of training programs

at American universities. The first full-length professionalized course of study was offered by the School for American Craftsmen at Dartmouth College, Hanover, New Hampshire, in 1944. Later held at Alfred University and finally located at the Rochester Institute of Technology, both in New York State, the school trained many metalworkers, including numerous former servicemen searching for new skills and a way of life after their release from the military. The form and emphasis of the programs bear witness to the evolution of the field. John Prip, an American trained in Denmark, was an early metalwork professor at the school. The program at Rochester continues today and, since the days of Prip's tenure, many other influential metalwork teachers including Ronald Hayes Pearson and Albert Paley have placed their stamp on the course of studies.

John Prip and Ronald Pearson were also instrumental in the establishment of Shop One in Rochester in 1952. One of the first studio craft galleries, Shop One held regular exhibitions of new work, bringing contemporary material to the attention of fellow artists and building a base of collectors from Rochester and around the country.[19]

University metals departments have served as the primary locus for the development of current ideology; the universities themselves also have effectively been major patrons of contemporary American metalwork, through their support for the artists, creation of technical facilities, and sponsorship of exhibitions and publications. For ex-

ample, Stanley Lechtzin was able to build a sophisticated teaching lab for electroforming processes at the Tyler School of Art in Philadelphia. Heikki Seppa worked with students at Washington University in St. Louis to develop his shell-structure technique. And Helen W. Drutt English advanced the field by teaching in 1973 the first craft history course at the Philadelphia College of Art.

The influence of great teachers has been crucial to the development of the field. Complex and close-knit educational family trees include Harry Bertoia, Fred Fenster, Gary Griffin, Stanley Lechtzin, and Richard Thomas at the Cranbrook Academy of Art; Alma Eikerman and Helen Shirk at Indiana University at Bloomington; Mary Lee Hu, L. Brent Kingston, Richard Mawdsley, and Jim Wallace at Southern Illinois University at Carbondale; Gary Griffin, Stanley Lechtzin, and Olag Skoogfors at the Tyler School of Art, Philadelphia; and Ruth Pennington, Kiff Slemmons, and Ramona Solberg at the University of Washington, Seattle.

Most master metalworkers and jewelers remain associated with a university program throughout their careers. This arrangement has been instrumental in maintaining the universities as vital centers for innovation. A distinct type of "academic" metalwork and jewelry has emerged, characterized by inventive, abstract, and often nonfunctional and conceptual forms. The work tends to rely on nontraditional materials or combinations, in bold stylistic and technical manifestations.

**Figure 3**
The Metropolitan Museum of Art, New York, installation: "Form in Handwrought Silver," 1949

A high level of insularity exists within the field. Metal-workers and jewelers have created a tight-knit network in which colleagues generally remain their own critics, curators, collectors, and dealers. Metalwork centers have developed in urban areas with access to large consumer clientele, including New York, San Francisco, Seattle, and Philadelphia. Equally important, though, are scattered regional strongholds concentrated around the academic bases of the artists. Currently, these include Madison, Wisconsin; Carbondale, Illinois; and New Paltz, New York.[20] Galleries and private collectors have remained similarly scattered between urban and rural locations.

After the initial spurt of important postwar exhibitions, there were few landmark shows of new work in metals and jewelry during the late 1940s and 1950s. Important work was produced and displayed regularly by artists such as Irena Brynner, Ed Wiener, Salvador Dalí, and Sam Kramer, but highly innovative exhibitions or installations were rare. One notable exception was the "Knife / Fork / Spoon" traveling exhibition of flatware that was sponsored by Towle Silversmiths in cooperation with the Walker Art Center in Minneapolis (1951). Minneapolis / St. Paul became a center of metals, hosting a series of "Craftman's Markets" at the Minnesota Museum of Art throughout the 1950s. These pioneering efforts in the now-established tradition of museums exhibiting and selling contemporary metalwork were the forerunners of museum gift shops. Today's stores at The Museum of Modern Art and the American Craft Museum, New York, and the Museum of Contemporary Art, Chicago, serve almost as galleries for new jewelry and metalwork. The "Craftsman's Markets" also helped to develop interest and encourage collecting within the community.

## The 1960s to the Present

The studio craft movement gained considerable momentum during the 1960s. Following a rising trend, glass, wood, fiber, clay, and metals were often shown together. Metalwork was included in important comprehensive craft shows, such as the "Young Americans" at the Museum of Contemporary Crafts, New York (1962), and "Objects: USA" at the National Collection of Fine Arts, Washington, D.C. (1969). The latter exhibition was particularly important in validating the studio craft movement and placing metalwork and jewelry prominently in the center of this new constellation. Contextualization within the studio craft tradition was the most significant occurrence in metalwork and jewelry during the last thirty years. Important new metalwork and jewelry are now regularly included in general studio craft exhibitions. Simultaneously, though, the number of important exhibi-

tions dedicated solely to metalwork and jewelry has risen dramatically, and there has been a notable increase in innovative and ground-breaking work from the 1960s to the present. Exhibitions and publications underscored the revolutionary broadening of materials, forms, concepts, and types of work that has occurred. Body sculpture, conceptual pieces, and jewelry made of nonprecious and nontraditional materials became areas of intensive work. Architectural metalwork and blacksmithing arose as vital forces.

The first influential jewelry exhibition during this period was the "International Exhibition of Modern Jewellery," held at Goldsmiths' Hall in London (1961); Graham Hughes's catalogue was the first important new scholarly text in the field. Subsequent important exhibitions in the United States and Europe have included "Goldsmith '70," at the Minnesota Museum of Art, St. Paul, and the Museum of Contemporary Crafts, New York (1970); "Forms in Metal, 275 Years of Metalsmithing in America," at the Cranbrook Academy of Art, Bloomfield Hills, Michigan, and the Museum of Contemporary Crafts, New York (1975); "Silver in American Life," at Yale University Art Gallery, New Haven, Connecticut (1979); "Jewelry and Metal Objects from the Society of North American Goldsmiths," organized by the Schmuck-museum in Pforzheim, Germany (1979–80); "Copper 2," at the University of Arizona Museum of Art, Tucson; "Schmuck International 1900–1980," at the Künstler-haus, Vienna (1980); "Good as Gold," at the Renwick Gallery, Washington, D.C. (1981); "The Jewellery Project," at the Craft Council, London (1983); "Structure and Ornament, American Modernist Jewelry 1940–1960," at Fifty / 50 Gallery, New York (1984); "Jewelry USA," at the American Craft Museum, New York (1984); "Masters of American Metalsmithing," at the National Ornamental Metal Museum, Memphis, Tennessee (1988); and "Copper 3," at the Old Pueblo Museum, Tucson, Arizona (1991–92).

Major museum shows devoted to individual metalsmiths or jewelers have been a rarity. The 1991–92 exhibition at the Renwick Gallery, "Albert Paley, Sculptural Adornment," is a giant step forward.[21] Previously, solo shows of masters such as Olaf Skoofgors, Albert Paley, and Helen Shirk were generally mounted in university museums or commercial galleries.

The list of exhibitions reveals pertinent facts about the evolution of contemporary metalwork and jewelry. First, separation of work into categories has increased over the decades. Broader craft exhibitions generally include both metalwork and jewelry under the heading "metalwork," but focused shows feature either metalwork or jewelry alone.

Second, jewelry has become the most visible metals medium, gaining a dominant public position. Correspondingly, its realm has expanded and a new aesthetic shaped, focusing on personal expression and a conceptual relationship between the work and the body of the wearer. Body sculpture and bold nonfunctional jewelry have become new areas of serious experimentation and innovation, reflecting an emphasis on freedom and individualism in contemporary society.

Third, fascination with nonprecious metals and recently invented materials has become a hallmark of the field, as demonstrated in the Renwick Gallery's "Good as Gold" show, organized for the Smithsonian Institution Traveling Exhibition Service by Lloyd E. Herman (1981).[22] The informality, disposability, and affordability of the work shown echoed changes in American life-styles from the 1960s through the 1980s. Most significantly, the show challenged the traditional idea of jewelry and validated the use of nonprecious materials. The effect on metalsmiths, collectors, and dealers in the field was profound; the parameters of the field exploded.

Fourth, review of the 1960s to the present demonstrates that traditional silver and holloware have faded from public view. As society and its requisite commodities have altered, the role, function, and shape of domestic metalwork has undergone reconsideration. There have been few highly visible exhibitions of metalwork, and the majority of young metalsmiths train in jewelry. There are no major galleries devoted solely to holloware. However, dialogue about the nature of the metalwork genre, including holloware, blacksmithing, silver, architectural work, serially produced metalware, and flatware, has provided a quiet but rich area of debate and critical analysis. A landmark essay by Jamie Bennett in 1984 questioned the functionalist tradition in metalwork. He complained:

> Ironically, the Modern style has become just one more on the list of historical styles which one can imitate. The style is emulated since the guidelines are there, but without understanding of why one makes things. As a result, most of today's holloware objects are unimportant and superficial because what should be emulated is the spirit in which the work was made, not the style.
> . . . Somewhere during the last 20 years we have let pass the opportunity to clearly represent our time and our world view.[23]

Bennett urged experimentation but warned that a practical and theoretical basis for fresh forms, styles, and ornamentation had to exist in order to avoid triviality in new work.

In June 1985 a panel discussion, "The Smith's Mandate: Looking at the Future," was held at the Society of North

American Goldsmiths' conference in Toronto.[24] Led by Lois Etherington Betteridge and including major figures such as Albert Paley, Gary Griffin, Randy Long, and Kurt Matzdorf, the panel tackled tough issues and asked pointed questions, including, "Does our collective imprecise vocabulary affect acceptance or rejection of our work among the buying public and in the art gallery?"[25]

Exhibitions such as "The Art of the Blacksmith," at the Gallery of Contemporary Metalsmithing in Rochester, New York (1981), and "Holloware '87: A National Juried Exhibition of Holloware Made Primarily of Metal," held at SUNY museums at Brockport, Oswego, and Potsdam, New York (1987), presented new work. The shows received little critical attention outside the immediate field, despite the fact that important names participated.

Competitions have been significant catalysts for revitalizing the metalwork field. The Sterling Silver Design Competition, organized through the Sterling Silver Guild of America, has taken place regularly since 1958. Fortunoff, the well-known New York firm, began holloware competitions in 1989. Fortunoff's sponsorship has been an important act of patronage and has served as a challenge for innovation and excellence in new work. The most important museum competition was initiated by the Renwick Gallery in 1973. The museum called for designs of entrance gates to their new museum in Washington, D.C. The competition and subsequent commission for Albert Paley's Portal Gates (see fig. 4) was undoubtedly the most important and pioneering example of institutional patronage and collecting in the metalwork field.

Many of the best and most important exhibitions of metalwork and jewelry over the last thirty years took place in Europe, where modern American work has been very positively received. This support and patronage are not surprising: metalsmithing has a long and honored history in Europe; remarkable collections are housed in museums specifically devoted to decorative arts. A centuries-old tradition of collecting, exhibiting, studying, and writing about metalwork remains strong and alive in Europe today.

Museums such as the Victoria and Albert Museum in London, the Stedelijk Museum in Amsterdam, and the Museum Bellerive in Zurich are leaders in the contemporary metals field, mounting exhibitions and producing new publications regularly. The leading museum in the jewelry field is unquestionably the Schmuckmuseum (Jewelry Museum) in Pforzheim, Germany. Its advocacy of American trends was demonstrated through its sponsorship of the major exhibition "Jewelry and Metal Objects from the Society of North American Goldsmiths," which traveled throughout Europe in 1979–80. Since its reestablishment after World War II, the Schmuck-

museum has acquired important contemporary American jewelry for its extensive permanent collection.

Connections between Europe and America in metalwork and jewelry are very strong, probably more so than in any other craft medium. The master metalsmiths of Europe, including Otto Künzli, Bruno Martinazzi, and Hermann Jünger, have taught in American programs. Most jewelry galleries in the United States show both American and European work; similarly, the Americans are a regular presence in Europe.

One of the most significant private collecting endeavors in contemporary jewelry underscored the importance of the European-American connection. In 1980 Malcolm, Sue, and Abigale Knapp of New York gave the British artists Susanna Heron and David Ward the challenge to assemble for them a collection of important European work being created at that time.[26] This was the start of what became a three-year, all-consuming project. The Knapps wanted to "spread the word" to American craftspeople about the incredible revolutionary jewelry being produced in Europe. The Knapps purchased each object, but took no part in the selection process. The collection was exhibited at the Craft Council in London in 1983 and later at the Harbourfront Gallery, Toronto. Unfortunately, the show never came to the United States,[27] but the catalogue continues to be a source of inspiration for many young American artists and collectors and is one of the most important historical and contextual discussions in the field.[28] The installation photography was particularly eloquent in expressing the ideas of the objects and their relationship to the human body (see fig. 5).

The history of museum and private collecting of contemporary American metalwork and jewelry in this country is complex. In-depth research remains to be done on the careers of early collectors and dealers of the 1950s, such as Peggy de Salle in Birmingham, Michigan. Many works were purchased directly from the artists and never publicly exhibited or reviewed. Metalworkers and jewelers often took part in craft fairs such as that in Rhinebeck, New York, from which sales information is not available. The craft fair as a "gallery" is an ongoing tradition and makes collecting difficult to document. Important pieces are also often sold through gift boutiques, jewelry stores, design shops, and at the annual Jewelers of America convention in New York. And most significantly, according to metalworker Ronald Hayes Pearson, "In those early years, no one really talked about collectors. If the term was used at all in that time, it was used in a different way. The term 'collectors' did not start until the 1970s."[29]

There are no well-known private collections of contemporary holloware. Architectural metalwork is beginning to be collected by a limited but growing number of adven-

PLATE 114
William Harper
**Saint Sebastian Aborigine,**
1982
(cat. 32)

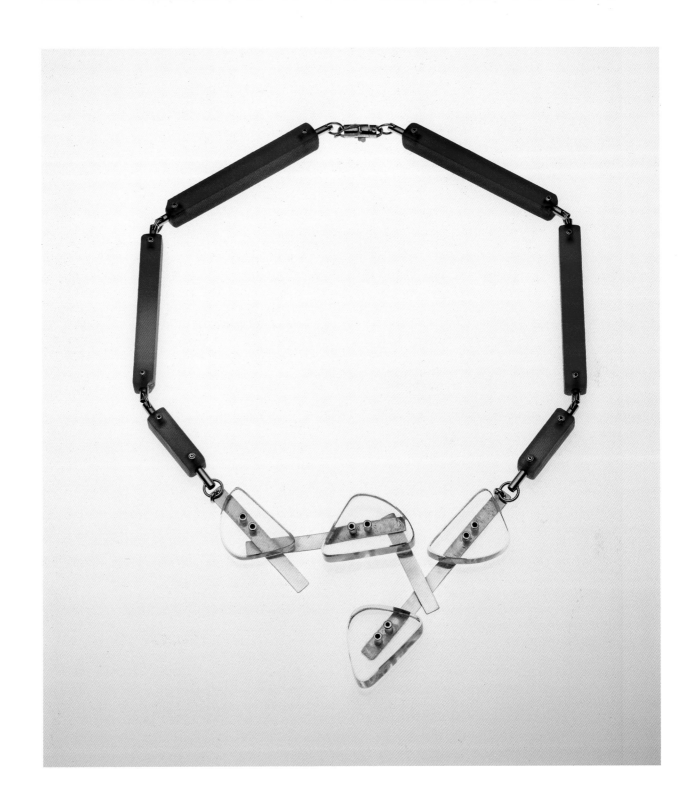

PLATE 115
Linda MacNeil
**Untitled,** 1982
(cat. 55)

turesome buyers. Jewelry collections are also rare. This dearth is perhaps due to the fact that metalwork and jewelry constitute the most private realm of collecting within the entire studio craft movement. Clay, glass, fiber, and furniture inhabit and define a living environment and are placed in sight of the collector or visitor. Jewelry and metalwork are often more personal — traditionally the silver is stored away and jewelry is kept in the bank or hidden in drawers or boxes; rarely are they on view. In an extreme example, the Knapps' *Jewellery Project* remains in a crate, a time capsule and archive of a moment, unopened since it was shown in London and Toronto in 1983.[30]

Within the field the lack of "so-called serious collectors"[31] is a common topic. Some collectors do not see their holdings as conforming to the traditional requirements of a collection. Sue Knapp states, "I would not consider myself a collector of jewelry. I simply always wore jewelry. . . . We buy things to enhance our lives. If anything, we are collectors of experiences. The object is the reminder of the experiences."[32] There are collectors, such as Dorothy and George Saxe, whose holdings of studio crafts include important works in metal by major artists, but who reject the idea of being categorized as specialized metals collectors. Dorothy Saxe feels her jewelry, by artists such as Mary Lee Hu, Linda MacNeil, William Harper, Deborah Aguado, and Linda Threadgill, is a form of affordable crafts which she wears, claiming, "When the walls are filled, this is something which we can put on ourselves."[33]

Jewelry is the one form of studio craft that is directly viewed in its relationship to the collector's body. The collector / dealer Helen W. Drutt English explained on the occasion of "Modern Jewelry, 1964–1984. The Helen Williams Drutt Collection" at the Château Dufresne, Le Musée des Arts Décoratifs de Montréal, in 1984: "Initially, my reasons for owning them [jewelry] were in order to promote my newly born interest in modern crafts. It was logical that no one could carry a vessel or chair into a meeting. Wearing a brooch was no different from being a living billboard. Jewelry acted as a catalyst for questions and queries from museum directors, curators, acquaintances, students, and strangers."[34]

Helen W. Drutt English is the dean of the jewelry field, a collector, gallery owner, and guru to many collectors. Her interest in jewelry started in the 1960s as part of a wider fascination with the broad range of contemporary studio crafts. Her knowledge of metals was a "process of self-education," as she became "excited by material she had never seen before."[35] Since opening her gallery in 1974, she has consistently exhibited work by the best American and European jewelers. Her own collection is extensive. A selected portion, 187 pieces by fifty-seven artists, was ex-

hibited in North America during 1984–86, opening in Montreal, and then traveling to the Philadelphia Museum of Art, the Cleveland Institute of Art, and the Honolulu Academy of Arts, and internationally to the Museum of Applied Arts in Helsinki in 1992.[36] Helen Drutt is a vocal and ardent advocate and patron of the field.

Sandra and Louis W. Grotta, Jr., are also established private collectors of contemporary jewelry. They began purchasing pieces as a young couple in the 1950s. Jewelry is still a primary focus among what is now a much larger collection of studio crafts, and through Sandra Grotta's work as a designer and the couple's active role in the American Craft Council, their interests have inspired many other collectors. Their holdings include examples by European artists as diverse as Gijs Bakker, Otto Künzli, and Wendy Ramshaw, and pieces by a wide range of American metalsmiths including Lisa Gralnick, Charles Loloma, and Kiff Slemmons.[37] Other visible collectors include Isabel and William Berley, Edna Beron, Sharon and Mark L. Bloome, Daphne Farago, and Christine Carter Lynch.

Metalsmiths themselves are among the most important patrons of each other's work. The Rachelle Thiewes Jewelry Collection, which was exhibited at Brigham Young University, Provo, Utah, in 1991, is a prime example of a jeweler collecting the work of her peers.

It is noteworthy that many influential metalwork and jewelry galleries, in both Europe and the United States, have been established by artists. Galerie RA in Amsterdam was founded by Paul Derrez. In Washington, D.C., VO Galerie was established by the Dutch artist Joke van Ommen; it has been renamed Jewelerswerk under the ownership of the American jeweler Ellen Reiben. Concepts gallery in Carmel, California, is run by the silversmith Douglas Steakley, and for several years Suzan Rezac had an innovative gallery in Chicago specializing in conceptual jewelry.

Most metalworkers and jewelers bemoan the lack of institutional patronage in the metals field. In contrast to many European museums, most American museums have more generalized and broad-based collections; acquisition funds are spread among all the departments. Often, contemporary studio crafts (and in particular innovative conceptual metalwork) are ignored in favor of painting and sculpture. This bias has led to a sense of second-class citizenship among some metalsmiths.[38]

Nevertheless, general museums are definitely acquiring more metalwork. Building on its longtime commitment to contemporary decorative arts, The Metropolitan Museum of Art continues to add selected examples to its holdings.[39] The Detroit Institute of Arts, The Saint Louis Art Museum, The Oakland Museum, the Cooper-Hewitt

National Museum of Design, Smithsonian Institution, and the Museum of Fine Arts, Boston, are also collecting in this area.

Specialized museums have been more active institutional collectors. According to Curator-in-Chief Michael W. Monroe, the Renwick Gallery includes about fifty pieces of metalwork in its permanent collection, and the curatorial staff has identified a group of artists, including William Harper, Albert Paley, and J. Fred Woell, whose work they hope to collect in some depth.[40] Albert Paley's gates were the springboard of the Renwick's architectural metalwork collection. With the acquisition of a necklace by Paley just prior to the opening of the major exhibition of Paley's work in 1991, the museum added an important work of jewelry by the artist and set a shining example of institutional patronage and collecting in the metalwork field.

The American Craft Museum is also committed to collecting contemporary metalwork and jewelry. One of its most important contributions, however, has been its dedicated effort to build a strong community of supporters. Every collector of metalwork and jewelry states categorically that involvement with the artists, curators, dealers, and fellow collectors has been a main source of inspiration. The roles of the American Craft Museum and the American Craft Council in promoting these relationships have been enormous.

From the perspective of collecting and scholarship, contemporary metalwork and jewelry remain solidly within the studio craft movement. Several writers, including Toni Lesser Wolf, Sarah Bodine, and Vanessa Lynn, and artists such as Robert Cardinale and Arline Fisch have consistently produced excellent reviews, essays, articles, and catalogues, but there is a dearth of significant critical writing on the subject.[41]

The field seems plagued by its own need for a history and for definition of itself. For example, innovative and exciting metal furniture by artists including Ron Arad, Scott Burton, Robert Wilson, and Forrest Meyer, or production metalwork by commercial firms such as Alessi after designs by architects such as Michael Graves and Aldo Rossi, are only briefly noted in current literature and exhibitions. In the entire run of *Metalsmith*, there is only one in-depth article on metal furniture and one review of Alessi's *Tea and Coffee Piazza* competition (see fig. 6).[42] The metalwork category of design, which was accepted as part of the field during the 1930s, is today growing faster than any other area of metalwork. However, although it was generally accepted in the early years, it now seems to have been ousted from the realm of contemporary metalwork and jewelry and placed within a framework of sculpture or industrial design.

Yet the boundaries remain blurred and variable. For example, David Tisdale's anodized aluminum pieces, created by industrial methods but made entirely under the supervision of the artist, are considered part of the studio craft tradition and exhibited in contemporary metalwork galleries. Tisdale's pieces, though, can also be found in sleek and high-tech design stores throughout the United States and are highly representative of a type of design object eagerly purchased by young, aesthetically curious potential collectors.

It is apparent from the recent CDK Gallery debates that the field is poised and eager for reappraisal. The process should foster efforts to resolve the problematic dilemma of the relationship between craft and design in contemporary metals. Innovative metalwork is being created simultaneously by both hand and industrial methods. By working together as a larger group, perhaps the field of contemporary metalwork can indeed become, as collector Sue Knapp predicts, "the new frontier."[43]

**Figure 6**
Michael Graves (American, born 1934) for Alessi FAO s.p.a.
*Prototype, Six-Piece Tea and Coffee Service Set,* 1982
Silver plate, lacquered aluminum, Bakelite, glass, and mock ivory
The Detroit Institute of Arts Founders Society Purchase with Funds from Founders Junior Council, James F. Duffy, Jr. Fund, Lenora and Alfred Glancy Foundation Fund, Modern Decorative Arts and Sculpture Fund, Dr. and Mrs. George Kamperman Fund, Mr. and Mrs. Alvan Macauley, Jr. Fund

## Notes

1. Donald Friedlich and Judith Mitchell, ''The Closing of Doors: An Interview with Garth Clark,'' *Metalsmith* 10 (Summer 1990), pp. 14–15, 40–41.

2. See ''Letters,'' *Metalsmith* 11 (Winter 1991), pp. 6, 15; Donald Friedlich and Judith Mitchell, ''Reflections & Remedies, A Continuing Dialogue on the State of Metalsmithing and Jewelry,'' *Metalsmith* 11 (Fall 1991), pp. 36–40.

3. Other partners included Mark Del Vecchio and Wayne Kuwada.

4. Friedlich and Mitchell, ''The Closing of Doors'' (note 1), p. 14.

5. Friedlich and Mitchell, ''Reflections & Remedies'' (note 2).

6. Ibid., p. 39.

7. Friedlich and Mitchell, ''The Closing of Doors'' (note 1), p. 41.

8. Friedlich and Mitchell, ''Reflections & Remedies'' (note 2), p. 39.

9. Ronald Hayes Pearson, interview with the author, May 1992.

10. The history of the Memphis museum is explained in F. Jack Hurley, ''Jim Wallace and the National Ornamental Metal Museum,'' *Metalsmith* 2 (Fall 1982), pp. 35–38. The Renwick Gallery held a major metalwork exhibition, ''Albert Paley: Sculptural Adornment'' (1991–92). The catalogue is the first of the Renwick's series of monographs on important studio craft artists.

11. *Metalsmith* was originally published under the title *Goldsmith's Journal*; it was renamed in 1980.

12. There are three good sources for information on this early period: New York, Fifty / 50 Gallery, *Structure and Ornament. American Modernist Jewelry 1940–1960* (New York, 1985); New Haven, Connecticut, Yale University Art Gallery, *At Home in Manhattan, Modern Decorative Arts, 1925–Depression,* text by Karen Davies (New Haven, 1983); Montreal, Le Musée des Arts Décoratifs de Montréal, *Design 1935–1965. What Modern Was. Selections from the Liliane and David M. Stewart Collection,* ed. Martin Eidelberg (New York: Harry N. Abrams, Inc., 1991).

13. Montreal (note 12), pp. 274, 380.

14. Ibid., p. 253.

15. According to Peter Dormer and Ralph Turner, *The New Jewelry* (London: Thames & Hudson, 1985), p. 17, de Patta was particularly affected by Moholy-Nagy's ''exhortation to 'catch the stones in the air, make them float in space — don't enclose them.' ''

16. Craver studied in Sweden with Baron Erik Fleming. See Lisa Hammel, ''On Her Mettle,'' *American Craft* 51, 5 (June–July 1991), p. 56.

17. Ibid., p. 59.

18. Through the sponsorship of Handy & Harman and The American Federation of the Arts, the show traveled to other museums in the United States and Europe. Although a lack of literature makes the effects of the exhibition difficult to assess, it most likely had widespread impact.

19. The original founders remained active in running the gallery until 1971; thereafter it was taken over by Wendell Castle and Thomas Markusen, closing in 1976.

20. Helen W. Drutt English suggested to me the importance of looking at regionalism in the history of the metals field (interview, Dec. 14, 1991). The first study of this phenomenon has just been published by Matthew Drutt in ''A Sense of History: Albert Paley and Philadelphia in the 1960s,'' in Washington, D.C., Renwick Gallery of the National Museum of American Art, Smithsonian Institution, *Albert Paley:*

*Sculptural Adornment,* Renwick Contemporary American Craft Series (Washington, D.C., and Seattle, in association with the University of Washington Press, 1991), pp. 57–68.

21. Washington, D.C. (note 20).

22. See Gail Goldman and Jan Maddox, ''Good as Gold: Alternative Materials in American Jewelry,'' *Metalsmith* 2 (Summer 1982), pp. 48–49.

23. Jamie Bennett, ''American Holloware, Changing Criteria,'' *Metalsmith* 4 (Summer 1984), pp. 9–10.

24. Lois Etherington Betteridge, ''The Smith's Mandate: Looking at the Future,'' *Metalsmith* 6 (Fall 1986), pp. 8–11.

25. Ibid., p. 8.

26. The following description was drawn from an interview with Malcolm and Sue Knapp in December 1991 in their New York apartment.

27. This was caused by bureaucratic error on the part of the British funding body just before the show was scheduled to travel to the ''Britain Salutes America'' celebration at the American Craft Museum in New York.

28. London, Craft Council, *The Jewellery Project,* text by Susanna Heron and David Ward (London, 1983).

29. Ronald Hayes Pearson, interview with the author, May 1992.

30. Sue Knapp, interview with the author, Dec. 1991.

31. Friedlich and Mitchell, ''The Closing of Doors'' (note 1), p. 40.

32. Sue Knapp said, ''I love this crate . . . the whole show is in there. . . . I love the concept'' (note 30).

33. Dorothy Saxe, interview with Davira S. Taragin, Dec. 1991.

34. Carole Hanks, ''Discursive Art, The Helen Williams Drutt Collection of Modern Jewelry 1964–1984,'' *Metalsmith* 5 (Summer 1985), pp. 7–13; Toni Lesser Wolf, ''The Helen Drutt Gallery, Philadelphia / New York,'' *Metalsmith* 9 (Fall 1989), p. 38.

35. Helen W. Drutt English, interview with the author, Dec. 1991.

36. Montreal, Le Musée des Arts Décoratifs de Montréal, Château Dufresne, and Philadelphia, Philadelphia Museum of Art, *Modern Jewelry 1964–1984. The Helen Williams Drutt Collection* (Montreal, 1984).

37. See New York, American Craft Museum, *Approaches to Collecting, Profiles of Recent Private and Corporate Collections* (New York, 1982); ''The Collector's Eye, a Special Three-Day Event to Benefit the American Craft Museum,'' Oct. 1991.

38. Bruce Metcalf, ''Crafts: Second-Class Citizens?'' *Metalsmith* 1 (Fall 1980), pp. 14–21.

39. Penelope Hunter-Stiebel in Paula S. Dineen, ''The Criteria of Collecting Crafts,'' *Metalsmith* 1 (Winter 1981), p. 28.

40. Michael Monroe, interview with the author, Dec. 1991.

41. Susan Grant Lewin is preparing an analytical history of the movement.

42. Akiko Busch, ''The Art and Industry of Metal Furniture,'' *Metalsmith* 6 (Spring 1986), pp. 24–31; and Kurt Matzdorf, ''Architecture in Silver,'' *Metalsmith* 4 (Spring 1984), pp. 36–38, respectively.

43. Sue Knapp (note 30).

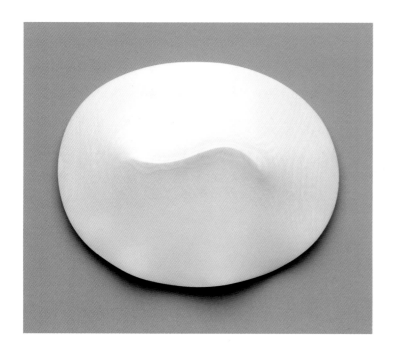

PLATE 116
Pavel Opočenský
**Ivory Brooch,** 1986
(cat. 72)

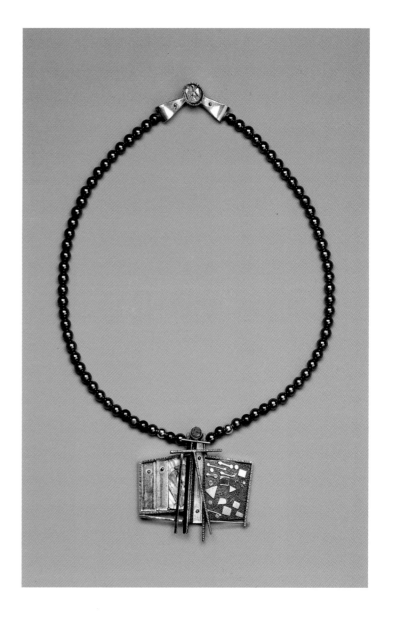

PLATE 117
Earl Pardon
**Necklace,** 1984
(cat. 73)

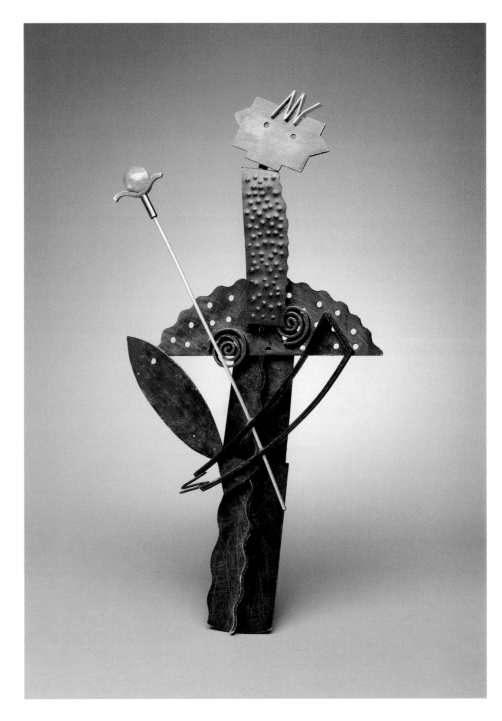

PLATE 118
Ramón Puig Cuyás
**The King,** 1989
(cat. 80)

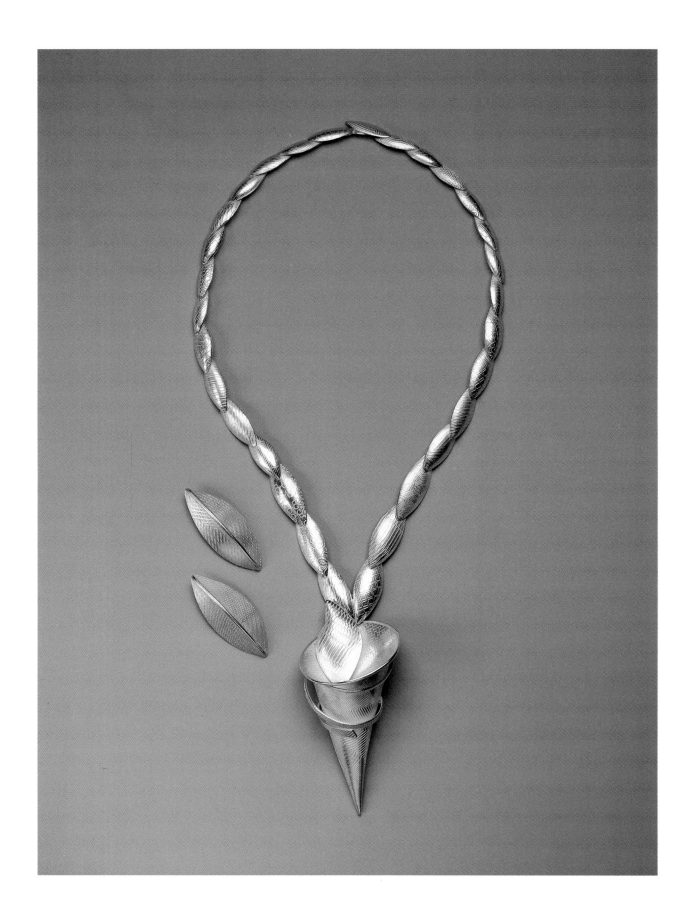

PLATE 119
Linda Threadgill
**Earrings,** 1987
(cat. 107)

**Pendant,** 1987
(cat. 108)

**Necklace,** 1989
(cat. 109)

# The Dorothy and George Saxe Collection: A Case Study

*Davira S. Taragin*

Narcissus Quagliata
(American, born 1942)
Fabricated by Dorothy
Lenehan
*Portrait of George Saxe;
Portrait of Dorothy Saxe*
(from the *Ongoing Portrait*
series), 1990
Stained glass
Collection of Dorothy and
George Saxe, San Francisco

One of the best-known studio craft collections formed in the 1980s is that of Dorothy and George Saxe of Menlo Park and San Francisco, California. Since they began collecting contemporary glass in 1980, the Saxes have traveled farther afield than most other collectors in search not only of art in craft media but also information on the artists and the studio craft movement. Portions of their collection have been the subject of several exhibitions, lectures, and symposia. Overall, the collection has generated more discussion than any other private studio craft collection in the United States, giving the Saxes celebrity status. During this last decade of the century, as one assesses the contemporary craft movement, it is appropriate to examine this collection and the context in which it was assembled.

When the Saxes began collecting, they had the resources to be among the many collectors of contemporary painting and sculpture who rose to prominence in the 1970s and 1980s.[1] Instead, they chose to champion the studio craft movement, focusing first on glass of the late 1970s and 1980s, and later on ceramics. Investment has never motivated their collecting; guided by their genuine love for the objects, they have made their goals the encouragement and promotion of the crafts and the acceptance of handcrafted objects within the mainstream of American art.

The Saxes have acquired over the past thirteen years more than six hundred works in all craft media, many of which are of exceptional quality. They do not, however, have the largest collection in any one medium in the United States. For instance, while their holdings in glass are significant, with over three hundred objects, their collection is not comparable in size to the one assembled by Irvin J. Borowsky and Laurie Wagman of Philadelphia. Nor are they unique in their efforts to get to know the artists or to make their collection readily available to collectors, museum professionals, artists, and students.

Yet, overall, they have emerged as leading collectors of the studio craft movement. Their glass collection alone contains some of the strongest work done in that medium since 1980. In fact, for many collectors of contemporary glass, they have become paradigms to follow, not only in terms of the artists they pursue but in the manner they

support contemporary glass education and display their holdings. The Saxes are among the very few studio craft collectors in this country who, by major gifts, are actively encouraging American art museums to acquire and exhibit contemporary crafts. They have continually served as staunch supporters of the network of galleries showing ceramics and glass, believing this to be necessary if these media are to be treated as important art forms rather than as secondary works within the art world.

The Saxes were not involved in the arts until 1980. George Saxe, who was born in 1921, specifically recalls that the working-class environment of Mount Union, Pennsylvania, in which he grew up, was not conducive to learning about art. He majored in business at Cornell University and then joined the army for a two-year tour of duty. In 1946 he met Dorothy Ruby, then a senior at Northwestern University in Evanston, Illinois, who had been born and raised in Michigan City, Indiana. A year later, they were married.

Although Dorothy Saxe had received some training in the arts, having taken college courses in art history and modern architecture, the Saxes' life together for the first thirty years of marriage focused on their three children, Loren, Ellen, and Joel; George's business dealings, first in retail and manufacturing ready-to-wear clothing and then real-estate investment; and community service.

Within six months after moving to Palo Alto, California, in 1959, they were actively engaged in the Jewish community, becoming immersed in a number of philanthropic causes. Over the years, George became increasingly involved in spectator sports. Dorothy regularly went to the theater, opera, concerts, and ballet, and made yearly trips to New York to see exhibitions. Sometimes she traveled even farther: among the noteworthy shows she saw was the 1971 "Biennale Internationale de la Tapisserie" in Lausanne, Switzerland, which appealed to her emerging interest in textiles. Although both Dorothy and George were aware of the abundance of private art collections in the Bay Area, they felt little motivation during these years to begin collecting art themselves.

Their decision in 1980 to collect developed out of a desire to find a project that they could undertake together. With their children grown and married, several grand-

children, and successful businesses, they found themselves looking for other activities to share. They had already sold their house in Palo Alto for a smaller condominium in Menlo Park and a pied-à-terre in San Francisco in order to have freedom to travel. Dorothy recalls, "We didn't have any idea what we wanted to do, but we knew we had to find something."[2]

The Saxes did not immediately decide to collect glass. Dorothy's first exposure to contemporary glass occurred in the summer of 1979 when she saw Mark Peiser's show at Toronto's Glass Art Gallery. When several months later the Saxes acquired their first piece, a soft cylinder by Dale Chihuly, they intended it as a decorative accessory.

George specifically attributes the beginning of his own interest in glass to an exhibition catalogue, The Corning Museum of Glass's 1979 *New Glass: A Worldwide Survey,* which Mimi Santal, a friend formerly affiliated with Sterling Associates, a Palo Alto contemporary crafts gallery, gave the couple. "Staggered" by the sensuousness of the glass, he recalls, "The catalogue was very exciting. I had never seen such colors before nor such forms, all made from such an ordinary material."[3] After seeing the exhibition "Americans in Glass 1978," shown at The Oakland Museum from December 1979 to February 1980, both he and Dorothy resolved to become major collectors of contemporary glass. Little did they realize that within a short time, collecting was to become an all-consuming passion that would fill their lives.

Establishing a precedent that they would continue to follow, the Saxes first turned to galleries in San Francisco to learn about the medium, buying glass in some quantity from Elaine Potter's Contemporary Artisans Gallery and from Dorothy Weiss, who was then affiliated with Meyer Breier Weiss. Both dealers proved enormously helpful, Potter providing information about other glass galleries in the country and Weiss introducing the Saxes to local artists such as Richard Marquis and Marvin Lipofsky, the latter then head of the glass program at the California College of Arts and Crafts. In turn, these artists introduced them to visiting glass artists, particularly those invited to give workshops at the California College of Arts and Crafts.

The program at the California College of Arts and Crafts soon became an important part of the Saxes' lives. Although George was not appointed a member of the board until 1985, under the influence of Lipofsky in the early 1980s, the Saxes took an active role in the school's growth. As well as establishing a scholarship in glass in 1983, they have regularly attended lectures and exhibitions held at the school; they also frequently invite students to visit and study their collection.[4]

When they first began to buy art and met artists and dealers active in glass, the Saxes made a point of asking them about the ten artists whose work they most respected. When names of certain artists whose work they did not know kept reappearing, they began to investigate the artists' work. On occasion, they also talked about different approaches to collecting.[5]

At a time when critical literature on contemporary glass was scant, this system of researching was useful; among its lasting results were close friendships with Washington State artists Joey Kirkpatrick and Flora C. Mace, who have helped the Saxes develop a discerning eye by frequently sending them slides of their work to critique. Kirkpatrick recently noted: "Over the years we have developed with the Saxes an ongoing dialogue about our work that is one step beyond what an artist generally has with a collector. They are honest about what they see, willing to look and talk about it even if it does not immediately appeal to them. They are even willing to keep on looking at a sculpture they do not immediately like, gaining a new appreciation of it as their knowledge and taste grow."[6]

Through Mace and Kirkpatrick, the Saxes learned about the dynamic program of glass at Pilchuck Glass School in Stanwood, Washington. The Saxes were so excited by the level of energy at the school and its distinguished teaching staff that in 1981 they became its first out-of-state board members. Today the school continues to fascinate them, but now they are as interested in meeting and talking with the students as with the faculty. Dorothy enthusiastically says that visits to the school serve to "recharge her batteries."

Realizing that the San Francisco galleries could teach them only a limited amount about glass, in the early 1980s the Saxes began to make trips that brought them to other, more distant centers for contemporary glass in this country. Ferdinand Hampson, owner of Habatat Galleries in Farmington Hills, Michigan, recalls that "no one rivaled the Saxes in the time they spent during the early 1980s in visiting galleries and studios."[7] They made their first buying foray to New York in the summer of 1980, highlighted by a visit to the Contemporary Art Glass Gallery (later Heller Gallery). A few months later they visited The Metropolitan Museum of Art to see the landmark "New Glass" exhibition. By the end of the following year, they had visited the Penland School in Penland, North Carolina; Arrowmont School of Arts and Crafts in Gatlinburg, Tennessee; the Massachusetts College of Art in Boston; the Rhode Island School of Design in Providence; the Pilchuck Glass School; Habatat Gallery's "Ninth Annual Glass Invitational" in Lathrup Village, Michigan; and many artists' studios. In 1980 they

Figure 1
Dorothy Saxe blowing
glass at Pilchuck Glass
Center, 1985(?)

the collection has grown to such a degree that it fills every available shelf, closet, and drawer of their two San Francisco apartments.

Except for a few figures such as Dale Chihuly, Marvin Lipofsky, Harvey Littleton, Joel Philip Myers, and Mark Peiser, the studio glass movement in the early 1980s was still too young to have a large number of recognized mainstream artists. Thus, although the Saxes purchased works such as Chihuly's *Untitled Blanket Cylinder* and Littleton's *300° Rotated Ellipsoid* (pls. 7, 28), many of their objects were by artists who were just beginning to show their work with dealers. Key among their early acquisitions were David Huchthausen's *Alpine Landscape* and Peiser's *Leda and the Swan* (pls. 19, 43). Their acquisition in 1980 of Mary Shaffer's *Hanging Series #24* (pl. 50) was particularly adventuresome for the time, since Shaffer's method of slumping window glass over metal or wire armatures was considered highly innovative in the studio glass movement of the 1970s.

Like other glass collectors at the time, the Saxes began with what was most accessible — the vessel form — and shortly thereafter embraced the more sculptural objects that were gradually appearing on the market. Over the years, as more non-vessel-oriented glass sculpture became available, they have made a point of pursuing such work. They have continued to collect, however, the work of artists such as Dan Dailey who use the container form as a point of departure to create nonfunctional sculptures.

While in these years most collectors in this country focused on American work, the Saxes from the beginning documented European developments as well. Among the international figures whose work they began to collect were Erwin Eisch, Klaus Moje, Bertil Vallien, and Ann Wärff (now Wolff).

Even in these early years, connoisseurship played an important role in the acquisitions. Douglas Heller of the Heller Gallery recently noted that the Saxes would spend considerable time investigating works to which they did not immediately respond in order to see if they could ultimately find an example by the artists that they both liked.[9]

During this two-year period, the couple also commissioned several works. They are most proud of Howard Ben Tré's *Cast Form XXIV* or *Blenko #4* (pl. 2), because they feel it epitomizes their early support of artists who became leaders in the field. In 1981 the Saxes were among three collectors who responded to Ben Tré's request for funds to build an oven at the Blenko Glass Company in Milton, West Virginia. Ben Tré promised that in return for helping to fund the project, they would have first choice of his subsequent work. The artist felt comfortable about approaching the Saxes at the time, since they were

became members of the Glass Art Society and later attended several of its annual conferences. They both recall that during this time they allowed themselves to become real "glass groupies," buying aggressively, meeting artists, and talking to these artists about developments in glass and issues of quality; whenever possible, they experienced the thrill of seeing an object blown (see fig. 1).

In spite of their increasing contact with artists, the Saxes were unlike many of the other studio glass collectors because they insisted on buying work from the emerging dealers in this field. Believing strongly that the gallery system lent credibility to the movement, they frequently admonished artists who were represented by galleries not to undermine the gallery system by selling directly to collectors. In those years, most of the objects they bought came from shows they had seen at Contemporary Artisans and Meyer Breier Weiss in San Francisco as well as at the Heller and Theo Portnoy galleries in New York and at Habatat.

By the middle of 1982, the Saxes had acquired more than 150 works of glass, representing more than 70 artists; these works constitute the core of their glass collection. Installed in their San Francisco apartment, every piece was at the time "placed so that it can be viewed while sitting on the living room sofa, giving the viewer a feeling of being completely surrounded by glass."[8] Today,

among the few collectors who bought work that had been included in his first one-person show in Detroit in 1981.[10] The Saxes' generosity in this instance was not an isolated occurrence. Also in 1981 they offered financial backing that would have allowed Chihuly and William Morris to build a studio in California. Unfortunately, construction difficulties with the site tabled the project.[11]

By the end of 1982, the Saxes were receiving national recognition for their glass. Six works from their collection were included in "Glass: Collectors' Choice," organized by Elaine Potter for the Palo Alto Cultural Center.[12] More important, they received even wider recognition by being among ten private collectors featured in the survey, "Approaches to Collecting," that Paul J. Smith organized for the American Craft Museum in New York. In the catalogue that accompanied this exhibition, Smith described the Saxes as "relative newcomers to collecting," who were proud to say that "glass has really changed our lives."[13]

In spite of the reputation they were developing as glass collectors, by late 1981–82 the Saxes had begun to slow down their acquisitions. Having acquired so much in such a short time, they were finding it difficult to discover new artists and works of exceptional caliber. Aware that "they had the collecting bug," they decided to investigate other craft media.

On the recommendation of Mimi Santal, George Saxe began to study the work of the Bay Area woodturner Bob Stocksdale (pl. 112). Attracted by the purity of Stocksdale's forms, he decided to assemble a "sub-collection" focusing on this artist's oeuvre. Since 1981 George Saxe has become one of the artist's major patrons, acquiring more than twenty works in order to document Stocksdale's exploration of diverse woods. Dorothy Saxe now refers to George's acquisition of Stocksdale's work as his "fix," for when he feels a need to own a superbly crafted, sensuous work in wood, he acquires another bowl by Stocksdale. In recent years the Saxes have supplemented their holdings of Stocksdale's work with examples by other turners, such as Mark and Melvin Lindquist and Edward Moulthrop. They also have bought some furniture, notably pieces by Sam Maloof, Alphonse Mattia, and Jay Stanger (pls. 109–11).[14]

At the same time, the Saxes began buying contemporary fiber (including paper) and clay, particularly the latter. As they had done earlier with glass, they immediately defined the scope of their collecting. They saw this second collection, however, as less encyclopedic. In contrast to the glass collection, which was international in scope, they resolved to buy primarily American ceramics and fiber, concentrating on the work of craftspeople either living or exhibiting in California. Because of the rougher surfaces and earth-related tonalities of the clay forms, they decided to house the ceramics, along with fiber and wood, in their Menlo Park condominium, as complements to the natural outdoor environment.

George Saxe recently discussed the differences between their approaches to collecting glass and ceramics. "The glass is a serious collection. We try to keep it current. With the ceramics we don't feel an obligation to buy in depth. We buy what we like, without the need to consider the entire collection." By deciding to focus on American ceramics, the Saxes were following a direction not often taken by American collectors, who generally buy both European and American work.[15]

As with the glass, they immediately saw themselves as serious collectors of these media. Louise Allrich, whose San Francisco gallery has been showing contemporary fiber since 1974, remembers being shocked upon meeting the Saxes for the first time in 1981, since they introduced themselves as contemporary fiber collectors; never before had any of her clients thus identified themselves.[16] Significantly, the Saxes still consider themselves fiber collectors, even though their holdings in this medium are considerably less extensive than those in glass and ceramics.

At first the Saxes did not want to devote as much time to learning about contemporary clay and fiber as they had to glass, but they soon realized that if they were to be collectors, they needed to do research. As they had done earlier, they turned to California galleries to learn about the artists. Local dealers such as Ruth Braunstein, who had been encouraging them for years to acquire clay, Garth Clark, who had just opened his Los Angeles gallery, and Louise Allrich were particularly helpful in providing the kind of advice the Saxes needed. The book A Century of Ceramics in the United States, 1878–1978, written by Clark and Margie Hughto in 1979 to accompany a major traveling exhibition, became a source of inspiration for George as much as Corning's New Glass had been several years earlier.

George Saxe notes with pride that a plate and a stacked vessel by Peter Voulkos were the first significant works purchased for the Menlo Park collection. Ruth Braunstein, who was a member of the synagogue to which the Saxes belonged, had tried unsuccessfully for a year to get them interested in clay. Finally, one afternoon in 1981, she convinced them to visit Peter Voulkos's studio while he was preparing for a show at Exhibit A in Chicago. After selecting one of his plates, the Saxes saw Untitled (Stack) (1981). Reluctant at first to buy it, the couple finally agreed to have it brought to Menlo Park. George Saxe reminisces that Voulkos himself brought the piece, spending an enjoyable afternoon with them. However, they did not immediately decide to acquire it. It was only after liv-

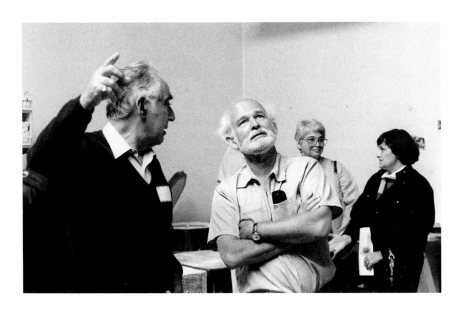

textiles had greater appeal to them than did the expressionistic, off-loom structures of the 1960s and 1970s. Lia Cook's *Lattice: Ode to O.Be,* Olga de Amaral's *Riscos I (Fibra y Azul),* and Cynthia Schira's *Near Balceda* (pls. 99, 100, 104) are examples of the work they have acquired.

As for jewelry, the Saxes have purchased work that is comfortable and practical to wear, alternating between figurative and abstract designs, primarily by American artists. Typical of the two strains of work they pursue are the more narrative *Rangefinder* by Deborah Aguado and the richly patterned, late necklace by Earl Pardon (pls. 113, 117). They have favored American jewelry over European because it is generally conceived as small-scale sculpture. On occasion, as with William Harper, they have pursued works in depth by a particular jeweler in order to document the variety within the artist's work. Since they approach the acquisition of jewelry casually, never considering themselves collectors, they do not feel it necessary to follow closely the exhibition programs of the nationally recognized jewelry galleries. Therefore, a few of the Saxes' jewelry purchases come directly from the artists, while others reflect the stock of local and national craft galleries. In some instances they have bought pieces upon the recommendation of friends; for example, the Saxes met Pavel Opočenský through Stanislav Libenský and Jaroslava Brychtová and now own two of his brooches.

The Saxes' collection of ceramics, fiber, wood, and jewelry reflects their travels. They have generally not developed the same kind of close personal relationships with ceramic or fiber artists that they have with many of those working in glass. Nevertheless, in order to meet the artists, they attended conferences such as the 1983 "Ceramic Echoes" symposium in Kansas City,[19] as well as several meetings of the National Council on Education for the Ceramic Arts (NCECA), and visited art centers such as Boston University's Program in Artisanry, the Cambridgeport Cooperative Woodshops (also known as Emily Street Shop of Boston),[20] and the Anderson Ranch Arts Center in Colorado. They found, however, that the best way to develop their knowledge of ceramics, fiber, wood, and jewelry was through other craft collectors.

When the Saxes became interested in ceramics, they visited other early collectors of studio ceramics such as Betty Asher of Los Angeles and Drs. Elaine and R. Joseph Monsen of Seattle;[21] they also made a special trip in 1984 to Lincoln, Massachusetts, to see the exhibition of the Daniel Jacobs collection of contemporary ceramics at the DeCordova and Dana Museum and Park. In retrospect, the Saxes feel that they benefited greatly from these experiences and from meeting other collectors through the American Craft Museum's Collectors Circle trips, as well as from George

ing with the sculpture for some time that the Saxes finally purchased it.[17]

From 1981 to 1984 the Saxes bought chiefly clay, some fiber wall hangings and baskets, and a few turned-wood bowls, furniture, and pieces of jewelry. Although they acquired a greater number of objects by established artists such as Robert Arneson (see fig. 2), Ken Price, Ron Nagle, and Beatrice Wood, they did purchase works by emerging artists, some of whom have subsequently achieved national recognition. Most were selected from one-person gallery exhibitions the Saxes visited. In acquiring these works, the Saxes found that they not only strengthened their relationships with California dealers such as Allrich, John Berggruen, Rena Bransten, Braunstein, Clark, Dorothy Goldeen, Elaine Potter, and Dorothy Weiss, but they also began to work actively with East Coast and Midwest galleries such as Charles Cowles, Helen Drutt, Exhibit A, the Great American Gallery, Hadler / Rodriguez, and Julie: Artisans' Gallery. Dorothy Saxe recalls that it was during this time that she expanded her knowledge of fiber by artists who were not from the Bay Area.[18]

As they pursued the ceramics of the 1980s, the Saxes bought sculptural works as well as nonfunctional vessel forms. Today, the latter type predominates in their Menlo Park collection. Some key ceramic works that they have acquired include Ruth Duckworth's *Untitled,* Jack Earl's *Josiah Wedgwood built his city . . . ,* Viola Frey's *Man Observing Series II,* and Wayne Higby's *Rapids Canyon* (pls. 67, 68 A, B, 70, 72).

The fiber they purchased was also representative of the 1980s. The simple, ordered compositions of loom-woven

Saxe's active involvement as an American Craft Council trustee. He notes, for instance, that trustee Jack Lenor Larsen has always been available to help with questions regarding textiles.[22] Similarly, he credits fellow board members Sandra Grotta and Andrew Lewis for awakening the couple's interest in contemporary wearable jewelry, and for introducing them to leading metalsmiths.

However, both Dorothy and George Saxe feel strongly that the collectors who have had the greatest impact on their own aesthetic growth are Mary and Alfred Shands of Louisville, Kentucky, who have important contemporary ceramics holdings; Anne and Ronald Abramson of Potomac, Maryland, with their extensive contemporary furniture collection; and Diane and Sanford M. Besser of Little Rock, Arkansas, and Santa Fe, New Mexico. The Saxes greatly appreciate their discussions with the Bessers, who have built several important collections since the late 1960s, including one of the largest private contemporary basket collections as well as an especially fine one of contemporary ceramic teapots. The Saxes' admiration for the Bessers' basket holdings may have been one of the primary factors prompting the Saxes' own investigations in this field.[23] They also give credit to former American Craft Council Trustee Barbara Okun, a dealer who exhibited the masters of contemporary clay along with painting and sculpture in her St. Louis gallery between 1978 and 1982, and now has a gallery in Santa Fe with an expanded focus on contemporary crafts. She kindled their interest in certain key ceramists, such as Richard DeVore and Robert Turner, and in nonfunctional, sculptural basketry.

As might be expected, fund-raising and marketing efforts by the American Craft Museum and Council have been an important source for the Saxes' acquisitions of clay, wood, and jewelry. While they have regularly attended and purchased primarily jewelry and wearable art (including a silk jacket by Tim Harding) from the council-sponsored fairs held in San Francisco and at New York's Seventh Regiment Armory, they have also acquired significant works, such as Jack Earl's *There Was a Man,* Mark Lindquist's *Ascending Bowl #9,* and Alphonse Mattia's *Hors d'Oeuvre Server* (pls. 69, 107, 110), from the American Craft Museum's annual fund-raising auctions held in New York. In addition, attendance at the board meetings has led to warm friendships and certain commissions to the artists who also serve as trustees; for example, both George Saxe and Sam Maloof attribute their close relationship and commission for a chair to this contact.[24]

The Saxes have continued to buy steadily in all media since 1985. They have benefited greatly from the increased number of dealers in this country showing glass and ceramics, as well as from the annual Chicago International New Art Forms Exposition. Of their two collections, the glass has changed most radically in the past few years. First, it has grown so large that the Saxes decided to buy the apartment adjacent to the one they owned in San Francisco, converting it into a small gallery. Secondly, the scope of the collection is now strongly international, with a significant representation of contemporary Czechoslovakian work. While the Saxes had acquired a few examples of Czechoslovakian glass in the early 1980s, their commitment to work from Eastern Europe was strengthened by a 1984 trip that took them to many of the Czechoslovakian artists' homes and studios. They were among the few glass collectors at that time to have undertaken such a trip,[25] and their enthusiasm and love of the art left a lasting impression on those whom they visited. As a result, because these artists make every effort to see that the Saxes own major examples by them, their collection now includes some of the most important contemporary Czechoslovakian glass in private hands in the United States. Their early holdings, which included masterpieces such as Dana Zámečníková's *Theater* (pl. 59), recently have been augmented with such major pieces as Libenský and Brychtová's *Head-Dish* and *The Cube in Sphere,* as well as František Vízner's *Sculpture VIII* (pls. 24, 25, 53).

Perhaps the most powerful recent influence on the couple's collecting was the exhibition at The Oakland Museum in 1986 of selected works of American and European glass from their collection. Organized by Kenneth Trapp, the museum's Associate Curator of Crafts and Decorative Arts, and guest-curated by William Warmus, former Assistant Curator of Twentieth-Century Glass at The Corning Museum of Glass, the exhibition, which subsequently traveled to the American Craft Museum in New York, featured fifty-six objects by fifty-three artists. Arousing considerable response, it catapulted into the public eye for the first time both contemporary glass and the Saxes as collectors. While it was an inspiration for emerging craft collectors such as Margaret A. Pennington of Florida,[26] it also subjected the Saxes' enterprise to intense critical scrutiny.[27]

Since 1986 the Saxes have reexamined their approach to collecting. With both glass and clay, they pursue the works of emerging artists with less vigor than they did in the early 1980s and focus instead on documenting in some depth the careers of leading artists in these media. At one time they considered the possibility of selling or donating some of the glass from the 1970s and early 1980s; while a few such works have been given either to museums or to auctions to raise money for arts-related projects, the Saxes, acting upon the advice of Marvin Lipofsky, have now decided to retain many of the earlier pieces, juxtaposing them with more recent ones to give the collection a greater historical context. In addition, they have begun to focus on building a library and archive, even though they both agree that their acquisi-

tions result more from the direct experience of visiting galleries and artists' studios than from extensive research.

Like many studio craft collectors, the Saxes realize that the movement's acceptance within the mainstream of American art depends upon museum recognition. Unlike many of their colleagues, they have actively tried to persuade fine-arts museums to support the crafts. Applying the same determination and persistence that have guided them in building their collection, over the past few years they have contacted various museums to determine if a major gift of contemporary crafts would influence their programming. They have focused their attention on institutions that have significant twentieth-century painting and sculpture collections so that the crafts can be seen in terms of the art of this century. Their only stipulation is that these institutions be committed to showing and acquiring contemporary glass. Their gift of fifty-seven studio glass objects, one drawing, three ceramic sculptures, and two turned-wood bowls to The Toledo Museum of Art in 1990, which came at the suggestion of Paul J. Smith, represents their first step in this direction. The Museum has used their gift toward building a strong collection of twentieth-century glass and placing the studio glass movement within the larger context of contemporary art.

When talking to the Saxes, one immediately senses their love for crafts and their thirst to learn more. Everyone who knows them recognizes their deeply genuine commitment to studio crafts. In fact, one soon realizes that George Saxe's frequent declarations that he will not buy any more work are invariably followed by the acquisition of several new pieces. Dorothy and George Saxe's enthusiasm and the intensity of their pursuit of objects have influenced the quality of the collection that they have built over the past thirteen years. Their example may be a factor that will ultimately help convince more major art museums to take seriously the studio craft movement.

## Notes

**Author's note:** This essay is based upon a series of interviews that took place with Dorothy and George Saxe from July 1990 to February 1992. The Saxes kindly also made available their archive in Palo Alto, California.

1. For a brief discussion of the collector of contemporary painting and sculpture in the 1970s and 1980s, see Neal Benezra, ''Collecting Contemporary Art: A Profile of Gerald S. Elliott,'' in Chicago, The Art Institute of Chicago, *Affinities and Intuitions: The Gerald S. Elliott Collection* (New York, 1990), pp. 10–11; and Mary Jane Jacob, ''Art in the Age of Reagan: 1980–1988,'' in Los Angeles, Museum of Contemporary Art, *A Forest of Signs: Art in the Crisis of Representation* (Los Angeles, Cambridge, and London, 1989), pp. 15–20.

2. ''Peninsula Husband and Wife Discover New World through Sculpture in Glass,'' *The Peninsula Times Tribune*, Sept. 17, 1982, pp. C1, C3.

3. Ibid., p. C1.

4. Neil Hoffman, in conversation with the author, Dec. 1991.

5. Among the artists, dealers, and museum professionals they remember querying were Thomas Buechner, Dale Chihuly, Fritz Dreisbach, Ferdinand Hampson, Douglas Heller, Joey Kirkpatrick, Marvin Lipofsky, Flora Mace, Richard Marquis, William Morris, Elaine Potter, Italo Scanga, William Warmus, and Steven Weinberg.

6. Joey Kirkpatrick, in conversation with the author, Feb. 1992.

7. Ferdinand Hampson, in conversation with the author, Feb. 1992.

8. New York, American Craft Museum, *Approaches to Collecting* (New York, 1982), p. 14.

9. Douglas Heller, in conversation with the author, Feb. 1992.

10. The other collectors to respond were Ronald and Anne Abramson of Washington, D.C., and Ferdinand Hampson of Habatat Gallery, Lathrup Village, Michigan. Howard Ben Tré, in conversation with the author, Nov. 11, 1991.

11. Chihuly and Morris were very appreciative of the Saxes' proposed assistance. At one point Chihuly wrote them, ''I want to thank you both for all your support throughout the project — you're a GREAT pair — like our parents.'' For an account of this transaction, see Chihuly to Dorothy and George Saxe, June 7, 1981, and Dec. 14, 1981, Saxe Archive, Palo Alto, California.

12. For a description of this show, see ''Glass Collectors' Choice to Open the Cultural Center Fall Season,'' *The Peninsula Times Tribune*, Sept. 17, 1982, p. C1.

13. New York (note 8), p. 14.

14. Bob Stocksdale, in conversation with the author, Dec. 1991.

15. Gretchen Adkins, in conversation with the author, Feb. 1992.

16. Louise Allrich, in conversation with the author, Aug. 1991.

17. Peter Voulkos, in conversation with the author, Dec. 1991. Voulkos takes great pride in having helped the Saxes to start their collection.

18. In 1990 Dorothy Saxe became one of the original directors of the first national support group for contemporary fiber, the Friends of Fiber International, headed by the Illinois collector Camille Cook.

19. Held in Kansas City, Missouri, this international ceramics symposium was the third such event sponsored by the Institute of Ceramic History under the leadership of Garth Clark.

20. For much of the 1980s, the Emily Street shop in Boston housed the studios of some of the leading furniture artists in the United States. See Edward S. Cooke, Jr., ''Coming of Age in Boston,'' *Art in New England* 11 (Dec. 1989–Jan. 1990), pp. 10–13, 49, passim.

21. The Saxes had not seen the exhibition of the Monsens' collection that had been on view (Oct. 14–Dec. 3, 1972) at the San Francisco Museum of Art.

22. Although interested in acquiring Olga de Amaral's *Riscos I (Fibra y Azul)*, at the time the Saxes were unable because of George Saxe's health to travel to New York to see it on exhibit at the Modern Masters. They purchased it upon Larsen's recommendation.

23. They own baskets by, among others, David Bacharach, Carol Eckert, Patti Lechman, Jane Sauer, Sekimachi, and Sylvia Seventy.

24. Sam Maloof, in conversation with the author, Nov. 1991.

25. William Warmus, in conversation with the author, Mar. 1992.

26. Margaret A. Pennington, unpublished paper presented at the ''Symposium: Public / Private Collecting into the New Millennium,'' organized by the Coalition of Creative Organizations, Chicago (Sept. 18, 1992), p. 4.

27. For some of the critical response to their collection, see Robert Kehlmann, ''Glass of the 80s,'' *American Craft* 47, 2 (Apr.–May 1987), pp. 34–35; Vanessa S. Lynn, ''The Art of Collecting,'' *American Ceramics* 7, 2 (1988), p. 12.

# An Observation of the Early Years: A Dialogue Between Helen W. Drutt English and Davira S. Taragin

**Davira S. Taragin:** Within the twentieth century, the significant increase in the number of collections focusing on studio craft can be considered a phenomenon of the 1970s and 1980s. People initially purchased or commissioned studio crafts directly from the artists or from local craft fairs or guild and craft shops. Frequently these objects were acquired to serve a functional need or indicated the buyers' preference for the handmade. These individuals did not think of themselves as collectors or patrons until they were formally recognized in the 1970s as a result of several museum exhibitions and publications.

Because of your long-term involvement with the craft movement as curator, historian, dealer, and collector, I would like you to discuss several of these early publicly recognized collections, in order to determine the available markets and sources for collecting crafts at that time. Essentially, we will use these collections as case studies to analyze first-generation craft collecting in the United States.

One of the earliest postwar exhibitions to focus on collecting craft was organized in 1965. Could you describe its focus and impact?

**Helen W. Drutt English:** First, I wish to emphasize that I do not consider the acquisition of contemporary crafts a phenomenon. Throughout history, individuals have formed collections consciously and unconsciously which have reflected their taste and recorded the history of their time. Because it is natural to acquire contemporary possessions as well as historical works, it stretches the imagination to say that collectors suddenly discovered contemporary crafts in the 1960s. It was rather the recognition of the contemporary craft collector vis-à-vis exhibitions and documentation that was the phenomenon.

The exhibition, organized in 1965 by Paul J. Smith, director of the Museum of Contemporary Crafts, was entitled "Collector: Object / Environment." It focused on selected objects or commissioned works that complemented an architectural environment. John Mason's ceramic doors for Sterling Holloway's residence and Glen Michaels's mosaic mural for the home of Mr. and Mrs. Burke Dowling Adams, for example, illustrated the potter's ability to respond to architecture. On the other hand, Paolo Soleri's bells from the collection of Clare Booth Luce were probably a once-in-a-lifetime purchase as opposed to an ongoing commitment to contemporary crafts. This exhibition was an attempt to bring craft objects as well as commissioned works to the attention of the public; it broadened the spectrum of the craft object and created an awareness outside the field.

The exhibition that I believe had the greatest impact on collecting crafts was "Objects: USA," at the National Collection of Fine Arts [1969]. Because this exhibition made available information heretofore largely known only regionally, or to a small national community, it affected collecting patterns for over a decade.

The catalogue that accompanied "Objects: USA" provided a document of the time. Lee Nordness's introductory essay explored the history of crafts since World War II. It established media categories for selected artists who were working throughout America — a system that remained fairly constant until the catalogue *Contemporary Arts: An Expanding View* was published by the Squibb Corporation in 1986. Condensed biographical data brought together information that could be found only in regional documents: who was there? where were they? what were they doing?

**DST:** "Objects: USA" represents a testament to the arts patronage of the Johnson family of Racine, Wisconsin. Is there one member who has been particularly distinguished as a patron of the studio craft movement?

**HWDE:** Karen Johnson Boyd resides in a Frank Lloyd Wright home built in 1956. For many years she has been a serious and devoted collector of contemporary American crafts. Her interest in the arts was responsible a decade ago for the founding of Chicago's Perimeter Gallery, which maintains a strong focus on American crafts. Among the craft artists she represents are Ken Loeber, Donna Look, Graham Marks, John McQueen, Eleanor Moty, and Toshiko Takaezu. Karen Johnson Boyd is unique in the sense that she simultaneously acquires and deaccessions — giving works to museums in support of their collections.

Although Karen had visited America House when she first got married, essentially she began collecting work by Wisconsin artists, for example, Verne Funk, one of the Midwest artists who was experimenting with decals on porcelain and slip cast elements. Even before "Objects: USA" was organized, she had acquired works by Fred Bauer, Erik Gronborg, and Harrison McIntosh. When Karen Johnson Boyd built the Wright house, she began also to collect works that would look appropriate in the environment. She was familiar with Stickley furniture and Edward Dunbar, and then discovered the Natzlers at the fine-arts gallery at Marshall Field and Company in Chicago. She often worked closely with the New York dealer Lee Nordness and went to see local museum shows as well as keeping abreast of America House and the Museum of Contemporary Crafts. Through Nordness, she was also introduced to people such as Paul Soldner. Karen Johnson Boyd already had developed an interest in pottery during her years at Bennington College in Vermont.

**DST:** "Objects: USA" was probably the most important exhibition to have increased awareness of the studio craft movement. What immediate effect did it have on the marketplace?

**HWDE:** There is little doubt that the show was the catalyst that encouraged galleries to commit themselves to crafts and to flourish. "Objects: USA" toured for years throughout the United States, accompanied by a catalogue as well as a film entitled *With These Hands*. The artists were there, the work was there — the public was waiting in the wings.

The exhibition also provided the artists with an important introduction to the art world. Paul Smith and Lee Nordness selected works; they visited artists' studios. I know from conversations during that period that there was little lead time — perhaps a year or so. Ruth Duckworth was in the midst of working on major commissions at the time of their visit and had small-scale porcelain objects for their selection. I actually acquired a work from William Wyman's studio, Herring Run Pottery, in Massachusetts, that they had been considering. I simply arrived before the final selection. Works had to be available for purchase.

Many artists led them to other artists and promising students. Wayne Higby's early work was selected from a solo exhibition in Omaha, Nebraska. Lee Nordness was directed to his work by Fred Bauer, with whom Higby had studied at the University of Michigan. At the same time, William Daley, Viola Frey, and Betty Woodman, among others, were not included. This process of peer recommendation happened frequently —

especially in the early years of the craft movement. The artists were not prepared for this curatorial process — it was not part of their education. Most craftsmen made work and it was sold via craft shops or from studios or in fairs. The gallery system for contemporary crafts, as it is defined today, had not yet begun. Bodies of work were not "held" for research or acquisitions consideration with annotated lists of private and public collections.

**DST:** Over the next ten years, several exhibitions specifically focusing on these early craft collections were organized. Could you elaborate on the key shows and collections featured?

**HWDE:** Most important among the exhibitions organized between 1970 and 1980 were "A Decade of Ceramic Art, 1962–1972, From the collection of Professor and Mrs. R. Joseph Monsen," San Francisco Museum of Art (1972); "The Fred and Mary Marer Collection," Scripps College, Claremont, California (1974); and "Robert L. Pfannebecker Collection," Moore College of Art, Philadelphia (1980). In 1974 the Museum of Contemporary Crafts mounted an exhibition called "The Collector." Though I am certain that there were many individuals forming collections at that time, public identification was not always possible. The exhibition in New York drew from the contemporary craft collections of Robert L. Pfannebecker, Theo and Sy Portnoy, the Marers, the Monsens, and myself. I never considered myself a collector; when Paul Smith asked to exhibit the contemporary jewelry and ceramic cups I had acquired, I was flattered. Although I had become a voice for these works, the depth of my involvement in acquiring cups could not compare with that of Betty Asher, part of whose collection was acquired by the Los Angeles County Museum of Art in 1983. However, the museum was in New York and I was in Philadelphia, and at times regional proximity plays an important part in the selection process. Essentially, the visibility of collections related directly to their connections with the artists: artists talk, and in those days, the telephone wires were quite busy.

The acquisitions of the Marers, the Monsens, and Pfannebecker brought together seminal moments in the history of the modern craft movement. Major institutions depend on boards and committees to raise funds before they acquire objects. The selection process for contemporary work is often made by a private collector who creates a personal museum with works by unrecognized artists. When exhibited within the confines of a public institution, these collections educate and broaden public awareness. The curator at the San Francisco Museum of Art, Suzanne Foley, was encouraged to show the Monsen collection by the late artist Howard Kottler and the Bay Area ceramics community from whom they

were acquiring work. This exhibition explored a decade of change in the ceramics movement.

In the mid-1950s Fred Marer began to visit Peter Voulkos at the Otis Art Institute. Malcolm McClain and Paul Soldner had been among Voulkos's first students. Soon the circle of artists surrounding Voulkos included Ken Price, Billy Al Bengston, John Mason, and Jim Melchert. Marer followed Soldner to Scripps College and Voulkos to Berkeley. Paul Soldner knew and understood Fred Marer's passion for clay; he was subsequently instrumental in organizing the first formal exhibition of the Marers' collection, held at Scripps College in honor of the thirtieth anniversary of the Scripps national ceramics exhibition.

The Marer Collection focused primarily on contemporary ceramics and was drawn from the western United States, Japan, and England. It featured the American artists Robert Arneson, Rudy Autio, Billy Al Bengston, Philip Cornelius, Michael and Magdalena Frimkess, Wayne Higby, John Mason, Jim Melchert, Ken Price, Jerry Rothman, David Shaner, Pat Siler, Paul Soldner, Henry Takemoto, Peter Voulkos, Patti Warashina (then Bauer), and Betty Woodman. The Europeans included Hans Coper, Bernard Leach, and Lucie Rie. Among the potters from Japan were Shoji Hamada, Jun Kaneko, Ryosaku Miwa, Mineo Mizuna, and Kazuo Yagi. The interest in Japan probably came through Kaneko, who as a young painting major was close to Fred Marer. He may have introduced him to Japanese work just as Marer introduced Kaneko to clay.

Marer was a mathematics professor at Los Angeles City College. He was inquisitive about the arts and realized that the acquisition of works by young artists would help them economically. The Marers' home was a central meeting place for artists, students, and professors; it was a casual and vital salon.

**DST:** In retrospect, the collection that the Monsens built in Seattle also reflected the milieu in which it developed. Which artists were represented?

**HWDE:** The Monsens made a conscious effort to document the developments of ceramic art during a particular period. John Coplans's exhibition, "Abstract Expressionist Ceramics," at the University of California, Irvine (1966), reviewed major developments in ceramics since 1955. Certain individuals central to this new movement, among them Howard Kottler, Fred Bauer, and Patti Warashina, made their way to Seattle. Their energy established the University of Washington's Department of "Fire Arts" as a center; a generation of now widely recognized clay artists studied there during the 1970s. Among them were Mark Burns, Nancy Carman, Clair Colquitt, Anne Currier, Michael Lucero, Joyce Moty, and Anne Perrigo.

The Monsen Collection represents the innovative scene that developed not only in Seattle, but whose roots were also in Los Angeles and San Francisco and in Montana. Some of the artists such as Mason and Soldner included in their collection were in the circle of Peter Voulkos in California.

**DST:** Were there any central figures who guided or assisted the Marers and the Monsens?

**HWDE:** Paul Soldner, Robert Arneson, Peter Voulkos, Jun Kaneko, Jim Melchert, Jerry Rothman, and Howard Kottler had an impact on the formation of both collections.

**DST:** While the Monsen and Marer collections were formed in centers of great craft activity, in the mid-1960s Robert L. Pfannebecker of Lancaster, Pennsylvania, was geographically isolated from such areas, and as a result, his collection differs greatly. Could you describe his collection and its formative sources?

**HWDE:** In 1979 I had already known Robert Pfannebecker for a decade. During my tenure as gallery director at the Moore College of Art, I encouraged him to allow me to organize the first public exhibition of works from his collection; it seemed appropriate to have it at a teaching institution. Robert Pfannebecker's collection reflects his warm personal relationship with the artists and reveals his passionate interest in the various craft media. An unconscious early inspiration came from his late brother-in-law, J. Douglas Smith, who was sensitive to ideas and interested in poetry, music, and photography. Smith, his wife (Pfannebecker's sister), and their children had driven Bob as a high-school student over 9,500 miles to visit Smith's family, who lived throughout the United States. Perhaps this alliance was a major influence in Pfannebecker's later life-style — certainly his passion for driving and listening to great music can be attributed to those years. It is this pattern that takes him to Cranbrook Academy of Art or Alfred University for a weekend.

Meeting Donald Wright in Lancaster almost thirty years ago was the catalyst for the formation of the Pfannebecker collection. A graduate of the Cranbrook Academy of Art in Bloomfield Hills, Michigan, Wright filled his home and Lancaster gallery, The Source, with works by contemporaries such as Kay Sekimachi and Ted Hallman. Moving in the early 1960s to Seattle, Wright became aware of Patti Warashina and Fred Bauer, graduate students at the University of Washington. It was Wright who brought them to Pfannebecker's attention — an act that apparently triggered the collection and altered its direction. In the mid-1960s Patti and Fred Bauer joined the faculty of the University of Michigan. Pfannebecker began to purchase their work and

developed close personal ties with the two artists. He also met Wayne Higby, a graduate student there, with whom he has shared a close personal relationship for over twenty years. Because of Pfannebecker's interest in functional pottery, the Bauers also sent him to see John Parker Glick, a well-known studio potter who lived nearby.

DST: Did any of these collectors regularly frequent particular craft fairs or shops?

HWDE: Like everyone else in the field, Pfannebecker subscribed to *Craft Horizons* and followed the exhibition schedule of the Museum of Contemporary Crafts. He remembers frequenting America House in New York and the American Crafts Council fair at Mt. Snow, Vermont, where he met Toshiko Takaezu and Mary Nyburg. He remembers acquiring a Nancy Jurs piece and a blue-black pot by Bob Turner which was exhibited in the Court of Honor. In Bryn Mawr, Pennsylvania, he went to Elliot Herman's Peasant Shop, and in Lambert, New Jersey, Byron Temple's pottery. He also frequented Allan Stone's gallery in New York, initially drawn to it because Stone had acquired a major Jack Earl from the exhibition "Clayworks: 20 Americans" at the Museum of Contemporary Crafts, New York (1971).

Pfannebecker also went to The Works in Philadelphia and Fairtree Gallery in New York (Stan Reifel was director) when it opened across the street from the Whitney Museum of American Art. Shop One in Rochester, New York, became well known in a relatively short period of time. Though not a direct course of acquisition for Pfannebecker, it was certainly a source of information for everyone. Pfannebecker also frequented Philadelphia, whose craft renaissance flourished in the 1960s as expanding programs in the schools gave rise to regional exhibitions at the Museum of the Philadelphia Civic Center and to the formation of the Philadelphia Council of Professional Craftsmen, of which I was a founding member. When my gallery opened in 1974 as a natural outgrowth of these activities, Bob Pfannebecker was a frequent visitor. I first met him as a result of a telephone call in the late 1960s from Byron Temple, who encouraged our meeting.

I am not as familiar with the pattern of the Monsens and Marers — Los Angeles and Seattle were thousands of miles away. It seems unlikely that they followed the same approach as Pfannebecker. They lived on the West Coast and were part of an urban community. Their sources were the activities and artists that centered around the ceramics departments in Seattle, Los Angeles, Berkeley, and Davis, California. Wanda Hansen of Hansen Fuller Gallery in San Francisco was critical in her knowledge of artists working in the Bay Area. She has continued enthusiastically to share her knowledge.

DST: How involved were any of these collectors in commissioning work?

HWDE: Pfannebecker commissioned Dale Chihuly and Jamie Carpenter to design a leaded-glass window for Gallery Two, one of the buildings that houses his collection. In addition, he commissioned countless dinner sets from artists who produced functional objects, such as Rob Forbes, Betty Woodman, Ken Ferguson, John Parker Glick, and Bill Brouillard. Pfannebecker also commissioned Fred Bauer's brother John to make a dining-room table and a storage chest, and Bill Daley to make a tureen similar to the one exhibited in "Soup Tureens '76" that was acquired by the Campbell Museum, Camden, New Jersey.

DST: In the 1950s and 1960s, fine-arts galleries such as Ferus Gallery in Los Angeles, Dilexi in San Francisco, and Allan Stone began to show clay. Did these collectors ever patronize these galleries?

HWDE: I do not believe that any of these collectors were regular clients of these galleries, but the exhibitions certainly educated those interested in crafts. Most of these collectors went directly to the studios of the artists; friendships and direct dialogue supported the acquisition of work. Pfannebecker worked via the telephone and slides in addition to his famous car trips to the Rhode Island School of Design, Alfred University, and Cranbrook Academy of Art. It always amazed me how well known he was by those who had never met him. In the case of the Monsens, Howard Kottler made many introductions for them and, at times, selected works for them to consider.

DST: Was installation in their homes a primary concern of these collectors?

HWDE: Pfannebecker built a house and then two additional structures to accommodate his expanding collections; Donald Wright designed the primary residence and the two additions, Galleries One and Two. The Marers lived in a modest home completely packed with objects; no attempt was made to create a special environment to house the work. I never saw it, but the stories are legion. The Monsens lived quite formally, with the collection interspersed in a considered fashion throughout their home. Mark Burns actually remembers seeing a large selection of recently acquired works by Richard Shaw placed like a median strip on the dining-room table.

DST: Could you discuss your own collection, which was among those shown in these early exhibitions?

HWDE: In 1974 what was called a collection was quite modest. My initial jewelry acquisitions

were made in the mid-1960s: an Olaf Skoogfors gold-plated brooch with biwa pearls and a Stanley Lechtzin electroformed silver brooch with an uncut tourmaline crystal. My introduction to the works came through my affiliation as a founding member of the Philadelphia Council of Professional Craftsmen. I had never before seen jewelry that incorporated the aesthetic qualities of painting and sculpture. My emotional response was strong, and I began to have an intellectual encounter with the work. Skoogfors and I had lengthy dialogues about nature, music, industrialism, socialism, and constructivism — all topics evoked by the search evident in his work. The innovations made possible by Lechtzin's investigation and use of electroforming created jewelry that was unlike any earlier work. Wearing these works was like being a living billboard; the jewelry acted as a catalyst for queries from museum directors, curators, acquaintances, students, and strangers — it opened doors for me to give public voice to my emerging convictions. Their works caused continuous debate and inquiry. I became an unannounced guest lecturer on the streets of Philadelphia or on an airplane.

By 1974, the year of the "Collector" exhibition, I had acquired works by Claus Bury, Toni Goessler-Snyder, Stanley Lechtzin, Eleanor Moty, Albert Paley, Wendy Ramshaw, Gerd Rothmann, Olaf Skoogfors, David Watkins, and J. Fred Woell. There were probably not more than twenty pieces in my collection at that time. I responded viscerally and emotionally to work as I encountered it. More than twenty years later, I recognize the importance of this early pattern, although it began almost by instinct. "Objects: USA" and "Goldsmith 70," held at the Minnesota Museum of Art, St. Paul, were among the most important events and publications that molded my thinking. It was through the catalogue that documented "Gold + Silber, Schmuck + Gerät" (Landes-gewerbeanstalt Bayern in der Norishalle, Nürnberg, 1971) that I was at last introduced to the world of European goldsmiths.

More important for me than exhibitions or publications has been the continuing dialogue with artists and those interested in the field. My passion for the crafts began early in my life — my grandmother made quilts and embroidered, my father's eye was magnetically drawn to porcelain, my mother designed and made my clothes. I was always attracted to the decorative arts. In the 1950s I commissioned furniture from George Nakashima and Phillip Lloyd Powell, and in the 1960s weavings by Ted Hallman. I never thought of myself as a collector; for me, it was a way of life. I was drawn to the aesthetics of the Arts and Crafts Movement — the environments created by Duncan Grant and Carl Larsson appealed to my sensibility. My acquisitions enabled me to live within the chrome and steel of the twentieth-

century's urban environment. I loved the idea that my dishes were made by people who were friends, that living and working were inseparable.

The ceramist Rudolf Staffel was my teacher at the Tyler School of Art in Philadelphia, but my deep appreciation for his work developed almost eight years after my graduation. My affiliation with William Daley, Daniel Jackson, Stanley Lechtzin, Olaf Skoogfors, Rudolf Staffel, Paula Winokur, and Robert Winokur played an important formative role in the 1960s, but my real interest in collecting began when I opened my gallery in 1974. It was one of the first *galleries*, not shops, devoted to the modern craft movement; it drew attention from artists not only throughout the United States but also from Europe. I remember being surprised by a telephone call from Peter Voulkos and Ken Ferguson. The National Conference for Education in the Ceramic Arts (NCECA) was holding its annual conference in Philadelphia in 1975. The Voulkos exhibition, which was organized by the Kansas City Art Institute, could not locate an institution to receive it during the conference. The gallery was designated for the event.

I often acquired works because they were not acquired by others; I felt an obligation to support the artists. There were times when I simply bought a piece in order to inform the artist that there had been a sale. It is amazing today to recall that I sponsored exhibitions for Albert Paley before his work entered public collections. The first European works I acquired were by Gerd Rothman from Electrum Gallery in London — then Claus Bury when he visited the United States; Wendy Ramshaw and David Watkins on the occasion of their first American exhibition, which the Philadelphia Council of Professional Craftsmen had cosponsored with the American Institute of Architects with the support of the Matthey-Bishop Corporation. Unbelievable! Because Olaf Skoogfors and Stanley Lechtzin were in Philadelphia, European goldsmiths came to visit them, and I found myself in dialogue with Friedrich Becker, Claus Bury, Arie Ofir, Gijs Bakker, and the late Emmy van Leersum. Often the artists were my houseguests. Arie Ofir simply called me from a phone booth announcing his arrival from Israel — I did not even know who he was. He was given my name by Olaf Skoogfors, who had neglected to inform me; before I knew it, Ofir was living in my house and stayed for a month. Robert Arneson's student Tom Rippon came for a day and stayed for a summer — he actually turned the back sun porch into a studio and had an exhibition at my gallery in the fall. My home to this very day is often filled with artists, writers, poets, architects.

**DST:** How has your friendship with Robert Pfannebecker affected what you acquired?

**HWDE:** Interesting. If one were to look at each of our homes, there would be few obvious correspondences in our acquisitions or life-styles. However, beneath the surface, certain connections become clear: a mutual passion for the work of Wayne Higby and Mark Burns, for example. Friendship with Bob Pfannebecker influenced the way in which I conceived earlier exhibitions. The "Seattle USA" exhibition (1970), though encouraged by Eleanor Moty, who was Stanley Lechtzin's student at the Tyler School of Art, and her sister Joyce Moty, who lived in Seattle, was reinforced by Pfannebecker's passion for Patti Warashina, Joyce Moty, Clair Colquitt, and Howard Kottler. My interest in the Cranbrook Academy of Art and the work of Richard DeVore came from my interaction with Bob Pfannebecker. My knowledge of the metal arts seems to have had an impact on him — Lechtzin and Skoogfors brought that world into my life, and I, in turn, stimulated Bob Pfannebecker's interest.

**DST:** Robert Pfannebecker once said that the Monsen Collection show made him realize that there were other craft collectors in the United States. Did such collecting shows affect other collectors?

**HWDE:** Vicente Lim and Robert Tooey began collecting ceramics after they saw the Pfannebecker exhibition at Moore College of Art. The exhibition augmented the dialogue among those who were already collecting. These exhibitions also affected those of us who were interested in the emerging history of the modern craft movement. The Marer and Monsen exhibition catalogues were prized possessions in the 1970s; they were critical sources of information. The Monsens were *consciously* forming a collection; they were analytical and concerned with history — they had previously collected Persian miniature paintings. Perhaps this is a moment where we should define "collecting." In recent years those who acquire more than ten pieces proclaim themselves as collectors. The title often seems more important than the passion for the work. Indiscriminate accumulation characterized the habits of many in the 1980s. Pfannebecker loved the objects, the people, the ideas; he was accumulating voraciously — I do not think in the beginning he thought of himself as a "collector."

**DST:** What is the status today of the early collections?

**HWDE:** The Marer Collection has been donated to Scripps College. It is quite appropriate that the works supported by that institution and recognized through exhibitions and documentation remain there as an educational resource for future generations. Paul Soldner was a faculty member at Scripps and his friendship with Marer has a legacy in those holdings.

In recent years the Monsens have deaccessioned works from their clay collection and have become strongly interested in photography. Their commitment to clay had its moment in time. In 1991 works from their collection appeared at auction at Christie's, New York, and there have been signals that other works are being deaccessioned.

Robert Pfannebecker has *never* deaccessioned so much as a cup. It is all still there: in-depth collections of Dominic Di Mare, Wayne Higby, John McQueen, Eleanor Moty, Warren Seelig, and Patti Warashina, among others, and constantly growing acquisitions of emerging artists as well as selected works from the cutting edge that few others would acquire.

The collection of contemporary jewelry that I have acquired over the past twenty-eight years has remained together since its first public viewing at the Musée des Arts Décoratifs de Montréal. I have continued to acquire works that have been considered seminal in the field and that document my discourse with the artists. I always thought that I would stop by 1990, hoping that by that time other collectors would have begun to examine the metals field in depth, and by doing so support it through acquisition. Since the public exhibitions have taken place, I have chosen not to wear many of the works, because I view them as history and feel an obligation to preserve the text. My increased responsibility to the artists and their work went beyond acquisition and I became a voice for the movement through lectures. Philadelphia was the beginning, and invitations to study, visit studios, and research abroad have widened the scope of the collection. Most recently "Modern Jewelry: 1964–Present" was exhibited at the Museum of Applied Arts in Helsinki (March–April 1992) and at the Rohsska Museum, Göteborg, Sweden (November 1992–January 1993).

Contemporary jewelry, which has received the most public attention, is only one part of my acquisition pattern. In 1987 Tyler Gallery, Temple University, Philadelphia, organized "The Alternative Studio: Three Decades of Selected Works." Vessels, furniture, quilts, and functional objects from my home were shown as vignettes. (Can you believe that my Esherick music stand was acquired from an antique-shop window as I strolled home from the gallery? — no one knew what it was!)

In recent years, Paula Winokur was commissioned to make a fireplace surround in my home and Mark Burns painted the ceiling above it — his own version of late-twentieth-century heaven and hell. The real acquisitions have been the information, the books, the catalogues, the slides, the numerous dialogues with artists, collectors, curators, and writers, all of which have supported the fervor and passion that make the crafts inseparable from my daily living.

DST: You have said, "The foundation laid by the energy of the 1960s and 1970s has resulted in the evolution of numerous collections, many of which have not had public exhibitions." Could you discuss this point?

HWDE: Jack Lenor Larsen has been an avid collector of contemporary crafts for over thirty years. Though there has not been a formal exhibition of his acquisitions and commissioned works, his residence in East Hampton, Long Island, is itself a museum housing a collection as a way of life.

Another way of life has been embraced by Laila and Thurston Twigg-Smith, whose vigorous collection of contemporary art has never denied clay; their interest has spawned The Contemporary Museum in Makiki Heights, Honolulu. In the late 1960s I encountered Helen Bershad — she was waiting for her child at school and wearing an Olaf Skoogfors. The Bershads are consummate collectors; they commissioned Daniel Jackson to make their dining-room table twenty years ago, and more recently, Jere Osgood to make a desk. Tribal textiles coexist with contemporary sculpture, painting, and ceramics — Rudolf Staffel and Louise Nevelson are side by side.

Well documented in recent years has been the Grotta House designed by architect Richard Meier for Sandra and Louis Grotta. Less well documented have been the decades of critical collecting that brought together within the structure a choice collection of American crafts. The architecture and the works are joined together as a testament to "high art."

Edna Beron had always loved objects and collected boxes and Georg Jensen's silver before contemporary painting and sculpture began to dominate her existence. In 1974 she acquired a George Timock vessel and her journey in art began to embrace the crafts. Today Louise Bourgeois, Scott Burton, William Daley, Wayne Higby, Rebecca Horn, Pat Steir, Lenore Tawney, and Paula Winokur all coexist. The National Craft Planning Project sponsored by the NEA over a decade ago introduced me to Lois Boardman; today she calls herself an "accumulator" of contemporary jewelry and is among the select group of individuals throughout our country who are "writing" the history of crafts through their acquisitions and responses to the work.

Contemporary collectors hold the reins of history and in doing so develop an affinity with the ideas of their time. Like historical collectors Gertrude Stein and Albert Barnes, a symbiotic relationship develops between the maker and the respondent, giving full meaning to the process of art and its privileged position of creating the legacy of its moment.

# Catalogue of the Exhibition

## HANK MURTA ADAMS
Born: 1956, Philadelphia
Resides: Albany, New York
Education: 1978, BFA, Rhode Island School of
Design, Providence; 1980, Penland School of
Crafts, Penland, North Carolina; 1981, Tennessee
Technological University, Cookeville

**1 Norty,** 1988
Cast glass, copper, and found objects (including
marbles, painted wire screen, and spool)
28⅛ × 22¾ × 17½ inches
Marks: engraved on metal plate in rear,
Hank M. Adams 1988
Provenance: Betsy Rosenfield Gallery, Chicago,
1988; Dorothy and George Saxe, San Francisco,
1988–92; The Toledo Museum of Art, 1993.1.
Exhibitions: 1988: Chicago, Navy Pier, "Chicago
International New Art Forms Exposition" (exh.
cat.); 1988–89: Sheboygan, Wisconsin, John
Michael Kohler Arts Center, "Perspectives:
Hank Murta Adams" (exh. cat., ill.)
PLATE 1

## DEBORAH AGUADO
Born: 1939, New York
Resides: New York
Education: 1965, Penland School of Crafts,
Penland, North Carolina; 1967, Tyler School of Art,
Temple University, Philadelphia; 1970, State
University of New York College, Cortland; 1972, BA,
Brooklyn College, CUNY, Brooklyn, New York;
1973–76, Internationale Sommerakademie für
Bildende Kunst, Salzburg; 1982, MA, New York
University, New York
Selected References: Merle Berk, "Deborah
Aguado," *Lapidary Journal* 39, 12 (Mar. 1986),
pp. 35–37; Susan Grant Lewin and Toni Lesser
Wolf, *Contemporary American Jewelry,* intro. by
Barbara Rose (New York, in press).

**2 Rangefinder** (from the *Night Train* series), 1981
Sterling silver, natural agate, and smoky quartz
3½ × 2⅞ × ¾ inches
Marks: marked on side of underside of upper
section, AGUADO; marked on opposite side of
underside of upper section, ©
Provenance: Dorothy and George Saxe, Menlo
Park, 1985–present (purchased from the artist).

Exhibitions: 1981: New York, American Craft
Museum, "Craft in Progress: A Living Workshop";
1981–82: New York, American Craft Museum,
"Beyond Tradition: 25th Anniversary Exhibition"
Publications: Akiko Busch, "Deborah Aguado:
A Perceptualist's Use of Image and Enigma in
Jewelry," *Metalsmith,* Winter 1984, p. 43 (ill.).
PLATE 113

## NEDA AL HILALI
Born: 1938, Cheb, Czechoslovakia
Resides: Hollywood, California
Education: 1957, St. Martin's School of Art,
London; 1958, Akademie der Bildenden Künste,
Munich; 1965, BFA, University of California,
Los Angeles; 1968, MFA, University of California,
Los Angeles
Selected References: "Neda Al Hilali, an Interview
by Betty Park," *Fiberarts* 6, 4 (July–Aug. 1979),
pp. 40–45; Los Angeles, Los Angeles Municipal Art
Gallery, *Neda Alhilali,* text by Sandy Ballatore
(Los Angeles, 1985).

**3 White Square,** 1981
Paper on canvas
62½ × 63 × ⅛ inches
Marks: painted in lower right corner,
N / Al Hilali / '81
Provenance: The Allrich Gallery, San Francisco,
1981; Dorothy and George Saxe, Menlo Park,
1981–present.
Exhibitions: 1981–82: San Francisco, The Allrich
Gallery, "Neda Al Hilali"
Publications: Jane Knoerle, "The Saxes' Hobby Has
Grown into a World Class Collection," *The Country
Almanac,* Apr. 3, 1991, p. 27 (ill.) (Home & Garden
Special Section).
PLATE 98

## ROBERT ARNESON
Born: 1930, Benicia, California
Died: 1992
Education: 1949–51, College of Marin, Kentfield,
California; 1954, BA, California College of Arts &
Crafts, Oakland; 1958, MFA, Mills College,
Oakland, California
Selected References: Des Moines, Iowa, Des
Moines Art Center, *Robert Arneson, A*

*Retrospective,* text by Neal Benezra (Des Moines,
1985); Robert C. Hobbs, "Robert Arneson: Critic
of Vanguard Extremism," *Arts Magazine* 62, 3
(Nov. 1987), pp. 88–93.

**4 Alfred,** 1981
Glazed clay
14½ × 10⅝ × 6⅛ inches
Marks: inscribed on reverse, "ALFRED" / BOB
ARNESON / 1981
Provenance: Hansen Fuller Goldeen, San Francisco,
1982; Dorothy and George Saxe, Menlo Park,
1982–present.
Exhibitions: 1982: San Francisco, Hansen Fuller
Goldeen, "Robert Arneson"; 1984–85: New York,
Whitney Museum of American Art at Philip Morris,
"Modern Masks" (exh. brochure)
Publications: Allan Temko, "A Shocker from the
Ever-Controversial Robert Arneson," *San Francisco
Chronicle,* May 28, 1982, p. 65; "On Art: Robert
Arneson's Sculpture at Hansen Fuller Goldeen
Gallery, 228 Grant, S.F.," *The Voice* (Berkeley),
June 4, 1982, p. 22; Jane Knoerle, "The Saxes'
Hobby Has Grown into a World Class Collection,"
*The Country Almanac,* Apr. 3, 1991, p. 26 (ill.)
(Home & Garden Special Section).
PLATE 62

## RUDY AUTIO
Born: 1926, Butte, Montana
Resides: Missoula, Montana
Education: 1950, BS, Montana State College,
Bozeman; 1952, MFA, Washington State University,
Pullman
Selected References: Missoula, Montana,
University of Montana, School of Fine Arts, *Rudy
Autio: A Retrospective,* text by Matthew Kangas,
James G. Todd, and Ted Waddell (Missoula, 1983);
Edward Lebow, "The Flesh Pots of Rudy Autio,"
*American Ceramics* 4, 1 (1985), pp. 32–37; Lela
and Lar Autio, *Rudy Autio Work: 1983–1989,*
foreword by Michael G. Rubin (Missoula, 1989).

**5 Sitka Ladies and White Horse,** 1982
Glazed stoneware
20 × 18 × 12¾ inches
Marks: inscribed on side at lower edge, Autio 82
Provenance: Garth Clark Gallery, Los Angeles,
1982; Dorothy and George Saxe, Menlo Park,
1982–present.

Exhibitions: 1982: Los Angeles, Garth Clark Gallery, "Rudy Autio"
PLATE 63

**BENNETT BEAN**
Born: 1941, Cincinnati, Ohio
Resides: Blairstown, New Jersey
Education: 1959–62, Grinnell College, Grinnell, Iowa; 1963, BA, University of Iowa, Iowa City; 1963–64, University of Washington, Seattle; 1966, MFA, The Claremont Graduate School, Claremont, California
Selected References: Akiko Busch, "Bennett Bean," *American Craft* 48, 2 (Apr.–May 1988), pp. 24–29, 88–89; Bruce Pepich, "Bennett Bean," *Art Gallery International* 10, 3 (Mar.–Apr. 1989), pp. 14–17.

6 **Bowl #154,** 1990
Glazed earthenware, terra sigillata, gold leaf, and acrylic paint
8¼ × 15⅞ × 15⅛ inches
Provenance: Susan Cummins Gallery, Mill Valley, California, 1990; Dorothy and George Saxe, Menlo Park, 1990–present.
Exhibitions: 1990: San Francisco, Monsoon Restaurant Opera Plaza
Publications: "The Art of Giving," *Northern California Home and Garden,* Jan. 1991, p. 10; Jane Knoerle, "The Saxes' Hobby Has Grown into a World Class Collection," *The Country Almanac,* Apr. 3, 1991, p. 27 (ill.) (Home & Garden Special Section).
PLATE 64

**HOWARD BEN TRÉ**
Born: 1949, Brooklyn, New York
Resides: Providence, Rhode Island
Education: 1978, BSA, Portland State University, Portland, Oregon; 1980, MFA, Rhode Island School of Design, Providence
Selected References: Ronald J. Onorato, "Howard Ben Tré," *Art New England* 11, 10 (Nov. 1990), pp. 18–19, 32.

7 **Cast Form XXIV** or **Blenko #4,** 1981–82
Cast glass and copper
23½ × 13⅝ × 11 inches
Marks: engraved vertically on the lower rear edge, BEN TRÉ 1982
Provenance: Dorothy and George Saxe, San Francisco, 1982–92 (purchased from the artist); The Toledo Museum of Art, 1993.2.
Publications: Sally Vallongo, "Gifts of Glass: Couple's Collection Helps Art Museum to Rebuild," *The Blade* (Toledo), June 14, 1992, p. 1 (ill.).
PLATE 2

8 **Column 16,** 1983
Cast glass and copper

79½ × 16¾ × 9¼ inches
Provenance: Habatat Galleries, Lathrup Village, Michigan, 1983; Dorothy and George Saxe, San Francisco, 1983–91; The Toledo Museum of Art, 1991.111.
Exhibitions: 1983: Lathrup Village, Michigan, Habatat Galleries, "New Structures and Works on Paper: Howard Ben Tré"; 1986: Oakland, California, The Oakland Museum, "Contemporary American and European Glass from the Saxe Collection" (exh. cat., p. 43, ill.); 1992: Toledo, Ohio, The Toledo Museum of Art, "Crossing the Boundaries: The Sculpture of Howard Ben Tré"
Publications: Paul Hollister, "Studio Glass: Young Craft Comes of Age," *The New York Times,* Apr. 9, 1987, p. C5; Günter Nicola, "American and European Glass from the Saxe Collection" (review), *Neues Glas* 3 (1987), p. 215; "Picks of the Week," *The Blade* (Toledo), Apr. 30, 1992, p. 37 (ill.) (Living/Weekend section); Toledo, Ohio, The Toledo Museum of Art, *The Toledo Museum of Art* (a bimonthly newsletter and program of events), Apr.–May 1992 (ill.).
PLATE 3

9 **Cast Form 69,** 1989
Cast glass, gold leaf, and pigmented wax
16 × 8 × 35 inches
Provenance: Dorothy Goldeen Gallery, Santa Monica, California, 1989; Dorothy and George Saxe, San Francisco, 1989–91; The Toledo Museum of Art, 1991.112.
Exhibitions: 1989: Santa Monica, California, Dorothy Goldeen Gallery, "Howard Ben Tré: New Work"; 1989–90: Washington, D.C., The Phillips Collection, "Howard Ben Tré: Contemporary Sculpture" (exh. cat., pp. 30, 37, 39, 48, ill.) (traveled to Pittsburgh, Carnegie-Mellon Art Gallery; Lincoln, Massachusetts, DeCordova Museum and Sculpture Park); 1992: Toledo, Ohio, The Toledo Museum of Art, "Crossing the Boundaries: The Sculpture of Howard Ben Tré"
Publications: Matthew Kangas, "Engendering Ben Tré," *Glass* 40 (Spring–Summer 1990), pp. 26–27 (ill.).
PLATE 4
(Toledo only)

**BILLY AL BENGSTON**
Born: 1934, Dodge City, Kansas
Resides: Venice, California
Education: 1953–55, Los Angeles City College, Los Angeles; 1955–56, California College of Arts & Crafts, Oakland; 1956–57, Los Angeles County Art Institute, Los Angeles
Selected References: Los Angeles, Los Angeles County Museum of Art, *Billy Al Bengston,* intro. by James Monte (Los Angeles, 1968); Sandy Nelson, "Beginning in the Middle, Billy Al Bengston Pictures for the Eighties," *Images & Issues* 3, 6 (May–June 1983), pp. 30–33; Houston,

Contemporary Arts Museum, and Oakland, California, The Oakland Museum, *Billy Al Bengston: Paintings of Three Decades,* interview with Bengston by Maurice Tuchman (San Francisco, 1988).

10 **Kane Variation #20** (number 5 from an edition of 5 from the *"Kane"* variations), 1983
Benno Spingler, fabricator
Red oak, Hong Kong rosewood, Brazil wood, walnut, and Formica
20⅛ × 35¼ × 14⅛ inches
Marks: artist's identification label, BILLY AL BENGSTON STUDIO / 110 MILDRED AVENUE, VENICE, CALIFORNIA 90291 / TELEPHONE (213) 822–2201 / BILLY AL BENGSTON / Table Twenty, 1983 / H: 20¼ L: 35½ W: 14¼" / various hardwoods and formica / Fabricated by Benno Spingler
Provenance: John Berggruen Gallery, San Francisco, 1983; Dorothy and George Saxe, Menlo Park, 1983–present.
Exhibitions: 1983: San Francisco, John Berggruen Gallery, "Billy Al Bengston: Recent Work"
Publications: Jane Knoerle, "The Saxes' Hobby Has Grown into a World Class Collection," *The Country Almanac,* Apr. 3, 1991, p. 27 (ill.) (Home & Garden Special Section).
PLATE 106

**CHRISTINA BERTONI**
Born: 1945, Ann Arbor, Michigan
Resides: Pascoag, Rhode Island
Education: 1967, BFA, University of Michigan, Ann Arbor; 1976, MFA, Cranbrook Academy of Art, Bloomfield Hills, Michigan
Selected References: James Cobb, "Christina Bertoni," *American Ceramics* 6, 3 (1988), front cover, pp. 30–37.

11 **By This Immovability All Things Are Moved,** 1987
Terra-cotta and acrylic paint
7 × 16⅞ × 15¾ inches
Marks: painted on bottom in center of bowl, *Christina Bertoni / 1987*
Provenance: Victoria Munroe, New York, 1987; Dorothy and George Saxe, Menlo Park, 1987–present.
Exhibitions: 1987: New York, Victoria Munroe, "Christina Bertoni: Painted Ceramic Vessels"
PLATE 65

**WILLIAM CARLSON**
Born: 1950, Dover, Ohio
Resides: Urbana, Illinois
Education: 1969–70, Art Students League, New York; 1971, Pilchuck Glass Center, Stanwood, Washington; 1973, BFA, Cleveland Institute of Art,

Cleveland; 1976, MFA, New York State College of Ceramics at Alfred University, Alfred
Selected References: Chloe Zerwick, "William Carlson: Balanced Asymmetry," *American Craft* 42, 3 (June–July 1982), pp. 2–5.

12 **Kinesthesis Series Vessel**, 1980
Blown and cast glass and sterling silver
6 × 4⅛ × 5⅞ inches
Marks: engraved on lower edge, *William Carlson 1980* ©
Provenance: Contemporary Artisans, San Francisco, 1980; Dorothy and George Saxe, San Francisco, 1980–91; The Toledo Museum of Art, 1991.113.
Exhibitions: 1980: San Francisco, Contemporary Artisans, "William Carlson: Sculptural and Vessel Forms"
PLATE 5

13 **Pragnanz Series II**, 1986
Cast glass, Vitrolite, granite, and wire
20 × 11½ × 4 inches
Marks: engraved on underside, *William Carlson 1986* ©
Provenance: Elaine Potter Gallery, San Francisco, 1986; Dorothy and George Saxe, San Francisco, 1986–91; The Toledo Museum of Art, 1991.114.
Exhibitions: 1986: San Francisco, Elaine Potter Gallery
PLATE 6

## DALE CHIHULY
Born: 1941, Tacoma, Washington
Resides: Seattle
Education: 1965, BA, University of Washington, Seattle; 1967, MS, University of Wisconsin–Madison; 1968, MFA, Rhode Island School of Design, Providence
Selected References: Tucson, Arizona, Tucson Museum of Art, *Dale Chihuly Glass,* intro. by Linda Norden (Seattle, 1982); Bellevue, Washington, Bellevue Art Museum, *Chihuly, A Decade of Glass,* text by Karen Chambers and Jack Cowart (Bellevue, 1984); Karen Chambers, Henry Geldzahler, Michael Monroe, and Dale Chihuly, *Chihuly Color, Glass and Form* (Tokyo, San Francisco, and New York, 1986); Seattle, Seattle Art Museum, "Dale Chihuly: Installations 1964–1992," text by Patterson Sims (Seattle, 1992).

14 **Untitled Blanket Cylinder**, 1975
Blown glass
10 × 5 (dia.) inches
Marks: engraved on underside, *Chihuly / 1975*
Provenance: Dorothy and George Saxe, San Francisco, 1981–91 (purchased from the artist); The Toledo Museum of Art, 1991.90.
PLATE 7

15 **Venetian Drawing**, 1988
Charcoal and watercolor on paper
22¼ × 30⅛ inches (unframed)
Marks: signed and dated in graphite on front mid-right, Chihuly 1988
Provenance: Dorothy and George Saxe, San Francisco, 1988–91 (purchased from the artist); The Toledo Museum of Art, 1991.115.
PLATE 8

16 **Transparent Terra Rosa Venetian**
(from the *Venetian* series), 1988
Blown glass
6¼ × 16 × 17¼ inches
Marks: engraved on underside, *Chihuly 1988*
Provenance: Dorothy and George Saxe, San Francisco, 1988–91 (purchased from the artist); The Toledo Museum of Art, 1993.3.
PLATE 9

## MICHAEL COHN
Born: 1949, Long Beach, California
Resides: Emeryville, California
Education: 1967–68, Long Beach City College, Long Beach, California; 1972, BA, University of California, Berkeley
Selected References: Gregory Fullington, "Space Cups: Glassblowing's Future," *Prism* (San Francisco), Spring 1979, pp. 2–4; Michael Cohn, "Michael Cohn," *Glass Art Society Journal,* 1986, pp. 64–66.

17 **Space Cup #49**, 1981
Blown and plate glass
5⅞ × 12½ × 8½ inches
Marks: engraved on base, *Cohn 1981 SC49*
Provenance: Dorothy and George Saxe, San Francisco, 1981–91 (purchased from the artist); The Toledo Museum of Art, 1991.91.
Exhibitions: 1981: Palo Alto, California, Palo Alto Cultural Center, "Glass: Collector's Choice"; 1984–85: San Francisco, San Francisco International Airport North Terminal Connector Gallery, "Art and Travel"; 1986–87: Oakland, California, The Oakland Museum, "Contemporary American and European Glass from the Saxe Collection" (exh. cat., p. 54, ill.) (traveled to New York, American Craft Museum)
Publications: Oakland, California, The Oakland Museum, "The Glass Collectors," *Museum of California Magazine,* text by Abby Wasserman (Oakland, 1986), front cover, p. 4.
PLATE 10

## LIA COOK
Born: 1942, Ventura, California
Resides: Berkeley, California
Education: 1965, BA, University of California, Berkeley; 1973, MA, University of California, Berkeley

Selected References: Maureen Conner, "The Tapestries of Lia Cook," *Arts Magazine* 59, 6 (Feb. 1985), pp. 94–95; Washington, D.C., Arts in the Academy, National Academy of Sciences, *Lia Cook Fiber Art,* text by Nancy A. Corwin (Washington, D.C., 1990).

18 **Lattice: Ode to O.Be** (from the *Pressed Weaves* series), 1982
Rayon, acrylic paint, and dyes
57 × 42 × ¼ inches
Marks: painted in lower right corner of reverse side, © Lia Cook / LATTICE: / ODE TO O.BE
Provenance: The Allrich Gallery, San Francisco, 1982; Dorothy and George Saxe, Menlo Park, 1982–present.
Exhibitions: 1982–83: San Francisco, The Allrich Gallery, "Lia Cook: Recent Work"; 1983: Beauvais, France, Galerie Nationale de la Tapisserie et d'Art Textile-Beauvais, "Lia Cook" (exh. cat., pp. 20, 35, ill.)
Publications: "Lia Cook," *Dryade* (reprint of the Beauvais catalogue), May 1983.
PLATE 99

## DAN DAILEY
Born: 1947, Philadelphia
Resides: Kensington, New Hampshire
Education: 1969, BFA, Philadelphia College of Art, Philadelphia; 1972, MFA, Rhode Island School of Design, Providence; 1972–73, Fabbrica Venini, Murano
Selected References: Karen Chambers, "Dan Dailey: A Designing Character," *Neues Glas* 1 (1990), pp. 10–19; Koji Matano, "Dan Dailey" (interview), *Glasswork* 6 (Aug. 1990), pp. 12–19.

19 **Sick as a Dog**, 1984
Vitrolite, aluminum, and nickel-plated brass
18 × 11½ × 10¾ inches
Marks: stamped on base of metal, *Dailey*
Provenance: Kurland/Summers Gallery, Los Angeles, 1984–85; Dorothy and George Saxe, San Francisco, 1985–91; The Toledo Museum of Art, 1991.92.
Exhibitions: 1985: Los Angeles, Kurland/Summers Gallery, "Dan Dailey"; 1986–87: Oakland, California, The Oakland Museum, "Contemporary American and European Glass from the Saxe Collection" (exh. cat., p. 32, ill.) (traveled to New York, American Craft Museum); 1987: Philadelphia, Philadelphia Colleges of the Arts, The Rosenwald-Wolf Gallery, "Dan Dailey: Simple Complexities in Drawing and Glass 1972–1987" (exh. cat., pp. 10, 33, 61) (traveled to Washington, D.C., Renwick Gallery, National Museum of American Art, Smithsonian Institution)
Publications: Victoria Donohoe, "Major Exhibit in Glass Honors a Native," *The Philadelphia Inquirer,* Mar. 6, 1987, p. 2 (ill.); Robert Kehlmann, "Glass of the 80's Collectors George and Dorothy Saxe

Document a Decade," *American Craft* 47, 2 (Apr.–May 1987), p. 37; "The Saxe Collection in N.Y. City," *Neues Glas* 2 (1987), p. 105 (ill.); Nolo Raymond, "Reviews in Brief," *Art Matters* (Apr. 1987), p. 2 (ill.); Edward Sozanski, "On Galleries: A Museum's Latest Offerings Balance Art, Craft and Function," *The Philadelphia Inquirer,* May 14, 1987, p. 5C (ill.); Dan Klein, *Glass: A Contemporary Art* (New York, 1989), p. 72 (ill.).
PLATE 11

20 **The Chef** (from the *Head Vase* series), 1988
Blown glass and bronze
18 × 11½ × 10¾ inches
Marks: engraved on lower front at rear, Dailey; and on underside, HV-2-88 / "THE CHEF"
Provenance: Kurland/Summers Gallery, Los Angeles, 1988; Dorothy and George Saxe, San Francisco, 1988–91; The Toledo Museum of Art, 1991.117.
Exhibitions: 1988: Los Angeles, Kurland/Summers Gallery, "Dan Dailey"
Publications: *ArtScene,* May 1988, p. 11 (ill.).
PLATE 12

## OLGA DE AMARAL
Born: 1932, Bogotá
Resides: Bogotá
Education: 1954–55, Cranbrook Academy of Art, Bloomfield Hills, Michigan
Selected References: Charles Talley, "Olga de Amaral," *American Craft* 48, 2 (Apr.–May 1988), pp. 38–45; Overland Park, Kansas, Johnson County Community College, Gallery of Art, *Olga de Amaral: Lost Images, Inherited Landscapes,* text by Mildred Constantine (Overland Park, 1992).

21 **Riscos I (Fibra y Azul),** 1983
Linen, horsehair, and gesso
65 × 84 × 4 inches
Marks: handwritten on verso on linen strip at lower right, 342 "Fibra y AzuL" / 1983 Olga de AmaraL / *Olga de Amaral* / / 83
Provenance: Modern Masters Tapestries, New York, 1983; Dorothy and George Saxe, Menlo Park, 1983–present.
Exhibitions: 1983: New York, Modern Masters Tapestries, "Olga de Amaral: Woven Matter" (exh. brochure, ill.)
Publications: Jessica Scarborough, "Olga de Amaral: Toward a Language of Freedom," *Fiberarts* 12, 4 (July–Aug. 1985), p. 53 (ill.); Jane Knoerle, "The Saxes' Hobby Has Grown into a World Class Collection," *The Country Almanac,* Apr. 3, 1991, p. 27 (ill.) (Home & Garden Special Section).
PLATE 100

## STEPHEN DE STAEBLER
Born: 1933, St. Louis
Resides: Berkeley, California
Education: 1951, Black Mountain College, Black Mountain, North Carolina; 1954, AB, Princeton University, Princeton, New Jersey; 1958–59, General Secondary Teaching Credential, University of California, Berkeley; 1961, MA, University of California, Berkeley
Selected References: San Francisco, San Francisco Museum of Modern Art, *Stephen De Staebler, The Figure,* text by Donald Kuspit (San Francisco, 1987).

22 **Pointing Figure Column,** 1985
Stoneware, porcelain, and low-fired clays
95½ × 11⅜ × 20⅞ inches
Marks: inscribed on reverse, DE / STAE / BLER / 1985
Provenance: John Berggruen Gallery, San Francisco, 1986; Dorothy and George Saxe, Menlo Park, 1986–present.
Exhibitions: 1986: San Francisco, John Berggruen Gallery, "Stephen De Staebler: Recent Work"
PLATE 66

## RUTH DUCKWORTH
Born: 1919, Hamburg
Resides: Chicago
Education: 1936–40, Liverpool School of Art, Liverpool; 1946, Kennington School of Art, London; 1955, Hammersmith School of Art, London; 1956–58, Central School of Arts and Crafts, London
Selected References: Philadelphia, Moore College of Art, "Ruth Duckworth," text by Helen Williams Drutt (Philadelphia, 1979); Maureen Dawley, "Ruth Duckworth: Interview," *Dialogue, An Art Journal* 10, 4 (July–Aug. 1987), pp. 59–61; Harrie A. Vanderstappen, "Ruth Duckworth: Life Becomes Sculpture," *American Craft* 51, 5 (Oct.–Nov. 1991), pp. 34–39.

23 **Untitled** (from the *MaMa Pot* series), 1982
Glazed stoneware
17¼ × 21½ × 19½ inches
Marks: painted on bottom, R / 82
Provenance: American Art Incorporated, Atlanta, 1983; Dorothy and George Saxe, Menlo Park, 1983–present.
Exhibitions: 1983: Atlanta, American Art Incorporated, "Masters in Clay"
Publications: Jane Knoerle, "The Saxes' Hobby Has Grown into a World Class Collection," *The Country Almanac,* Apr. 3, 1991, p. 25 (ill.) (Home & Garden Special Section).
PLATE 67

## JACK EARL
Born: 1934, near Uniopolis, Ohio
Resides: Lakeview, Ohio
Education: 1956, BA, Bluffton College, Bluffton, Ohio; 1958, Dayton Art Institute, Dayton, Ohio; 1964, MA, Ohio State University, Columbus
Selected References: John Klassen, "A Conversation with Jack Earl," *Ceramics Monthly* 29, 8 (Oct. 1981), pp. 68–70.

24 **Josiah Wedgwood built his city out of clay and many people have visited his city and those who visited there and left to build their own cities couldn't help thinking of Josiah's,** 1979
Porcelain and oil paint
10⅝ × 11½ × 8¼ inches
Marks: inscribed along bottom side, JACK EArL / LAKEVIEW OHIO / 1979
Provenance: Theo Portnoy Gallery, New York, 1982; Dorothy and George Saxe, Menlo Park, 1982–present (promised gift to The Toledo Museum of Art).
Exhibitions: 1980: Philadelphia, Museum of the Philadelphia Civic Center (organized by Helen W. Drutt English for the Buten Museum of Wedgwood, Merion, Pennsylvania), "Contemporary Ceramics: A Response to Wedgwood"; 1982: New York, Theo Portnoy Gallery, "Jack Earl: New Ceramic Sculpture"; 1985–86: Albuquerque, University of New Mexico, University Art Museum, "Recent Ceramic Sculpture" (exh. cat., ill.); 1987–88: Sheboygan, Wisconsin, John Michael Kohler Arts Center, "Ohio Boy: The Ceramic Sculpture of Jack Earl" (exh. cat., no. 30, p. 41) (traveled to New York, American Craft Museum; Racine, Wisconsin, Charles A. Wustum Museum of Fine Arts; Ames, Iowa, Octagon Center for the Arts)
Publications: Lee Nordness, *Jack Earl / The Genesis and Triumphant Survival of an Underground Ohio Artist* (Chicago, 1985), pls. 38, 39; Jane Knoerle, "The Saxes' Hobby Has Grown into a World Class Collection," *The Country Almanac,* Apr. 3, 1991, p. 26 (ill.) (Home & Garden Special Section).
PLATE 68 A, B

25 **There was a man afloat in days, Believeing wisdom comes with time. He lived through people, cars and dogs in a house of tarpaper stone.,** 1983
Whiteware and oil paint
15⅝ × 22½ × 19¼ inches
Marks: inscribed on lower side, *There was a man / afloat in days, / Believeing wisdom comes / with time. He lived / through people, cars and / dogs in a house of / tarpaper stone. Jack Earl 1983* U.S.A.
Provenance: "Celebration 30" (The Sixth Annual Benefit Auction of Contemporary American Craft sponsored by the Associates of the American Craft Museum), New York, 1986; Dorothy and George Saxe, Menlo Park, 1986–present.
Exhibitions: 1985: Chicago, Perimeter Gallery, "Jack Earl Sculpture"; 1986: New York,

"Celebration 30" (The Sixth Annual Benefit Auction of Contemporary American Craft sponsored by the Associates of the American Craft Museum) (exh. cat., no. 13, ill.); 1987–88: Sheboygan, Wisconsin, John Michael Kohler Arts Center, "Ohio Boy: The Ceramic Sculpture of Jack Earl" (exh. cat., pp. 33, 42, pl. 38) (traveled to New York, American Craft Museum; Racine, Wisconsin, Charles A. Wustum Museum of Fine Arts; Ames, Iowa, Octagon Center for the Arts)
Publications: Lee Nordness, *Jack Earl / The Genesis and Triumphant Survival of an Underground Ohio Artist* (Chicago, 1985), p. 206, pls. 63, 64; Douglas C. McGill, "Art People: Soil Toiler Art," *The New York Times*, Jan. 29, 1988, p. C26.
PLATE 69

## ERWIN EISCH
Born: 1927, Frauenau (Bavaria), Germany
Resides: Frauenau (Bavaria), Germany
Education: 1946–48, Staatlichen Glasfachschule, Zwiesel, Germany; 1949–52, Akademie der Bildenden Künste, Munich; 1956–59, Akademie der Bildenden Künste, Munich
Selected References: Erwin Eisch, "Erwin Eisch," *Glass Art Society Journal,* 1979, pp. 10–13; Cullowhee, North Carolina, Western Carolina University, Chelsea Gallery, *Erwin Eisch: Retrospective Glass and Drawings* (Cullowhee, 1980); Paris, Musée des Arts Décoratifs, *Erwin Eisch: Peintures, Verres, Dessins,* text by Yvonne Brunhammer and Thomas Buechner (Paris, 1988).

26 **Tonfall** (from the *Gilt Vase* series), 1981
Blown glass and silver and gold leaf
17⅝ × 7⅜ × 7 inches
Marks: in gilt on center, Tonfall; engraved on front lower right, E. Eisch 81 / J. S. Tonefall
Provenance: Habatat Gallery, Lathrup Village, Michigan, 1981; Dorothy and George Saxe, San Francisco, 1981–91; The Toledo Museum of Art, 1991.93.
Exhibitions: 1981: Lathrup Village, Michigan, Habatat Gallery, "Harvey K. Littleton and Erwin Eisch"
PLATE 13

## VIOLA FREY
Born: 1933, Lodi, California
Resides: Oakland, California
Education: 1952–53, Stockton Delta College, Stockton, California; 1955, BFA, California College of Arts & Crafts, Oakland; 1958, MFA, Tulane University, New Orleans
Selected References: Sacramento, California, Creative Arts League of Sacramento, *California Crafts XII: Viola Frey Retrospective,* text by Garth Clark (Sacramento, 1981); Jeff Kelley, "Viola Frey," *American Ceramics* 3, 1 (1984), pp. 26–33;

Philadelphia, Moore College of Art, *It's All Part of the Clay: Viola Frey,* text by Patterson Sims and interview with Frey by Garth Clark (Philadelphia, 1984).

27 **Man Observing Series II,** 1984
Whiteware, steel, and cement
106 × 44 × 30 inches
Provenance: Rena Bransten Gallery, San Francisco, 1985; Dorothy and George Saxe, Menlo Park, 1985–present.
Publications: Jane Knoerle, "The Saxes' Hobby Has Grown into a World Class Collection," *The Country Almanac,* Apr. 3, 1991, p. 25 (ill.) (Home & Garden Special Section).
PLATE 70 AND FRONTISPIECE

## ANDREA GILL
Born: 1948, Newark, New Jersey
Resides: Alfred, New York
Education: 1971, BFA, Rhode Island School of Design, Providence; 1972–73, Kansas City Art Institute, Kansas City, Missouri; 1976, MFA, New York State College of Ceramics at Alfred University, Alfred
Selected References: Susan Wechsler, *Low-Fire Ceramics* (New York, 1981), pp. 76–81; Carolyn Carr, "Andrea Gill/John Gill," *American Craft* 43, 6 (Dec. 1983–Jan. 1984), front cover, pp. 19–23.

28 **Untitled** (from the *Fish Box* series), 1982
Glazed earthenware with slip
6⅝ × 12¹⁵⁄₁₆ × 18¼ inches
Marks: painted on bottom edge, A. Gill
Provenance: The Elements Gallery, New York, 1982; Dorothy and George Saxe, Menlo Park, 1982–present.
Exhibitions: 1982: New York, The Elements Gallery, "Andrea Gill"
PLATE 71

## MICHAEL GLANCY
Born: 1950, Detroit
Resides: Rehoboth, Massachusetts
Education: 1973, BFA, University of Denver, Denver; 1977, BFA, Rhode Island School of Design, Providence; 1980, MFA, Rhode Island School of Design, Providence
Selected References: Lisa Hammel, "Shadow and Substance: The Glass of Michael Glancy," in *Michael Glancy–June 1989* ([n.p.], 1989); Michael McTwigan, "Michael Glancy: Balancing Order and Chaos," *Glass* 42 (Winter 1990), pp. 20–29.

29 **Sovereign Cloister—Beyond War,** 1986
Blown glass, plate glass, and copper
13⅛ × 20⅞ × 13¾ inches
Marks: engraved on vessel bottom in center, MICHAEL M. GLANCY + SOVEREIGN +

CLOISTER BEYOND WAR MG; on upper side of smaller base, MICHAEL GLANCY / 1986 / SOVERIGN / CLOISTER / BEYOND / WAR; on top of large base, *Michael M. Glancy* / SOVEREIGN CLOISTER / 1986 / BEYOND WAR; on upper plate-glass sheet, SOVERIGN CLOISTER— BEYOND WAR; on lower plate-glass sheet, SOVERIGN CLOISTER—BEYOND WAR
Provenance: Habatat Galleries, Bay Harbor Island, Florida, 1988; Dorothy and George Saxe, San Francisco, 1988–92; The Toledo Museum of Art, 1993.4.
Exhibitions: 1986: New York, Heller Gallery; 1987: Chicago, Navy Pier, "Chicago International New Art Forms Exposition" (exh. cat.); 1987–88: Bay Harbor Island, Florida, Habatat Galleries, "The New Aesthetic: A Worldwide Survey of Contemporary Glass Sculpture"; 1988: Bay Harbor Island, Florida, Habatat Galleries, "Michael Glancy: New Works in Glass and Metal"
Publications: Gareth Fenley, "Silent Light for a Private Gallery," *Architectural Lighting,* June 1989, p. 40 (ill.); Basel, Switzerland, Edition Galerie von Bartha, *Michael Glancy—Interaction 1991* (Basel, 1991), pp. 38–39 (ill.).
PLATE 14

## HENRY HALEM
Born: 1938, New York
Resides: Kent, Ohio
Education: 1960, BFA, Rhode Island School of Design, Providence; 1968, MFA, George Washington University, Washington, D.C.; 1968–69, University of Wisconsin–Madison
Selected References: "Henry Halem," *Glass Studio* 12 (Mar.–Apr. 1980), front cover, pp. 18–19; Paul Hollister, "Henry Halem: The Plane Is the Message," *Neues Glas* 4 (1982), pp. 189–94; Rika Kuroki and Mayumi Shinohara, "Henry Halem," *Glasswork* 7 (Dec. 1990), pp. 12–21.

30 **Square Penetration,** 1981
Vitrolite
34⅛ × 27⅛ inches
Marks: engraved on lower right edge, *Henry Halem 81*
Provenance: Dorothy and George Saxe, San Francisco, 1981–91 (purchased from the artist); The Toledo Museum of Art, 1991.118.
Exhibitions: 1986–87: Oakland, California, The Oakland Museum, "Contemporary American and European Glass from the Saxe Collection" (exh. cat., p. 34, ill.) (traveled to New York, American Craft Museum)
PLATE 15

## JIŘÍ HARCUBA

Born: 1928, Harrachov, Czechoslovakia
Resides: Prague
Education: 1945–48, Střední škola sklářská v Novém Boru, Nový Bor, Czechoslovakia; 1949–54, Vysoká umělecko-průmyslová škola, Prague; 1964–65, Royal College of Art, London
Selected References: Eva Schmitt, "Jiri Harcuba: Porträtschnitt heute," *Neues Glas* 3 (1988), pp. 206–10; Düsseldorf, Kunstmuseum Düsseldorf im Ehrenhof, *New Glass in Europe: 50 Artists—50 Concepts* (Düsseldorf, 1990); Sylva Petrová, "Contemporary Creators," *Bohemian Glass 1400–1989* (New York, 1990), pp. 140–41.

31 **Portraits of Dorothy and George Saxe,** 1983
Cast glass
Dorothy Saxe: 5¹⁵⁄₁₆ × 5⁹⁄₁₆ × 1½ inches
George Saxe: 5⅝ × 5¹³⁄₁₆ × 1½ inches
Marks: engraved on bottom edge of each, *J Harcuba 1983*
Provenance: Art Centrum, Prague, 1983 (commissioned from the artist); Dorothy and George Saxe, San Francisco, 1983–91; The Toledo Museum of Art, 1991.94 a,b.
Exhibitions: 1986–87: Oakland, California, The Oakland Museum, "Contemporary American and European Glass from the Saxe Collection" (exh. cat., p. 36, ill.) (traveled to New York, American Craft Museum)
PLATE 16

## WILLIAM HARPER

Born: 1944, Bucyrus, Ohio
Resides: Tallahassee, Florida
Education: 1966, BS, Western Reserve University, Cleveland; 1967, MS, Western Reserve University, Cleveland; 1967, Certificate, Cleveland Institute of Art, Cleveland
Selected References: Orlando, Florida, The Orlando Museum of Art, *William Harper: Artist as Alchemist,* text by Thomas Manhart (Orlando, 1989); New York, Franklin Parrasch Gallery, *William Harper: Self-Portraits of the Artist Sacred and Profane,* text by Jane Allen (New York, 1990).

32 **Saint Sebastian Aborigine** (from the *Saints, Martyrs, and Savages* series), 1982
Pendant: gold and silver cloisonné enamel on copper and fine silver, 14K and 24K gold, sterling silver, claw, ivory and shell; chain: fine silver and 14K gold
Pendant: 5¾ × 3 inches; chain: L. 11½ inches (clasp closed); extended: 25½ inches (clasp opened)
Marks: marked at upper crest of rear, SAINT SEBASTIAN ABORIGINE; engraved along side of rear, *William Harper 1982*
Provenance: Dorothy and George Saxe, Menlo Park, 1986–present (purchased from the artist).

Exhibitions: 1982: Pforzheim, Germany, Schmuckmuseum Pforzheim, "Schmuck 82–Tendenzen?"; 1982–83: New York, Kennedy Galleries, "Saints, Martyrs, and Savages: Enameled Jewelry by William Harper" (exh. cat., no. 12, ill.)
PLATE 114

## WAYNE HIGBY

Born: 1943, Colorado Springs, Colorado
Resides: Alfred Station, New York
Education: 1966, BFA, University of Colorado, Boulder; 1968, MFA, University of Michigan, Ann Arbor
Selected References: Louise Klemperer, "Wayne Higby," *American Ceramics* 3, 4 (1985), pp. 32–37; Wayne Higby, "A Search for Form and Place," *Ceramics Monthly* 37, 10 (Dec. 1989), front cover, pp. 5, 27–37; Robert Turner, "Abstract Bowls—Emotional Connections, The Recent Work of Wayne Higby," *Ceramics: Art & Perception* 6 (1991), pp. 25–29; Joan Jeffri, ed., *The Craftsperson Speaks: Artists in Various Media Discuss Their Crafts* (Westport, Connecticut, 1992), pp. 44–62.

33 **Rapids Canyon,** 1984–85
Glazed earthenware
12 × 29⅛ × 16 inches
Marks: placement numbers painted on each bottom, 1 2 3 4; on underside of container "1," artist's stamp and '84'
Provenance: Helen Drutt Gallery, Philadelphia, 1985; Dorothy and George Saxe, Menlo Park, 1985–present.
Exhibitions: 1985: Philadelphia, Helen Drutt Gallery
PLATE 72

## JAN HOLCOMB

Born: 1945, Washington, D.C.
Resides: Pascoag, Rhode Island
Education: 1968, BA, University of Michigan, Ann Arbor; 1975, BFA, University of Michigan, Ann Arbor; 1977, MA, California State University, Sacramento
Selected References: M. F. Porges, "Children of an Anxious Age," *American Ceramics* 6, 4 (Summer 1988), pp. 20–25; Jan Holcomb, "Step by Step," *Ceramics Monthly* 36, 8 (Oct. 1988), pp. 34–37.

34 **Unexpected, Unknown,** 1984–85
Glazed stoneware and paint
24 × 25⅞ × 3⅛ inches
Provenance: Garth Clark Gallery, New York, 1985; Dorothy and George Saxe, Menlo Park, 1985–present.
Exhibitions: 1986: New York, Garth Clark Gallery, "Jan Holcomb New Works"
Publications: New Paltz, New York, State University

of New York at New Paltz, College Art Gallery, *In the Eye of the Beholder: A Portrait of Our Time* (New Paltz, 1985), p. 18 (ill.); Susan Wechsler, "A House Is Not Always a Home," *American Ceramics* 4, 3 (1985), p. 66 (ill.); Jane Knoerle, "The Saxes' Hobby Has Grown into a World Class Collection," *The Country Almanac,* Apr. 3, 1991, p. 26 (ill.) (Home & Garden Special Section).
PLATE 73

## DAVID R. HUCHTHAUSEN

Born: 1951, Wisconsin Rapids, Wisconsin
Resides: Seattle
Education: 1973, AA, University of Wisconsin–Wausau; 1975, BS, University of Wisconsin–Madison; 1977, MFA, Illinois State University, Normal
Selected References: Mark S. Talaba, "Projection and Transformation—Mysteries of the Leitungs Scherben," *Neues Glas* 3 (1983), front cover, pp. 134–41; St. Louis, The St. Louis Art Museum, *Currents 25: David Huchthausen,* text by Sidney M. Goldstein (St. Louis, 1984); Robert Silberman, "David Huchthausen: Controlled Fragments," *American Craft* 47, 4 (Aug.–Sept. 1987), front cover, pp. 54–59.

35 **Alpine Landscape** (from the *Alpine Fantasy* series), 1978
Blown glass
8¼ × 6⅝ (dia.) inches
Marks: engraved along bottom, *David R. Huchthausen* 1978 BADEN bei WIEN No. 99
Provenance: SM Galerie E. Gottschalk, Frankfurt, 1978–81; Contemporary Artisans, San Francisco, 1981; Dorothy and George Saxe, San Francisco, 1981–91; The Toledo Museum of Art, 1991.119.
Exhibitions: 1978: Frankfurt, SM Galerie E. Gottschalk, "David R. Huchthausen, Landschaften und Fantasien"; Vienna, J. & L. Lobmeyr, "David R. Huchthausen, 'Alpenländische Fantasien' "; 1981: San Francisco, Contemporary Artisans, "National Glass III"; 1986–87: Oakland, California, The Oakland Museum, "Contemporary American and European Glass from the Saxe Collection" (exh. cat., p. 30, ill.) (traveled to New York, American Craft Museum)
Publications: "Glass as Art," *Sunset Magazine* 177, 4 (Oct. 1986), p. 97 (ill.); Paul Hollister, "Studio Glass: Young Craft Comes of Age," *The New York Times,* Apr. 9, 1987, p. C5; Günter Nicola, "American and European Glass from the Saxe Collection" (review), *Neues Glas* 3 (1987), p. 214.
PLATE 19

36 **Leitungs Scherbe LS 282** (from the *Leitungs Scherben* series), 1982
Sheet glass, Vitrolite, and agate glass blocks
11 × 16½ × 11⅜ inches
Marks: sandblasted on inner side of leg, LS282DRH

Provenance: Heller Gallery, New York, 1982; Dorothy and George Saxe, San Francisco, 1982–91; The Toledo Museum of Art, 1991.95.
Exhibitions: 1982: New York, Heller Gallery, "David R. Huchthausen Leitungs Scherben"; 1982–83: New York, American Craft Museum, "Approaches to Collecting"; 1986: Oakland, California, The Oakland Museum, "Contemporary American and European Glass from the Saxe Collection" (exh. cat., p. 59, ill.) (traveled to New York, American Craft Museum)
Publications: Günter Nicola, "American and European Glass from the Saxe Collection" (review), *Neues Glas* 3 (1987), p. 214.
PLATE 18

## ROBERT HUDSON

Born: 1938, Salt Lake City, Utah
Resides: Cotati, California
Education: 1962, BFA, San Francisco Art Institute, San Francisco; 1963, MFA, San Francisco Art Institute, San Francisco
Selected References: San Francisco, San Francisco Museum of Modern Art, *Robert Hudson: A Survey*, text by Graham W. J. Beal, Jan Butterfield, and Michael Schwager (San Francisco, 1985).

37 **Teapot,** 1973
Porcelain with glaze
18⅝ × 9¾ × 7 inches
Provenance: Hansen Fuller Gallery, San Francisco, 1973; Professor and Mrs. R. Joseph Monsen, Seattle, 1973–85; Robert E. Aichele, Carmichael, California, 1986; Dorothy and George Saxe, Menlo Park, 1986–present.
Exhibitions: 1973: San Francisco, San Francisco Museum of Art, "Robert Hudson/Richard Shaw, Work in Porcelain" (exh. cat.); San Francisco, Hansen Fuller Gallery, "Robert Hudson"
PLATE 74

## MARGIE HUGHTO

Born: 1944, Endicott, New York
Resides: Jamesville, New York
Education: 1966, BS, State University of New York College at Buffalo; 1971, MFA, Cranbrook Academy of Art, Bloomfield Hills, Michigan
Selected References: Sherry Chayat, "The Ceramic Fans of Margie Hughto," *Ceramics Monthly* 28, 5 (May 1980), pp. 40–46; Sherry Chayat, "Landscapes without Boundary," *American Ceramics* 9, 3 (Fall 1991), pp. 18–25; Syracuse, New York, Everson Museum of Art, *Margie Hughto: Ceramics, 1980–1990* (Syracuse, 1991).

38 **Winter Sky,** 1983
Stoneware and porcelain with slip
29⅜ × 39 × 3¾ inches
Provenance: Garth Clark Gallery, Los Angeles,

1984; Dorothy and George Saxe, Menlo Park, 1984–present.
Exhibitions: 1984: Los Angeles, Garth Clark Gallery, "Margie Hughto"; Bennington, Vermont, Bennington College, Usdan Gallery, "Personal Imagery: Clay"
Publications: Jane Knoerle, "The Saxes' Hobby Has Grown into a World Class Collection," *The Country Almanac*, Apr. 3, 1991, p. 27 (ill.) (Home & Garden Special Section).
PLATE 75

## SIDNEY R. HUTTER

Born: 1954, Champaign, Illinois
Resides: Waltham, Massachusetts
Education: 1975, Pilchuck Glass Center, Stanwood, Washington; 1977, BS, Illinois State University, Normal; 1979, MFA, Massachusetts College of Art, Boston; 1979–80, Lowell Institute School at Massachusetts Institute of Technology, Cambridge; 1981, MA, Massachusetts College of Art, Boston
Selected References: "Hutter," *International Sculpture* 5, 5 (Sept.–Oct. 1986), p. 14; "How Art Springs Forth from Broken Windows," *The New York Times*, Jan. 3, 1988, sec. 1, p. 31; "Glass Art," *Rodale's Practical Homeowner* 3, 6 (July–Aug. 1988), p. 6.

39 **Plate Glass Vase #26,** 1981
Plate glass
11¾ × 7¹⁄₁₆ (dia.) inches
Marks: engraved on underside, Vase #26 / Sidney R. Hutter
Provenance: Habatat Gallery, Lathrup Village, Michigan, 1981; Dorothy and George Saxe, San Francisco, 1981–91; The Toledo Museum of Art, 1991.120.
Exhibitions: 1981: Lathrup Village, Michigan, Habatat Gallery, "9th Annual National Invitational Glass Exhibition"; 1986–87: Oakland, California, The Oakland Museum, "Contemporary American and European Glass from the Saxe Collection" (exh. cat., pp. 8, 80, ill.) (traveled to New York, American Craft Museum)
Publications: "Glass as Art," *Sunset Magazine* 177, 4 (Oct. 1986), p. 97; Robert Kehlmann, "Glass of the 80's," *American Craft* 47, 2 (Apr.–May 1987), p. 35 (ill.); Akiko Busch, "By Design: Art Glass Functions," *Metropolis* 7, 2 (Sept. 1987), p. 80 (ill.); Ferdinand Hampson, *Glass: State of the Art II* (Huntington Woods, Michigan [1989]), p. 14 (ill.).
PLATE 17

## DIANE ITTER

Born: 1946, Summit, New Jersey
Died: 1989
Education: 1969, BA, University of Pittsburgh, Pittsburgh; 1974, MFA, Indiana University, Bloomington

Selected References: Pam Scheinman, "Diane Itter," *Fiberarts* 5, 2 (1978), pp. 20–22; Janet Koplos, "The Knot as Brush Stroke: Diane Itter's Fiber Paintings," *American Craft* 40, 1 (Feb.–Mar. 1980), pp. 20–23; Diane Itter, "Making Patient Progress," *Surface Design Journal* 13, 4 (Summer 1989), pp. 11–13.

40 **Bandana Split #3,** 1985
Linen
16⅞ × 9⅞ inches
Marks: card on verso in printed typeface, DIANE ITTER / BANDANA SPLIT #3 / 1985 / Knotting / Linen
Provenance: Heller Gallery, New York, 1985; Dorothy and George Saxe, Menlo Park, 1985–present.
Exhibitions: 1985: New York, Heller Gallery, "Diane Itter: New Works of Knotted Linen"; 1989: Bloomington, Indiana, Indiana University, School of Fine Arts Gallery, "Diane Itter: Works in Knotted Linen"; 1990: Palo Alto, California, Palo Alto Cultural Center, "From Tapestry to Vessel: Contemporary Fiber Art" (exh. brochure, p. 3)
PLATE 101

## MARGIE JERVIS and SUSIE KRASNICAN

**Margie Jervis**
Born: 1956, Washington, D.C.
Resides: Seattle
Education: 1978, BFA, Rhode Island School of Design, Providence
**Susie Krasnican**
Born: 1954, Alliance, Ohio
Resides: Falls Church, Virginia
Education: 1978, Rhode Island School of Design, Providence; 1978, BFA, Cleveland Institute of Art, Cleveland
Selected References: "Margie Jervis & Susie Krasnican—Portfolio," *American Craft* 42, 6 (Dec. 1982–Jan. 1983), p. 42.

41 **Spotlit Bowl** (from the *Profiles and Silhouettes* series), 1982
Plate glass and enamel
9¼ × 19½ × 9½ inches
Marks: engraved on edge of base, JERVIS / Krasnican 1982
Provenance: Heller Gallery, New York, 1982; Dorothy and George Saxe, San Francisco, 1982–91; The Toledo Museum of Art, 1991.96.
Exhibitions: 1982: New York, Heller Gallery, "Silhouettes and Profiles: New Works by Margie Jervis and Susie Krasnican"; 1986–87: Oakland, California, The Oakland Museum, "Contemporary American and European Glass from the Saxe Collection" (exh. cat., p. 42, ill.) (traveled to New York, American Craft Museum)
PLATE 20

**KREG KALLENBERGER**
Born: 1950, Austin, Texas
Resides: Tulsa, Oklahoma
Education: 1972, BFA, University of Tulsa, Tulsa,
Oklahoma; 1974, MA, University of Tulsa, Tulsa,
Oklahoma
Selected References: Tulsa, Oklahoma, Philbrook
Art Center, *3 Series: Kallenberger in Glass* (Tulsa,
1986); Lindsay Heinsen, "The Southern Artist Kreg
Kallenberger," *Southern Accents* 14, 1 (Feb. 1991),
pp. 86–89.

42 **Hidden Springs** (from the *Osage* series), 1989
Cast optical crystal
9⅜ × 21⅝ × 5 inches
Marks: engraved on lower rear, K. Kallen 37389
Provenance: Habatat Galleries, Farmington Hills,
Michigan, 1989; Dorothy and George Saxe, San
Francisco, 1989–91; The Toledo Museum of Art,
1991.121.
Exhibitions: 1989: Farmington Hills, Michigan,
Habatat Galleries, "Kreg Kallenberger"
PLATE 21

**ROBERT KEHLMANN**
Born: 1942, Brooklyn, New York
Resides: Berkeley, California
Education: 1963, BA, Antioch College, Yellow
Springs, Ohio; 1966, MA, University of California,
Berkeley
Selected References: Robert McDonald, "Painting
in Glass," *Artweek* 9, 23 (June 17, 1978), p. 4;
Robert Kehlmann, "Lead and Glass Drawings,"
*Stained Glass* 73, 3 (Fall 1978), pp. 181–82;
Oakland, California, The Oakland Museum,
"Three Californians in Glass," *The Museum of
California* 3, 7 (Jan. 1980), pp. 10–12; Johannes
Schreiter, "Autonomous Panels by Robert
Kehlmann," *Neues Glas* 3 (1981), pp. 103–5.

43 **Composition #55**, 1979
Leaded glass with lead appliqués and steel
34 × 38⁷⁄₁₆ × 1 inches
Marks: engraved on front, lower right, RK 6/79 /
#55
Provenance: The William Sawyer Gallery, San
Francisco, 1981; Dorothy and George Saxe, San
Francisco, 1981–91; The Toledo Museum of Art,
1991.97.
Exhibitions: 1980: Walnut Creek, California,
Walnut Creek Civic Arts Gallery, "Current Trends in
Glass" (exh. cat.); 1982: San Francisco, The William
Sawyer Gallery, "Works on Glass"; 1986: Oakland,
California, The Oakland Museum, "Contemporary
American and European Glass from the Saxe
Collection" (exh. cat., p. 35, ill.) (traveled to New
York, American Craft Museum)
PLATE 22

**K. WILLIAM LeQUIER**
Born: 1953, Mount Holly, New Jersey
Resides: Readsboro, Vermont
Education: 1975, BS, Southern Connecticut State
University, New Haven

44 **Sentinel III**, 1985
Plate and blown glass
17¹⁄₁₆ × 18⅝ × 6 inches
Marks: engraved at lower right, KW LeQuier
7.1985
Provenance: Habatat Galleries, Lathrup Village,
Michigan, 1985; Dorothy and George Saxe,
San Francisco, 1985–91; The Toledo Museum
of Art, 1991.122.
Exhibitions: 1985: Lathrup Village, Michigan,
Habatat Galleries, "K. William LeQuier"; 1986–87:
Oakland, California, The Oakland Museum,
"Contemporary American and European Glass
from the Saxe Collection" (exh. cat., p. 47, ill.)
(traveled to New York, American Craft Museum)
Publications: Robert Kehlmann, "Glass of the
80's," *American Craft* 47, 2 (Apr.–May 1987), p. 33
(ill.); Gareth Fenley, "Silent Light for a Private
Gallery," *Architectural Lighting*, June 1989, p. 40
(ill.).
PLATE 23

**STANISLAV LIBENSKÝ and
JAROSLAVA BRYCHTOVÁ**
**Stanislav Libenský**
Born: 1921, Sezemice, Czechoslovakia
Resides: Prague and Železný Brod, Czechoslovakia
Education: 1937–38, Speciální škola sklářská, Nový
Bor, Czechoslovakia; 1938–39, Speciální škola
sklářská, Železný Brod, Czechoslovakia; 1939–44,
Speciální umělecko-průmyslová škola, Prague;
1949–50, Vysoká umělecko-průmyslová škola,
Prague
**Jaroslava Brychtová**
Born: 1924, Železný Brod, Czechoslovakia
Resides: Prague and Železný Brod, Czechoslovakia
Education: 1945–47, Vysoká umělecko-
průmyslová škola, Prague; 1947–51, Akademie
výtvarných umění, Prague
Selected References: Sylva Petrová,
"Contemporary Creators," *Bohemian Glass
1400–1989* (New York, 1990), pp. 160–65; Zurich,
Museum Bellerive, *Skulpturen aus Glas: Stanislav
Libenský und Jaroslava Brychtová, Prag Eine
Retrospektive 1945–1990*, text by Sigrid Barten,
Ludmila Vachtová, Sylva Petrová, Jaroslava
Brychtová, and Stanislav Libenský (Zurich, 1990);
Aleš Vašíček, "An Interview with Stanislav Libenský
and Jaroslava Brychtová," *Glasswork* 10 (Oct.
1991), front cover, pp. 10–19; Corning, New York,
The Corning Museum of Glass, *Stanislav Libenský
and Jaroslava Brychtová 1945–1993: A
Collaboration in Glass*, text by Susanne K. Frantz,
Jiří Setlik, and Sylva Petrová (Corning, in press).

45 **Head-Dish**, 1956 (issued 1983–84)
Saphirin-glass
4¾ × 11¾ × 5¾ inches
Marks: engraved on underside with artists' names
upside down, FOR GEORGE AND DOROTY
SAXE / 1956 / J. BRYCHTTOVÁ —
S. LIBENSKÝ–; white sticker reads OV 677
Provenance: Dorothy and George Saxe, San
Francisco, 1985–91; The Toledo Museum of Art,
1991.123.
PLATE 24

46 **The Cube in Sphere**, 1978–79 (issued in larger
version 1989)
Optical glass
15¼ × 15¼ (dia.) inches
Marks: engraved on rear at mid-right, S.LIBJBRY. /
1980–89
Provenance: Heller Gallery, New York, 1990;
Dorothy and George Saxe, San Francisco,
1990–92; The Toledo Museum of Art, 1993.5.
Exhibitions: 1990: New York, Heller Gallery,
"Libenský-Brychtová"
PLATE 25

47 **The Gray Table**, 1987 (issued 1988)
Cast glass
15⅝ × 30¼ × 10¼ inches
Marks: engraved along front leg on the side edge,
S LIBENSKÝ J BRYCHTOVÁ 1987
Provenance: Heller Gallery, New York, 1988;
Dorothy and George Saxe, San Francisco,
1988–91; The Toledo Museum of Art, 1991.98.
Exhibitions: 1988: New York, Heller Gallery,
"Stanislav Libenský, Jaroslava Brychtová: A 34 Year
Collaboration with Glass"
Publications: Paris, Clara Scremini Gallery,
*S. Libensky, J. Brychtova*, text by Sylva Petrová
(Paris, 1988), no. 12 (ill.); Sally Vallongo, "Gifts of
Glass: Couple's Collection Helps Art Museum to
Rebuild," *The Blade* (Toledo), June 14, 1992, p. 2.
PLATE 26

**MARK LINDQUIST**
Born: 1949, Oakland, California
Resides: Quincy, Florida
Education: 1971, BA, New England College,
Henniker, New Hampshire; 1971, Pratt Institute,
Brooklyn, New York; 1990, MFA, Florida State
University, Tallahassee
Selected References: Nancy Wright, "Mark
Lindquist: The Bowl Is a Performance," *American
Craft* 40, 5 (Oct.–Nov. 1980), pp. 22–27; Allys
Palladino-Craig, "Mark Lindquist: Making
Split Decisions," *Art Today* (Spring 1989),
pp. 24–28, 48.

48 **Ascending Bowl #9**, 1983
Elm burl
12 × 23⅛ × 24 inches
Marks: carved on underside of base, Mark

Lindquist / 1983 / Ascending Bowl / #9 / Elm Burl
Provenance: "Art for the Table" (The Fourth
Annual Benefit Auction for the American Craft
Museum), New York, 1984; Dorothy and George
Saxe, Menlo Park, 1984–present.
Exhibitions: 1984: New York, World Trade Center,
Windows on the World, "Art for the Table" (The
Fourth Annual Benefit Auction for the American
Craft Museum) (exh. brochure)
PLATE 107

**MELVIN LINDQUIST**
Born: 1911, Kingsburg, California
Resides: Quincy, Florida
Education: 1935, BS, Polytechnic College of
Engineering, Oakland, California
Selected References: Edward Jacobson, *The Art
of Turned-Wood Bowls,* with essays by Lloyd
Herman, Dale L. Nish, and Rudy H. Turk
(New York, 1985), pp. 45–46.

49 **Buckeye Root Burl Vase** (from the *Geometric*
series), 1983
Buckeye root burl
20¾ × 12¼ (dia.) inches
Marks: carved on underside, Mel Lindquist /
Buckeye Root / Burl / 5–83
Provenance: American Craft Enterprises, Inc.,
"The Fair at Rhinebeck," 1983; Dorothy and
George Saxe, Menlo Park, 1983–present
(purchased from the artist).
Publications: Jane Knoerle, "The Saxes' Hobby Has
Grown into a World Class Collection," *The Country
Almanac,* Apr. 3, 1991, p. 27 (ill.) (Home & Garden
Special Section).
PLATE 108

**MARVIN LIPOFSKY**
Born: 1938, Barrington, Illinois
Resides: Berkeley, California
Education: 1962, BFA, University of Illinois at
Urbana-Champaign; 1964, MS, MFA, University of
Wisconsin–Madison
Selected References: Cheryl White, "Marvin
Lipofsky: Roving Ambassador of Glass," *American
Craft* 51, 5 (Oct.–Nov. 1991), pp. 46–51; Maria
Porges, "Marvin Lipofsky—Artist and Educator,"
*Neues Glas* 4 (1991), pp. 8–15.

(assisted by Eric Bladholm, Tom Kreager,
and Fritz Dreisbach)
50 **Pilchuck Summer Series 1988–89 #3,**
1988–89
Blown glass
12 × 15¾ × 13 inches
Marks: engraved on bottom, PILCHUCK
SUMMER SERIES / 1988–89 *Lipofsky #3*
Provenance: Leo Kaplan Ltd., New York, 1989;
Dorothy and George Saxe, San Francisco,

1989–91; The Toledo Museum of Art, 1991.124.
Exhibitions: 1989: New York, Leo Kaplan Ltd.,
"Marvin Lipofsky: New Sculpture"
Publications: New York, American Craft Museum,
*The Collector's Eye* (New York, 1991), p. 42 (ill.).
PLATE 27

**HARVEY K. LITTLETON**
Born: 1922, Corning, New York
Resides: Spruce Pine, North Carolina
Education: 1939–42, University of Michigan,
Ann Arbor; 1941, Cranbrook Academy of Art,
Bloomfield Hills, Michigan; 1945, Brighton School
of Art, Brighton, England; 1947, BD, University of
Michigan, Ann Arbor; 1951, MFA, Cranbrook
Academy of Art, Bloomfield Hills, Michigan
Selected References: Atlanta, High Museum of Art,
*Harvey K. Littleton: A Retrospective Exhibition,*
text by Joan Falconer Byrd (Atlanta, 1984);
Ebeltoft, Denmark, Glasmuseum, *Littleton/Fujita,*
text by Joan Falconer Byrd (Ebeltoft, 1989).

51 **300° Rotated Ellipsoid,** 1980
Blown glass
Large piece: 15⅛ × 6⅝ × 7⅜ inches; small piece:
3½ × 6⅞ × 3¼ inches
Marks: engraved on the large piece on lower rear,
© *Harvey K Littleton 1980;* engraved on the small
piece on underside, © *Harvey K Littleton 1980*
Provenance: Heller Gallery, New York, 1980;
Dorothy and George Saxe, San Francisco,
1980–present.
Exhibitions: 1980: New York, Heller Gallery,
"Harvey Littleton & Raoul Goldoni: Masters of
Light, Volume and Space"; 1982–83: New York,
American Craft Museum, "Approaches to
Collecting"
PLATE 28

**MICHAEL LUCERO**
Born: 1953, Tracy, California
Resides: New York
Education: 1975, BA, Humbolt State University,
Arcata, California; 1978, MFA, University of
Washington, Seattle
Selected References: William Zimmer, "A New
Figure on the Horizon," *American Ceramics* 1, 1
(Winter 1982), pp. 26–29; Mark Shannon,
"Michael Lucero: The Unnatural Science of
Dreams," *American Ceramics* 5, 2 (1986),
pp. 28–33; Cincinnati, The Contemporary
Arts Center, *Michael Lucero: Recent Work,* text by
Jan Riley (Cincinnati, 1990).

52 **Self-Portrait (Pre-Columbus),** 1990
Glazed earthenware
19¼ × 11¾ × 11¾ inches
Marks: inscribed on underside, 1990 / *Michael
Lucero* / N.Y.C.

Provenance: Fay Gold Gallery, Atlanta, 1990;
Dorothy and George Saxe, Menlo Park,
1990–present.
Exhibitions: 1990: Atlanta, Fay Gold Gallery,
"Michael Lucero: Recent Ceramic Sculpture"
PLATE 76

**FLORA C. MACE and
JOEY KIRKPATRICK**
**Flora C. Mace**
Born: 1949, Exeter, New Hampshire
Resides: Seattle
Education: 1972, BS, Plymouth State College,
Plymouth, New Hampshire; 1975, University of
Utah, Salt Lake City; 1976, MFA, University of
Illinois at Urbana-Champaign
**Joey Kirkpatrick**
Born: 1952, Des Moines, Iowa
Resides: Seattle
Education: 1975, BFA, University of Iowa, Iowa
City; 1978–79, Iowa State University, Ames; 1979,
The Pilchuck School, Stanwood, Washington
Selected References: Bonnie Miller, "Double
Vision," *American Craft* 49, 5 (Oct.–Nov. 1989),
pp. 40–45; Susan Biskeborn, *Artists at Work:
Twenty-five Northwest Glassmakers, Ceramists,
and Jewelers* (Seattle and Anchorage, 1990),
pp. 10–15.

53 **First Doll Portrait/The Chinaman,** 1980
Blown glass, wire, and glass threads
10¼ × 5⅞ (dia.) inches
Marks: engraved on underside, *Joey Kirkpat/ 1980
Flora C Mace*
Provenance: Habatat Gallery, Lathrup Village,
Michigan, 1980; Dorothy and George Saxe, San
Francisco, 1980–91; The Toledo Museum of Art,
1991.99.
Exhibitions: 1982–83: New York, American Craft
Museum, "Approaches to Collecting"
Publications: Paul Hollister, "Personification of
Feelings: The Mace/Kirkpatrick Collaboration,"
*Neues Glas* 1 (1984), p. 15 (ill.); "Glass as Art,"
*Sunset Magazine* 177, 4 (Oct. 1986), p. 97 (ill.).
PLATE 31

54 **Garden of Ladders,** 1989
Blown glass, enamel, and painted alderwood
74 × 33½ × 16⅝ inches
Marks: engraved on lower rear of head,
*Joey Kirkpatk Flora C Mace 1989*
Provenance: Dorothy and George Saxe, San
Francisco, 1989–91 (purchased from the artists);
The Toledo Museum of Art, 1991.125.
Exhibitions: 1989: Seattle, Seattle Art Museum,
"Figures of Translucence" (exh. cat., *Documents
Northwest: The Poncho Series* 6, 4, ill.)
PLATE 30

**LINDA MacNEIL**

Born: 1954, Boston
Resides: Kensington, New Hampshire
Education: 1974, Massachusetts College of Art, Boston; 1976, BFA, Rhode Island School of Design, Providence
Selected References: Terri Lonier, "Linda MacNeil—Artistic Innovation in Glass," *Neues Glas* 2 (1985), front cover, pp. 60–65; Rika Kuroki, "Linda MacNeil" (interview), *Glasswork* 3 (1989), pp. 16–21.

**55 Untitled,** 1982
Lead crystal and 14k yellow gold
w. 4 inches, L. 9½ inches (clasp closed); extended 19 inches (clasp opened)
Marks: marked on verso of gold with artist's name encircled, macneil 14k
Provenance: Dorothy and George Saxe, Menlo Park, 1982–present (purchased from the artist).
PLATE 115

**SAM MALOOF**

Born: 1916, Chino, California
Resides: Alta Loma, California
Education: self-taught
Selected References: Washington, D.C., Renwick Gallery of the National Collection of Fine Arts, Smithsonian Institution, and St. Paul, Minnesota, Minnesota Museum of Art, *Woodenworks: Furniture Objects by Five Contemporary Craftsmen—George Nakashima, Sam Maloof, Wharton Esherick, Arthur Espenet Carpenter, Wendell Castle* (Washington, D.C., 1972), pp. 13–21; Sam Maloof, *Sam Maloof, Woodworker,* intro. by Jonathan Fairbanks (Tokyo, New York, San Francisco, 1983); Michael A. Stone, "Sam Maloof," *Contemporary American Woodworkers* (Layton, Utah, 1986), pp. 64–81.

**56 Untitled,** 1990
Fiddleback maple and ebony
30⁵⁄₁₆ × 22½ × 19³⁄₈ inches
Marks: marked under the seat near rear leg, No. 37 1990 / Sam Maloof f. A.C.C. / ©; jmó
Provenance: Dorothy and George Saxe, Menlo Park, 1991–present (purchased from the artist).
PLATE 109

**RICHARD MARQUIS**

Born: 1945, Bumblebee, Arizona
Resides: Freeland, Washington
Education: 1967, BA, University of California, Berkeley; 1972, MA, University of California, Berkeley
Selected References: Richard Marquis, "murrini/canne," *Glass Art Magazine* 1, 1 (Jan.–Feb. 1973), pp. 39–44; Bonnie Miller, "The Irreverent Mr. Marquis," *Neues Glas* 2 (1988), pp. 78–84;

Koji Matano, "Richard Marquis" (interview), *Glasswork* 2 (July 1989), pp. 20–25.

**57 FWS #2** (from the *Fabricated Weird* series), 1979
Blown and fabricated glass
3¾ × 5½ × 4¾ inches
Marks: engraved on base of teapot: ©1979 / Marquis / # FWS #2
Provenance: Meyer Breier Weiss, San Francisco, 1980; Dorothy and George Saxe, San Francisco, 1980–91; The Toledo Museum of Art, 1991.126.
Exhibitions: 1980: Los Angeles, Craft and Folk Art Museum, "Four Leaders in Glass" (exh. cat., no. 7, ill.)
Publications: Sally Vallongo, "Gifts of Glass: Couple's Collection Helps Art Museum to Rebuild," *The Blade* (Toledo), June 14, 1992, p. 1 (ill.), 2.
PLATE 33

**58 Personal Archive Unit — Granite-Ware Landscape Lamp,** 1981–84
Painted plywood, blown glass, and found objects (including ceramics, Bakelite, enamel, photograph, light bulb, and sand)
28 × 17 × 10 inches
Marks: location markers under objects; marked near neck of teapot, © 1980 / Marquis
Provenance: The Mindscape Collection, Chicago, 1984–85; Dorothy and George Saxe, San Francisco, 1985–91; The Toledo Museum of Art, 1991.127.
Exhibitions: 1984: Chicago, The Mindscape Collection, "Richard Marquis: New Works in Glass and Mixed Media" (exh. announcement, ill.); 1986–87: Oakland, California, The Oakland Museum, "Contemporary American and European Glass from the Saxe Collection" (exh. cat., p. 31, ill.) (traveled to New York, American Craft Museum)
Publications: "G.A.S. Gallery," *Glass Art Society Journal,* 1986, p. 97 (ill.); Robert Kehlmann, "Glass of the 80s," *American Craft* 47, 2 (Apr.–May 1987), back cover (ill.); Providence, Rhode Island, Rhode Island School of Design, "Department of Decorative Arts," *Museum Notes 1988,* text by Thomas S. Michie (Providence, 1988), p. 27.
PLATE 32

**ALPHONSE MATTIA**

Born: 1947, Philadelphia
Resides: Westport, Massachusetts
Education: 1969, BFA, Philadelphia College of Art, Philadelphia; 1973, MFA, Rhode Island School of Design, Providence
Selected References: Boston, Museum of Fine Arts, *New American Furniture: The Second Generation of Studio Furniture Makers,* text by Edward S. Cooke, Jr. (Boston, 1989), pp. 76–79; Debra Scott, "Boston's Originals," *Boston Magazine* 8, 10 (Oct. 1989), pp. 118–21; Joan Jeffri, ed., *The*

*Craftsperson Speaks: Artists in Various Media Discuss Their Crafts* (Westport, Connecticut, 1992), pp. 97–116; New York, Peter Joseph Gallery, and East Hampton, Long Island, Pritam & Eames, *Speaking of Furniture: Conversations with the New American Masters,* text by Edward S. Cooke, Jr., Rose Slivka, Roger Holmes, Rosanne Somerson, Joan Retalluck, Warren Eames Johnson, and Bebe Pritam Johnson (New York, in press).

**59 Hors d'Oeuvre Server** (from the *Valets & Butlers* series), 1984
Bleached and dyed mahogany, ebonized walnut, purpleheart, holly, boxwood, poplar, beefwood, ebony, lacquered Baltic birch plywood, and birch
65¾ × 22¾ × 15¾ inches
Marks: carved, then painted on stretcher (rail), *Alphonse Mattia / Boston 1984*
Provenance: "Art for the Table" (The Fourth Annual Benefit Auction of Contemporary American Craft sponsored by the Associates of the American Craft Museum), New York, 1984; Dorothy and George Saxe, Menlo Park, 1984–present.
Exhibitions: 1984: New York, "Art for the Table" (The Fourth Annual Benefit Auction of Contemporary American Craft sponsored by the Associates of the American Craft Museum) (exh. brochure); 1988–90: Tulsa, Oklahoma, The Philbrook Museum of Art, "The Eloquent Object" (exh. cat., p. 181, ill., hardcover edition; p. 97, ill., paperback edition) (traveled to Oakland, California, The Oakland Museum; Boston, Museum of Fine Arts; Chicago, Chicago Public Library Cultural Center; Orlando, Orlando Museum of Art; Richmond, Virginia, Virginia Museum of Fine Arts; Kyoto, The National Museum of Modern Art; Tokyo, The National Museum of Modern Art)
PLATE 110

**RICHARD MEITNER**

Born: 1949, Philadelphia
Resides: Amsterdam
Education: 1972, BA, University of California, Berkeley; 1974–75, Rijksakademie van Beeldende Kunsten, Amsterdam; 1975, State Diploma, Gerrit Rietveld Academie, Amsterdam
Selected References: Cees Straus, "Glass Evokes Emotion—The Art of Richard Meitner," *Neues Glas* 2 (1985), pp. 82–87; Jean Luc Olivié, "Richard Meitner," *Neues Glas* 4 (1991), pp. 26–31.

**60 Untitled,** 1984
Blown glass and enamel
14½ × 9¼ × 6 inches
Marks: engraved on underside, *R Meitner 84*
Provenance: Habatat Galleries, Lathrup Village, Michigan, 1984; Dorothy and George Saxe, San Francisco, 1984–91; The Toledo Museum of Art, 1991.100.
Exhibitions: 1984: Lathrup Village, Michigan,

Habatat Galleries, "The 12th National Glass Invitational Exhibition"; 1986–87: Oakland, California, The Oakland Museum, "Contemporary American and European Glass from the Saxe Collection" (exh. cat., p. 51, ill.) (traveled to New York, American Craft Museum)
Publications: Paris, Musée des Arts Décoratifs, *Richard Meitner—Le Verre, le contraire et l'autre,* text by Yvonne Brunhammer, Jean Luc Olivié, and Gérard Gaveau (Paris and Liège, 1991), p. 30 (ill.); Paris, Galerie D. M. Sarver, and Frankfurt, SM Galerie Edith Gottschalk, *Meitner,* text by Yvonne Brunhammer (Paris, 1985), (ill.).
PLATE 29

## KLAUS MOJE
Born: 1936, Hamburg
Resides: Canberra, Australia
Education: 1957, Staatliche Glasfachschule, Rheinbach, Germany; 1959, Masters Certificate, Staatliche Glasfachschule, Hadamar, Germany
Selected References: Paul Hollister, "Klaus Moje," *American Craft* 44, 6 (Dec. 1984–Jan. 1985), pp. 18–22; Ebeltoft, Denmark, Glasmuseum, *Klaus Moje/Dale Chihuly,* text by Finn Lynggaard, Helmut Ricke, and Karen S. Chambers (Ebeltoft, 1991).

### 61 Untitled (Bowl or Lifesaver), 1979
Fused rods of glass
3⅞ × 10¹⁄₁₆ (dia.) inches
Marks: engraved on underside, Moje / 1979
Provenance: Dorothy and George Saxe, San Francisco, 1981–92 (purchased from the artist); The Toledo Museum of Art, 1993.6.
Exhibitions: 1980: Kyoto, The National Museum of Modern Art, and Tokyo, The National Museum of Modern Art, "Contemporary Glass—Europe & Japan" (exh. cat., no. 352, ill.); 1982–83: New York, American Craft Museum, "Approaches to Collecting"; 1986–87: Oakland, California, The Oakland Museum, "Contemporary American and European Glass from the Saxe Collection" (exh. cat., pp. 8, 62, ill.) (traveled to New York, American Craft Museum)
Publications: "Klaus & Isgard Moje," *Glass Art Society Journal,* 1979, p. 19 (ill.); Kyoto, The National Museum of Modern Art, *Contemporary Studio Glass: An International Collection,* text by Shigeki Fukunaga (New York, Tokyo, and Kyoto, 1982), no. 42 (ill.); Robert Kehlmann, "Glass of the 80's," *American Craft* 47, 2 (Apr.–May 1987), p. 35 (ill.); Ferdinand Hampson, *Glass: State of the Art II* (Huntington Woods, Michigan, 1989), p. 14.
PLATE 34

### 62 Untitled 11–1989 #47 (Mailupi #5), 1989
Fused rods of glass
19¾ × 19¾ × 2³⁄₁₆ inches
Marks: engraved on lower left corner, *Klaus Moje 11–1989#47*

Provenance: Habatat Galleries, Bay Harbor Island, Florida, 1990; Dorothy and George Saxe, San Francisco, 1990–92; The Toledo Museum of Art, 1993.7.
Exhibitions: 1989: Bay Harbor Island, Florida, Habatat Galleries, "7th International Glass Exhibition"
Publications: Geoffrey Edwards, "New Glass by Klaus Moje—'Like an Oriental Calzedonio,'" *Neues Glas* 3 (1990), pp. 201, 203 (ill.); Shawn Waggoner, "The Work of Klaus Moje: A New Order," *Glass Art* 7, 4 (May–June 1992), p. 6 (ill.).
PLATE 35

## JUDY MOONELIS
Born: 1953, Jackson Heights, New York
Resides: New York
Education: 1975, BFA, Tyler School of Art, Temple University, Philadelphia; 1978, MFA, New York State College of Ceramics at Alfred University, Alfred
Selected References: Gnosis Nos, "Crossing the Boundaries of Intimacy," *American Ceramics* 5, 2 (1986), pp. 18–27.

### 63 Untitled (Green Storm), 1985
Ceramic with terra sigillata
14¾ × 21¾ × 13¼ inches
Marks: inscribed along lower side of base, JUDY MOONELIS / 1985
Provenance: Robert L. Kidd Associates Incorporated, Birmingham, Michigan, 1986–87; Dorothy and George Saxe, Menlo Park, 1987–present.
Exhibitions: 1985: San Francisco, Rena Bransten Gallery, "Judy Moonelis: Sculpture"; 1986–87: Birmingham, Michigan, Robert L. Kidd Associates Inc., "Major Concepts: Clay"
PLATE 77

## WILLIAM MORRIS
Born: 1957, Carmel, California
Resides: Arlington, Washington
Education: 1975–76, California State University, Chico; 1977–78, Central Washington University, Ellensburg; 1978–79, The Pilchuck School, Stanwood, Washington
Selected References: Henry Geldzahler, Patterson Sims, and Narcissus Quagliata, *William Morris Glass: Artifact and Art* (Seattle, 1989); Susan Biskeborn, *Artists at Work: Twenty-five Northwest Glassmakers, Ceramists, and Jewelers* (Seattle and Anchorage, 1990), pp. 34–38.

### 64 Petroglyph Vessel, 1989
Blown glass
21¼ × 20¹⁵⁄₁₆ × 4⁷⁄₁₆ inches
Marks: engraved along base, *William Morris 1989*
Provenance: Dorothy and George Saxe, San

Francisco, 1989–91 (purchased from the artist); The Toledo Museum of Art, 1991.128.
PLATE 36

### 65 Artifact Still Life, 1989–90
Blown glass, scavo, gold leaf, and copper
15 × 44 × 22¼ inches (with base)
Marks: engraved on center of clear bone, *William Morris 1990;* on edge of large blue bone, *William Morris;* on top of small central bone, WM 90; on bone farthest to the side, *William Morris 1989;* on white bone, *William Morris 1990*
Provenance: Dorothy and George Saxe, San Francisco, 1990–present (purchased from the artist).
PLATE 37

## JAY MUSLER
Born: 1949, Sacramento, California
Resides: Berkeley, California
Education: 1968–71, California College of Arts & Crafts, Oakland
Selected References: Paul Hollister, "Jay Musler's Painted Glass: The Face of Anger," *Neues Glas* 1 (1985), pp. 12–19; Lisa Hammel, "An Apocalyptic Art," *American Craft* 48, 5 (Oct.–Nov. 1988), front cover, pp. 26–31.

### 66 Rock around the Clock, 1982
Blown Pyrex and paint
6¾ × 17¼ × 16⅛ inches
Marks: engraved on underside, –MUSLER–© / 82
Provenance: Dorothy and George Saxe, San Francisco, 1983–91 (purchased from the artist); The Toledo Museum of Art, 1991.129.
Exhibitions: 1983: Tucson, Arizona, Tucson Museum of Art, "Sculptural Glass" (exh. cat., p. 46) (traveled to Toledo, Owens-Illinois Art Center); 1984: Huntington, West Virginia, Huntington Galleries, "New American Glass: Focus West Virginia 1984" (exh. cat., pp. 11–12)
PLATE 40

## JOEL PHILIP MYERS
Born: 1934, Paterson, New Jersey
Resides: Bloomington, Illinois
Education: 1951–54, Parsons School of Design, New York; 1957–58, Kunsthaandvaerkerskolen, Copenhagen; 1962, BFA, New York State College of Ceramics at Alfred University, Alfred; 1968, MFA, New York State College of Ceramics at Alfred University, Alfred
Selected References: Michael Boylen, "Compositions on Black: Joel Philip Myers," *American Craft* 40, 5 (Oct.–Nov. 1980), pp. 8–11; Paul Hollister, "Joel Philip Myers' Glass: 'A Quiet, Peaceful Way of Working,'" *Neues Glas* 3 (1983), pp. 128–33.

**67 Untitled** (CFBLACD) (from the *Contiguous Fragment* series), 1981
Blown glass
12½ × 4¹³⁄₁₆ × 5⅛ inches
Marks: engraved along base, *Joel Philip Myers 1981*
Provenance: Dorothy and George Saxe, San Francisco, 1990–91 (purchased from the artist); The Toledo Museum of Art, 1991.130.
Exhibitions: 1981: Wausau, Wisconsin, Leigh Yawkey Woodson Art Museum, "Americans in Glass" (exh. cat., published as CFBLYW, p. 56, ill.) (traveled to New York, The Cooper-Hewitt Museum, The Smithsonian Institution's National Museum of Design; Champaign, Illinois, The Krannert Art Museum; Baltimore, Walters Art Gallery; Monroe, Louisiana, Masur Museum of Art; Coral Gables, Florida, University of Miami, Lowe Art Museum; Minneapolis, University of Minnesota, University Art Museum; Anchorage, Anchorage Historical and Fine Arts Museum; Colorado Springs, Colorado Springs Fine Arts Center; Honolulu, Honolulu Academy of Arts; Pittsfield, Massachusetts, The Berkshire Museum)
Publications: Paris, Clara Scremini Gallery, *Joel Philip Myers: Oeuvres,* text by Dan Klein (Paris, 1988), no. 7 (ill.).
PLATE 39

**68 Untitled** (CFOURTURBLUEJPM)
(from the *Contiguous Fragment* series), 1988
Blown glass
13¼ × 4 (dia.) inches
Marks: engraved along base, *Joel Philip Myers 1988*
Provenance: Dorothy and George Saxe, San Francisco, 1990–92 (purchased from the artist); The Toledo Museum of Art, 1993.8.
PLATE 38

**RON NAGLE**
Born: 1939, San Francisco
Resides: San Francisco
Education: 1961, BA, San Francisco State University, San Francisco
Selected References: St. Louis, The St. Louis Art Museum, *Currents 4: Ron Nagle,* text by Jack Cowart (St. Louis, 1979); Susan Wechsler, *Low-Fire Ceramics* (New York, 1981), pp. 100–105; Barbaralee Diamonstein, *Handmade in America: Conversations with Fourteen Craftmasters* (New York, 1983), pp. 166–79.

**69 Untitled (Saxe Appeal),** 1982
Earthenware with overglaze
5¼ × 3⅞ × 3⅝ inches
Provenance: Quay Gallery, San Francisco, 1982; Dorothy and George Saxe, Menlo Park, 1982–present.
Exhibitions: 1982: San Francisco, Quay Gallery, "Ron Nagle: Recent Work"; 1986: Oakland,

California, The Mills College Art Gallery, "Mills College Art Department Faculty Retrospective Exhibition"
Publications: Jane Knoerle, "The Saxes' Hobby Has Grown into a World Class Collection," *The Country Almanac,* Apr. 3, 1991, p. 26 (ill.) (Home & Garden Special Section).
PLATE 78

**70 Red and Turquoise Knob Job,** 1984
Earthenware with overglaze in box construction
2⅞ × 4¼ × 2¼ inches
Provenance: The Quay Gallery, San Francisco, 1984; Dorothy and George Saxe, Menlo Park, 1984–present.
Exhibitions: 1984: San Francisco, The Quay Gallery, "Ron Nagle"
Publications: Jane Knoerle, "The Saxes' Hobby Has Grown into a World Class Collection," *The Country Almanac,* Apr. 3, 1991, p. 26 (ill.) (Home & Garden Special Section).
PLATE 79

**NANCE O'BANION**
Born: 1949, Oakland, California
Resides: Oakland, California
Education: 1971, BA, University of California, Berkeley; 1973, MA, University of California, Berkeley
Selected References: Mary Stofflet, "Nance O'Banion: Illusions and Ambiguities," *American Craft* 42, 3 (June–July 1982), pp. 16–19, 80; Claire Campbell Park, "Finding the Link between Fiber and Mixed Media," *Fiberarts* 18, 1 (Summer 1991), pp. 39–42.

**71 Naked Compound Compression**
(from the *Naked* series), 1982
Abaca paper, rattan, bamboo, acrylic paint, pastel, and wax-coated linen
41½ × 55¾ inches
Marks: painted on lower right, *Nance O'Banion 1982*
Provenance: The Allrich Gallery, San Francisco, 1983; Dorothy and George Saxe, Menlo Park, 1983–present.
Exhibitions: 1983: San Francisco, The Allrich Gallery, "Split Vision: Paper Planes and Bamboo Obstacles"
PLATE 102

**PAVEL OPOČENSKÝ**
Born: 1954, Karlovy Vary, Czechoslovakia
Resides: Brooklyn, New York
Education: 1971–72, Střední umělecko-průmyslová škola—kov a šperk, Jablonec nad Nisou, Czechoslovakia; 1973–74, Střední umělecko-průmyslová škola šperkařska, Turnov, Czechoslovakia

Selected References: JoAnn Goldberg, "Pavel Opočenský," *Ornament* 9, 4 (1986), pp. 44–49; Susan Grant Lewin and Toni Lesser Wolf, *Contemporary American Jewelry,* intro. by Barbara Rose (New York, in press).

**72 Ivory Brooch,** 1986
Ivory with gilded fasteners
3⅜ × 2⅝ × ¾ inches
Marks: carved in verso between pins, P inside a circle
Provenance: Dorothy and George Saxe, Menlo Park, 1986–present (purchased from the artist).
PLATE 116

**EARL PARDON**
Born: 1926, Memphis, Tennessee
Died: 1991
Education: 1951, BFA, Memphis Academy of Arts, Memphis, Tennessee; 1959, MFA, Syracuse University, Syracuse, New York
Selected References: JoAnn Goldberg, "Earl Pardon: Master American Jeweler," *Ornament* 10, 1 (1986), pp. 42–49; Sharon Church, "Color, Construction and Change: The Inventive Jewelry of Earl Pardon," *Metalsmith* 10 (Winter 1990), front cover, pp. 18–25.

**73 Necklace,** 1984
14K gold, sterling silver, hematite beads, garnets, enamel, shell, and a red cubic zirconium
w. 2 inches, L. 9⅝ inches (clasp closed); extended 16½ inches (clasp opened)
Marks: marked and stamped on verso of pendant, proper left side, STERLING / *Pardon* / 14K
Provenance: Aaron Faber Gallery, New York, 1985; Dorothy and George Saxe, Menlo Park, 1985–present.
Exhibitions: 1984: New York, Aaron Faber Gallery, "Neo-Constructivism"
PLATE 117

**TOM PATTI**
Born: 1943, Pittsfield, Massachusetts
Resides: Plainfield, Massachusetts
Education: 1967, BID, Pratt Institute, Brooklyn, New York; 1969, New School for Social Research, New York; 1969, MID, Pratt Institute, Brooklyn, New York; 1970, Penland School of Crafts, Penland, North Carolina
Selected References: Springfield, Massachusetts, The George Walter Vincent Smith Art Museum, *Tom Patti: Glass,* text by Robert Henning, Jr. (Springfield, 1980); Paul Hollister, "Tom Patti: The Code Is in the Glass," *Neues Glas* 2 (1983), pp. 74–83; St. Louis, The St. Louis Art Museum, *Currents 24: Tom Patti,* text by Sidney M. Goldstein (St. Louis, 1984).

**74 Split Ascending Red,** 1990
Float glass
5½ × 4⅞ × 3¼ inches
Marks: engraved on side along base, *Patti* 1990
Provenance: Holsten Gallery, Palm Beach, Florida, 1990; Dorothy and George Saxe, San Francisco, 1990–present.
PLATE 41

## MICHAEL PAVLIK

Born: 1941, Prague
Resides: Shelburne Falls, Massachusetts
Education: 1964, MA, Škola Užitkové Grafiky, Prague
Selected References: Michael Pavlik, "Michael Pavlik," *Glass* 6, 1 (Jan. 1978), pp. 11–13; Marilyn Becker, "Michael Pavlik, a Biography," unpublished manuscript, Heller Gallery Archives, New York; New York, Heller Gallery, *Michael Pavlik: Ecstatic Geometry,* text by Donald Kuspit (New York, 1992).

**75 Equivocal Equinox,** 1983
Blown and cast glass
12⅛ × 13⅛ × 10¼ inches
Marks: engraved on bottom left edge of the outer circular form, *Michael Pavlik 1983 #1759*
Provenance: Heller Gallery, New York, 1983–84; Dorothy and George Saxe, San Francisco, 1984–91; The Toledo Museum of Art, 1991.131.
Exhibitions: 1983: New York, Heller Gallery, "Michael Pavlik: New Glass Sculpture"; 1986–87: Oakland, California, The Oakland Museum, "Contemporary American and European Glass from the Saxe Collection" (as *Dual Gate Series,* p. 52, ill.) (traveled to New York, American Craft Museum)
PLATE 44

## MARK PEISER

Born: 1938, Chicago
Resides: Penland, North Carolina
Education: 1955–57, Purdue University, West Lafayette, Indiana; 1962, BS, Illinois Institute of Technology, Chicago; 1964–66, DePaul University, Chicago; 1967, Penland School of Crafts, Penland, North Carolina
Selected References: Maureen Michelson, "Profile: Mark Peiser," *Glass* 9, 1 (Jan. 1982), pp. 74–80; Joan Falconer Byrd, "Mark Peiser," *New Work* 37 (Spring 1989), pp. 8–13.

**76 Leda and the Swan**
(from the *Paperweight Vase* series), 1980
Zinc crystal, flourine opal, and gold foil
7¾ × 7⅝ (dia.) inches
Marks: engraved on bottom edge, MARK PEISER · PMV 285 · 1980
Provenance: Habatat Gallery, Lathrup Village, Michigan, 1980; Dorothy and George Saxe, San

Francisco, 1980–91; The Toledo Museum of Art, 1991.132.
Exhibitions: 1980: Lathrup Village, Michigan, Habatat Gallery, "Mark Peiser: An Exhibition of Recent Work"
PLATE 43

**77 IS 458 (After the Storm)**
(from the *Skyscape* series), 1988
Cast glass
9⅝ × 19 × 3⅛ inches
Marks: engraved on front, bottom edge, *PEISER · IS458 88 ©*
Provenance: Heller Gallery, New York, 1988; Glass Art Gallery, Toronto, 1989; Dorothy and George Saxe, San Francisco, 1989–92; The Toledo Museum of Art, 1993.9.
Exhibitions: 1988: New York, Heller Gallery, "Mark Peiser: Inner Spaces"; 1989: Toronto, Glass Art Gallery, "Recent Works by Mark Peiser"
Publications: New York, American Craft Museum, *The Collector's Eye* (New York, 1991), p. 42 (ill.).
PLATE 42

## KENNETH PRICE

Born: 1935, Los Angeles
Resides: Venice, California
Education: 1956, BFA, University of Southern California, Los Angeles; 1957, Los Angeles County Art Institute, Los Angeles; 1959, MFA, New York State College of Ceramics at Alfred University, Alfred
Selected References: Joan Simon, "An Interview with Ken Price," *Art in America* 68,1 (Jan. 1980), pp. 98–104; New York, Whitney Museum of American Art, *Ceramic Sculpture: Six Artists,* text by Suzanne Foley and Richard Marshall (New York, Seattle, and London, 1981).

**78 Untitled (Ferro or Block),** 1983
Painted clay in box construction
4⅜ × 4½ × 4⅝ inches
Marks: on upper side of wood base in middle of member, KP#7©
Provenance: Charles Cowles Gallery, New York, 1983; Dorothy and George Saxe, Menlo Park, 1983–present.
Exhibitions: 1983: New York, Leo Castelli Gallery, "Ken Price"
Publications: Jane Knoerle, "The Saxes' Hobby Has Grown into a World Class Collection," *The Country Almanac,* Apr. 3, 1991, p. 26 (ill.) (Home & Garden Special Section).
PLATE 80

**79 Gunktor,** 1985
Fired clay with acrylic and metallic paint
Large piece: 7⅝ × 8¾ × 7¾ inches; small piece: 6⅞ × 6 × 5¹³⁄₁₆ inches
Provenance: Willard Gallery, New York, 1985; Dorothy and George Saxe, Menlo Park, 1985–present.

Exhibitions: 1985: New York, Willard Gallery, "Ken Price: Recent Sculpture"
Publications: Jeanne Silverthorne, "Ken Price: Willard Gallery," *Artforum* 24, 5 (Jan. 1986), p. 91 (ill., as *Mungor*); Joshua Teplow, "Ken Price" (review), *Arts Magazine* 60, 5 (Jan. 1986), p. 130 (ill., as *Mungor*); Houston, The Menil Collection, *Ken Price* (Houston, 1992), pp. 40–41, pl. 17 (ill., as *Mungor*).
PLATE 81

## RAMÓN PUIG CUYÁS

Born: 1953, Mataró, Spain
Resides: Barcelona
Education: 1969–74, Escola Massana, Barcelona
Selected References: Barcelona, Fundació Caixa de Pensions, *Joieria Europea Contemporània,* text by Fritz Falk, Francesc Miralles, Daniel Giralt-Miracle, and Peter Dormer (Barcelona, 1987), pp. 56–57, 211–12, 259–60; Pforzheim, Germany, Schmuckmuseum, *Ornamenta 1: Internationale Schmuckkunst* (Munich, 1989), pp. 41, 178–79.

**80 The King,** 1989
Sterling silver and enamel paint
5⅝ × 3⅛ inches
Marks: stamped on head of figure on verso, PUIG / CUYAS
Provenance: Helen Drutt Gallery, New York, 1990; Dorothy and George Saxe, Menlo Park, 1990–present.
Exhibitions: 1990: New York, Helen Drutt Gallery, "Adela Akers/William Daley/Ramón Puig Cuyás"
PLATE 118

## CLIFFORD RAINEY

Born: 1948, Whitehead, County Antrim, Northern Ireland
Resides: Oakland, California, and London
Education: 1968–69, Hornsey College of Art, London; 1969–71, North East London Polytechnic, London; 1971–73, Royal College of Art, London
Selected References: Belfast, Arts Council of Northern Ireland, *Clifford Rainey: Sculpture & Drawings, 1967–1987* (Belfast, 1987).

**81 Fetish,** 1989
Recycled cast glass, plate glass, and nails
23¾ × 9¾ × 10⅜ inches
Marks: engraved on top side center of each piece of plate glass,
A. ONE   B. TWO   C. THREE
   Rainey   Rainey   Rainey
Lower three cast sections each marked on top side center with grease pencil, one, 2, 3
Provenance: Habatat Galleries, Boca Raton, Florida, 1989; Dorothy and George Saxe, San Francisco, 1989–91; The Toledo Museum of Art, 1991.101.

Publications: Sally Vallongo, "Gifts of Glass: Couple's Collection Helps Art Museum to Rebuild," *The Blade* (Toledo), June 14, 1992, p. 1 (ill.), 2.
PLATE 45

## COLIN REID

Born: 1953, Cheshire, England
Resides: Stroud, Gloucestershire, England
Education: 1970–72, St. Martin's School of Art, London; 1981, BA, Stourbridge School of Art, Stourbridge, England
Selected References: Los Angeles, Kurland/ Summers Gallery, *Colin Reid,* text by Dan Klein, Stephen Proctor, Colin Reid, and Ruth T. Summers (Los Angeles, 1984); Penny Sparke, "Casting from Nature," *Crafts* 79 (Mar.–Apr. 1986), pp. 39–41.

**82 Double Arches R 237 A & B,** 1987
Cast glass with underglaze
A. 10⅞ × 18⁹⁄₁₆ × 1¼ inches;
B. 11¹⁄₁₆ × 18¹¹⁄₁₆ × 1⅜ inches
Marks: engraved at rear base of front arch, *Colin Reid* R237 1987; engraved at rear base of inner arch, *Colin Reid* 1987 R237/B
Provenance: Maurine Littleton Gallery, Washington, D.C., 1987–90; Dorothy and George Saxe, San Francisco, 1990–91; The Toledo Museum of Art, 1991.133 a,b.
Exhibitions: 1987: Washington, D.C., Maurine Littleton Gallery, "Colin Reid" (exh. cat.); 1989: Washington, D.C., Maurine Littleton Gallery, "Colin Reid" (exh. brochure)
Publications: New York, American Craft Museum, *The Collector's Eye* (New York, 1991), p. 42 (ill.).
PLATE 46

## DANIEL RHODES

Born: 1911, Fort Dodge, Iowa
Died: 1989
Education: 1929–30, The School of The Art Institute of Chicago, Chicago; 1932–33, Stone City Art Colony, Stone City, Iowa; 1933, PhB, University of Chicago, Chicago; 1933–34, Art Students League, New York; 1943, MFA, New York State College of Ceramics at Alfred University, Alfred
Selected References: Daniel Rhodes, "The Search for Form," *The Studio Potter* 13 (Dec. 1984), pp. 2–20; Santa Cruz, California, The Art Museum of Santa Cruz County, *Daniel Rhodes, The California Years,* text by Gary Smith (Santa Cruz, 1986); Daniel Rhodes, "A Clay Life," *Ceramics Monthly* 35, 7 (Sept. 1987), pp. 28–31, 64.

**83 Abique Head** (#245), 1988
Stoneware
17⅛ × 16¾ × 21¾ inches
Marks: painted on lower side, "215"
Provenance: "Bewitched by Craft" (The Ninth Annual Benefit Auction of Contemporary American Craft sponsored by the Associates of the American Craft Museum), New York, 1989; Dorothy and George Saxe, Menlo Park, 1989–present.
Exhibitions: 1988: Chicago, Navy Pier, "Chicago International New Art Forms Exposition" (exh. cat.); 1989: Chicago, Esther Saks Gallery, "Daniel Rhodes: The Last Years, Recent Sculpture and Drawings"; Chicago, Navy Pier, "Chicago International New Art Forms Exposition" (exh. cat., p. 131, ill.); New York, "Bewitched by Craft" (The Ninth Annual Benefit Auction of Contemporary American Craft sponsored by the Associates of the American Craft Museum) (exh. cat., live auction no. 16, ill.)
PLATE 82

## TOM RIPPON

Born: 1954, Sacramento, California
Resides: Missoula, Montana
Education: 1971–74, University of California, Davis; 1979, MFA, The School of The Art Institute of Chicago, Chicago
Selected References: Sheboygan, Wisconsin, John Michael Kohler Arts Center, *Tom Rippon: A Poet's Game,* text by Nancy Bless (Sheboygan, 1993).

**84 Pirouette,** 1981
Porcelain, lustres, pencil, and acrylic paint
29 × 6⅜ × 8⅞ inches
Marks: painted on bottom, RIPPON / 81
Provenance: Quay Gallery, San Francisco, 1981; Dorothy and George Saxe, Menlo Park, 1981–present.
Exhibitions: 1981: San Francisco, Quay Gallery, "Tom Rippon—Porcelain Sculpture"
Publications: Jane Knoerle, "The Saxes' Hobby Has Grown into a World Class Collection," *The Country Almanac,* Apr. 3, 1991, p. 28 (ill.) (Home & Garden Special Section).
PLATE 85

**85 That's Your Father,** 1984
Porcelain, lustres, acrylic paint, and pencil
12⅞ × 15¾ × 13¾ inches
Marks: painted on the bottom, "THAT'S YOUR FATHER" / RIPPON / 84'
Provenance: Traver Sutton Gallery, Seattle, 1984; Dorothy and George Saxe, Menlo Park, 1984–present.
Exhibitions: 1984: Seattle, Traver Sutton Gallery, "Clay: 1984"
PLATE 84

## JERRY ROTHMAN

Born: 1933, Brooklyn, New York
Resides: Laguna Beach, California
Education: 1953–55, Los Angeles City College, Los Angeles; 1954–55, University of California, Los Angeles; 1956, Art Center School of Design, Los Angeles; 1956–58, Los Angeles County Art Institute, Los Angeles; 1961, MFA, Otis Art Institute, Los Angeles
Selected References: Lukman Glasgow, "Jerry Rothman," *Ceramics Monthly* 29, 7 (Sept. 1981), pp. 37–43; Thomas C. Folk, "Jerry Rothman: Studio Potter and Sculptor," *Ceramics Art & Perception* 5 (1991), pp. 36–41.

**86 Classic/Baroque Tureen**
(from the *Ritual Vessels* series), 1978
Porcelain with glaze
16½ × 16⅝ × 10¼ inches
Provenance: Garth Clark Gallery, New York, 1986; Dorothy and George Saxe, Menlo Park, 1986–present.
Exhibitions: 1986: New York, Garth Clark Gallery, "Jerry Rothman"
Publications: Jane Knoerle, "The Saxes' Hobby Has Grown into a World Class Collection," *The Country Almanac,* Apr. 3, 1991, p. 26 (ill.) (Home & Garden Special Section).
PLATE 83

## GINNY RUFFNER

Born: 1952, Atlanta
Resides: Seattle
Education: 1974, BFA, University of Georgia, Athens; 1975, MFA, University of Georgia, Athens
Selected References: Susan Biskeborn, *Artists at Work: Twenty-five Northwest Glassmakers, Ceramists, and Jewelers* (Seattle and Anchorage, 1990), pp. 28–33; Matthew Kangas, "Unravelling Ruffner," *Glass* 43 (Spring 1991), front cover, pp. 20–29; Shawn Waggoner, "With Visibility Comes Greater Responsibility: A Conversation with Ginny Ruffner," *Glass Art* 7, 2 (Jan.–Feb. 1992), front cover, pp. 4–8.

**87 City of Broad Shoulders,** 1989
Lamp-worked glass and applied pigments
19⅝ × 22¼ × 9¼ inches
Marks: engraved on rear, lower right near edge of base, *Ginny Ruffner* 89
Provenance: Heller Gallery, New York, 1989; Dorothy and George Saxe, San Francisco, 1989–91; The Toledo Museum of Art, 1991.102.
Exhibitions: 1989: Chicago, Navy Pier, "Chicago International New Art Forms Exposition" (exh. cat.)
Publications: Sally Vallongo, "Gifts of Glass: Couple's Collection Helps Art Museum to Rebuild," *The Blade* (Toledo), June 14, 1992, p. 1 (ill.), 2.
PLATE 47

## JANE SAUER

Born: 1937, St. Louis
Resides: St. Louis
Education: 1959, BFA, Washington University, St. Louis

Selected References: Crisa Meaħl Falconer, "The Knotted Sculpture of Jane Sauer," *Fiberarts* 13, 3 (May–June 1986), front cover, pp. 31–33; Patricia Degener, "Emotive Basketry," *American Craft* 46, 4 (Aug.–Sept. 1986), pp. 42–47, 59; St. Louis, The Saint Louis Art Museum, *Currents 36: Jane Sauer* (St. Louis, 1988).

88  **Thank You, P.M.** (from the *P.M. Color* series), 1984
Waxed linen and paint
14⅜ × 3¾ (dia.) inches
Marks: signed on bottom, SAUER
Provenance: B. Z. Wagman Gallery, St. Louis, 1984–85; Dorothy and George Saxe, Menlo Park, 1985–present.
Exhibitions: 1984: St. Louis, B. Z. Wagman Gallery, "Dan Ziembo Paintings and Jane Sauer Fiber Sculptures"; 1990: Palo Alto, California, Palo Alto Cultural Center, "From Tapestry to Vessel: Contemporary Fiber Art" (exh. brochure)
Publications: Patricia Degener, "Small Baskets That Contain a Strong Primordial Force," *St. Louis Dispatch*, Dec. 12, 1984, p. 4B; Jane Knoerle, "The Saxes' Hobby Has Grown into a World Class Collection," *The Country Almanac*, Apr. 3, 1991, p. 26 (ill.) (Home & Garden Special Section).
PLATE 103

**ADRIAN SAXE**
Born: 1943, Glendale, California
Resides: Los Angeles
Education: 1965–69, Chouinard Art School, Los Angeles; 1974, BFA, California Institute of the Arts, Valencia
Selected References: Peter Schjeldahl, "Adrian Saxe and the Smart Pot," *The Hydrogen Jukebox: Selected Writings of Peter Schjedlahl, 1978–1990*, ed. MaLin Wilson, intro. by Robert Storr (Berkeley, Los Angeles, and Oxford, 1991), pp. 256–61; Kristin McKirdy, "Adrian Saxe: Céramiste Californien," *La Revue de la céramique et du verre* 50 (Jan.–Feb. 1990), pp. 30–35; Christopher Knight, "The Global Potter," *Los Angeles Times/ Calendar*, Nov. 24, 1991, pp. 92, 98; Los Angeles, Los Angeles County Museum of Art, *Adrian Saxe and the Cultured Pot*, text by Martha Drexler Lynn and Jim Collins (Los Angeles, in press).

89  **A&B** (Gourd Garniture), 1987
Porcelain, glazes, and lustres
A: 11⅝ × 5¼ × 5¼ inches;
&: 19 × 7½ × 9 inches;
B: 12 × 4¾ × 4¾ inches
Marks: A, label on inside of stopper, 87.52 / NYSa; B, label on inside of stopper, 87.52 / NYSb; &, same label on inside of stopper; signed and stamped on underside of A and B, SAXE 1987 / SAXE / with artist's hallmark; signed and stamped on underside of &, Saxe / ????1987???? / Saxe / artist's hallmark

Provenance: Garth Clark Gallery, New York, 1987; Dorothy and George Saxe, Menlo Park, 1987–present (promised gift to The Toledo Museum of Art).
Exhibitions: 1987: New York, Garth Clark Gallery, "Adrian Saxe"
Publications: Jane Knoerle, "The Saxes' Hobby Has Grown into a World Class Collection," *The Country Almanac*, Apr. 3, 1991, p. 28 (ill.) (Home & Garden Special Section).
PLATE 86

**CYNTHIA SCHIRA**
Born: 1934, Pittsfield, Massachusetts
Resides: Lawrence, Kansas
Education: 1956, BFA, Rhode Island School of Design, Providence; 1956–57, L'Ecole d'Art Décoratif, Aubusson, France; 1967, MFA, University of Kansas, Lawrence
Selected References: Lawrence, University of Kansas, Spencer Museum of Art, *Cynthia Schira— New Work*, text by Nancy Corwin (Lawrence, 1984).

90  **Near Balceda** (from the *Woven Field* series), 1984
Cotton, linen, rayon, and mixed fibers
50 × 65½ × ¹³⁄₁₆ inches
Marks: signed lower verso, 'NEAR BALCEDA' / BY CYNTHIA SCHIRA
Provenance: Hadler/Rodriguez, New York, 1985; Dorothy and George Saxe, Menlo Park, 1985–present.
Exhibitions: 1985: New York, Hadler/Rodriguez, "Cynthia Schira: Woven Fields"; 1986: Berkeley, California, Fiberworks Center for the Textile Arts, "Bay Area Collects: A Two-Part Exhibition of Traditional and Contemporary Fiber Arts from Bay Area Collectors"
Publications: Betty Park, "Poetic Evocations: The Woven Cloth of Cynthia Schira," *American Craft* 45, 5 (Oct.–Nov. 1985), p. 22 (ill.); Jane Knoerle, "The Saxes' Hobby Has Grown into a World Class Collection," *The Country Almanac*, Apr. 3, 1991, p. 27 (ill.) (Home & Garden Special Section).
PLATE 104

**JACK SCHMIDT**
Born: Toledo, Ohio
Resides: Toledo, Ohio
Education: 1968, BS, Bowling Green State University, Bowling Green, Ohio; 1973, MS, Illinois State University, Normal
Selected References: Jack Schmidt, "Artist Presentations: Jack A. Schmidt," *Glass Art Society Journal*, 1986, pp. 87–88.

91  **Purple Walker** (from the *Walker* series), 1988
Plate glass, stainless steel, and slate
58⅛ × 12 × 9 inches

Marks: engraved on base, *Schmidt © 1988*
Provenance: Habatat Galleries, Lathrup Village, Michigan, 1987; Dorothy and George Saxe, San Francisco, 1987–91; The Toledo Museum of Art, 1991.134.
Exhibitions: 1988: Lathrup Village, Michigan, Habatat Galleries, "Jack Schmidt"
PLATE 48

**PAUL SEIDE**
Born: 1949, New York
Resides: New York
Education: 1971, Certificate, Egani Neon Glassblowing School, New York; 1974, BS, University of Wisconsin–Madison
Selected References: Sylvia Netzer, "Rays of Glass—Paul Seide: Radio Light Sculpture," *Neues Glas* 3 (1988), pp. 196–200; "Glass Focus Interviews Paul Seide," *Glass Focus*, June–July 1990, pp. 10–12.

92  **Radio Light,** 1985
Blown glass, mercury, and argon gas
16½ × 16¾ × 18½ inches
Marks: engraved on top and base of smaller spiral form and on outer side of larger one, *Seide*
Provenance: Heller Gallery, New York, 1985; Dorothy and George Saxe, San Francisco, 1985–91; The Toledo Museum of Art, 1991.135.
Exhibitions: 1986: Oakland, California, The Oakland Museum, "Contemporary American and European Glass from the Saxe Collection" (exh. cat., p. 57, ill.) (traveled to New York, American Craft Museum)
PLATE 49

**KAY SEKIMACHI**
Born: 1926, San Francisco
Resides: Berkeley, California
Education: 1946–49, California College of Arts and Crafts, Oakland; 1954–55, California College of Arts and Crafts, Oakland; 1956, Haystack Mountain School of Crafts, Liberty, Maine
Selected References: Melinda Levine, "Parallel Views: Kay Sekimachi, Nancy Selvin," *American Craft* 42, 2 (Apr.–May 1982), pp. 31–35; Charles Talley, "Kay Sekimachi: Successful on Her Own Terms," *Fiberarts* 9, 5 (Sept.–Oct. 1982), pp. 72–74; Palo Alto, California, Palo Alto Cultural Center, "Marriage in Form: Kay Sekimachi and Bob Stocksdale," text by Jack Lenor Larsen, Sam Maloof, and Signe Mayfield (Palo Alto, in press).

93  **Untitled** (from the *Paper Bowl* series), 1982
Japanese handmade papers and linen threads
3⅝ × 7¼ (dia.) inches
Marks: artist's stamp on bottom
Provenance: Dorothy and George Saxe, Menlo Park, 1982–present (purchased from the artist).
PLATE 105

**94 Untitled** (from the *Flax Bowl* series), 1987
Flax, paper, and gel medium
3½ × 7⅝ × 8 inches
Provenance: Dorothy and George Saxe, Menlo Park, 1989–present (purchased from the artist).
PLATE 105

## MARY SHAFFER

Born: Walterboro, South Carolina
Resides: Silver Spring, Maryland
Education: Rhode Island School of Design, Providence; MFA, University of Maryland, College Park
Selected References: Barbaralee Diamonstein, *Handmade in America: Conversations with Fourteen Craftmasters* (New York, 1983), pp. 216–23; Karen S. Chambers, "Modern Alchemist: Mary Shaffer—Transforming Glass into High Art," *The World & I* (Feb. 1989), pp. 204–9; John Perreault, "Mary Shaffer: A Discourse on Innovation," *New Work* 37 (Spring 1989), pp. 14–17.

**95 Hanging Series #24,** 1978
Plate glass and wire
40¼ × 28¼ × 2 inches
Marks: engraved on rear, lower right, *Mary Shaffer '78*
Provenance: Habatat Gallery, Lathrup Village, Michigan, 1980; Dorothy and George Saxe, San Francisco, 1980–91; The Toledo Museum of Art, 1991.136.
Exhibitions: 1979: New York, O.K. Harris Gallery, "Mary Shaffer — Recent Work"
PLATE 50

## RICHARD SHAW

Born: 1941, Hollywood, California
Resides: Fairfax, California
Education: 1961–63, Orange Coast College, Costa Mesa, California; 1965, BFA, San Francisco Art Institute, San Francisco; 1965, New York State College of Ceramics at Alfred University, Alfred; 1968, MFA, University of California at Davis
Selected References: New York, Whitney Museum of American Art, *Ceramic Sculpture: Six Artists,* text by Suzanne Foley and Richard Marshall (New York, Seattle, and London, 1981); San Francisco, Braunstein Gallery, *Richard Shaw: Illusionism in Clay, 1971–1985,* text by Joseph Pugliese (San Francisco, 1985); Cheryl White, "Master of Illusion Richard Shaw," *American Ceramics* 6, 2 (1988), pp. 30–37.

**96 Book Jar with Ash Tray,** 1980
Porcelain with decal overglaze
4¼ × 9¾ × 7¾ inches
Marks: signed on middle of the base, *Richard Shaw / 1980*

Provenance: Braunstein Gallery, San Francisco, 1980–83; Dorothy and George Saxe, Menlo Park, 1983–present.
Exhibitions: 1981–83: San Francisco, Braunstein Gallery, "Richard Shaw/Ceramic Sculpture" (exh. cat., p. 13, ill.) (traveled to Newport Beach, California, Newport Harbor Art Museum; San Jose, California, San Jose Museum of Art; Boise, Idaho, Boise Gallery of Art; Saskatoon, Canada, Mendel Art Gallery; Calgary, Canada, Alberta College of Art; Madison, Wisconsin, Madison Art Center; San Francisco, San Francisco Museum of Modern Art); 1987: Stockton, California, University of the Pacific, The University of the Pacific Gallery, "Illusion in Clay"
Publications: Jane Knoerle, "The Saxes' Hobby Has Grown into a World Class Collection," *The Country Almanac,* Apr. 3, 1991, pp. 25, 28 (ill.) (Home & Garden Special Section).
PLATE 89

**97 Boy with Blue Glove,** 1985
Porcelain with decal overglaze
26½ × 19½ × 11⅝ inches
Marks: signed on top of base, *Richard Shaw 1985*
Provenance: "Celebration 30" (The Sixth Annual Benefit Auction of Contemporary American Craft sponsored by the Associates of the American Craft Museum), New York, 1986; Dorothy and George Saxe, Menlo Park, 1986–present.
Exhibitions: 1986: New York, Allan Frumkin Gallery, "Richard Shaw, New Ceramic Sculpture: In the Drawing Gallery"; New York, "Celebration 30" (The Sixth Annual Benefit Auction of Contemporary American Craft sponsored by the Associates of the American Craft Museum) (exh. cat., no. 10); 1988–89: Syracuse, New York, Everson Museum of Art, "American Ceramics Now: The 27th Ceramic National: Invitational Section" (exh. cat.) (traveled to Seoul, Arts Center of the Korean Culture and Arts Foundation; Lincoln, Massachusetts, DeCordova and Dana Museum and Park; Youngstown, Ohio, Butler Institute of Art; Lincoln, Nebraska, Sheldon Memorial Art Gallery, University of Nebraska–Lincoln; Birmingham, Alabama, Birmingham Museum of Art); 1990–91: Palo Alto, California, Palo Alto Cultural Center, "Richard Shaw" (exh. brochure)
Publications: Kenneth Baker, "Fine Art Brings Printed Pages to Life: Show of Custom-Illustrated Books from Blake to Hockney at Palo Alto Cultural Center," *San Francisco Chronicle,* Jan. 10, 1991, p. E4; Jane Knoerle, "The Saxes' Hobby Has Grown into a World Class Collection," *The Country Almanac,* Apr. 3, 1991, p. 27 (ill.) (Home & Garden Special Section).
PLATE 88

## PETER SHIRE

Born: 1947, Los Angeles
Resides: Los Angeles

Education: 1970, BFA, Chouinard Art Institute, Los Angeles
Selected References: "Interview with Peter Shire," *Glass Art Society Journal,* 1986, pp. 40–43; Peter Clothier, "A Carnival World of Color," *American Ceramics* 7, 2 (1989), pp. 26–33; Norman M. Klein and Hunter Drohojowska, *Tempest in a Teapot: The Ceramic Art of Peter Shire,* foreword by Ettore Sottsass (New York, 1991).

**98 Pinwheel Teapot,** 1980
Glazed earthenware
11⅜ × 17⅝ × 3¾ inches
Marks: painted on base, SHIRE / 190 / E.X.P.
Provenance: Smith Andersen Gallery, Palo Alto, California, 1982; Dorothy and George Saxe, Menlo Park, 1982–present.
Exhibitions: 1982: Palo Alto, California, Smith Andersen Gallery, "Ceramics: David Best, David Gilhooly, Michael McCollum, Mineo Mizuno, Elsa Rady, Linda Rosenus, Peter Shire"
PLATE 87

## ROBERT SPERRY

Born: 1927, Bushnell, Illinois
Resides: Seattle
Education: 1950, BA, University of Saskatchewan, Saskatoon, Canada; 1953, BFA, The School of The Art Institute of Chicago, Chicago; 1955, MFA, University of Washington, Seattle
Selected References: Bellevue, Washington, Bellevue Art Museum, *Robert Sperry: A Retrospective,* preface by Jeffrey Moore, text by LaMar Harrington and Matthew Kangas (Bellevue, 1985); Robert Sperry, "Portfolio: Abstractions in Black and White," *Ceramics Monthly* 38, 6 (June–Aug. 1990), pp. 33–40.

**99 Untitled #794,** 1987
Stoneware with slip
26¾ × 26¾ × 3⅝ inches
Marks: inscribed within a circle on verso, *Sperry / 87*
Provenance: Dorothy and George Saxe, Menlo Park, 1988–present (purchased from the artist).
Exhibitions: 1988: Marylhurst, Oregon, Marylhurst College, The Art Gym, "New Work by Robert Sperry"
Publications: Jane Knoerle, "The Saxes' Hobby Has Grown into a World Class Collection," *The Country Almanac,* Apr. 3, 1991, p. 25 (ill.) (Home & Garden Special Section).
PLATE 90

## RUDOLF ("RUDY") STAFFEL

Born: 1911, San Antonio, Texas
Resides: Philadelphia
Education: 1932–36, The School of The Art Institute of Chicago, Chicago

Selected References: 's Hertogenbosch, The Netherlands, Museum Voor Hedendaagse Kunst Het Kruithuis, *Transparency in Clay: Rudolf Staffel*, foreword by Yvonne G. J. M. Joris, text by Ivy L. Barsky and Stephen Berg ('s Hertogenbosch, 1990); Janet Koplos, "Rudolf Staffel: Playful Magician," *American Ceramics* 9, 2 (Summer 1991), pp. 18–25; Joan Jeffri, ed., *The Craftsperson Speaks: Artists in Various Media Discuss Their Crafts* (Westport, Connecticut, 1992), pp. 175–91.

### 100 Light Gatherer, 1985
Porcelain and applied vitreous elements
7¼ × 5 × 4⅝ inches
Marks: inscribed on bottom, Rudy / Staffel
Provenance: Helen Drutt Gallery, Philadelphia, 1985; Dorothy and George Saxe, Menlo Park, 1985–present.
Exhibitions: 1985: Philadelphia, Helen Drutt Gallery, "Rudolf Staffel"
PLATE 91

### JAY STANGER
Born: 1956, Boston
Resides: Charlestown, Massachusetts
Education: 1975–77, Rochester Institute of Technology, Rochester, New York; 1977–79, Leeds Design Workshop, Easthampton, Massachusetts; 1982, BFA, Program in Artisanry, Boston University, Boston
Selected References: "Jay Stanger—Portfolio," *American Craft* 51, 1 (Feb.–Mar. 1991), pp. 52–53.

### 101 Side Chair, 1986
Bloodwood, curly maple, pearwood, lacewood, pau amarillo, amaranth, wenge, ebony, and aluminum
50⅜ × 24⅞ × 23½ inches
Provenance: Helander Gallery, Palm Beach, Florida, 1988; Dorothy and George Saxe, Menlo Park, 1988–present.
Exhibitions: 1987: Philadelphia, Snyderman Gallery, "New Furniture: Kristina Madsen, Peter Pierobon, Jay Stanger"; Washington, D.C., McIntosh/Drysdale Gallery, "Jay Stanger"; 1987–88: Palm Beach, Florida, Helander Gallery, "Don't Knock Wood"
PLATE 111

### THERMAN STATOM
Born: 1953, Winter Haven, Florida
Resides: Los Angeles
Education: 1972, Pilchuck Glass Center, Stanwood, Washington; 1974, BFA, Rhode Island School of Design, Providence; 1980, MFA, Pratt Institute, Brooklyn, New York
Selected References: Cincinnati, Ohio, The Contemporary Arts Center, *Transparent Motives: Glass on a Large Scale,* text by Karen S. Chambers (Cincinnati, 1985–86), pp. 8–9; Ben Marks, "Therman Statom's New Paintings on Plate Glass," *New Work* 34 (Summer 1988), pp. 18–21.

### 102 Pink Ladder, 1986
Plate and blown glass, paint, adhesive tape, found objects (including mirror fragments and colored pencils)
84½ × 18½ × 4¼ inches
Marks: signed on inside of leg below lowest rung, STATOM 86
Provenance: Wita Gardiner, San Diego, 1986–87; Dorothy and George Saxe, San Francisco, 1987–91; The Toledo Museum of Art, 1991.103.
Exhibitions: 1986–87: San Diego, California, Wita Gardiner, "Interior: The Home—Exterior: The Landscape"; 1987: New York, American Craft Museum, "Contemporary American and European Glass from the Saxe Collection"
Publications: Sally Vallongo, "Gifts of Glass: Couple's Collection Helps Art Museum to Rebuild," *The Blade* (Toledo), June 14, 1992, p. 1 (ill.).
PLATE 51

### BOB STOCKSDALE
Born: 1913, Warren, Indiana
Resides: Berkeley, California
Education: self-taught
Selected References: Richard La Trobe-Bateman, "World-Class Turner," *American Craft* 47, 6 (Dec. 1987–Jan. 1988), pp. 30–34; Robert Bruce Duncan, "Bob Stocksdale: Still on a Roll at 75," *Woodwork* 1 (Spring 1989), front and back covers, title page, pp. 16–21; Palo Alto, California, Palo Alto Cultural Center, "Marriage in Form: Kay Sekimachi and Bob Stocksdale," text by Jack Lenor Larsen, Sam Maloof, and Signe Mayfield (Palo Alto, in press).

### 103 Ebony Bowl, 1981
Ebony
4 × 7⁷⁄₁₆ × 6¹⁄₁₆ inches
Marks: carved on bottom, Ebony / from / Ceylon / Bob Stocksdale / 1981
Provenance: Dorothy and George Saxe, Menlo Park, 1982–present (purchased from the artist) (promised gift to The Toledo Museum of Art).
Publications: Jane Knoerle, "The Saxes' Hobby Has Grown into a World Class Collection," *The Country Almanac,* Apr. 3, 1991, pp. 27–28 (ill.) (Home & Garden Special Section).
PLATE 112

### 104 Footed Blackwood Bowl, 1983
Blackwood
3⅞ × 4¹⁄₁₆ × 4⅛ inches
Marks: carved on bottom, Blackwood / from / Africa / Bob Stocksdale / 1983
Provenance: Dorothy and George Saxe, Menlo Park, 1983–present (purchased from the artist).
Publications: Jane Knoerle, "The Saxes' Hobby Has Grown into a World Class Collection," *The Country Almanac,* Apr. 3, 1991, p. 27 (ill.) (Home & Garden Special Section).
PLATE 112

### 105 Macadamia Bowl, 1986
Macadamia wood
3½ × 4⅝ × 4⁹⁄₁₆ inches
Marks: carved on underside, Macadamia / from / Hawaii / Bob Stocksdale / 1986
Provenance: Dorothy and George Saxe, Menlo Park, 1986–present (purchased from the artist) (promised gift to The Toledo Museum of Art).
Publications: Jane Knoerle, "The Saxes' Hobby Has Grown into a World Class Collection," *The Country Almanac,* Apr. 3, 1991, p. 27 (ill.) (Home & Garden Special Section).
PLATE 112

### IRVIN TEPPER
Born: 1947, St. Louis
Resides: Petaluma, California, and New York
Education: 1969, BFA, Kansas City Art Institute, Kansas City, Missouri; 1971, MFA, University of Washington, Seattle
Selected References: Paul Schimmel, "Conversation Pieces: The Cups of Irvin Tepper," *American Ceramics* 3, 2 (1984), pp. 30–39.

### 106 Roger, 1986
Porcelain
9⅝ × 14⅞ × 9⅞ inches
Provenance: Gallery Paule Anglim, San Francisco, 1987; Dorothy and George Saxe, Menlo Park, 1987–present.
Exhibitions: 1987: San Francisco, Gallery Paule Anglim, "Irv Tepper: New Work"
Publications: Jane Knoerle, "The Saxes' Hobby Has Grown into a World Class Collection," *The Country Almanac,* Apr. 3, 1991, p. 26 (ill.) (Home & Garden Special Section).
PLATE 96

### LINDA THREADGILL
Born: 1947, Corpus Christi, Texas
Resides: East Troy, Wisconsin
Education: 1970, BFA, University of Georgia, Athens; 1978, MFA, Tyler School of Art, Temple University, Philadelphia
Selected References: "Portfolio: Linda Threadgill," *American Craft* 47, 2 (Apr.–May 1987), pp. 56–57.

### 107 Earrings, 1987
Sterling silver
2⅛ × ¹³⁄₁₆ × ⁷⁄₁₆ inches (without fasteners)
Marks: signed on both earrings, *Threadgill / sterling*
Provenance: Concepts, Palo Alto, California, 1987–88; Dorothy and George Saxe, Menlo Park, 1988–present.
Exhibitions: 1988: Palo Alto, California, Concepts, Gallery Jewelers Exhibition
PLATE 119

108 **Pendant**, 1987
Sterling silver
4³⁄₁₆ × 2⅛ × 1½ inches
Marks: signed on verso at lower center, *Threadgill / sterling*
Provenance: Concepts, Palo Alto, California, 1988–89, Dorothy and George Saxe, San Francisco, 1989–present.
Exhibitions: 1988: Palo Alto, California, Concepts, Gallery Jewelers Exhibition
PLATE 119

109 **Necklace**, 1989
Sterling silver
L. 12¼ inches (clasp closed); extended 22¼ inches (clasp opened)
Marks: signed on verso at left side on center link of chain, *Threadgill / sterling / 1989*
Provenance: Dorothy and George Saxe, Menlo Park, 1989–present (purchased from the artist).
PLATE 119

**MARK TOBEY**
Born: 1890, Centerville, Wisconsin
Died: 1976
Education: self-taught
Selected References: New York, The Museum of Modern Art, *Mark Tobey*, text by William C. Seitz (New York, 1962); Arthur L. Dahl et al., *Mark Tobey: Art and Belief* (Oxford, 1984); Comune di Torgiano Azienda Promozione Turistica Consorzio Socio-Urbanistico di Perugia-Deruta-Corciano-Torgiano, Italy, *Egidio Costantini a Torgiano con "La Fucina degli Angeli" il vetro-il vino—l'arte* (Torgiano, 1985); Basel, Switzerland, Galerie Beyeler, *Mark Tobey: A Centennial Exhibition*, text by Gottfried Boehm (Basel, 1990).

110 **Volto**, 1974
Produced for Egidio Costantini's Fucina degli Angeli, Murano, by IZR di Mazzega, Murano, Italy
Cast glass with applied colored glass trailings
15 × 8¼ × 7¼ inches
Marks: engraved on underside, 1974 1/1 / M. Tobey / E. Costantini / Fucina Angeli Venezia / Mark Tobey / E. Costantini / 1974. © 1/1 / Fucina degli Angeli / Venezia *
Provenance: Fucina degli Angeli Venezia, 1974–80; Foster/White Gallery, Seattle, 1980; Dorothy and George Saxe, San Francisco, 1980–91; The Toledo Museum of Art, 1991.116.
Exhibitions: 1976: Brindisi, Italy, Rotary Club Comune Provincia Camera di Commercio, "Sculture in Vetro, E. Costantini" (exh. brochure); 1982: Seattle, Foster/White Gallery, "Mark Tobey, New Acquisitions"; 1982–83: New York, American Craft Museum, "Approaches to Collecting"; 1986–87: Oakland, California, The Oakland Museum, "Contemporary American and European Glass from the Saxe Collection" (exh. cat., p. 38,

ill.) (traveled to New York, American Craft Museum)
Publications: Vincenzo Maddaloni, "Soffia nel vetro i capolavori," *Famiglia Cristiana*, Nov. 10, 1974, p. 86 (ill.); *Fucina degli Angeli Venezia*, text by Carlo della Corte [Venice, 1979], (ill).
PLATE 52

**ROBERT TURNER**
Born: 1913, Port Washington, New York
Resides: Alfred Station, New York
Education: 1936–41, Pennsylvania Academy of the Fine Arts, Philadelphia; 1936, BA, Swarthmore College, Swarthmore, Pennsylvania; 1949, MFA, New York State College of Ceramics at Alfred University, Alfred
Selected References: Johanna Burstein Hays, "Robert Turner (profile)," *American Ceramics* 3, 4 (1985), pp. 50–57; Edward Lebow, "Robert Turner," *American Craft* 46, 3 (June–July 1986), pp. 28–33, 67; Ward Doubet, "Robert Turner," *American Ceramics* 9, 4 (1991), front cover, pp. 12–25.

111 **Ashanti**, 1987
Stoneware with glaze and slip
13⅝ × 11½ × 11⅝ inches
Marks: inscribed on base, TURNER; sticker (in handwriting), Ashanti / Turner
Provenance: Dorothy Weiss Gallery, San Francisco, 1987; Dorothy and George Saxe, Menlo Park, 1987–present (promised gift to The Toledo Museum of Art).
Exhibitions: 1987: San Francisco, Dorothy Weiss Gallery, "Robert Turner"; Richmond, California, Richmond Art Center, "Eye of the Writer, Language of Form/Voice of Materials" (exh. brochure)
Publications: Jane Knoerle, "The Saxes' Hobby Has Grown into a World Class Collection," *The Country Almanac*, Apr. 3, 1991, p. 28 (ill.) (Home & Garden Special Section).
PLATE 93

112 **Form IV**, 1989
Stoneware with glaze and slip
10⁷⁄₁₆ × 9⅜ × 9⅜ inches
Marks: inscribed on base, TURNER
Provenance: Helen Drutt Gallery, New York, 1989; Dorothy and George Saxe, Menlo Park, 1989–present.
Exhibitions: 1989: New York, Helen Drutt Gallery, "Robert Turner"
Publications: Jane Knoerle, "The Saxes' Hobby Has Grown into a World Class Collection," *The Country Almanac*, Apr. 3, 1991, p. 26 (ill.) (Home & Garden Special Section).
PLATE 92

**BERTIL VALLIEN**
Born: 1938, Stockholm
Resides: Afors, Sweden
Education: 1957–61, Konstfackskolan, Stockholm
Selected References: Gunnar Lindqvist, *Bertil Vallien*, trans. Angela Adegren (Stockholm, 1990); Rika Kuroki, "Interview—Bertil Vallien," *Glasswork* 8 (Feb. 1991), front cover, pp. 2–11.

113 **Untitled**, 1980
Blown glass
9⁹⁄₁₆ × 11¼ × 8¾ inches
Marks: engraved on underside, KOSTA / UNIK / 4377 / B. VALLIEN
Provenance: Contemporary Art Glass Gallery, New York, 1980; Dorothy and George Saxe, San Francisco, 1980–91; The Toledo Museum of Art, 1991.137.
Exhibitions: 1980: New York, Contemporary Art Glass Gallery, "The Great Scandinavian Glass Show"
PLATE 55

114 **Crystal Arrow** (from the *Boat Form* series), 1987
Cast glass, copper, metal, and wire
41⅜ × 75¾ × 7¹⁵⁄₁₆ inches
Marks: engraved on upper rear, 305870412 KOSTA– BODA– B. Vallien
Provenance: Heller Gallery, New York, 1988; Dorothy and George Saxe, San Francisco, 1988–91; The Toledo Museum of Art, 1991.138.
Exhibitions: 1987: New York, Heller Gallery, "Bertil Vallien: Cast Glass Sculpture"; 1987–88: Tokyo, Seibu Museum of Art, and Kyoto, The National Museum of Modern Art, "Scandinavian Craft Today" (exh. cat.) (traveled to Tokyo, Yurakucho Art Forum; New York, American Craft Museum; Cleveland, Cleveland Institute of Art; Mobile, Alabama, The Fine Arts Museum of the South at Mobile)
PLATE 54 A, B

**FRANTIŠEK VÍZNER**
Born: 1936, Prague
Resides: Žd'ár Nad Sázavou, Czechoslovakia
Education: 1953–56, Střední umělecko-průmyslová škola sklárská v Železném Brodu, Železný Brod, Czechoslovakia; 1956–62, Vysoká umělecko-průmyslová škola, Prague
Selected References: František Vízner, "1984 G.A.S. Conference Featured Artists: František Vízner," *Glass Art Society Journal*, 1984–85, pp. 94–95; William Warmus, "František Vízner," *New Work* 33 (Spring 1988), pp. 26–27; "František Vízner," *Glass Art Society Journal*, 1989, pp. 23–26.

**115 Sculpture VIII** (from the *Bowl* series), 1987
Cast glass
4 × 10⁹⁄₁₆ (dia.) inches
Marks: engraved on underside, VÍZNER 87
Provenance: Heller Gallery, New York, 1988;
Dorothy and George Saxe, San Francisco,
1988–92; The Toledo Museum of Art, 1993.10.
Exhibitions: 1988: New York, Heller Gallery,
"František Vízner"
Publications: New York, American Craft Museum,
*The Collector's Eye* (New York, 1991), p. 42 (ill.).
PLATE 53

PETER VOULKOS
Born: 1924, Bozeman, Montana
Resides: Oakland, California
Education: 1950, BS, Montana State University,
Bozeman; 1952, MFA, California College of Arts &
Crafts, Oakland
Selected References: Rose Slivka, *Peter Voulkos: A
Dialogue with Clay* (New York, 1978); New York,
Whitney Museum of American Art, *Ceramic
Sculpture: Six Artists,* text by Richard Marshall and
Suzanne Foley (New York, Seattle, and London,
1981); Hal Fischer, "The Art of Peter Voulkos,"
*Artforum* 17, 3 (Nov. 1978), pp. 41–47.

**116 Untitled (Stack),** 1980–81
Stoneware
46 × 13⅝ × 14⅜ inches
Marks: painted on side of base, 80 V·O·U·L·K·OS
Provenance: Braunstein Gallery, San Francisco,
1981; Dorothy and George Saxe, Menlo Park,
1981–present.
Publications: Jane Knoerle, "The Saxes' Hobby Has
Grown into a World Class Collection," *The Country
Almanac,* Apr. 3, 1991, p. 25 (ill.) (Home & Garden
Special Section).
PLATE 95

**117 Untitled (Ice bucket),** 1983
Stoneware and painted engobes
11⅝ × 12¾ × 12½ inches
Marks: inscribed on base, Voulkos / 1983
Provenance: Charles Cowles Gallery, New York,
1983; Dorothy and George Saxe, Menlo Park,
1983–present.
Exhibitions: 1983: New York, Charles Cowles
Gallery, "Peter Voulkos"; 1985: Sacramento,
California, Crocker Art Museum, "California Crafts
XIV—Living Treasures of California" (exh. cat.,
pp. 37, 84, ill.)
Publications: Richard Armstrong, "Peter Voulkos"
(review), *Artforum* 22, 3 (Nov. 1983), p. 97; Jane
Knoerle, "The Saxes' Hobby Has Grown into a
World Class Collection," *The Country Almanac,*
Apr. 3, 1991, p. 25 (ill.) (Home & Garden Special
Section).
PLATE 94

STEVEN WEINBERG
Born: 1954, Brooklyn, New York
Resides: Pawtucket, Rhode Island
Education: 1976, BFA, New York State College of
Ceramics at Alfred University, Alfred; 1979, MFA,
Rhode Island School of Design, Providence
Selected References: Paul Hollister, "Steven
Weinberg's Casting Technique Something New
under the Sun," *Neues Glas* 4 (1981), pp. 142–47;
Providence, Rhode Island, Matrix Gallery,
*Concatenation,* text by Robert G. Loeffler
(Providence, 1983); Jean Luc Olivié, "Acquisitions
No. 88: Steven Weinberg, Sculpture, Cast Crystal
Cube, 1990," *Revue du Louvre* 42, 1 (Apr. 1992),
pp. 115–16.

**118 Untitled 800808,** 1980
Cast glass
7⅞ × 7⅞ × 2⅝ inches
Marks: engraved on left side, WEINBERG 800808
Provenance: Heller Gallery, New York, 1980;
Dorothy and George Saxe, San Francisco,
1980–91; The Toledo Museum of Art, 1991.104.
Exhibitions: 1980: New York, Heller Gallery,
"Steven Weinberg: Cast Glass Sculpture";
1986–87: Oakland, California, The Oakland
Museum, "Contemporary American and European
Glass from the Saxe Collection" (exh. cat., p. 58,
ill.) (traveled to New York, American Craft
Museum)
PLATE 56

**119 Untitled 880206,** 1988
Cast crystal
8³⁄₁₆ × 8³⁄₁₆ × 8³⁄₁₆ inches
Marks: engraved along bottom side edge,
WEINBERG 880206
Provenance: Habatat Galleries, Bay Harbor Island,
Florida, 1988; Dorothy and George Saxe, San
Francisco, 1988–91; The Toledo Museum of Art,
1991.139.
Exhibitions: 1988: Bay Harbor Island, Florida,
Habatat Galleries, "Steven I. Weinberg"
PLATE 57

ANN WOLFF (née Ann Schaefer)
Born: 1937, Lübeck, Germany
Resides: Transjö, Sweden
Education: 1953–54, Meisterschule für
Mode, Hamburg; 1956–59, Hochschule für
Gestaltung, Ulm
Selected References: New York, Heller Gallery;
Palm Beach, Florida, Holsten Galleries; and Los
Angeles, Ivor Kurland Gallery, *Ann Wärff, "Glass
Carries My Scattered Thoughts into the Light,"*
text by Helga Hilschenz and Barbro Werkmäster
(Transjö, 1982–83); Verena Tafel, "Discoveries and
Changes, New Works by Ann Wolff," *Neues Glas* 4
(1986), pp. 258–65; Palm Beach, Florida, Holsten
Galleries; New York, Heller Gallery; and Los
Angeles, Kurland/Summers Gallery, *Ann Wolff,*

text by Verena Tafel, trans. Patricia Ferer and Karen
Chambers (Transjö, 1986–87).

**120 December Woman,** 1988
Blown glass, painted wood, and metal
48 × 12⅝ × 24½ inches
Provenance: Clara Scremini Gallery, Paris, 1988;
Dorothy and George Saxe, San Francisco,
1988–92; The Toledo Museum of Art, 1993.11.
Exhibitions: 1988: Paris, Clara Scremini Gallery,
"Ann Wolff: Short Sketch about Ann Wolff's Faces,
Their Land, Their Lives" (exh. cat., p. 6, ill.);
Chicago, Navy Pier, "Chicago International New
Art Forms Exposition" (exh. cat.)
Publications: Gareth Fenley, "Silent Light for a
Private Gallery," *Architectural Lighting,* June 1989,
p. 40 (ill.).
PLATE 58

BEATRICE WOOD
Born: 1893, San Francisco
Resides: Ojai, California
Education: 1910, Académie Julian, Paris; 1911,
Finch School, New York; 1933, Hollywood High
School, Adult Education, Ceramic Class; 1938,
University of Southern California, Los Angeles,
studies with Glen Lukens; 1940, studies with
Gertrud and Otto Natzler, Los Angeles
Selected References: Fullerton, California,
California State University, The Main Gallery,
*Beatrice Wood Retrospective,* foreword by Dextra
Frankel, text by Francis M. Naumann and Garth
Clark (Fullerton, 1983); Beatrice Wood, *I Shock
Myself* (Ojai, California, 1985); Oakland,
California, The Oakland Museum, *Intimate
Appeal: The Figurative Art of Beatrice Wood,*
intro. by Kenneth R. Trapp, text by Dr. Francis
M. Naumann (Oakland, 1989).

**121 Large Footed Bowl #63B,** 1987
Earthenware with lustre
12½ × 11½ (dia.) inches
Marks: on inside of foot, BEATO 63 B /
NWD206 54 B
Provenance: Garth Clark Gallery, New York, 1988;
Dorothy and George Saxe, Menlo Park,
1988–present.
Exhibitions: 1988: New York, Garth Clark Gallery,
"Beatrice Wood"
Publications: Jane Knoerle, "The Saxes' Hobby Has
Grown into a World Class Collection," *The Country
Almanac,* Apr. 3, 1991, p. 28 (ill.) (Home & Garden
Special Section).
PLATE 97

## DANA ZÁMEČNÍKOVÁ

Born: 1945, Prague
Resides: Prague
Education: 1962–68, České vysoké učení technické v praze, Prague; 1969–72, Vysoká Umělecko-průmyslová škola, Prague
Selected References: Paris, Clara Scremini Gallery, "Dana Zámečníková Oeuvres," text by Carole Andreani and Sylva Petrová (Paris, 1990); Kristián Suda, "Zámečníková: A Singular Encounter," Glass 45 (1991), pp. 30–37.

122 **Theater,** 1983
Sheet glass, wire, and lead
18¹/₁₆ × 26⅝ × 4 inches
Marks: engraved on lower right front, Zámečníková 83
Provenance: Heller Galley, New York, 1984; Dorothy and George Saxe, San Francisco, 1984–91; The Toledo Museum of Art, 1991.140.
Exhibitions: 1984: New York, Heller Gallery, "Dana Zámečníková: New Works from Czechoslovakia" (exh. announcement, ill.); 1986–87: Oakland, California, The Oakland Museum, "Contemporary American and European Glass from the Saxe Collection" (exh. cat., front cover, p. 41, ill.) (traveled to New York, American Craft Museum)
Publications: Tokyo, Japan Glass Artcrafts Association, Glass '84 in Japan (Tokyo, 1984), p. 111 (ill.); Karen S. Chambers, "Dana Zámečníková: Artist and Magician," Craft International 4, 3 (Jan.–Mar. 1985), pp. 20–21; Karen S. Chambers, "The Saxe Collection," Glass Art Society Journal, 1986, p. 123 (ill.); Kenneth R. Trapp, "A Touch of Glass," in San Francisco, San Francisco Craft and Folk Art Museum, A Report, Summer 1987, p. 4 (ill.); Patricia Malarcher, "Exhibitions New York," Craft International 6, 2 (Aug.–Sept. 1987), p. 28 (ill.).
PLATE 59

## YAN ZORITCHAK

Born: 1944, Ždiar, Slovakia
Resides: Talloires, France
Education: 1959–63, Střední umělecko-průmyslová škola sklářská v železném brodu, Železný Brod, Czechoslovakia; 1969, State diploma, Vysoká umělecko-průmyslová škola, Prague
Selected References: Geneva, Galerie Trois, Yan Zoritchak, text by Jean-Pierre Couren, Georgette Strobino, and Albane Dolez (Geneva, 1989); Dagmar Sinz, "Yan Zoritchak: The 4th Dimension," Neues Glas 1 (1989), pp. 17–21; Annie Ducreux and Helmut Ricke, Zoritchak (Niort, France, 1992).

123 **Fleur Celeste #7202,** 1987
Optical glass
22¾ × 11¼ × 3½ inches
Marks: engraved on front lower left near bottom edge, ZORITCHAK YAN 87
Provenance: Galerie Noella Gest, Rémy-de-Provence, France, 1988; Dorothy and George Saxe, San Francisco, 1988–91; The Toledo Museum of Art, 1991.105.
PLATE 60

## TOOTS ZYNSKY

Born: 1951, Boston
Resides: Amsterdam
Education: 1973, BFA, Rhode Island School of Design, Providence; 1979, Rhode Island School of Design, Providence
Selected References: Dagmar Sinz, "Toots Zynsky: Color for Color," Neues Glas 4 (1987), pp. 276–79; Paris, Clara Scremini Gallery, Toots Zynsky: Oeuvres, text by Aline Jaulin, Linda Norden, and Nane Stern (Paris, 1987); Robert J. Charleston with David B. Whitehouse and Susanne K. Frantz, Masterpieces of Glass (New York, 1990), pp. 236–37; Paris, Clara Scremini Gallery, Toots Zynsky, text by Jean Luc Olivié and Jean-Pascal Billaud (Paris, 1990).

124 **Untitled**
(from the Tierra del Fuego series), 1988
Glass threads
6⅝ × 10¾ × 10 inches
Marks: formed on underside by glass threads, Z
Provenance: Clara Scremini Gallery, Paris, 1988; Dorothy and George Saxe, San Francisco, 1988–91; The Toledo Museum of Art, 1991.141.
Publications: "Toot Zinsky" (interview), Glasswork 1 (Apr. 1989), p. 21 (ill.); Sally Vallongo, "Gifts of Glass: Couple's Collection Helps Art Museum to Rebuild," The Blade (Toledo), June 14, 1992, p. 1 (ill.), 2.
PLATE 61

# Index

Numbers in *italics* refer to illustrations.

## Photograph Credits

Photographs by Tim Thayer and Robert Hensleigh, except:

Dirk Bakker, Chief Photographer, The Detroit Institute of Arts, pages 152 top and 173

Chris Bartol Photography, page 157

Bobby Hanson, page 151 bottom

Kathy Lindquist, page 154

Kathy Merski and John Vanco, page 140

Gary Mortensen, page 135

Paul Parker, Courtesy of The Metropolitan Museum of Art, page 166

Beth Phillips, page 164

David Ward/Crafts Council, page 169 bottom